T0322891

OLIVE COTTON
A LIFE IN PHOTOGRAPHY

OLIVE COTTON
A LIFE IN PHOTOGRAPHY
HELEN ENNIS

FOURTH ESTATE

Australian Government

Australia **Council**
for the Arts

This project has been assisted by the Australian
Government through the Australia Council, its arts
funding and advisory body.

Fourth Estate

First published in Australia in 2019
by HarperCollins*Publishers* Australia Pty Limited
ABN 36 009 913 517

harpercollins.com.au

HarperCollins*Publishers*
Level 13, 201 Elizabeth Street, Sydney NSW 2000, Australia
Unit D1, 63 Apollo Drive, Rosedale, Auckland 0632, New Zealand
A 53, Sector 57, Noida, UP, India
1 London Bridge Street, London SE1 9GF, United Kingdom
Bay Adelaide Centre, East Tower, 22 Adelaide Street West, 41st floor, Toronto,
 Ontario M5H 4E3, Canada
195 Broadway, New York NY 10007, USA

A catalogue record for this book is available from the National Library of Australia

ISBN: 978 1 4607 5834 2 (hardback)
ISBN: 978 1 4607 1204 7 (ebook)

Cover design by Sandy Cull, gogoGingko
Front cover image: Max Dupain, *Olive Cotton holding camera, Culburra Beach, NSW,* 1938, courtesy
 Mitchell Library, State Library of NSW
Back cover image: Olive Cotton, *Shasta daisies,* 1937, courtesy National Gallery of Australia,
 Canberra
Case image: Olive Cotton, *Interior (my room),* 1933, courtesy National Gallery of Australia, Canberra
All photographs are by Olive Cotton unless otherwise stated, and are gelatin silver prints,
 dimensions variable.
Reproductions are courtesy of the Cotton family and the Josef Lebovic Gallery, Sydney.
The author would like to acknowledge the generous support of the National Gallery of Australia
 for providing reproductions of photographs in their collection.
Typeset in Bembo Std by Kirby Jones
Index by Kerryn Burgess
Printed and bound in Australia by McPhersons Printing Group
The papers used by HarperCollins in the manufacture of this book are a natural, recyclable product
made from wood grown in sustainable plantation forests. The fibre source and manufacturing
processes meet recognised international environmental standards, and carry certification.

In loving memory of
Janet Ennis and Joan Maxwell

Contents

PART ONE

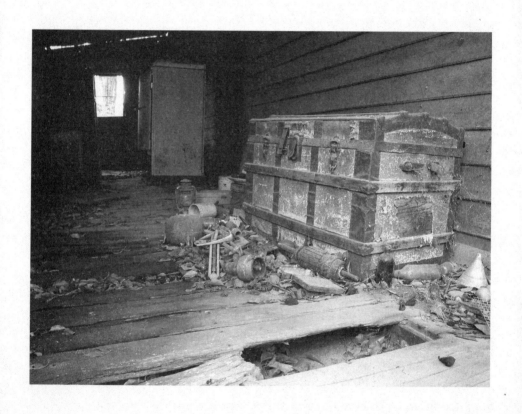

The trunk on the verandah at Spring Forest, 2016, courtesy Roger Butler

The trunk

At Spring Forest, the property where Olive Cotton lived for over fifty years, there is a large traveller's trunk that originally carried her belongings from Sydney to her new home in the country. At one point, it was filled with her photographs, the negatives and prints from the years spent working at the Max Dupain Studio. These days, the trunk sits on the dilapidated back verandah of the 'old house', which was Olive and her husband Ross McInerney's first home. It is part of an odd array of abandoned items: nearby is an old fridge, a kerosene lamp, some broken-down machinery, glass bottles and other bits and pieces. Still structurally sound, the trunk is battered on the outside – some of its waterproof covering is peeling off – but not to the point that any of its contents are endangered. Inside, in no particular order, are notebooks from Olive's student days, programs for music recitals and concerts she attended in Sydney in the 1930s, sheet music for piano, and an assortment of books: novels, poetry and plays, some of which were gifts or prizes. One has a book plate in it saying 'Olive Dupain'; another has a handwritten inscription, 'Love from Daddy'. None of these things made it into the 'new house' at Spring Forest, which she and Ross moved into in 1973, and so they were not physically present in her later life. The trunk, in its rundown location, looks unimportant and could easily be overlooked. And yet it is unexpectedly helpful, because it points to the way Olive viewed not only her past, but also her legacy as a photographer.

Olive Cotton didn't fuss about the future. She wasn't one of those photographers who self-consciously assemble and arrange

their photographic material, business and personal papers and memorabilia with posterity in mind. She was not at all anxious about controlling her own life narrative and the readings of her photographs. Certainly, she kept things that were important to her – the contents of the trunk are proof of that – and she ensured that her most valued photographs went into public collections in art museums and libraries around the country. This was a process that started in earnest in the mid-1980s, when her work from four and five decades earlier began to reappear in exhibitions and publications. However, her personal archive, housed in the trunk and numerous cardboard boxes stored inside her home, is informal at best, reflecting an attitude to the past that was benign, verging on the fatalistic. So far as we know, she didn't embark on any dramatic editing or purging, even though there was ample time to annotate or destroy material if she had wanted to – the most intimate being a long letter from photographer Max Dupain, whom she married in 1939 and left two years later, and correspondence with farmer Ross McInerney, her husband of nearly sixty years. Olive chose not to intervene and instead left her past open to the future – any kind of future – free of her dictates and demands.

This position wasn't simply the result of her view on the value of her work and its legacy; it also related to her understanding of time as being beyond human consciousness and experience. As the daughter of a geologist, she was at ease with notions of geological time and its impersonality, and with what others might see as the wearing physical effects of the natural elements. The state of Olive's informal archive at Spring Forest suggests that she could accept the deterioration and eventual obliteration of belongings she was once attached to and associated with.

There are pockets of intense fascination in the archive, but it is limited as a potential source of information and illumination, frustrating the biographical process. So few of the items either speak of, or to, Olive's inner life. The letters from Max and Ross are revealing, although they say more about each of them than they do

about her; she flickers in and out of their writing as the one being addressed but never assumes a firm presence. There are no diaries, only a small number of personal papers and some letters, mostly those she sent to Ross during the war and extended periods in the late 1940s and early 1950s when they were apart. As a biographical subject then, Olive has surprisingly little weight. This is compounded by the kind of person she was – her character, her personality, her disposition. A long-term friend, Ernest Hyde, described her as 'a background figure', which accords with my own view, gained from a professional relationship that began in 1985, when I was Curator of Photography at the National Gallery of Australia, and which later became a friendship. Reminiscences and anecdotal evidence from other people have reinforced this assessment: her reserve, reticence and modesty were commented on frequently, as was her goodness and kindness. Ross told me, proudly, that in their six decades together, he never heard her speak ill of anyone, not once.

During her long career, which spanned two intense phases, from 1934 to 1946, and from 1964 until the early 1990s, Olive never sought the limelight and was not interested in consolidating or extending her influence and reputation. When she spoke about photography publicly, it was only ever her own; she did not comment on the work of others or address the state of photography more generally. On the few occasions she entered into commentary on her work – in oral histories (two of which are in the National Library of Australia's collection), and in publications – it was invariably due to the initiative of others. While she was delighted by the attention she eventually received, and respectful of it, she was, I suspect, slightly bemused by the fuss.

There may not be a large volume of personal documentation, but there are, of course, her photographs – the very reason for this biography. Olive Cotton is recognised as one of Australia's most important photographers of the modern period. She created a highly original body of work – landscapes, flower studies, portraits and still lifes – that related to contemporary developments, nationally

and internationally, in modernism and modernist photography. Her experimentation with light and its effects, with composition and vantage point, extended the vocabulary of modernism in Australian art to encompass gentler, less heroic modes of expression. Today, her photographs still stand out for their beauty and serenity, and often for their sensuousness as well. In their own quiet way, they have enlarged our sense of the capacity of art photography to move its viewers.

This biography deals with the specifics of Olive's life and photographic work, but her story, like everyone's, belongs to its own particular historical moment. As a woman whose life spanned nine decades of the 20th century, she was subject to the larger forces and events that defined her times. Born in 1911, three years before the outbreak of the Great War, Olive entered her thirties during the tumult of the Second World War. She studied at university, worked in the photography industry, and for a short time was a high school teacher. She grappled with marriage, divorce, remarriage and motherhood. She experienced gender discrimination in society and culture. She lived in the city and in the country, drew strength from her close family connections and strong enduring friendships with women, coped with personal loss, and dealt creatively with isolation and ageing. Olive also saw the population of Australia grow and its ethnic composition alter, its economic fortunes fluctuate and its geopolitical alliances change as it emerged as a middle power in the global arena. But it wasn't these big socio-political shifts and associated issues that found their way into her art. Her concerns and preoccupations were far more personal, always oriented inwards, rather than outwards. As her sister-in-law, Haidee McInerney, perceptively noted, Olive 'had another world inside her head'[1] – a secret, private world that depended on her own highly individual responses to what she saw around her. Max Dupain understood this, too. In a review of her 1985 solo exhibition, he remarked that, although Olive's style was 'in some ways ... documentary ... her personal approach is very evident ... her work is filtered through *her* before it goes on to the paper.'[2] The emphasis was his.

The dearth of primary material has been only one complicating factor in writing Olive Cotton's biography. Another stems directly from her two marriages. Max Dupain and Ross McInerney were both domineering, charismatic men whose voices in life were far louder than hers. In death, too, Dupain and McInerney each left substantial, albeit very disparate archives. As a consequence, Olive's presence in her own life narrative is frequently imperilled, at risk of being swamped, even extinguished, by theirs. Wherever possible, I have quoted her as a way of introducing and asserting her voice, and have drawn on a mix of sources to help build a fuller picture of her: official records, books, exhibition catalogues and other publications, my own observations, and comments and anecdotes recounted by her family, friends and acquaintances alike.

Some aspects of Olive's life are quite straightforward and can be accounted for easily. A geospatial map is, for example, not at all complicated to draw. She did not travel far during her ninety-two years, with her movements centring on two main areas: Sydney and its environs, including Newport on the northern beaches, and the area around Koorawatha in central western New South Wales, where the McInerneys' property, Spring Forest, is located. The furthest point north she went was Coffs Harbour, on the northern New South Wales coast, and the furthest south was Hobart in Tasmania (on a trip as a member of her high school's basketball team). She never travelled to any other states. The only other place outside New South Wales she visited was Canberra, where she honeymooned with Max Dupain in 1939, and went to every now and then in the last two decades of her life to see exhibitions of her work and members of the McInerney family. She never went overseas and flew only a few times, once in Ross's brother John's small plane, an experience she enjoyed. She did not learn to drive until she was in her early fifties and was always a reluctant driver. First Max and then Ross were the ones who did the driving, even on her behalf when she had to be somewhere specific. Olive loved to walk, or to use a verb she favoured, 'to roam', an activity she

embraced from childhood onwards. With its implication of freedom and possibility of chance discoveries, roaming was enmeshed with the joys that came from repeated visits to the same ground: at Hornsby, where she grew up; at Newport, where her family had a holiday house; and at Spring Forest, where she lived with Ross.

There is an additional, far more unusual, though challenging, biographical resource: the three houses where Olive spent the majority of her life. All are still standing, despite the time that has elapsed: Wirruna, the grand Cotton family home in Hornsby, which she left at the age of twenty-seven to marry, and the two-room weatherboard cottge and the construction workers' barracks, known as the 'old' and 'new' houses respectively, where she lived for half a century at Spring Forest. Olive died in 2003, and Ross in 2010, but Spring Forest, which is protected by a voluntary conservation agreement, has remained in her daughter Sally McInerney's family. In the living room of the new house, Olive's and Ross's books are still on the bookshelves near the dining table that looks out to the front yard; in the kitchen, their crockery is in the cupboards and cutlery in the drawers, and in the large pantry, jars of fruit Ross preserved are lined up in rows. Olive's bedroom still contains her made-up bed, and her clothes are hanging in the wooden wardrobe. In the adjacent room, her piano, which originally belonged to her mother, has pride of place; positioned on the left-hand wall, it is the first thing you see as you open the door. In the bathroom, towels are hanging on a makeshift line over the bath and a cake of soap sits on the side of a washbasin. Many of Ross's clothes and personal items are still in his bedroom.

In the front yard, in the area between the old and new houses, Ross's broken-down cars, mainly Austin 1200s and 1800s – seventeen of them, at final count – are parked close to an ancient drycleaner's van and the remains of a rusted-out Buick that Olive's father, Leo, gave the couple as a wedding present. Ross's tools, bits of machinery, wood-heaters and fencing wire lie on the ground in rough groupings, and around the back of the new house, near

the chook pen, are more vehicles and farm machinery, several stoves, dozens of plastic plant pots, sections of beehives and other paraphernalia.

Spring Forest is a curiously paradoxical site, simultaneously a biographer's treasure trove and nightmare. Its chief characteristic is excess, the extraordinary profusion of things proving to be more baffling than revelatory. Indeed, if everything had a sound, the noise would be discordant, deafening, overwhelming. This surfeit is at odds with the refinement of Olive's photography, her elegant, highly organised and uncluttered compositions, and although it means Olive's lived environment requires no reimagining or recreating – signs of her and Ross's life are literally everywhere – the stuff left behind gives very little sense of her.

There are a few exceptions. The piano, for example, which Olive had always hoped to have restored so she could play it again, makes her love of music tangible. But the most confounding detail is relatively inconspicuous. On some of the bedroom doors in the new house, small Dymo labels are attached, each of which bears an initial for a first name and a full surname. These identified some of the barracks' previous occupants, who were workers involved in the construction of a dam at Carcoar in central western New South Wales. The bedroom housing Olive's piano was once delegated to 'N. Boardman', a man Olive probably never knew and about whom she may not have been curious. In the thirty years she and Ross lived in the new house, they chose not to remove the labels on the doors, not to erase the signs of the past, but to leave them there indefinitely.

* * *

Olive wasn't tall, a little over 150 centimetres, and was of slight build; Ross, at more than 180 centimetres, towered over her. Her hair and eyes were brown. People did not describe her as a beauty, but said she was 'pretty' and remarked on the qualities of her smile,

her eyes – their liveliness in particular – and her voice, which everyone agreed was beautifully modulated. In early adulthood, she dressed fashionably, though not flamboyantly, but she did not pay any special attention to matters of clothing or fashion as she grew older. She wore her wedding ring, and a watch on her left wrist, but rarely any other items of jewellery. She never used much make-up, applying lipstick only when she was going out or expecting visitors. Her hair was thick with a slight wave. When she was a young woman, she grew it long for a while, occasionally tying it up in braids she wrapped round her head, but most of the time, she kept it at shoulder length, parting it on the right-hand side and sometimes using a hairclip to keep it in place. She wore a fringe when she was older. She didn't colour her hair, which greyed slowly but never completely. She was not glamorous, and she was not vain.

From the outset, Olive struck me as someone who was non-materialistic (anti-materialistic is far too aggressive a term to be applied to her life view), who placed little store in external 'reality' and whose preoccupations were neither literal nor obvious.

The way Olive Cotton presented herself to the world has been crucial to my conceptualisation of this biography. So has the way she spoke. She chose and enunciated her words carefully, there was never any wasted or extravagant language (I couldn't imagine her ever swearing), no erraticism or emotional eruptions. She spoke softly and slowly, never rushing to fill the silences between thoughts and sentences or chatting merely for the sake of it.

What I have taken from her presence, manifest in part in her way of speaking, is a sense of the deliberation and purposefulness that underpinned her photography. Olive Cotton had an unwavering belief in the value of a creative life and experienced first-hand the struggles and compromises that can threaten to destabilise or even destroy it. She was determined – 'quietly determined', as more than one person told me – to succeed in her photography. This meant not accepting the world of external appearances at face value, and searching instead for underlying relationships between physical and

non-physical forces, and for intricate, highly mobile patterns that resulted from the unceasing, complex dance between light and shade. In other words, being alive to the lyrical possibilities of her chosen medium of photography, which, in one of her few public comments, she defined as 'drawing with light'.[3]

This brings me to another fundamental element that has set the tone of my story of Olive's life: the qualities of the photographs themselves. Olive Cotton's style did not change radically over the years. She was consistent in her approach, ever respectful and attentive to her chosen subject matter and to the medium she had joyfully discovered as a child. In her photographs, there is no over-elaboration or striving for effect, but there is abundant evidence of her ambition and integrity, of seeking what she regarded as pictorially right and true.

Wirruna

Hornsby, a suburb on Sydney's upper North Shore, was home for the Cotton family, the centre of their world. Traces of their deep and enduring connection to the area are still there, some of which are very substantial, others less so. Florence Cotton Park in Blue Gum Valley was created on land donated to the local council by Olive's father, Leo, in memory of Olive's mother; Florence Street was also named after her. Lisgar Gardens, located nearby, were developed by Max Cotton, Olive's camellia- and orchid-loving uncle, and are now open to the public. Olive's family home in Pretoria Parade, which her parents named Wirruna, is still there, too, heritage-listed in 2001 and impeccably restored by its current owners. More than anything, this large sandstone and brick Federation-style house speaks of privilege. When the Cottons moved into Wirruna in 1925, the property comprised eighteen acres of bushland, and Leo and Florence planted orchards and built terraced gardens in the areas closest to the house. Over the next few years, they kept buying land until the property reached a total of twenty-six acres.

Leo and Florence designed Wirruna, an Aboriginal word meaning 'sunset glow', with comfortable family living in mind. The house's interior layout was spacious and attractive, with Australian timbers used throughout, and specially designed stained-glass windows installed in some of the rooms. Each bedroom was equipped with a hand basin and hot and cold running water, and there was a separate maid's room. Verandahs – one of which was fully enclosed and three open-sided – gave views onto the bush

and were pleasant places to sleep when the weather was hot. Outside in the expansive grounds, which were cared for by two gardeners, Olive and her siblings enjoyed a tennis court and a turf cricket pitch, and in summer swam in a rock pool that had been created from the hole where the sandstone for the house had been quarried.[1] Whenever they wanted, the children could go further afield and roam the bush that ran down the ridge into the gully and up to their Uncle Max's place on the other side. There were options for more serious pursuits at home, too. Leo installed a telescope in the attic to obtain views of the night skies and provide opportunities for astronomical instruction, and he built a physics and chemistry laboratory underneath the house for conducting scientific experiments devised for his children. A few years later, he would set up a darkroom there for Olive's use.

Hornsby, then on the northern outskirts of Sydney, was growing quickly in the 1920s and appealed to prospective residents for all sorts of reasons. It was close to Ku-ring-gai Chase National Park, known for its Aboriginal heritage and beautiful bushland, and yet was within easy commuting distance from downtown Sydney, following the completion of the North Shore railway line in 1890. The suburb's higher altitude was also attractive because of its assumed health benefits.

As both sides of Olive's family lived in Hornsby, grandparents, uncles, aunts and numerous cousins were all within walking distance. This co-location was not exceptional for the period, but Olive's childhood cannot be understood without recognising its overriding importance. Always, there was family – extended family – and large gatherings of the Channons and Cottons were routine. It was within this extended family environment, with its complicated mix of world views, that Olive's moral precepts were formed. However, even as a child, she found herself gravitating more towards one side of the family than the other – towards the liberal-minded Cottons.

Olive's maternal grandparents, James and Sarah Channon (née Newbery), moved to Hornsby in 1894. Her mother, Florence Edith,

nicknamed 'Tootie', was born in Canterbury in south-western Sydney in 1885 and was the youngest of six surviving children.[2] The Channons were conspicuous for their wealth and their deep involvement in the local Wesleyan Methodist Church, which was the hub of their family and social lives. James Channon made his fortune through successful business and mining activities, and also owned large tracts of land in the Hornsby area. The Channons' large, two-storey home, called Pakenham after an English ancestor, boasted many rooms, extensive verandahs and beautiful manicured grounds. The family displayed their affluence in other ways, as the extravagant and fashionable weddings of their daughters made abundantly clear.[3]

James Channon's generosity extended to giving each child a furnished house on the occasion of their marriage. His will for probate purposes was assessed in 1920, when Olive was nine years old, at nearly £100,000, a substantial sum, given that the average yearly wage for Australian workers during the 1920s was less than £500, and in today's figures it would amount to millions of dollars. Provisions in James's will draw attention to the family's comfortable lifestyle: he stipulated, for instance, that a sum be set aside for the continued payment of the family's servants.

In the household of her paternal grandparents, things were markedly different. Her grandfather, Francis, universally known as Frank, and his fabulously named wife, Evangeline Mary Geake (née Lane), settled in Hornsby in 1907. Olive's father, Leo Arthur Cotton, the first of the couple's six children, was born in the small town of Nymagee in north western New South Wales in 1883. He had already entered the workforce when the family moved to Hornsby, where they lived in a small weatherboard cottage at 45 William Street, in a less prestigious area than the Channons. The Cottons' three sons, Leo, Max and Frank, had to fund their own education, and two of their daughters, Ethel and Janet (christened Ivy), trained as teachers and supported themselves. In contrast, the four Channon daughters, as Olive tactfully put it, 'were not expected to earn a living'.[4]

The Cottons were, however, very notable for other reasons – political, historical and social. Frank Cotton senior had already earned a place in history as a politician who served in the Labor Party's first caucus; he was the member for the Lower House seat of Newtown in Sydney.[5] Before entering politics, he had variously worked as a shearer, farmer, drover and timber-getter, all of which was pivotal in the formation of his progressive socialist views. Frank also worked as a journalist and wrote for the *Sydney Morning Herald* and several left-wing publications, including *Australian Worker* and *The World News*. Under his nom de plume, 'Porkobidni', which he told Olive came from an Aboriginal word meaning 'unknown', he published several books, mostly on political subjects.

In historical research, men invariably emerge as more substantial figures than women, because of the tangible, often well-documented traces of their deeds and passage through the world, and this holds true for Olive's relatives. Information on her grandmothers, and indeed on her own mother, Florence, is scant. Her paternal grandmother, Evangeline, apparently met Frank, her husband to be, while he was working at a timber camp in central western New South Wales; she was an orphan and was living with her uncle at Bathampton, a magnificent rural property and homestead on the outskirts of Bathurst. About Sarah, Olive's maternal grandmother, whom she remembered as 'a very handsome woman', there are even fewer details, aside from what the minister at Sarah's funeral service in March 1930 described as 'her Christian character and devotion to the church'.[6]

The lack of information about Florence Cotton is compounded by the fact that she died relatively young, at the age of forty-five. Within her family, she was remembered as 'a very gracious and lovely person'[7] and a committed Christian. She was a talented pianist, as well as an amateur artist, who studied in Sydney with the well-respected artist and teacher Dattilo Rubbo, and her particular interest was china painting. Olive especially admired a set of sweet dishes her mother decorated with images of flannel flowers, an Australian native plant common in bushland around Sydney.

For Leo, Olive's father, there is a plethora of material in the public domain.[8] He shone as a student at Fort Street Model Public School and at the University of Sydney, where he won several academic prizes. By the time of his marriage to Florence, he had already completed two undergraduate degrees – a Bachelor of Arts, majoring in mathematics, and a Bachelor of Science – and was a demonstrator at the university's Department of Geology, where Professor Edgeworth David was Chair.

Leo Cotton stood out for another reason: he went to Antarctica on Lieutenant Ernest Shackleton's first British Antarctic Expedition team in 1908. He was not a member of the expedition party itself, which made an arduous, ultimately unsuccessful attempt to reach the South Geographic Pole, but was a meteorological observer based at the expedition's summer camp at Cape Royds on Ross Island. A few years later, in recognition of his standing as a geologist, English geographer and explorer Thomas Griffith Taylor, who was on Robert Scott's ill-fated British Antarctic Expedition (1910–13), named Cotton Glacier in Antarctica for him.

On the family and anecdotal level, Leo is remembered fondly, almost indulgently, as a gentle, sweet person, kind, caring and approachable, learned and unworldly.

Olive's parents were married at Hornsby Methodist Church on 9 February 1910; he was twenty-seven years old and she was twenty-five. According to Olive's recollections, Florence's mother, Sarah, was hoping for 'a more successful marriage',[9] presumably to a wealthier man, better placed in society than Leo. James Channon presented the newlyweds with a large house he already owned, Heatherlie, in George Street, Hornsby, close to other members of the family. Olive was the first of Leo and Florence's five children, born on 27 July 1911, the year after their marriage; she was named after her mother's sister. Joyce was born three years later, followed by James in 1915, Frank in 1919, and Leslie in 1925.

The early years of the Cotton marriage were devoted to child-rearing and the advancement of Leo's career. He completed a

PhD in science in 1920, for which he was awarded the University Medal. His research was highly specialised, focusing on 'isostasy, diastrophism, polar wanderings and the strength of the earth's crust – geophysical studies that reflected his mathematical expertise', and built on extensive fieldwork in Australia, New Zealand and the Pacific Islands.[10] He was appointed Assistant Professor of Geology in 1920 and five years later was promoted to Chair at the University of Sydney.

Crucially for Olive's development, her parents had enlightened views about education, influenced in part by Leo's sisters, Janet and, especially, Ethel. Both were graduates of Sydney Kindergarten Teachers College and were passionate about transforming the quality of early childhood education through the involvement of professionally trained teachers. Leo and Florence expected their daughters to have every opportunity to develop their learning. Olive recollected that at the age of three and a half she began attending Norwood Kindergarten, a private facility, which she understood her father had started in 1914.[11] She probably then attended the state-run Hornsby Primary School and Kindergarten, which had a direct family connection in Ethel Cotton, the highly regarded Principal.[12] The school championed 'physical, mental, and spiritual development' as the central elements in 'a proper education', which accorded with the Cotton family's beliefs.[13]

When she was a young girl, Olive's considerable abilities were noticed. Her glowing report for the first two terms of 1918, when she was aged six, stated that: 'Olive is interested in all her work – she has a remarkable power of concentration … Olive has an excellent influence in the school & is a born leader. She is thoroughly reliable & capable.'

For the next stage of their daughter's education, Florence and Leo selected Methodist Ladies' College (MLC), nearly thirty kilometres away in Burwood, in Sydney's inner west. MLC was one of the first schools in Australia to offer girls the same level of education as boys and from its inception prepared students for entrance into

university. The curriculum also placed a strong emphasis on music, which was important to the Cottons. Florence fostered a love of piano in Olive, who learned to play on an imported Belgian piano, manufactured by Berden & Company, which had been given to her mother by her parents. Olive may also have taken lessons with the distinguished pianist Harry Lindley Evans, accompanist to Dame Nellie Melba, who taught at the State Conservatorium in Sydney. From 1921 to 1929, Olive attended MLC, taking the train each day to and from their home at Hornsby. Her sister, Joyce, joined her a few years later.

* * *

When the Cottons moved to Wirruna, Olive was fourteen years old, Leo had just been appointed Chair of Geology, and Florence was preoccupied with running a busy household, as well as participating in various church-related activities. It was clear that help at home was needed, and the task of filling the room designated for 'the maid' became more urgent. The decision to find a live-in housekeeper and nanny also reflected the family's prosperity and social standing. Florence had grown up in a household with servants, and, in the interwar period, middle- and upper-middle-class homes across Sydney still commonly employed domestic help. The woman whose service the Cottons secured, Miss Lilian Reed, had worked as house matron at an industrial school in Leytonstone, Essex, in England, before applying for an assisted passage to Australia, to begin a new life here. She arrived in Sydney on the SS *Baradine* in November 1924, aged twenty-eight. Leo apparently went down to the docks at Woolloomooloo with the aim of finding 'somebody suitable ... amongst the group of newly arrived young women to help with the large household'. Olive later recollected that:

> According to family lore, he saw Miss Reed and chose to speak
> to her first, and she later told me that when she met my father

she thought, 'This is a good man.' So she was engaged as our Lady Help, and came to live with us.[14]

Miss Reed, or 'Reedy' as the children called her, was a big, plain woman. She was warm and friendly but took no nonsense from her charges. Her housekeeping skills were second to none and she prided herself on not using labour-saving devices – preferring, for example, to boil up the laundry in a copper, rather than use a washing machine, despite how long it took. In the words of a neighbour, Miss Reed 'ruled the family', and her services became even more indispensable when Florence (probably unexpectedly) became pregnant with her fifth child.

* * *

When Olive reflected on her childhood, it was the Cotton branch of the family, and her grandparents Frank and Evangeline in particular, that she spoke of most warmly and identified with most closely. For her maternal grandmother, Sarah Channon, she placed only one story on the public record, recounting it in an amused rather than overtly critical tone. Olive remembered that on Sunday afternoons Sarah entertained visitors at Pakenham and when her grandchildren went there after Sunday school, they were summarily introduced, then instructed to take a piece of cake and go outside, taking care not to drop any crumbs along the way.[15] At the Cotton grandparents' home, the atmosphere was much warmer and far livelier. Evangeline treated her granddaughters, Olive and Joyce, 'like princesses',[16] while Frank regaled them with colourful anecdotes about his past exploits.

The Cotton grandparents provided Olive with compelling precedents in terms of character and life choices. She admired her grandmother, who, in a spectacular show of independence and spiritedness, had eloped with Frank after her wealthy guardian (her uncle) had objected to him as her choice of husband. Evangeline

had no idea where they were going to live or what their future as a married couple held. Olive tellingly drew attention to what she saw as the strengths in Evangeline's character, remarking that 'she must have had terrific courage and backbone' to make the decisions she had.[17] Her grandfather Frank, who outlived his wife by thirteen years (she died in 1929 and he in 1942), assumed an even greater presence in Olive's moral universe. She vividly recalled his tales about various kinds of injustice and his responses to it: giving money away to those who needed it more than he and his family did, supporting downtrodden shearers and striking maritime workers. And, she later noted with wry amusement, reflecting the ardour of his political beliefs, he had 'christened one of his sons "Karl Marx" Cotton, although that child later called himself the non-political "Max"'.[18] ('Karl' was actually spelled 'Carl', but the reference remained obvious.)

Frank Cotton's legacy for Olive was not politics as such. She did not grow up radicalised and become a socialist or a champion of socialism; she did not join any political movement or, indeed, become a political activist of any kind. What she took from her grandfather, and other members of her family, was a philosophy of life based on clear moral values and a strong sense of moral purpose. In the extended Cotton family, Frank senior's example was not an isolated one: Olive was surrounded by luminaries, by extremely engaged and talented individuals who contributed to an extraordinarily wide range of fields, including industry, agriculture, science, politics, sport, arts, culture and education.

The Cotton family were also very creative. Olive's grandfather had been a prolific inventor, holding more than fifty patents for various scientific apparatuses. During the Second World War, her Uncle Frank developed an anti-gravity flying suit in secret at the University of Sydney, the aim of which was to prevent pilots losing consciousness during rapid aerial manoeuvres (its merit was immediately recognised by the military but mass production could not be commenced before the end of the war). Frank junior

also became Professor of Physiology at the University of Sydney, specialising in sports medicine, and was a champion swimmer.[19]

In the arts, Olive had the inspiring example not only of her mother: her aunts Alice and Effie Channon were accomplished pianists and her aunt Janet Cotton later became an artist. Other creative endeavours within her family circle included gardening, exemplified in the ambitious efforts of her Uncle Max, a specialist in biochemistry and physiology with a lifelong passion for plant breeding. Max's extensive garden, on land purchased from Leo, united his scientific and aesthetic interests.

There were common threads linking the seemingly disparate activities of family members. They did not make decisions on superficial or frivolous grounds. They were all well educated and well informed – substantial libraries were part of their households – and could fully immerse themselves in an activity or idea. Olive remembered her grandfather Frank always being absorbed in something, and there were many humorous stories of Leo's and Frank junior's absent-minded behaviour: 'Once, they were in the train coming back to Hornsby playing chess, each thinking it was the other's turn, and they ended [up] in the train shed [at the end of the line].'[20] Sometimes, Leo became so engrossed in gardening, he had to be reminded to change out of his gardening clothes before going in to work at the university.

The Cottons' shared desire to make a worthwhile contribution to society, one that transcended self-interest and egotism, drew equally from religious faith and spiritual values, and from science. Idealism was a unifying and motivating factor, expressed in terms of bettering human life in tangible, practical ways. This helps explain the sense of moral purpose, the motivation behind the good works that preoccupied them. For Ethel and Janet Cotton, for example, it meant educating young children so that they would flourish and reach their full potential, and for the younger Frank Cotton it meant better understanding physical performance in order to enhance it in competitive sports and other settings.

Another key feature in Olive's upbringing was her family's love of nature and, most especially, the bush. Wirruna was idyllic, set in the midst of acres of native vegetation, with extensive stands of ironbarks, blue gums and other eucalypts, and with an immensely rich birdlife. Growing up on this Hornsby property gave the Cotton children direct contact with the natural world and lived experience of the kinds of freedom that came from roaming the bush.

On the few occasions Olive spoke publicly about her childhood and family life, she stressed that it was happy, and that she was immensely proud of two people in particular: her grandfather Frank, and her father, whom she always called 'Daddy'. A family friend described Olive and her sister, Joyce, as 'happy, easy going, cheerful', but the most illuminating remark was made by Olive's brother Frank. Shortly after her death in 2003, he wrote to her family, relaying that: 'In our early childhood and school days Olive would often gently give us sound advice which always proved very helpful.'[21] Here in a nutshell were some of the qualities – gentleness, helpfulness, kindness and thoughtfulness – that became more apparent as she matured and as signs of her inwardness and exquisite sensitivity began to be noticed outside the family.

'My medium'

Whenever Olive talked about her introduction to photography, it was in terms of self-identification. At different times during her life, she said it was 'my medium', 'my thing', which she embraced because of what she recognised as its creative, self-expressive potential. One of her aunts gave her a camera, a Kodak Number 0 Box Brownie, in 1922, when she was eleven;[1] she was buying a new model and thought her niece would appreciate the gift. While Olive had always wanted to draw – and did draw, botanical specimens and the like – she did not think she had any special talents in this area, feeling that her sister Joyce's abilities as a draughtswoman were far superior to her own. She may also have compared her efforts with her mother's, which would have contributed to her lack of confidence. By her early teens, photography eclipsed drawing and it and playing the piano became her primary creative pursuits from that point on.

Being interested in photography in the early 1920s was commonplace, as its democratisation had been underway for two decades. Kodak released its first Brownie camera in 1900, and the numerous models that followed adhered to the basic tenets of being easy to use and inexpensive to purchase, facilitating the mass take-up of photography and proliferation of a new form of photograph – the snapshot. Olive's camera was small, lightweight, made of cheap materials (the body of the camera was cardboard), and used roll film. It did, however, produce surprisingly good-quality negatives.

Olive's enthusiasm for photography was typical of the period but her approach was not. Within a short time, she began to imagine

expanded possibilities for her medium that went beyond being a snapshooter. In this 'great awakening', as she poetically termed it, her father Leo's role cannot be overestimated. Prior to joining Shackleton's expedition in 1908, he had sought informal instruction in photography from a technical officer at the University of Sydney, probably the very knowledgeable Harry Gooch, who worked in the Geology Department. During the few weeks Cotton spent at Cape Royds on Ross Island, he photographed the surrounding landscape, including the active volcano, Mt Erebus (first climbed by men on this expedition), wildlife, especially the ubiquitous seals and penguins that were never far from the camp, and the men's work and leisure activities.[2]

Leo, in Olive's own words, 'started me off'. He shared the skills he had developed on the expedition and taught her how to process her own films and make her own prints, instead of utilising the commercial processing and printing services that underpinned mass amateur photography. He set up a rudimentary darkroom in the laundry under the house specifically for Olive, which meant that, even as a young girl, she could begin exploring the creative possibilities of printing.

As well as giving Olive a head start technically and helping her understand the crucial separation between taking a photograph and making a print, Leo's own photographs of Antarctica had an inadvertent and important function. His children were enthralled by his images of the little-known white continent and the stories that went with them. (In the attic at Wirruna, he kept the winter gear he had worn on the expedition, which friends of the family also loved to see.) Her father's photographs were likely to have been the first Olive came to know well as a result of repeated viewings. While they did not stimulate a taste for travel or photography of faraway places in her, their basis in observation and their honesty were values she intuited and appreciated. Leo took photography seriously, as did she.

Olive's induction into photography reiterated her privileged upbringing in several ways. Not only did she have ready access to the

Gum blossoms in a vase, c.1923

necessary resources and knowledge, she also enjoyed the advantages of a supportive environment that celebrated both scientific enquiry and the power of the visual. Of Olive's first photographs that have survived, one in particular warrants attention – a photograph of gum blossoms in a small glass vase. The composition is a little awkward and the focus isn't sharp but it is telling for a number of reasons. Taken about 1923, when Olive was twelve years old and already passionate about photography, it displays an unusual degree of deliberation and concentrated attention. It is obvious what the point of the photograph is, what Olive chose to look at, to frame and to capture.

The subject matter was also a significant choice for the aspiring young photographer. Flower studies would in time become one of the most distinctive and important parts of her creative practice; she would select flowers with characteristics she admired and arrange them for the express purpose of photography. Her photograph of gum blossoms marked a promising beginning.

Newport

Hornsby wasn't the only stronghold for Olive's family. Newport, on Sydney's northern beaches, thirty-five kilometres from the city, was the other place that held deep and enduring significance for them all. Its attraction was of a different order to Hornsby, as one of those places enriched by ritualised, seemingly endless returns associated with leisure, holidays and summer, rather than with the demands of daily life.

The Cottons' attachment to the area started early. In 1929, they bought a holiday house at 113 Queen's Parade, the main street that turns off the now very busy Barrenjoey Road and heads uphill towards Bungan Head. They had already been visiting Newport for several years by then. The purchase was another indication of their affluence; having moved into their huge new house, Wirruna, which had cost £5000, they still had sufficient extra capital to buy another property. They also gave their holiday house an Aboriginal name, Lyeltya, a word used by Aboriginal people in northern Tasmania, which translates as 'rippling water'.

When their association with Newport began, the area was still semi-rural, a mix of dairy farms, orchards and market gardens. Although not far from Sydney, it had been protected from large-scale residential development by the difficulty of access. The small settlement was serviced from Sydney by ship, rather than by road. Even by 1931, fewer than two hundred permanent residents were recorded as living there. However, the construction of bridges at Roseville and The Spit, which both opened in 1924, proved a

turning point almost immediately; holiday houses, mainly modest weatherboards, began to be erected near the coast on what had been paddocks.

Newport was an ideal holiday spot for the Cotton family, because of its natural beauty and proximity to both the sea and the bush. Their house was well positioned, just a short walk away from the beach, where they could swim either in the sea or the rock pool at the base of the cliffs. To the west, extensive tracts of bushland stretched towards Pittwater and Ku-ring-gai Chase National Park, which provided perfect spots for picnicking. Whenever they could, they went to Newport – on weekends, short breaks such as Easter, and on their annual summer holidays, when they usually stayed for a few weeks. Sometimes, they drove up from Hornsby in Leo's car; otherwise they took a train and bus, a journey that took a few hours.

Newport was to have great personal significance to Olive for another reason. It was there, in December 1924, at the age of thirteen, she met Max Dupain, who was the same age and equally keen on photography. Their meeting was not a matter of chance. Max was the son of George and Ena Dupain, who shared a number of close professional and personal links with the extended Cotton family, and had done for many years. Leo's brother Max was a good friend and colleague of George Dupain. Around 1910, Max Cotton had joined the Dupain Institute of Physical Education, which George Dupain, a pioneer of physical education in Australia, had founded in Sydney in 1900. The depth of their friendship was such that, according to Olive's later recollections, George and Ena may have named their son Max after him.[1] The Dupains had purchased land at 15 Calvert Parade, Newport, in 1920, and built a very basic two-room timber weekender, which they called Waioni.[2] It was Max Cotton's visits to the Dupains here that apparently inspired Olive's parents to buy into the area.

There were other important connections between the Cottons and George Dupain, though none were as close as Max Cotton's. Leo gave Dupain's Institute his professional endorsement[3] and his

sister Janet was affiliated with it as a visiting lecturer from 1920 until 1935.[4]

The Cottons and Dupains had similar values, attitudes and aspirations, which contributed to the easy, almost intuitive understanding Olive and Max gained of each other. Their family units were strong, enmeshed in tight-knit extended networks with grandparents, aunts, uncles and cousins all living nearby – in Hornsby, in the Cottons' case, and in the southwestern suburb of Ashfield, in the Dupains'. Both sets of parents valued education and learning, selecting a private secondary school education for their children (MLC for Olive and Sydney Grammar for Max), and expected them to attend university and develop professional careers. Work was of undisputed importance, and Florence and Ena supported their husbands in their demanding and absorbing occupations. The women were religious – Florence was a Methodist, and Ena an Anglican – whereas the men shared a scientific, rationalist bent that underpinned their professional and personal lives. There were, of course, also differences between the two families, but these were relatively minor. The Cottons were far more affluent and their household was much larger, with four children before Leslie was born, while Max was an only child.

Crucially, the families shared a deep love of Newport and everything it had to offer. The Dupains didn't own a car and used public transport for their journey from Ashfield. In Max's view, distance and time counted for nothing when they had the chance to spend a weekend at the beach:

> … mother packed bags of food and clothing early Saturday
> morning and we took off in the first bus to come rattling up
> the then dirt surfaced Parramatta Road; first stop was Central
> Station. From there it was tram to Circular Quay, ferry boat
> to Manly, then tram to Narrabeen and finally bus to Newport.
> Three hours in time did not matter …[5]

The proximity of the Cotton and Dupain holiday houses also facilitated contact. To get to Waioni, only a few hundred metres away from Lyeltya, Olive walked up Queens Parade towards Bungan Head and its wonderful, expansive views over the ocean, and turned into the last street on the left, where the Dupains' block sat on the clifftop. The beach and rock pool below could be directly accessed from steps cut into the cliff at the back of the yard. As Max later explained, the site was:

> beautiful … looking out over the Pacific Ocean and the
> sun would rise in the east, just out there, and we'd have
> this beautiful, glistening stretch of water in front, and that
> would … start the day, and it was leisurely … the beach and
> the surf were all that mattered … you ate well, slept well, and
> had all the exercise in the world during the day. What more
> would you want?[6]

The combination of family connections, similar backgrounds and a relatively free and relaxed lifestyle at Newport, created an informal setting for the development of Olive and Max's friendship. Indeed, the degree of freedom they seemed to enjoy is striking, at least in the early years, when close parental supervision and chaperoning do not seem to have been an issue. (That would change as signs of their romantic attachment began to emerge in their later teens.) What originally drew the two youngsters together was very specific; in her characteristically straightforward, understated way, Olive later explained:

> We were both interested in photography (though … [Max]
> had a more sophisticated camera, with a bellows) and we could
> roam all around Newport together taking pictures.[7]

In the first few years, when they were getting to know each other, Olive and Max were more likely to meet up at the beach, or on

the Bungan headland, rather than at each other's house. In this stage, although they took photographs together, they developed their negatives independently, in their own home darkrooms built by their equally encouraging parents. However, as their interest in photography became more serious and their friendship strengthened, they began sharing darkroom work, their interactions extending beyond Newport and the short stints their families spent together. Contact gradually became more planned and regular. Olive recalled that she sometimes developed Max's negatives in her darkroom at Wirruna, or she went to his place in Ashfield on weekends, where they would work together in his darkroom. It was, she said, 'stimulating to have someone else doing the same thing',[8] reinforcing the centrality of photography in their initial friendship.

Maxwell Spencer Dupain

Because Olive said so little about her childhood and formative influences, it is necessary to rely on historical documents and secondary sources that are mostly impersonal. They have the effect of making her a distant figure, in many ways, with her early life already well and truly historicised. The situation with Dupain is totally different. There is no shortage of first-person material, as he gave numerous interviews during his life, wrote extensively and published several autobiographical accounts. The narrative of his life that he assiduously constructed is full of colourful detail and anecdotes, which help bring a strong sense of him into the present.

Maxwell Spencer Dupain was an energetic, physically capable and confident child – probably overconfident, indulged or, as he put it, 'spoiled rotten'.[1] Born in Ashfield, Sydney, on 4 April 1911, he was the only child of George Zephirin Dupain and Thomasine Farnsworth (née Hawthorne), known as 'Ena', who had both been born in Sydney. They married in 1910, the same year as Olive's parents. Max attributed his self-described romantic nature to the combination of his father's French and mother's Irish ancestry. As a child, he was doted on – 'worshipped' was the word he used – 'by three adoring females', from three generations: his mother; his maternal grandmother, Susan Farnsworth; and his great grandmother, Sarah Mortley, the matriarch, whom he held in great affection.[2]

The Dupains' connections with the suburb of Ashfield went back to 1882, when his English-born great grandfather Joseph William

Mortley, a builder, settled there (he was also a very successful mayor of Ashfield). Like Olive, Max grew up surrounded by relatives. Residences on Parramatta Road, built by his great grandfather, housed different members of his family over the years. When he was a boy, he lived at number 162, Symington (where he kept rosellas and galahs and had a rabbit and guinea pigs), and then at number 158, Rose Bank, which had formerly been his great grandparents' home. He went to Ashfield Preparatory School and attended the local Anglican church, St John's, with his mother and her relatives.

Max valued three aspects of his childhood above all others: the slow pace, simple pleasures and the stability of his family life. His family and neighbours enjoyed games of tennis, an occasional outing to a movie, nothing that was complicated to organise or expensive. His parents were very happily married; they were, he later said, 'devoted to each other', and there was no domestic conflict. He felt their example was one to emulate, and painted an alluring picture of their family life in interviews and publications:

> There was a huge library at home [George owned around 10,000 books on health-related subjects] where my father would sit, read and write almost every night and my mother would sit on the opposite side of the vast desk and read also. They would exchange thoughts on their specific books every so often. There would be laughter and harmony prevailed.[3]

He was deeply attached to both parents and readily acknowledged their influences on him, drawing a vital distinction between his mother's interest in subjective matters, especially in English literature, and his father's intellect and rationalism.

Ena ruled the domestic space – care of her husband and son were her top priorities – and George worked extremely long hours building up his business and developing his specialisation. His Institute of Physical Education, located in the Manning Building at 449 Pitt Street, Sydney, boasted an impressive set-up, with

laboratories, lecture hall, hydro-therapeutic room, anthropometrical testing room, special physical education reference library and a gymnasium. The young Dupain, who often worked in the gym, remembered that its facilities were first class 'for fencing, parallel and wall bar exercises, weight lifting, running, giant tennis'.[4] The latter game, which used a heavy ball, was invented by Dupain senior and was one Max himself loved to play. George Dupain wrote several influential books on the benefits of a good diet and physical exercise, and was a supporter of eugenics.[5]

The family followed the strict dietary regime George developed. Max's solicitous mother would regularly check whether her young son had eaten the celery biscuits or other nutritious items she baked especially for him. One friend, Joan Sample, who became close to Max in the late 1930s, remembered George as 'a very kind man, a gentle person', who 'almost dedicated his life to building the perfect specimen of humanity in his son. And Max seemed to accept it all very well.'[6] By his own accounts, Max was eternally grateful for his family's commitment to excellent nutrition and exercise, which set him up for a healthy adulthood.

Although only a young teen when he and Olive first met, like her, he had already discovered his love of photography, having been introduced to it by a close family member. His mother's younger brother, Clarence, was an amateur photographer, and Max recalled watching, fascinated, as his uncle processed film in an improvised darkroom in the laundry at his home. It was Clarence who gave Max his first camera, when he was twelve or thirteen years old, a rudimentary Box Brownie, which Max recalled leaked light, but which nevertheless enabled him to begin seeing his world through a camera lens. As Olive had done, he was fortunate to find photography at a time of emerging adult consciousness, making a profound connection with something that was uniquely meaningful to him, even if he could not yet articulate the specific nature of the attraction.

Deepening thought

'Farewell to Seventeen' 11/7/29
Youth wore its bright ideals. All the world
Lay waiting to be conquered at my feet.
I tasted rain, and warmth, and light and wind
And felt exultantly that life was sweet.
O.C. [final verse]

The green traveller's trunk at Spring Forest, in which Olive stored items from her early life in Sydney, is still half full of printed material. Most of it relates to literature and music: books, programs for concerts and recitals she had attended, and musical scores which she had learned to play on her mother's piano. There is also a small group of exercise books dating from 1928 and 1929, her final two years at Methodist Ladies' College. In its totality, this assortment of items creates a picture not only of a cultured and sensitive young woman with a love of literature and music, but also of a very clever, high-achieving student. Teachers' comments on her English essays testify to her outstanding academic abilities, as do the number of books awarded to her as prizes.

The exercise books are mainly from her English classes and plot her journey through the western literary canon: from Chaucer, the Metaphysical poets, the Romantic poets, through to Jane Austen and the 19th-century English novel. She usually scored A or A plus for her essays and assignments and received abundant praise from her satisfied teachers for her sensitivity, insights and powers

of discrimination. Her response to the topic 'Distinguish between Romanticism and Classicism in literature' earned an A and the glowing comment 'You have a rare gift for associating ideas, Olive', while an essay on the functions of criticism was commended as being 'finely perceptive'. Poetry was one of her strongest interests, and an essay addressing the questions 'Is there any satisfactory definition of poetry? Has poetry any use? What does it mean to you?' attracted an A plus and the comment 'Subtle; discriminating; lit with poetic truth.' At the same time Cotton was immersed in the English classics, she was reading the works of French writer Gustave Flaubert and Australian fiction writer and poet Dorothea Mackellar. On a few occasions, she was required to write a creative essay rather than respond to a set topic or question, and she excelled in this less structured, less analytical area, too; one essay was graded 91 per cent and received still more praise, 'Very appealing. Form, conception, and style are all admirable.'

The assignments in the exercise books give a semi-public view of Olive, showing how she presented herself – and how she was judged – in the educational sphere. But once they had fulfilled their official role, perhaps at the end of a term or an academic year, Olive turned the books over to her personal use and filled up any blank pages with her introspective musings. This writing introduces a rare personal dimension and illuminates her predispositions at a crucial stage in her life, when she was becoming increasingly self-aware and open to the largeness of the world. The writing takes different forms: there are several poems, a short story, and transcriptions of what amounted to instructional texts that helped her think about how she wanted to live, and about her values and ideals. One such transcription came from *The Story of My Life* (1903), the autobiography of Helen Keller, the deaf and blind American author and political activist who triumphed against all odds and fulfilled her aim of going to university. In the passage Olive transcribed, Keller reflects on what she learned in 'the transition from romantic to actual' and comes to the hard-won conclusion that:

I have learned many things I should never have known had
I not tried the experiment. One of them is the precious
science of patience, which teaches us that we should take our
education as we would take a walk in the country, leisurely,
our minds hospitably open to impressions of every sort. Such
knowledge floods the soul unseen with a soundless tidal wave
of deepening thought ... to have knowledge – broad, deep
knowledge – is to know true ends from false, and lofty things
from low ...

The appeal of Keller and her life story is hardly surprising. It is
rousing stuff that affirmed the Cotton family's commitment to
cultivating both a reflective and engaged approach to life. Olive
continued to explore these lofty ideals in an autobiographical short
piece she titled 'Crowded hours'. Its springboard was the poem 'The
Call' by British poet and military officer Thomas Osbert Mordaunt,
which she and Max both admired. She took the last two lines from
the verse which reads, 'Sound, sound the clarion, fill the fife! /
Throughout the sensual world proclaim, / One crowded hour of
glorious life / Is worth an age without a name', and incorporated
them into what is effectively her personal manifesto, as she
transitioned from adolescence into adulthood.

Have you ever tried to count up all your crowded hours? – by
crowded hours I mean those times when you have enjoyed
yourself to the very utmost. Something set me thinking the
other day, when we were discussing whether we would rather
be persons who would feel intensely – feel radiantly happy,
perhaps only for a fleeting moment, yet a crowded moment,
but in time of trouble or sorrow, would suffer deeply – for
natures extremely sensitive to joy would be sensitive to sorrow
in a like degree: or whether we would rather be mediocre, and
neither live intensely nor suffer deeply, keeping more to the
even, undisturbed course of life.

I would rather the former, for I think 'one crowded hour of glorious life is worth an age without a name.' 'Crowded hours' have I had any? ... Of course I had – what about that holiday at Newport? – it was one long series of crowded hours – when we ran barefooted, bareheaded all day long – played cricket on the green, unfenced paddock nearby – or went, fourteen of us, in the sturdy little car for a picnic some miles away, and I sat in the open side-door way, with my legs hanging out – or, best of all, when tea was finished and washing up done, we played chasings in the twilight with the girls and boys next door, and I found that I could outrun everyone – even lumbering Charlie who was so good at cricket.

'Crowded hours?' – yes, what about those ... bright Sunday mornings, when Daddy and I would go for a walk in the bush; the one persuading, the other cajoling mother that it was much better to be in the sunshine than in a cold, stuffy church ...

Here, flushed with romantic idealism and passionate feelings, the eighteen-year-old Olive declares her desire to live as intensely as possible even if it proves painful. In her ambition, perhaps unconsciously she aligns herself with her father, rather than her religious mother and the church with which Florence was associated. This is itself significant. It indicates her desire to imagine a future beyond women's conventional and stereotypical roles, as embodied in her mother's life, and to look to her father's way of being in the world as an alternative. Even more consequential, in terms of the evolution of her photography, is her recognition of the powerful attraction of nature. As a teenager, Olive feels that, in contrast to being in 'a cold, stuffy church', the experience of 'a walk in the bush ... in the sunshine' offers the possibility of experiencing 'one crowded hour of glorious life'.

The exalted hours she identified were confined to her experiences within her family and the familial domain and, in that sense, are

striking in their innocence. However, a handful of intimate poems allude to other major changes that were occurring in her life. They may not have literary merit but they do usefully establish that Olive and Max's relationship – she called him 'Laddie' and he called her 'Lassie' – was becoming more intense in their last months of high school. One poem, titled 'Laddie in the greenwood', ends with the announcement that 'they are waking to a world of youth with lovelight in their eyes'. Another, titled 'A song that came in the train at night', from September 1929 goes like this:

> Laddie called me 'dearest',
> (All the lights are winking
> In and out the windows as the train goes
> by).
>
> Laddie called me 'dearest'
> And 'Lassie, Lassie darling',
> (Little clouds are playing with the moon
> on high).
>
> Laddie called me 'dearest'
> And 'Lassie, Lassie darling',
> And – Laddie called me 'Sweetheart',
> – I wonder why ...?

Olive completed her high school education in 1929, although she could have done so one or even two years earlier. She spent two years in fifth form, apparently because she was considered too young to go on to the Senior School, and then two years in sixth form because her father did not want her to start university until she was eighteen. He told Olive that he had seen young students too often floundering in their studies due to their lack of maturity, and did not want to subject his own children to such stress. She completed the Intermediate Certificate in 1926, and the Leaving

Certificate in 1929. By the end of her studies, she had a great deal to be proud of, as a later tribute in the MLC magazine, *Lucis*, made clear, describing her as 'a star'.[1] Her impressive school record shows she was a talented all-rounder, excelling academically and in sport, and fulfilling multiple leadership roles at the school. She was a member of the Senior Swimming Team and the First Senior Netball Team in 1928 (Premiers) and again in 1929, a Prefect in 1928, and Senior School Prefect in her final year, which was effectively school captain. She was also Vice-President of the Christian Union. Her outstanding academic performance culminated in being awarded the School Prize and the prestigious Old Girls' Union Prize, which *Lucis* states, 'was, and still remains, the School equivalent of a Rhodes scholarship'.[2]

Despite the intensity of her studies, Olive continued to pursue extracurricular activities. Encouraged by her mother, she took private piano lessons and participated in the musical section of eisteddfod competitions. Her engagement with photography also flourished while she was at MLC. In her last year, she became a member of the Photographic Society of New South Wales, the unofficial hub for both amateur and professional photographers in Sydney. Joining the society was an unequivocal statement about her passion for the medium, which was becoming an essential part of her life, and her desire to become a better photographer. It was also something she shared with Max, who had already become a member.

The university years

In 1930, the year Olive started university, the effects of the Great Depression had begun to bite in Australia. Her family was shielded to a large extent by Leo's secure university appointment and salary and there was no expectation or necessity for Olive to consider finding work to contribute to the family's livelihood, as in less privileged households. Her decision to study for a Bachelor of Arts was not at all surprising, given her class, background and circumstances, and her impressive high school results.

Tertiary education was the norm in Olive's immediate circle, but what was unusual was the involvement of the women as well as the men. Frank Cotton's wife, Olive's aunt Catherine (née Drummond Smith), was an excellent student, graduating from the University of Sydney in 1911 with First Class Honours and receiving the university medal in geology. The example of her aunts Ethel and Janet Cotton, both graduates of Sydney Kindergarten Training College, was particularly significant. Not only were they professionally trained, they were pursuing careers based on ideals of self-realisation they had absorbed in their studies. A Sydney Kindergarten Training College brochure described kindergarten teaching as 'a new call to consecration of womankind to the highest element in her nature–nurture … Her new view of her work, its responsibilities and its importance, will give to her a sincerity, a depth and a dignity that will need no argument to prove her to be a man's equal.'[1]

The involvement of women in higher education and professional training was not typical of the time, however, and when Cotton

began her degree, the number of women studying at university was still small. University of Sydney statistics for 1930 establish that the ratio was around one-third women to two-thirds men – 776 women and 2048 men attended lectures that year – and in 1933, her final year of study, the proportion of women studying was slightly less, with 757 women to 2305 men. By 1939, only 28 per cent of undergraduate students Australia-wide were women (this is the earliest gender breakdown for undergraduate enrolments at Australian universities). As Janine Burke emphasises in her ground-breaking book, *Australian Women Artists 1840–1940* (1980),[2] the years immediately after the Depression saw a resurgence of conservative views on the role of women that reversed gains feminists had made in the 1920s. Put bluntly, women were seen to belong at home, serving exclusively as homemakers and child-bearers, a view that neither Cotton nor her family subscribed to.

As Olive was immersing herself in her studies, her aunt Ethel was taking on an increasingly public role in early childhood education. She was becoming recognised as an expert with a deep commitment to developing innovative forms of pedagogy and popularising practical applications for effective teaching and learning, in spelling and mathematics in particular. Ethel, inspired in part by Italian educator Maria Montessori's approach, advocated active learning or 'self-help for children', and parental involvement in their children's education. Her first spelling primer came out in 1932, *The Modern Speller: Word building and grouping for children from six to eight years,* and was followed by a co-authored mathematics primer, *Rainbow-pattern Arithmetic for Children of 6 and 7 Years* in 1934.[3] These primers became foundational texts in the Australian education system and more were to come in the next two decades. For Olive, the seriousness of Ethel's commitment to her field was exemplary.

* * *

During Olive's first year at university, her family faced an unexpected and far-reaching personal tragedy. On 7 October 1930, her mother, Florence, died at the age of forty-five. She had undergone an operation, and died at home from a haemorrhage a few days after being discharged from hospital. Olive was nineteen years old at the time, Joyce was sixteen, Jim was fifteen, Frank was nearly eleven and Leslie, her youngest sibling, was only four. Florence's funeral service was held at the Hornsby Methodist Church, with which she and the Channon family were so closely associated, and she was buried at the Northern Suburbs Cemetery. Reflecting the family's high status in the community, the *Sydney Morning Herald* published an obituary for Florence,[4] reporting on the large gathering of friends and family at the funeral, and listing some of the distinguished mourners in attendance, who included Sir Edgeworth David and his wife Lady David, several professors from the University of Sydney, the President of the Royal Society and members of the Linnaean Society (Leo belonged to both societies). Although not listed in the obituary, the closeness of the family connections meant the Dupain family, including Max, were almost certainly among the mourners.

With Florence's sudden death, family life was thrown into turmoil. Olive's brother Frank later said the household became awfully sad and bereft. One of Leo's students, David Branagan, remembered that Leo's work patterns changed after Florence died; as soon as he finished teaching for the day, he took the train home to Hornsby and his family instead of staying at the university to converse with his colleagues. His research output diminished and never regained its earlier impact (although he was called on to publicly comment on the geological significance of an earthquake that occurred in Napier, New Zealand, only a few days after Florence died). Olive referred obliquely to their forlorn situation when describing her father's actions in the years after Florence's death. In what she summed up as 'desperation', Leo wrote to their former housekeeper, Lilian Reed, whose homesickness had forced her back to England in 1933,[5] imploring her to return to Sydney to

resume her pivotal role in their family life. Fortunately, she agreed to his request, leaving her home in Grays, in Essex, where she had been working as a domestic, and arriving in Sydney in 1934. Miss Reed took control once again, running the home, looking after the children as each one completed school and university, and supporting the bereaved Leo.

Florence's death was one in a cluster that devastated Olive's close family in a three-year period. Her maternal aunt Alice Rishworth died in 1927 (aged forty-nine), her young cousin Bruce Channon died in August 1930, and both her grandmothers died within a few months of each other: Evangeline Cotton in June 1929 (aged seventy-six), followed by Sarah Channon in March the following year (aged eighty-two). By the time of Olive's mother's death, Frank Cotton was her only surviving grandparent, and on her mother's side, only three of the six Channon children, one aunt and two uncles were still alive.

Fortunately, there weren't only funerals to attend. There were also innumerable gatherings of the Channon and Cotton families, and birthdays and weddings to celebrate. Olive was one of the bridesmaids at her first cousin Madge's wedding in 1932, another occasion for a public display of the Channons' wealth and social standing.[6]

Olive did not interrupt her degree to grieve her mother's death, but there is no doubt that it and the resultant familial and emotional difficulties weighed heavily on her. She continued her majors in English and mathematics, and also studied botany and geology, subject choices that affirmed her family's dual interests in science and the arts. However, not everything went according to plan. In third year, she made the decision to take an anthropology course and for the first time in her life had to deal with academic failure. She later outlined the reasons for this:

> I was too prim and proper for anthropology. You had to talk
> about all sorts of things and I couldn't bring myself to do it.

I failed that year and even though I spent fifteen hours a day swotting up in the holidays I still failed … Looking back I can see I really dodged the big questions, the things I didn't feel I could talk about comfortably, so I had to spend another year at university to make up the subject.[7]

This admission of her limitations, and her inability to address 'the big questions' in the study of human societies and cultures, points to the relatively rarefied and protected life she was leading. On an academic level, the solution was to replace anthropology with psychology, which she went on to pass, successfully completing her Bachelor of Arts degree at the end of 1933. On a more personal level, she remained tightly bound to her family, and was yet to establish her full independence.

'A perfect specimen'

Max Dupain's parents had high expectations of their only child; George hoped that he would study medicine and then perhaps follow in his footsteps in the field of physical education. Sydney Grammar School, which Max's parents chose for his secondary education, enjoyed the support of pillars of New South Wales society; the newspaper magnate Sir James Oswald Fairfax, for example, served on the school board and was a generous patron while Max was a student. The school's commitment to physical education as part of a rounded curriculum was an important attraction. As the Governor of New South Wales, Sir Dudley de Chair, told the student body in his end of year speech in 1927, 'The essentials of character building ... were self-respect, self-control and physical fitness.'[1]

But if George and Ena hoped Max would excel academically, they would have been disappointed very early on. By his own assessment, his academic record was 'shocking'.[2] He was not interested in science or mathematics, failed French in the Intermediate Certificate, and did not complete the Leaving Certificate, which was the prerequisite for university entrance. However, while at Sydney Grammar, Max discovered a love of English literature, and sport, especially rowing, along with the extracurricular activity of photography, which were all to assume lifelong importance.

The pairing of English and sport reflected the dualistic nature of his parents' legacy: his mother's interest in literature and his father's in physical fitness. What excited Dupain about the English texts he studied was their creative strength and power. Being introduced to

the works of Shakespeare was a life-changing experience; when I interviewed him in 1991, he quoted several passages from *Macbeth* he had learned at school and still loved. And, like Olive, he enjoyed poetry, English poetry in particular, which stimulated him to try writing his own. Some of his poems were published in Grammar's student magazine, *The Sydneian*, during his sixth form year. While other boys dealt with the trials and tribulations of student life in jocular tones – one published an ode to the tuckshop woman – Max explored far more serious themes. There is no mockery or self-deprecation in his poems, which stand out for their earnestness and romanticism. His first published efforts were 'Contentment', 'The sea at night' and 'Sea murmur', the latter being the most ambitious, full of feeling and literary flourishes, as the first verse reveals:

Smothered, unceasing and dull, through the long dead night
Cries the mournful, monotonous murmur of the sea;
And I lie in a restless sleep here, wondering why
So peaceful a thing
As the ceaseless old chant of the deep
Should suddenly
Piteously revoke
A dreadful and bitter mistrust
That youth must die.[3]

The emotional nature of the poems paralleled his nascent landscape photography and, in one instance at least, he paired the written and the visual. 'The Tree' was accompanied by a moody photograph taken at Bungan Beach, near Newport, underlining the fact that, at this stage of his development, his poetry and photography were entwined, thematically, intellectually and emotionally.

At the same time as studying the classics of English literature and poetry, Max began some self-directed reading and became, as he put it, 'infatuated with Norman Lindsay',[4] the well-known Australian artist and writer. Lindsay's book *Creative Effort: An essay*

in affirmation, which had been published by Sydney Ure Smith's firm Art in Australia in 1920, was especially appealing. At the age of sixteen or seventeen, Max wrote to Lindsay, presumably to express admiration for his work, and received a reply with an invitation to visit his home at Springwood in the Blue Mountains, west of Sydney. It wasn't an invitation he could accept, because his 'mother wouldn't hear of it'.[5] Ena's disapproval probably stemmed from Lindsay's notoriety as a painter of female nudes that left nothing to the imagination, as well as his very public bohemianism. While still married to his first wife, Catherine, the mother of three of his children, Lindsay had lived with Rose Soady, formerly one of his models.

While Max had little interest in his academic subjects at school, sport was different. Sydney Grammar's offerings were wide-ranging and well resourced. Boat sheds at Glebe, for example, housed all the equipment for students' rowing sessions on Sydney Harbour. The school celebrated sporting prowess at both individual and group levels, dedicating pages of every issue of *The Sydneian* to summaries of results and frank commentary about the abilities and performance of their aspiring sportsmen. In his junior years, nothing indicates that Dupain was an outstanding athlete; he was mentioned only once in *The Sydneian* for athletics, winning third place in the 440 yards running race in the 'Open Handicap' section.[6] However, once he became involved in rowing, he began to excel, regarding his achievements as a highlight of his school career. He rowed for Grammar's First IV rowing team in 1929, and delayed leaving school so that he could compete again in early 1930. In the group photographs taken at the school's rowing camp in the years 1929 and 1930, he appears as a handsome, fit-looking young man, his dark hair fashionably parted in the middle.

The pleasures of extreme physical exertion and intense mental focus that he experienced when rowing sustained him in his creative pursuits as well.[7] From the outset, the personal photography he undertook outdoors was a very physical activity, and many

of his images celebrated the power of the elemental forces that underpinned the vitalist philosophy he would become attracted to.

The most significant development in his high school education was his growing interest in the visual arts. Two drawings signed 'M. Dupain' were published in *The Sydneian* in April 1929. One, of an historic building at Grammar, was selected as a banner image for the magazine and was received favourably by other students – they regarded it as 'excellent'. Another, a drawing of a tree published later that year, incorporated a literary reference that once again showed the young Dupain's emergent romanticism. Underneath the drawing, he inscribed a line from a poem by English writer Alfred Noyes, 'Grow, my son, like a tree', a sincere but unsubtle pairing.[8]

By the end of his schooling, however, photography had become his obsession. Max later identified it as the reason he failed his Intermediate Certificate – all he could think about during the final oral exam in French was buying a new camera. The purchase was tantalisingly within reach because his sympathetic great grandmother had given him some money on the morning of the exam. Once he had purchased the Kodak Folding Brownie, he was filled with great anticipation and 'kept thinking about the photography adventures ahead'.[9]

His artistic bent was recognised by his teachers. He was twice awarded the Carter Memorial Prize for the profitable use of his spare time, in 1928 and again in 1929. To be eligible for the prize, students had to present an exhibit of some kind 'accompanied by a written description of the work and the history of its development', and assessors took into account 'handicraft, originality, proportion of outside assistance, research, economy and ingenuity'.[10] Exhibits were diverse, ranging from aquariums of rare fish to working models of motors. In Max's case, in 1929, he presented an exhibition of pictorialist-inspired soft-focus landscape photographs, some of which may have benefitted from him joining the Photographic Society of New South Wales the year before. With funds from the Carter Memorial Prize, he selected books that revealed the love of

English poetry he shared with Olive: he chose the collected works of popular English poets John Masefield and Alfred Noyes, as well as a book on how to draw. Quotations from Masefield's poems would soon find their way into a love letter to Olive.

When it became clear to George Dupain that his son was creatively rather than academically oriented, he fully supported him. He initially gave him access to his own 'cherished laboratory', which Max used as a darkroom at night, and then they converted the pantry in their house into a well-equipped darkroom with 'all the mod cons of a going concern: sink, running water, shelves and a work bench, also an old horizontal enlarger'.[11]

By June 1930, Olive was already halfway through her first year at university, but Max, now aged nineteen, had not yet completed his Leaving Certificate. There was no point in him staying on at Sydney Grammar. George and Ena may not have expressed it overtly – Max said that his parents were always open-minded and exceedingly generous towards him – but they must have been anxious about his future. Presumably, in an attempt to help find him a suitable career, his father arranged a meeting with one of his colleagues, Joe Collins, an art director who worked for a leading advertising executive, George Patterson. Max duly showed him examples of his recent drawings and photographs, and received a response that would determine not only his immediate future, but also his lifelong career. Collins dismissed the drawings and the prospect of working in the field of commercial art, and praised the photographs, which he felt showed considerable promise. On the strength of this positive assessment, he gave Max an introduction to Cecil Bostock, a well-established, artistically inclined commercial photographer, whose studio was in Castlereagh Street in the city. Bostock agreed to take on the young man and so Max began his working life, as an apprentice earning thirty shillings per week. This meant he had secured employment and training that pleased his parents, and, at the same time, he could continue exploring the possibilities of an artistic photographic practice.

A strange dream

The rawest piece of writing Olive kept was on a couple of scraps of paper tucked into one of the exercise books stored in her trunk. It was reworked to include some corrections but is an intensely private outpouring that was unlikely to have been shared. It dates from 1930, her first year of university, and was written in September, a month before her mother died. Although the protagonists in the text have no proper names, the male being referred to as 'he' or as 'Laddie' and the female as 'she', their respective identities are obvious. More than any other surviving document from this early period, nineteen-year-old Olive's account here of a distressing dream illuminates the evolving dynamic of her romantic relationship with Max.

She flung herself into bed, miserable and defiant.

That afternoon she had said something which led him to think that she was jealous of all the interest he took in his Art. And then she was angry at being thus misunderstood and had blurted out something about his 'old Art' that hurt him. In a flash she had got up and left him before he realised what she was doing – and now she was angry with herself and miserable because she knew he must be unhappy too. She fell into a troubled sleep and in the early hours of the morning she had a strange dream:

Away up under the fir trees sad little puffs of blue smoke were mingling fitfully with the leaves; they were coming from a fire, built in that very nook where they had so often

been together, and he was standing there with an armload of pictures. One by one he looked at them lingeringly, one by one he slowly and deliberately thrust them into the fire; she stood powerless to move or cry out, watching this destruction that somehow she had caused. All were burnt save one now and that was a portrait of herself. He looked at it long and intently, once he made a reckless move to thrust it in the fire, and once he drew it back. Would he burn it? Would he? ... If he did it would be the end of all their happiness together. She struggled to cry out and woke up to see the grey cheerless light of early morning in the sky. She lay awake sobbing and restless. She must go and see her Laddie, she must, she must − it was too early yet, she would go as soon as the sun rose. How slow it was! She would go and slip into her bathers ...

Now the first rays of the sun appeared, she sped down the road and across the grass, her feet keeping time to a kind of sing-song that was running through her head 'Oh Laddie, Laddie, coming, coming, Laddie, coming, coming, oh −' she was at the gate, opening it stealthily, and now she crept round the verandah and uttered a faint little whistle.

Somebody stirred inside. He too had been awake since the early hours of morning, and now he heard − or was it his imagination? − he thought he heard her whistle. Surely it must only be his imagination, it couldn't be really true; still he must satisfy himself. He tumbled out of bed and opened the door and looked down on a tear stained face.

'Sorry' she blurted out − and then turned abruptly and ran down the narrow cliff path, for she had a sudden feeling that she was going to 'howl' again. Down she went, and round past the baths on to the big, friendly, sheltering rocks, and there she crept into a corner to have her 'howl' out. But something prompted her to look back, and she saw someone scrambling over the rocks towards her. She had hoped he would come but he was much sooner than she expected. Once again she fought

back the tears and bent her head to examine a shell, and waited with uncomfortable uncertainty.

Suddenly she felt herself lifted easily and strongly into the air and in another instant she was on his knees with her head snuggled up … against his right shoulder.

And somehow all her reserve left her, she crumpled up and sobbed with sheer glad relief. He was glad too, ['he knew he had won' is crossed out here] and he hadn't mistaken all the sincerity and meaning and pent up emotion in that brief 'Sorry', and he knew he had won.

'Laddie' she said later, 'You know I didn't mean the least little bit of what I said about your art? You do, don't you?' He hugged her still closer rubbing his cheek against her hair.

'I love your Art and I do want to learn to appreciate it properly with you. Do you know, I had an awful dream last night.' 'Did you?' he said lightly. She told it to him, and at the end he said, 'Do you really think I would have burned that last picture?'

'Well, you certainly looked as if you might,' she was half teasing now.

'But do I look now as if I might?' She buried her head in his shoulder and drew his hand that was against her cheek. His dear, rough hand, brown stained with developer and kissed it, hard.

This 'strange dream' is not entirely fanciful. Bar the bonfire and symbolic burning of Max's most loved possessions, it seems firmly embedded in the real rather than the imaginary. It does, for instance, provide incidental, highly credible information about Olive and Max's access to each other's holiday homes at Newport. Most importantly, however, the dream's contents signal Olive's anxiety about the strength of Max's feelings for her and whether she matters more to him than his art photography. None of her own activity is mentioned. All her effort is directed towards better appreciating his

art – even if it takes precedence over her and, by implication, her photography – and ensuring that he is happy. This involves a high-stakes capitulation when, in an ostensibly happy resolution, the dreamer kisses his 'dear, rough … brown stained' hand. Rich with symbolism, this image refers to their mutual and erotic exchange, as well as to his photography, signified by the chemical staining of his skin. The dreamer knows, however, that in the intense psychic and emotional struggle that has occurred, she is the loser. Her male protagonist 'knew he had won'.

Dupain's apprenticeship

Olive Cotton was not professionally trained in photography and so did not engage directly with other professional photographers working in Sydney. For several years, her interactions with them were at an amateur level, principally through her membership of the Photographic Society of New South Wales. She was, however, an indirect beneficiary of Max's apprenticeship with Cecil Bostock: by 1930, she and Max were sharing whatever they could in their lives and in photography. Much later, Max explained that they 'were quite close at the time and both shared photography as a hobby. It was one of those things that was a stimulant as far as I was concerned. We had that in common.'[1]

In many ways, Bostock's studio was perfect for a fledgling photographer – he and Harold Cazneaux were the most significant photographers working in Sydney at the time and had long, productive careers behind them. They belonged to the same generation (born 1884 and 1878, respectively) and were both pioneers in the field of photographic illustration, which was becoming increasingly important in the early 1930s, though drawings continued to dominate mass-produced advertising imagery. However, in contrast to Cazneaux, Bostock is a half-formed figure in Australian photographic history, having not received any in-depth scholarly attention to date. He was forty-six years old when Max began working for him: Max remembered him as a short man, with the most wrinkled skin that he had ever seen, and great horn-rimmed glasses through which he peered at

everything.[2] His interests were varied, encompassing photography, commercial art and bookbinding. He had even designed and built a powerboat.

Although Max felt that Bostock 'had no taste, no taste whatsoever',[3] his involvement in art photography was extensive and he actively promoted photography as a medium of artistic expression. His impressive *A Portfolio of Art Photographs* was published in 1917, and he edited *Camera Graphs of the Year*, for the First and Second Salons of Photography in 1924 and 1926, which showcased the latest in pictorialist photography.

However, Bostock was a troubled man and not at all easy to work with, as Max quickly discovered. He described his employer and mentor as 'a strange creature' with a 'mercurial temperament', someone who was 'difficult and intransigent'. In 1947, in a piece for the magazine *Contemporary Photography*, he gave a frank account of Bostock and what he regarded as his shortcomings:

> Underestimating his work in photography and overestimating
> it in business, he never seemed to achieve a state of happiness
> in his work. It was a struggle that he seemed predestined to
> suffer, come what may. He never sought publicity and hated
> those who did … He hated the necessary business routine and
> the attention required of clients. When his meticulous and
> carefully-handled work was rejected by uninformed people
> for trivial reasons, he would storm with rage and curse the
> person concerned from stem to stern. 'Damn and blast them,'
> he would rant, 'let them get to hell and [get] someone else!'
> Unfortunately they did.[4]

Joan Brown, who worked in the office not long after Max had left, summed up Bostock as 'dour'. It is now recognised that Bostock's wellbeing was gravely affected by his awful experiences as a gunner in the Australian Imperial Force (AIF) during the First World War, which he outlined in his diaries.[5] Max believed that the war

'just about did him in'[6] and all indications are that he endured the consequential psychological and emotional damage alone.

As a photographer, Bostock's technique could not be faulted and his impact on Max in this respect was profound. During his apprenticeship, he learned the technical skills that would set him up for life, and his intimacy with Bostock's approach to photography helped him define his own modus operandi. In his autobiographical essay 'Past imperfect', written nearly forty years later, Dupain gave a considered appraisal of Bostock's importance to the history of photography in Australia:

> Then there was Cecil Bostock, so often irreconcilable; loved one day and hated the next. I joined him immediately after school … He could barely afford to hire me because work in the early 1930s was hardly plentiful. Bostock was a foundation member of the Sydney Camera Circle which, despite its fixation with the English Pictorial School, did have an idealistic philosophy by today's standards. It was elitist. Bostock and Cazneaux were thought of as the exponents of upper crust photography in Australia. The former objective in approach and finish; the latter subjective in attitude and content. Bostock was versatile and had unquestionable technical ability, Cazneaux was a romantic, in love with life. It was my good fortune to be able to cope with Bostock's mechanical thoroughness and pragmatism; these elements helped straighten out my romantic schoolboy notions. I was very conscious of his methods and simple principles which aimed at perfection at any price within human limits.[7]

The implication here is that Dupain was attempting to reconcile what he saw as the respective strengths of Bostock and Cazneaux in particular, and to unite the technical and subjective or emotional aspects of photography. He also considered versatility to be a fundamental aspect of his inheritance from the two men, frequently

arguing that a successful business must 'be versatile or else'.[8] Bostock's perfectionism was vitally important, too, giving Dupain a goal, which he felt took years to achieve in his own work.

Although Bostock often frustrated and annoyed the young Dupain – he was so sick of him at one point, he considered asking Cazneaux if he would take him on – he valued his opinions nonetheless and sought them out whenever he could. Sometimes, he would bring in a recent photograph for an informal critique session. Bostock would 'lie it up against the wall and criticise it', a process Max found very useful, as it helped him form his own views about the qualities of a successful photograph in an era before formal education in art photography had been introduced.[9]

Max benefitted from working with the excellent clients in industry and retail Bostock had secured. They undertook photography for leading engineering firm Mauri Brothers and Thompson; shot window displays for David Jones, Sydney's premier department store; and photographed the showrooms of antique dealer and furniture manufacturer Francis De Groot (De Groot having famously disrupted the opening of the Sydney Harbour Bridge in 1932 by charging forward on his horse and slicing the ceremonial ribbon with his sword before New South Wales Premier Jack Lang could cut it as planned). This professional experience, Max later wrote, provided 'good material for good photo craftsmanship', but he ultimately found it unsatisfying because it excluded any possibility for self-expression – in his blunt assessment it was 'Emotionally nil'.[10]

Max's apprenticeship spanned the worst years of the Great Depression, from 1930 to 1932, but fortunately Bostock managed to eke out a living and keep him on. Max recognised that his employer's situation was sometimes precarious – Bostock, his English-born wife, Violet, and young child, Joyce, were all living in the studio at Castlereagh Street at one point because they could not afford to rent separate residential accommodation. Despite being sympathetic, Max felt that in the end Bostock was condemned by

the mediocrity and repetition involved in commercial work that he had no choice but to accept. In his view, Bostock was 'Pictorially emasculated by boredom'.[11]

During his apprenticeship, Max was keen to improve his understanding of art and sought out influences beyond photography and the confines of Bostock's studio. Citing his desire to learn how to paint landscape, he enrolled in night classes, first at East Sydney Technical College, and then at Julian Ashton's Art School, which were the premier places for studying art in Sydney. He enjoyed the social milieu of both institutions, as the students would get together after class, drink coffee and argue together endlessly. At this time, he met Peter Dodd and Chris Vandyke, who would become very close friends and whom Olive would come to know, too, as part of their circle. However, he didn't advance in his studies; he could draw at a basic level but felt that his lack of ability prevented him progressing to the life drawing class, which was the next step for a serious student. One of the most positive outcomes from his education at Ashton's was meeting the teacher and artist Henry Gibbons, whose maxim, 'It is all a matter of form and movement',[12] influenced his understanding of how to construct an image. Max also learned from Gibbons that the foreground is the most important part of a landscape, something he held dear throughout his life.

The combination of Max's on-the-job training with Bostock and his self-initiated arts education ensured that his growing knowledge of photography had rigorous underpinnings, technically and aesthetically. Max directly, and Olive indirectly, now had insider knowledge about what a professional career in photography entailed.

'Darling lass'

Olive kept a letter from Max – 'Your own lad' – that shows how deeply involved they were by 1931, when she was in her second year at university and he was well into his apprenticeship with Bostock.[1] (No letters from her are known to have survived.) He wrote it because they were apart during the Easter break in April. This was normally one of the prized, few occasions when they could spend a run of days together, and a perfect time to enjoy the beach after the intense summer heat had ended and the days were warm and still. He was at Waioni with his parents. She was camping with her friend Gwynneth Stone at Comboyne on the mid-New South Wales coast, and her family had been expected to spend Easter at home in Hornsby. However, the Cottons changed their plans at very short notice, unexpectedly turning up at Lyeltya. Max's heart leapt in the hope that Olive was with them and it was the 'bitterest surprise' to find that she was not. Several times over the ensuing days, he tried 'to discover the consolations of this holiday without having you' and came to the dispiriting conclusion, 'There are none.' In her absence, he filled twenty-three pages of notepaper with his feelings of love, longing and optimism about their future, when there would be no more 'sudden parting'. Retrospectively, this document is of unrivalled importance, giving insights into their relationship, as well as useful factual information about their circumstances and shared interests, especially in art.

Max was writing to his 'Darling lass', his 'own dear dearest Darling', 'the best girl in the world', his 'Darlingest', and was longing

to be with her because he hadn't seen her for 'an aching age'. What he sent was an earnest, tender and sometimes rambling epistle, the fulfilment of a promise he had made before going to Newport: 'I promised I would write you "the biggest and best" letter I have ever written. Well, here it is sweetheart, I think it is "the biggest" but I doubt if it's the best.'

The letter establishes that the couple had already been romantically involved for some time but were still shy about overtly displaying their passionate feelings for each other. When Max imagines jumping up and hugging Olive in front of their parents, he tellingly adds '(Not really!!!)', the triple exclamation marks indicating that he felt he must restrain himself. And yet Olive's father had acknowledged and encouraged their relationship a few months earlier in a scene that Max relived with pleasure:

Oh Lass, dearest, do you remember those four days we had together with Uncle Max and the others. I came down at night then; how excited I was as I crept up Lyeltya's steps and into the living room; 'Had I had tea?' everyone asked. 'No!' – of course I hadn't had tea but there was some lunch in my bag yet undemolished and that would do. But your Dad would not have that and strange to say he gave me 'the order of the kitchen' all because you were 'cookie', I think, and had not finished up at the time … Oh my own dear dearest Darling, I think I recall that hour as one of the 'scrummiest' I have ever had; if you were here I would kiss you as I did after that tea, and renew the thanks I gave you that night for your trouble.

When Olive's father dropped over to see his parents, Max made sure he walked past the drawing of her he was 'slaving over' in her absence: 'I'm sure he recognized it and how I chuckled!!' He hoped that the portrait would be 'the source of a little more understanding to him, that our love runs deeply, and like the course of all true love

"doesna" run smooth!!!' What this lack of smoothness referred to, there is no way of knowing.

Externally, Max notes, very little is happening at Newport – the days are 'uneventful' – but internally it's a very different story. He is in a tumult, thinking of Olive constantly, while swimming (the swims are for 'us'), walking (to places they must go to again together), drawing her, gazing at a photograph he had taken of her, replaying in his mind intimate moments they have enjoyed and imagining what it will be like to be with her again.

> I have a little glossy print in front of me ... you are looking
> straight at me with dear loving eyes; there are curls around
> your neck and your bare left arm is showing too; it looks a bit
> bigger than it is normally though – blame the 3" [inch] lens!
> You have a watch on, and a copy of *Photograms* and a camera
> case are on the rock beside you. On the back of the print I have
> written 21st Dec '30; oh Lass wasn't that one of the 'scrummy'
> weekends we had at Xmas time, besides the four days which
> we crammed full to the very limit? When I was going for that
> walk this morning I imagined what it would be like if you
> had been with me; I heard you talking and making pointed
> remarks (you were in a 'frisky' mood I think!) sometimes your
> shoulder gave me a 'dig' as much as to say 'I didn't mean it,
> and I still love you!' Oh I could have slipped my arms around
> you and hugged you ever so tightly when I thought of that. Do
> you know, Darlingest, sometimes it's quite easy to imagine you
> speaking and laughing; often and often I catch myself grinning
> at a little imaginary 'tête-a-tête' between 'us' ...

He tells her what time it is as he is writing, marking out the days and nights they are apart, describes the weather on several occasions and shows his extraordinary attentiveness to light: 'the shadows are beginning to lengthen and that mellow light of Autumn afternoon is commencing to flood the landscape highlights; people passing

are lit up with a warm glow particularly those in bathing suits that reveal contour of arm and shoulder.'

Throughout the letter Max develops their private language, their language of intimacy, repeating and extending his endearments. He frequently uses their nicknames and cites places that are significant to them and them alone, such as 'our fir trees'. Drawing on vivid memories of where and when they have kissed, he also offers her an account of an erotic (but impressively chaste) daydream of a few days before.

Let me see … oh yes it was Easter and we were both at Newport safe and sound. You came over one night to watch the moon rise and we went down the cliff path slowly in the dark, me going first and holding your hand for safety. We were going to sit on the seat at the foot of the cliff and wait for the moon. Down, down we went until we reached the seat; being forgetful I sat down first, but gently pulled you down onto my lap and snuggled and cuddled you up as tightly as I could. Oh Lass, it was sweet, and when I had 'thought' it over for about the fifth time, someone shouted 'Boulton's Corner!' and woke me up. I had a grudge against the conductor that lasted until I stepped out of the bus and looked onto Newport. There it was as I had never seen it before, for I had never been to Newport on a full moon night and so here again was something more to add to my little collection of Newport's delights and poetic beauties. Off I set down the road passing all the gums round the Church lit with white moonlight; how eerie and mysterious they looked …

Their intimate rituals are established as well. Olive had told him in one of her letters that she would be thinking of him 'at dawn and sunset', and he responded by saying, 'I have watched for you at each too.'

As one would expect of young lovers still living with their parents, the letter is filled with anticipation for their future and being

together forever. In his first extended postscript, Max imagines the days they spent apart will pale into insignificance, and is confident that, 'We shall have years and years and years and years together some day.'

While Max's letter is for Olive and speaks to their relationship, it does, of course, also reveal a great deal about him, too. The overwhelming impression is of a serious, often emotional young man who is deeply in love. Prompted by his disappointment that Olive wasn't with her family, he shows his vulnerability, telling her that, 'alas I'm a bit of a sensitive bird at times.' And his writing is conspicuously full of striving – 'to be a perfect lover' first and foremost, and to 'write a most perfect love letter'. This latest effort does not fulfil his high expectations and he stresses that he will do better next time: 'I shall try with all my heart to tell you some of the innermost feelings I have about you, they are the sweetest of tenderest joys.'

One of the letter's most striking features is the profusion of references to the arts, to literature, music, painting and photography. Some are overly self-conscious; for example, in a rather pompous start, Max compares the sunset at Newport to the painting *Afternoon glow*, by Australian artist Hans Heysen. However, as he settles into his writing, this self-consciousness gives way to less strained, sometimes very poetic observations and reflections that demonstrate how responsive he is to the natural world and its phenomena. The couple's shared love of literature, fiction and poetry especially, is very apparent. He is delighted by Olive's 'little touch' in an earlier letter, when, in a reference to C.S. Lewis's *The Chronicles of Narnia*, she declared, 'We could have our Easter together as we wished with its long long walks together at night under the broad sky and listening to "the sea and the singing stars".' The direct quoting suggests Max had Olive's letter with him, no doubt treasuring it and re-reading it as a way of keeping her close. In turn, he quoted from two poems by John Masefield, 'The west wind' and 'A consecration', from the book bought with money from the Carter

prize he won at Sydney Grammar. He tells Olive about the music he is listening to, mentions Heysen's art twice, and refers to the work of Belgian pictorialist photographer Léonard Misonne, which he so admired for its mastery of light. All this indicates that a wide-ranging and informed discussion on the arts was an integral part of their relationship.

Although only twenty, Max is already convinced of the importance of the arts and of his work, having identified what his lifelong profession and passion will be. In the agony of waiting to see Olive again, he explains that he finds 'consolation in that which I love best and it is my work and preparation of my ideals'. He outlines why he respects his employer Bostock – 'Boz' – but demonstrates his independent thinking and astute judgement when describing him as a consummate technician, rather than a visual poet. Although he refers to his participation in evening classes at Sydney Technical College, where the painter Douglas Dundas was teaching him drawing, it is clear he and Olive are pursuing their own informal education. Together, they look at publications such as *Australia Beautiful* and others specific to photography, including the influential English journal *Photograms*.

Max tells Olive about photographs he has taken, and is confident that he has 'made negatives of one or two beautiful landscapes, for the trees there are almost perfect in shape and are rather the type which Misonne would delight in'. Landscape, he believes, is the most emotional form of pictorial art, surpassing everything else, including still life studies, portraits and figure studies. It is 'the pure poetic landscapes' that 'set the imagination working ... [and] the heart aching'.

Finally, in the absence of any of Olive's correspondence, what sense of her emerges from his letter – aside from being immensely lovable and affectionate? The importance of her family, love of the outdoors, her companionability and enjoyment of life are overwhelmingly evident. Tellingly, however, Max finds her attitude to photography sometimes wanting: 'I wonder if you used your

camera successfully to record some pictorial mood or decoration, I do hope you did. I know you can if you only would take it a little more seriously!' Perhaps Olive was beginning to focus less on her photography than he was, or to downplay it in his company. Then, presumably to help develop her confidence and motivate her, he declares that she possesses the two great characteristics governing works of art in all media, which are 'Sympathy and Imagination'. Unfortunately, however, the tone of his comments is overbearing.

While full of dreaming – 'what a joy it will be when I can see you and hold you to myself with all your warmth and glowing eyes and lips' – Max's letter also deals with practical matters, the most pressing of which is arranging their next meeting. Significantly, it will be built around their shared photography.

> What about next Saturday, Dearest, do you think you can
> come. If I get a chance (and they're rare!) I'm going to ask your
> Dad if you can spend the afternoon at Rose Bank! Also you
> might bring some negatives which you would care to 'push'
> thro' the lantern, and perhaps the films you exposed this Easter
> (if they're undeveloped, that is!). Anyhow perhaps you could
> give me a ring ... either Tuesday or Friday night would do.

* * *

Five months after enduring the Easter separation that Max had found so interminable, he presented Olive with a gift, which she would keep until the end of her life. Everything about it shows deliberation, care and pride. It was a photograph he had taken at Pittwater, underneath which he had signed his nickname, 'Laddie', and on the reverse, written in pencil, is the dedication, 'to my beloved in memory of our birthday September 1928. Lad 22.9.31.'

The inscription is confirmation that their romantic relationship had begun at least three years earlier, when they were aged seventeen and in the second last year of high school; the reference to 'our

birthday' probably alludes to the day they effectively, though not necessarily publicly, committed to each other. In his Easter letter, he had noted that 'some sunsets brought back the dearest feelings and remembrances … we were only school kids then but heaven knows those minutes were the beginning of something – that something which counts for most in our lives.'

His anniversary gift was a sure sign that their relationship was growing stronger. The photograph he chose depicts a scene not far from Newport, which they both knew well. It is a pretty, calm image with a huge expanse of still water mirroring the soft clouds in the sky, and with a narrow band of land running horizontally through the centre of the composition. The main vertical accents are the sailboats, their slender upright masts elongated by their reflections. Here, the young Max shows his command of pictorial conventions, of composition and tone, but not in an arid, technical way. His concern was with evoking a gentle, reflective mood. How appropriate then to give the photograph to Olive, his 'beloved' and companion in photography.

Great possibilities

In September 1932, at the age of twenty-one Olive Cotton made her public debut as a photographer. Her landscape photograph *Dusk* was displayed in the Interstate Exhibition of Pictorial Photography, organised by the Photographic Society of New South Wales and held at the David Jones Exhibition Gallery in the city. This was a significant achievement for the aspiring photographer and showed how much she had already learned about the prevailing conventions of art photography through the combination of her membership of the Photographic Society of New South Wales, access to publications of photography and her relationship with Max. Whenever she could, she attended the society's meetings at their rooms in Elizabeth Street in the city and was especially appreciative of the critical feedback provided by senior members. She later recalled:

> [Harold] Cazneaux, [Cecil] Bostock, Bill [William] Buckle, all those wonderful people were there. You'd take photographs along and they would be criticised. What made it a terrific experience was that you tried so hard each time to have something worthwhile.[1]

Max, likewise, relished the rigorous process of peer review – subjecting the photographs to this kind of scrutiny was, he concluded, 'a great thing'.[2]

The society's competitions and exhibitions were also the primary means of seeing original prints at a time when exhibitions of art

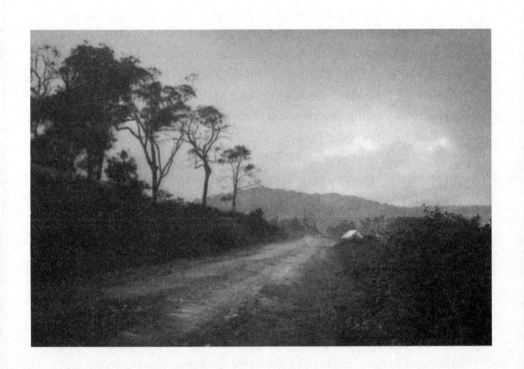

Dusk, 1932, National Gallery of Australia, gift of the artist 1987

photography were far fewer than they are now. It would be decades before art museums and galleries began developing extensive collections of art photographs and curating them into exhibitions.

Meeting the leading professional photographers involved in the society was inspiring for Olive. These men took photography seriously and enjoyed international reputations, frequently being selected to show work overseas alongside their international peers. Cazneaux was elected to the London Salon of Photography in 1921, the apogee of art photography at the time, and was a regular and highly regarded exhibitor in England. He was also the international voice for photography in Australia, contributing an annual round-up on national developments to the influential English publication *Photograms of the Year*, which Olive and Max both devoured (several copies were in Dupain's personal library at the time of his death).

Olive's entry to the 1932 exhibition is in the soft-focus or 'fuzzy wuzzy' pictorialist style, which had been flourishing in Australian photographic societies and clubs for nearly three decades by then. It originated in Great Britain and Europe in the 1890s and was championed by such groups as the Linked Ring Brotherhood in England, and later by the Photo-Secession in the United States. Adelaide-based photographer John Kauffmann is generally credited for introducing pictorialism to Australia in 1897, after returning from an extended stay in Europe, including Vienna, where he studied photography and contemporary reproduction processes. The photographs he exhibited on his return demonstrated his understanding of a European style of pictorial photography, one which greatly influenced Australian practitioners.

The exponents of pictorialism were determined to create photographs that were accepted as works of art, produced by an artist rather than a camera machine. To this end, they extolled the virtues of artistic manipulation and employed processes that involved highly skilled hand-work and permitted the introduction of subtle colour (brushes were used to apply different coloured inks, mainly brown, blue and green, to textured paper). The works they produced

often looked more like prints or drawings than photographs. Other readily identifiable features of pictorialism include a relatively narrow range of subject matter, with landscape being regarded as the most important; a predilection for atmospheric phenomena like smoke and mist that had softening effects; and literary, often flowery, titles. As a consequence, pictorialist photographs appear more 'olde worlde' than modern, which explains their fall from favour in art photography circles from the mid-1930s onwards.

Curiously, Olive did not embrace hand-worked processes like gum bichromate and bromoil,[3] which were stock in trade for Cazneaux and other eminent practitioners; the only form of manipulation she used in her early work was composite printing, where two or more negatives were combined to produce a print.

The softness of *Dusk* was achieved without any overt working of the print surface, but in every other respect, it is a standard pictorialist work – a generic landscape with picturesque qualities and a timeless feel. The unsealed country road, flanked by dark-toned, non-specific vegetation (it could be indigenous or exotic), provides the main diagonal axis in the composition, running towards a light-toned roof in the middle distance that indicates a farm dwelling of some kind. Over half of the composition is sky, touched with delicate light cloud that is barely discernible. Like fellow pictorialists, Olive avoided bright sunlight and made her exposure as light faded from the scene. In the darkroom, she paid careful attention to print quality, using specially made dodging and burning tools to control where the light fell on the print and to achieve the desired disposition of tones.

Like Olive, Max was attracted to pictorialism and he explored the style in a sustained way in his earliest works. As mentioned in his love letter to Olive, one of his favourite exponents was Belgian photographer Léonard Misonne, a regular exhibitor in the London Salon of Photography and a recognised master of the bromoil. Max owned a Misonne bromoil, *Nuages* from 1927 (presumably purchased at a society show in Sydney), which obviously Olive would have

seen. Misonne's prints were larger than most Australian works and particularly commanding in exhibition displays. However, what most inspired Max was Misonne's belief that, for photographers, light was everything. This dictum was pivotal in the development of his own approach; he felt it underscored the intellectual and emotional basis of a successful picture. Olive would certainly have agreed.

Max was also selected for the 1932 Interstate Exhibition, and Cazneaux responded enthusiastically to his work, especially a moody landscape, *The flight of the spectres*, executed in bromoil. In his review for *The Australasian Photo-review*, Cazneaux declared that, 'A new worker of more than ordinary promise has arisen in Max Dupain. Most of his essays are emotional in character.'[4] In the same review, Cazneaux flagged the beginning of a new era in photography that must have been inspirational for young practitioners such as Olive and Max. In the midst of the Great Depression, Cazneaux had lamented that professional photographers were feeling 'the pinch of the times. Many, especially those who are pictorialists, are having a woeful time.'[5] But now that the economic uncertainty was easing he was confident that a beneficial 'photographic atmosphere' would prevail, especially in Sydney, where the two premier photography organisations, the Photographic Society of New South Wales and the Sydney Camera Circle (an influential society formed in 1916 by Cazneaux and others) were co-located.

Arguing that 'photography should be kept pure, avoiding a fashion that makes a photograph look like an etching', Cazneaux called for improvements to ensure that the medium would have a dynamic future.

I do not wish to suggest that we sweep aside all the conventional principles of design and composition, they will always be the foundation. What we want is a greater knowledge of new ideas to break the monotony of the photographic exhibitions, wherein we have too much of the 'pretty' picture element ... The world is on the brink of new

things, new ideas, not to desert the old, only to improve, to portray them in a new light; the future holds great possibilities.[6]

While others, including Max, later came to rail against pictorialism as anti-photographic and a dead-end in the quest for modernity, Olive did not. For her, the pursuit of a modern style did not depend on a wholesale rejection of pictorialism and she remained respectful of its attributes and achievements. Indeed, her entire output was underpinned by its key tenets: the evocation of beauty, stimulation of the senses and emphasis on the effects of light. These concerns were already evident in *Dusk*, a competent, pretty and modest work, which also demonstrated the deliberation and sensitivity she would develop in her subsequent photography.

Art and science

From the outset, gender was exceptionally important in framing Olive's participation in photography, affecting her perceptions and expectations about what she could do and about what was actually possible. Gender differentiation was evident, too, in the way that she and Max each developed and communicated their public narratives about their lives in photography – what they chose to say, when, how and to whom. This helps explain why the volume of primary source material regarding the early influences that helped shape their evolving views on life and art is so unequal.

Determining the key influences in the formation of Olive's early views is difficult because she said so little publicly. We know, for instance, that she loved music, was a very accomplished pianist and ranked Chopin as her favourite composer. She was also a regular concert-goer who enjoyed the best classical music on offer in Sydney; concert programs in her traveller's trunk at Spring Forest establish that she heard performances by an impressive range of international musicians during the 1930s. But we do not have specific information about what else she most valued at this stage of her intellectual and artistic development. For Dupain, however, there is an abundance of lists filled with the artists, writers, composers and philosophers he revered. Everyone from Beethoven, British novelist and essayist Llewelyn Powys, Shakespeare, English poets T.S. Eliot and Rupert Brooke, D.H. Lawrence (his mother's favourite author), to Australian poet Christopher Brennan, American architectural historian Lewis Mumford, and more.[1]

Although Olive did not draw attention to science, its role in her life and work was fundamental. Not only did she have the examples of her father and extended family, who were deeply committed to science and scientific method, but she also had her own specific training, having studied botany and geology at university. This enabled her to conceptualise something quite complex and difficult to define: a form of reconciliation in her art photography that can be thought of as poetic rationalism, which united scientific principles of observation and detachment with visual lyricism. Crucially, this approach differentiates her work from Max's, and by 1937 it was beginning to have tangible results in her photography.

The divergence in Olive's and Max's viewpoints can be explained with reference to two of the lynchpins in Max's philosophy of life and photography: Australian artist and writer Norman Lindsay, and English novelist D.H. Lawrence. By association, Olive was intimately acquainted with both sources but did not find them relevant to her or her art practice.

Max regarded Lindsay as a genius. Discovering his book *Creative Effort: An essay in affirmation*, while a student at Sydney Grammar, paralleled Olive's inspiring encounter with the writings of Helen Keller at an equally formative stage in her development. The controversy Lindsay generated was no doubt another attraction, in light of Max's evolving anti-establishment views. (Lindsay's satirical novel, *Redheap*, was banned in Australia in 1930 for obscenity and indecency, and the following year police seized copies of the magazine *Art in Australia* that featured a portfolio of his works the authorities described as 'filthy'.)

Lindsay made his world view abundantly clear in *Creative Effort*, and from Max's perspective it was his most impressive and sustaining achievement. It expressed a quasi-religious belief that 'the gods had come down from Olympus in ancient times and begotten children on the earth people', creating a race of Olympians that was set apart from the rest of humanity and populated by great artists.[2] In this division of humankind into two groups, there could be no doubting

which one was superior. 'The great mass of humanity,' Lindsay claimed, 'is concerned with only three problems: filling its belly, clothing its body, exercising its senses.'[3] He dismissed this inchoate mass and those he described as the 'lesser intellects' and 'feminine half-minds that find in creeds, political or religious, a direction for life', whose sole goal was to 'make existence less difficult'.[4] Then there were the exalted few, himself included, who 'address themselves to the highest achievement – to the creative effort'.[5] These individuals did not seek dominion over others but only 'over self'. From Lindsay's understanding of world history, it was obvious that: 'One thing alone in existence is manifest, permanent, indestructible, and that is the individual effort to create thought and beauty.'[6]

Olive could remember Max keeping his copy of *Creative Effort* close at hand and reading extracts aloud to her, but she never identified with Lindsay's views or the absolutism, drama and excess that characterised both his visual and literary work. For Max, in these formative years, Lindsay's championing of the individual confirmed his own evolving romantic philosophy. He found Lindsay's views liberating because they stimulated his revolt against the status-quo.[7] The same can be said for the work of D.H. Lawrence, which he embraced for its anti-rationalism and elevation of subjectivity. As Max saw it, 'Lawrence was all instinct and intuition. He figured that man had lost his real lust for life because all his instincts and native intuitions had been civilised out of him.'[8] Lawrence offered him much to emulate and he 'worshipped his sensitivity to life and circumstances, his beautiful verbal response to nature, man and women'.[9] He also hoped that he himself was 'just as sensitive' as his hero.[10]

The other vital point of distinction at this stage in Olive's and Max's respective development is that while Olive revered science, Max revered classical mythology. In his world view, the classical Greek past always had a strong allure, due to the potency of its literature and visual art, the dramatic struggles it represented (as in the famous sculpture of Laocoön and his sons being crushed by serpents), its idealism and sculptural embodiments of perfection. For

Olive, however, it was the natural world that was most enduring and most perfect, its phenomena – including the action of light, its mysteries and intricacies – revealed to us by science.

Olive was very familiar with Max's enthusiasms and probably indulged them – after all, this was when they were growing ever closer – but she did not take them to heart. Though well informed, her evolving approach was not overtly theorised or intellectualised. It came principally out of practice and process, and was both organic and cerebral. And her artistic inclinations, which were exemplified in her musical tastes, notably her love of Chopin, were not oppositional or even dramatic.

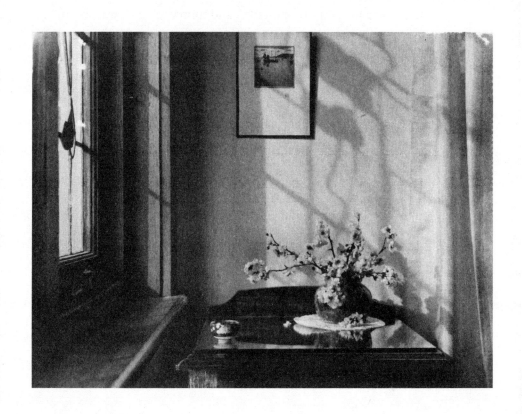

Interior (*my room*), 1933, National Gallery of Australia, purchased 2012

Interior (my room)

Olive's pictorialist beginnings were competent enough but not especially noteworthy. However, in 1933, when she was twenty-two, she made what I regard as her first truly successful photograph, still striking in its originality. She called it *Interior (my room)*, and it depicts a corner of the bedroom she and her sister, Joyce, shared at Wirruna. The image has very little in it that is concrete or weighty: a wooden window frame and sill, a stained-glass window, a single piece of furniture, a vase of plum blossom, a small piece of pottery (possibly Japanese) and a light-coloured curtain at the right-hand side of the composition. On the wall hangs a framed print, probably one that her father had brought back from his trip to Japan to attend a scientific congress in 1926. Late in life, Olive explained what attracted her to the scene in photographic terms: 'Its stained glass windows have a simple floral motif which cast attractive shadows on the wall in the late afternoon.' *Interior (my room)* displays not only her visual intelligence and elegant expression, but also some of the hallmarks of her mature practice.

The strongest photography Olive produced was born out of intimacy. In that sense, the impulse behind this interior view is typical: she habitually worked with subject matter she knew well and loved. Generally uninterested in the topical, in narratives established by external events, or in dramatic happenings, she chose instead to work with light and its transformative properties. As she stated in 1987, in one of her few comments on the medium, what invariably prompted her to take a photograph was 'light and shade'.

Interior (my room) makes this plain, giving equal weight to things that have substance and things that do not – their shadows – to create an image of great delicacy and lively patterns.

Interior (my room) also demonstrates what would become Olive's preferred way of working, one that was studied and highly considered, with all the pictorial elements and options able to be controlled. What Olive had in abundance throughout her life was patience, which, combined with her acute observational skills, meant that she was prepared to watch and wait until the time was right for an exposure.

Intentionally or not, *Interior (my room)* has another larger point to make. It introduces Virginia Woolf's ideas about the essential requirements for a woman to achieve independence, popularised in her book *A Room of One's Own* (1929). Olive may not have read Woolf's essay, but her choice of title asserts that this room, this space, is hers.

The title contains another significant allusion. Looked at in their totality, her photographs have a distinctive, interiorised quality. Even though their subject matter is always drawn from the physical world, from an external reality, they are inward looking, proceeding from Olive's perceptiveness and emotional state of being. Max responded to this decades later, describing her as a 'Romantic' – a photographer whose inner vision was all-important.

PART TWO

The Bond Street operation

After finishing her university studies in 1933, Olive made the first of her overtly adventurous and independent decisions. Women of her class and circumstances often went into the perfectly respectable profession of teaching, as her aunts Ethel and Janet had done, but she decided otherwise, even though it meant going against her father's expectations for her future. She chose to join Max in his newly established, very modest photography studio, in Bond Street, Sydney.

Max later described the end of his apprenticeship with Bostock in doleful terms – it was, he wrote, 'not a champagne affair'[1] – perhaps because both master and apprentice felt they had gone as far as they could together and had tired of each other. Max was certainly ready to get out on his own; he was ambitious and energetic, had his father's entrepreneurial example to inspire him and sufficient financial support from his parents and grandmother to make it possible.

Olive was intimately involved with the genesis of the Max Dupain Studio. She and Max were a couple in love, imagining their future together and sharing their passion for photography. Max later acknowledged her pivotal role, saying that: 'Olive Cotton who had been a very close companion shared the problems of photography with me ... [she] came to help in this little set up which I still think about in no uncertain terms with warm sentiment.'[2] Throughout his life, Max stressed that 'the Bond Street operation', as he termed it, had a central place in his affections, and that he held it 'exceptionally dear'.[3]

The studio, consisting of a single room and a shared processing room, was located at 24 Bond Street, in a building called Waltham Chambers. The location was ideal for an aspiring young photographer, with photographer Reg Johnson in the same building and the Russell Roberts studio nearby in Hamilton Street. The actual building was known for its concentration of artists and arts-related businesses and activities.[4] Tenants included the painter Charles Meere and his assistant, the artist Freda Robertshaw, and the commercial art studio of Smith & Julius, founded by artist and publisher Sydney Ure Smith and graphic artist Harry Julius, which employed Lloyd Rees, Roland Wakelin, Percy Leason and other leading Australian artists. Meeting Ure Smith was auspicious, as he was a powerful and influential leader in the art scene: 'a man who was the ceaseless organizer of exhibitions, magazines and art causes, a marvellous mimic, the delight of chic Sydney parties'.[5]

This was an intense learning period for Max. He considered himself extremely fortunate to have been able to call on Reg Johnson, who effectively picked up Max's professional training where Bostock had left off. According to Max, Johnson 'was carried away with photo-techniques and possessed all the latest in mechanical paraphernalia. He was a big influence on me as an older and more experienced practitioner, and I shall be forever thankful for his guidance.'[6] The two men frequently spent all night working in the studio and print room to complete orders and perfect their work.

The timing for the establishment of the studio could not have been better. The effects of the Great Depression had finally begun to dissipate. Australian unemployment rates, which had peaked at 32 per cent in 1932 – a rate that had been among the highest in the industrialised world – began to drop, and GDP began to increase. As manufacturing and business activity recovered, so did the demand for photographic illustration, encompassing advertising and fashion, creating ideal conditions for Max's business to flourish.

* * *

Olive recalled explaining her decision to join the studio to her father, telling him, 'Oh, I'll never be a teacher.'[7] He was disappointed because an involvement in photography 'wasn't really looked on as a very lucrative profession'; he may also have been concerned about the increasing intimacy between her and Max, as he questioned whether it was appropriate for them to work together. Decades later, Max recalled the exchange between Olive and her father on the matter. Leo had asked her directly: 'Do you think this is right and proper?' and Olive had assured him it was. However, Max did not agree with Olive's statement, making the enigmatic comment, 'it wasn't actually … who cares?'[8]

For Olive, the primary concern was being able to pursue what she liked best – photography. If working with Max was a major consideration, she did not say so, then or later on. As she stated in 1983:

> Photography was what I wanted to do. The alternative was a
> Diploma of Education and teaching, and I didn't want to teach.
> I thought it was important to be doing something you liked.[9]

Olive may have 'shared the problems of photography' with Max, as he put it, but she was always careful to emphasise that the studio was his business – not hers, or even theirs – and that she did not enter into it on an equal footing. She was not Max's business partner, but his assistant. He was the photographer who undertook work for clients. She did not take photographs in any professional capacity and instead oversaw the administrative side of things. This incorporated booking models, attending to clients in the studio and on location, and keeping the accounts. She washed Max's prints in the final stages of the printing process, spotted any blemishes that appeared on them (such as a hair or a speck of dust) and eventually did some of his actual printing, but the prints did not go out under her signature. In that sense, her role was invisible and comparatively minor.

But, as her later published comments make clear in their frequent, perhaps unconscious use of the collective pronoun 'we', she and Max shared a great deal in the business. She was totally committed to its advancement and proud of every success. 'It was', she said, 'big news when we made 30 pounds a month ... they were really exciting days because Max was attracting new people all the time. I remember how thrilled we were when we got a big job from David Jones.'[10]

Although Max disliked the touting for clients that was essential in these early years – he found it humiliating – the business grew quickly. Sydney Ure Smith's support was vital: as publisher of *The Home* and *Art in Australia* he was the first to promote Max's modernist photography, which appeared in his magazines from April 1934 onwards. The expansion facilitated a move to bigger, far more attractive premises on the fifth floor of the same building in Bond Street. Max acknowledged the joint effort involved, later writing that 'Olive assisted me greatly in establishing the new set-up. There was great excitement in installing new tungsten lighting and eventually a 10 x 8 [inch] Kodak enlarging instrument which was illuminated with soft reflected light instead of the usual hard [light].'[11] The space was perfect, with abundant natural light and large windows that faced east, which 'could be opened at any time in the summer months to let through great gusts of north-easterly wind, bringing its sweet-salty tang'.[12]

Olive loved the new arrangements, recalling that:

It was a very big space and Max had a large ground glass screen made in two or three pieces but it was very high, it was like another wall and you could slide it across on runners and ... you could put lights behind it and you could get this diffused lighting, back lighting and all sorts of things.[13]

Olive felt overwhelmingly positive about her Bond Street years – reiterating that they were very happy – but did not record much

detail about the work she did. In contrast, Max elaborated on the studio's operations, including the technical difficulties he faced in an era when some aspects of photography were still very basic. The use of artificial light was one such example. Before exposure meters were available, light levels 'had to be assessed by experience' and if artificial light was required, photographers had to use flash powder. Max had one especially colourful encounter with this rudimentary technique when Bostock sent him out to photograph a dinner. He arrived as the guests were 'about to hoe into the desserts', ignited the flash powder, which created 'a muffled roar' and deposited a pale, white cloud that settled 'into the strawberries and cream, lemon chiffon pie and ice cream, and crème de menthe marshmallow'.[14]

Recollections of these technical difficulties underscore an important point – they applied to Max's situation as a professional photographer, not to Olive's. She was largely immune to such pressures: she did not have to contend with the expectations and demands of clients and challenging on-location scenarios, and did not have to use flash unless she felt it necessary. She was in the enviable position of being able to control her imagery and process, taking and making only those photographs she wanted to.

At the most pragmatic level, the studio immediately gave Olive access to superior facilities and equipment. She did not have her own professional camera at this stage but was able to use Max's English camera, a Thornton Pickard Half Plate that was of excellent quality. Max's father had given him the camera 'as a starting off present', and it was a source of great pleasure – 'a beautiful, handmade timber camera with double dark slides made for housing glass plates, which preceded the cut film system. It weighed a ton.'[15] The studio was also a stimulating learning environment. Max generously shared the knowledge he had gained during his apprenticeship, and his advice and help were, Cotton said, 'a tremendous influence'.[16]

However, the studio was much more than a working or utilitarian space for both photographers. For Olive, its prime importance was as a creative site. She could concentrate fully there, burying herself

in her art photography. After hours, she transformed the studio and the darkroom into private spaces and set up shots, processed her film and did her printing. Max celebrated the studio's connections to 'creativeness in many forms of artistic endeavour'; he saw it as 'a haven' and a place where 'great things' happened, and later explained that: 'To live and work in my own studio was ... the embodiment of satisfaction.'[17]

* * *

Importantly, the Max Dupain Studio was also an increasingly vibrant social space where Olive and Max set about creating their own community. For two young people still living at home with their parents, this was where they could assert their autonomy and express themselves freely and spontaneously. Although they were a well-established couple by this stage, there is nothing to suggest that they had become lovers. Their activities in the years from 1934 to 1937 appear far more group- and family-oriented.

In an unpublished statement about life at the studio, Olive said: 'In spite of pressure of work we were like a happy family – no tension, lots of laughter, many of our clients and models became our friends of long standing, and often stayed for a cup of coffee.'[18] Members of their families also came and went, sharing conversation, cups of tea and coffee and sometimes a simple meal in the evenings. Olive's brother Frank and his girlfriend Marie (later his wife) sometimes called in on their way home from university, 'watching her at work, and developing our own films, wash[ing] up the tea cups etc. for her'.[19]

Being modern

'When is a work modern?' was the question artist Margaret Preston posed in a ground-breaking article published in 1923. She answered unequivocally, 'When it reflects the age it is painted in.'[1] This viewpoint was equally relevant to photographers, Olive and Max included.

It seems risky and unnecessarily dramatic to ascribe great significance to any one year in photographic history or indeed in any individual's life; doing so masks the build-up and coalescence of myriad factors that contribute to the culminating 'event'. Nonetheless, 1935 can be described as a breakthrough year, both in Olive's photography and in Australian photography more broadly, a time when a number of creative practitioners became preoccupied with expressing a contemporary spirit. What Olive had achieved in the years leading up to 1935 was akin to student work, oriented towards developing her conceptual, visual and technical skills. In her late teens and early twenties, there were some startling demonstrations of her talent and mastery – *Interior (my room)* is one such example – but her early photographs were still indebted to prevailing conventions and aesthetics that were not especially daring. So what were the factors in play that made 1935 so crucial?

In the mid-1930s, remnants of the past were still highly visible in Australia's cities. Many houses were yet to be connected to sewerage; domestic refrigeration was not yet widespread; and horse-drawn cabs were still in limited use in Sydney and Melbourne. However, signs of Australia's modernisation were beginning to

appear everywhere, in the take-up of various forms of technology in industry and the home, and in the introduction and expansion of modern means of transportation and mass communication. Qantas Airways began operating its first international service in May 1935, flying from Brisbane to Singapore. Orient Line's huge new ocean liner, the RMS *Orion*, with its much-praised modern interior design utilising chromium and Bakelite, made its maiden voyage from England to Australia in 1935, too.

Sydney was Australia's largest city, with a population of one and a quarter million (Australia's overall population by then was nearly seven million people, excluding Aboriginal and Torres Strait Islander people, who were not counted in the census until 1971). The city had embarked on the self-conscious process of defining itself as a modern metropolis, with the building of skyscrapers (very modest, by today's standards) and large blocks of flats. It boasted Australia's first underground railway, with the inner-city stations of St James and Museum opening in the late 1920s. The Sydney Harbour Bridge, completed in 1932, linked the north and south of the city and provided much greater access to the central business district, its shops and offices. In October 1935, Luna Park at Milsons Point was opened as a site of modern entertainment.

It was a city that seemed filled with movement, constantly in flux, epitomising the rush to modernity. As Ure Smith described it:

> Grinding trams and busy motor cars and … uncompromising
> flats … and always the patch of blue harbour. Hills, noise,
> traffic, careless pedestrians, yellow cabs … ferries darting in a
> tangle into the harbour from Circular Quay. Tall buildings,
> ugly buildings … wharves, masses of deep sea liners, cargo
> boats, ships from everywhere … crowded houses on the
> foreshore … excitement, bustle and movement.[2]

Culturally, Sydney's offerings were improving quickly, especially in music. Although it is not possible to know exactly which concerts

Olive attended, the options were varied. In March 1935, Australian pianist and composer Percy Grainger, then living in the United States and with an international reputation, gave two concerts at the Sydney Conservatorium. In July, the *Sydney Morning Herald* noted that recent musical events included opera performances, a 'memorable series of concerts' by American-born violinist Yehudi Menuhin, and singing by English contralto Madame Muriel Brunskill. In addition, visits from the very popular Vienna Boys Choir and Budapest String Quartet were imminent. The enthusiastic audiences and high attendances at these concerts and recitals were, the paper argued, proof that, despite the views of naysayers, Sydney could support a lively music scene. The unidentified writer declared that the city was 'exceedingly fortunate this year in its opportunities for hearing fine music', and concluded that 'as regards quality, 1935 may well be looked back on in the future as a sort of annus mirabilis in local history and (one hopes) the beginning of a musical renaissance'.[3]

The visual and decorative design arts were also faring well in Sydney by the mid-1930s. As is now widely accepted, there was not a unified modernist movement, but rather an eclectic range of approaches, concerns and ideologies.[4] Artists were engaging with diverse philosophical and religious ideas drawn from vitalism, spiritualism and theosophy. Women were at the forefront of radical forms of experimentation across different media: Margaret Preston, Thea Proctor, Dorrit Black, Eleanore Lange and Grace Cossington Smith were among those making enduring contributions to printmaking, painting, sculpture and design – although their efforts, like Olive's, were generally not acknowledged in major art historical texts until feminist art historians critiqued their exclusion in the 1970s. Sydney artists Roy de Maistre, Grace Crowley and Ralph Balson (both of whom Olive later photographed) were pursuing abstraction, and the investigation of colour was of sustained interest to them and other artists.

In photography, the groundwork for the modernist flowering of 1935 went back several years and involved a complex interaction

between international and local practices, conditions and circumstances. Publications were the crucial means of keeping practitioners up to date with international developments, as overseas travel was still extremely rare. Olive and Max were avid readers of material from England, France and Germany in particular, as Max later explained:

> We fed our spiritual selves on books and magazine articles. I can remember the excitement in the studio when a new copy of *Photographie* or *Das Deutsche* [*Lichtbild*] hit the book stalls. Souls condemned to starvation, saved once more from pictorial purgatory![5]

Gilmour's Bookshop in Bond Street, not far from the studio, was their primary source for 'the latest haul of photographic books from Europe'.[6] Max's photograph of the bookshop at night shows its packed window displays glowing enticingly in the darkness.

It is also highly likely Olive read G.H. Saxon Mills's influential essay 'Modern photography, its development, scope and possibilities', published in *Modern Photography* in 1931. Max is definitely known to have read the essay in 1933, if not earlier, as he quoted from it in the text accompanying the portfolio of his photographs published in *Art in Australia* in 1935. Saxon Mills persuasively argued that an exciting new era was emerging in which photography was being recognised as 'an art in itself', and the photographer as 'an artist'. As he saw it:

> There is no huge history behind photography, no traditions for it to live up to, or tragedies for it to live down. It has no past to obscure its future. It comes to us in the first bloom of youth, bright with its promises unbroken, and with its destiny ahead, not left behind in dead centuries and dusty galleries.[7]

Saxon Mills's definition of 'modern photography' was succinct and useful. Its aim, he wrote, 'is partly or wholly aesthetic, as opposed

to photography which is merely documentary or representational'.[8] The artist photographer should strive 'to achieve the expressionist ideal – "the objective world illuminated by the eye of the spirit"'.[9]

Another important point Saxon Mills made concerned the interrelationship between photography and contemporaneity. In a much-quoted conclusion to his essay, he declared that photography 'belongs to the new age':

> It is part and parcel of the terrific and thrilling panorama opening out before us to-day – of clean concrete buildings, steel radio masts, and the wings of the air liner. But its beauty is only for those who themselves are aware of the 'zeitgeist' – who belong consciously and proudly to this age, and have not their eyes forever wistfully fixed on the past.[10]

In any way they could, Olive, Max and their friends wanted to show their awareness of the 'zeitgeist', the spirit of the times, and consciously align themselves and their work with their own era. They may have strengthened their views through reading the landmark book *Malerie, Photographie, Film* (*Painting, Photography Film*), by influential European photographer and teacher at the German Bauhaus László Moholy-Nagy, which was advertised in *Australasian Photo-Review* as early as 1930. They were definitely acquainted with the work of another influential European photographer, the American-born, Paris-based photographer Man Ray, through James Thrall Soby's monograph on the artist, which Max enthusiastically reviewed for *The Home*, in 1935.[11]

Exposure to international developments also came through coverage in local publications, such as *Camera Graphs of the Year*[12] and *The Australasian Photo-Review*. The latter regularly discussed international photography and reviewed exhibitions, including The Modern Spirit, organised by the Royal Photographic Society in London, in 1932, which showed examples of modernist photography. *The Australasian Photo-Review*'s editors, notably Keast

Burke, were well disposed to new approaches, writing in favour of the modern movement and its potential benefits for photography.

The only international photographers Olive noted specifically (in her unpublished notes) were Man Ray, Moholy-Nagy, Edward Steichen and Margaret Bourke-White. Significantly, she added, 'I had a great admiration for the work of Bill Brandt, which often appeared in a small wartime magazine *London Opinion*.' The German-born Brandt worked in England, but Olive did not identify exactly which of his bodies of work impressed her most: whether it was his documentary series on the class divisions in British society and the effects of industrialisation, or his moody cityscapes, many of which were taken at night. It was an interesting nomination. Brandt was a modernist photographer who had assisted Man Ray in Paris during his early surrealist phase, but in the 1930s he began working in what is known as a straight mode (that is, unmanipulated). He was not as extreme in his experimentation as Man Ray or other European modernists, whose work Olive and Max also saw reproduced.

Max's chief inspirations in photography, which he came to know through magazines, included American, European and British photographers, above all Steichen, Horst P. Horst, Martin Munkacsi, George Hoyningen-Huene, Toni Frissell, Baron Adolph de Meyer, Louise Dahl-Wolfe, Bill Brandt, Brassaï, and Margaret Bourke-White.[13] This roll call reflected his immersion in the commercial world, and fashion photography in particular.

The milieu in which Olive found herself – in a modern city receptive to modern art, design and photography – was a great stimulus. As part of the Dupain studio, she had all the ingredients needed to flourish. She did not make it her project to photograph outward, obvious signs of modernity in Sydney, such as the Harbour Bridge – that was the domain of Harold Cazneaux, Henri Mallard and other photographers, who documented it from construction to completion. Nor did she compete with Max, who was beginning to make bold studies of urban and industrial subjects; these included

grain silos at Pyrmont, which he photographed through the windscreen of his car, and power poles and overhead wires in his home suburb of Ashfield. Indeed, from a 21st-century perspective, much of Olive's subject matter of the mid-1930s, especially the flowers, landscapes and portraits, does not conform to prevailing ideas of the modern. However, it wasn't what she photographed so much as her approach that confirms the modernity of her photographs – as a reflection of their times.

* * *

One of the earliest signs of Olive's modernity was her experimentation with still lifes, which she began in 1934. It is not surprising that at this stage, the only time in her long career, she turned to the genre. In Margaret Preston's view, still lifes were 'laboratories [sic] tables on which aesthetic problems could be isolated'[14] and solutions worked through. Olive constructed her still lifes from everyday objects – cups and saucers, clothes pegs, cardboard, ice-cream cones, cream bottles – and concentrated on developing her skills in composition and lighting, over which she could exert maximum control.

Her first conspicuous success was *Cardboard design* (1934), which avoids making reference to anything outside the camera frame. Corrugated cardboard, an inexpensive, everyday material, has no relevance of itself. Its elegant curling forms – corrugations turned to the outside to provide maximum visual interest – are the point of the picture. This 'design' is one of the sparest compositions of her entire career – spare, and yet dynamic, as the repeated semicircular lines and forms that dominate the image effortlessly generate a sense of rhythm and energy.

Cardboard design had immediate contemporary appeal. A variation of it was selected for publication in *Bank Notes*, December 1934, the high-quality staff magazine produced by the Commonwealth Bank, which featured lively articles on art, travel, hobbies, flora and fauna, along with news from bank branches around the country.

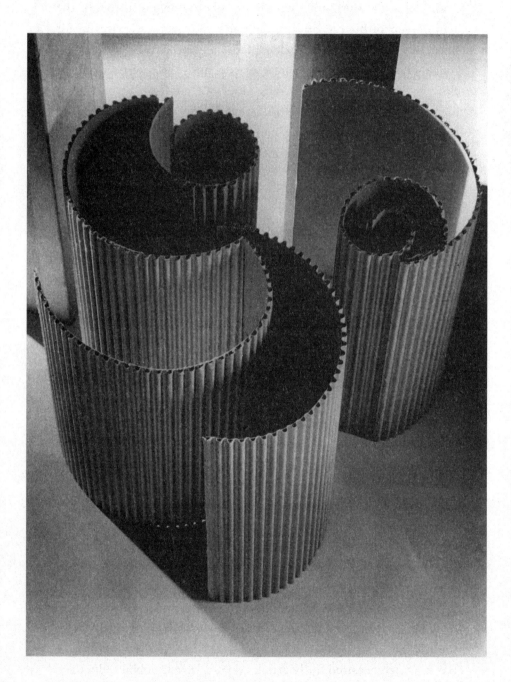

Cardboard design, 1934, courtesy Cotton family and Josef Lebovic Gallery, Sydney

The magazine sourced photographs from leading practitioners and gave prominence to their work in its layout. Another of her still lifes, *Cleanliness*, a study of wooden clothes pegs, appeared on the same page as *Cardboard design*. A total of four photographs by Olive and three by Max were published in this issue, acknowledgement that, within only a few months of opening the studio, their work was attracting considerable attention.

A few months later, in early 1935, Olive made *Teacup ballet*.

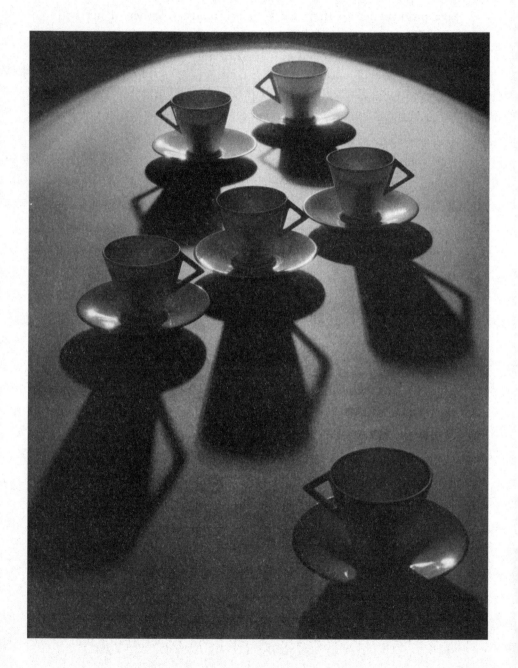

Teacup ballet, 1935, National Gallery of Australia, purchased 1983

Teacup ballet

A colleague of mine, a photographer, told me once that what she most admired about Olive's approach was the way she 'made do' with what was around her and didn't need to go anywhere exotic to take her photographs. Nowhere is this more obvious than in her still lifes from the mid-1930s, and above all in *Teacup ballet,* dating from the first half of 1935. This now iconic image came about after she purchased a set of inexpensive cups and saucers from Woolworths to replace the 'rather worn old mugs' they used in their coffee breaks at the studio. In these ordinary teacups, she saw transformative possibilities, which she was able to realise through a process of trial and error in the studio, focusing not only on the arrangement of the teacups, but also on the lighting. She explained decades later:

> The angular handles reminded me of arms akimbo, and that
> led to the idea of making a photograph to express a dance
> theme.
>
> When the day's work was over I tried several arrangements
> of the cups and saucers to convey this idea, without success,
> until I used a spotlight and realized how important the shadows
> were. Using the studio camera, which had a 6½ x 4½ inch
> ground glass focussing screen, I moved the cups about until
> they and their shadows made a ballet-like composition.[1]

One of the studies Olive judged as unsuccessful and put aside shows exactly what *Teacup ballet* did manage to achieve.[2] In the rejected

untitled image, four cups and saucers are lined up on the wooden bench in the studio, their matching bread and butter plates arranged in a parallel line next to them. The diagonal composition that proceeds from the left foreground to the top right achieves some dynamism but no transformation occurs: the cups, saucers and plates retain their specificity and are immediately recognisable for what they are – items of modern crockery. The most radical aspect of this visual experiment is the exclusion of explicit narrative elements or context. There are no signs of a domestic environment that would prompt a reading about modernity and the home (as with Margaret Preston's paintings and prints).

Olive said that she made *Teacup ballet* purely for her own pleasure. It had no commercial or commissioned purpose, though it is sometimes mistaken as an advertising photograph. On its own terms, the image achieved exactly what she wanted it to, expressing 'the idea of dance in a visual form'.[3] Eliminating the bread and butter plates in favour of the cups and saucers was essential; with their elongated shadows, they work together to create an image of ballerinas standing with hands on hips – three dancers in one row and two in the other. The principal ballerina is positioned in the lower right of the composition, standing on her own on the stage, well apart from the rest of the troupe. In keeping with the theme of the performance, Olive introduced lighting that is both theatrical and otherworldly.

Teacup ballet achieves far more than the successful elaboration of a theme. It also demonstrates what would become some of the hallmarks of her creative practice. It is an outstanding example of what she described as 'drawing with light', which arose from her attentiveness to the visual power of shadows; she alluded to this herself when describing the process of setting up the photograph and realising 'how important the shadows were'. And it conveys a sense of energy without agitation, which is also present in *Interior (my room)*, made two years earlier. Though the image is quiet and still, it is not static. This results in part from the strategy of asymmetry, with each row containing a different number of cups/ballerinas.

While the photograph was not an explicit address to the evolving category of Australian modernist photography, or modernist art more broadly, it can be readily contextualised in terms of an international modernist style. The most obvious comparison is with Margaret Preston's bold oil painting *Implement blue* (1927), which depicts a jug, two glasses and three cups and saucers arranged in two asymmetrical, diagonally oriented rows. Preston's rigorous, reductive image – regarded as one of her most uncompromising – eliminates any extraneous detail and adopts a restricted palette in order to focus on an analysis of form. Olive would certainly have known Preston's work, given its high visibility in exhibitions and publications during this period.[4]

The success of *Teacup ballet* was immediate. It was selected for exhibition in the prestigious London Salon of Photography that opened in September 1935, marking Cotton's international debut. She was delighted with this major achievement, which affirmed that her work was of an equal standard to that of her contemporaries overseas.

Since first being published – in *Bank Notes* two years later, in December 1937 – *Teacup ballet* has become Olive's best-known photograph, achieving iconic status. This is a social phenomenon whereby an image, as Australian writer Frank Moorhouse suggests, becomes part of 'the communal visual memory',[5] and assumes new significance.

> An image somehow becomes alive when its relationship to
> history and public awareness has reached a certain critical
> point. Adoption of an image signifies that the image is alive
> with meanings and gives a sensation at each viewing, it is a
> form of ownership by a communal sensibility.[6]

For *Teacup ballet*, the 'critical point', when it started to become 'alive with meanings', occurred in the 1980s, when it found its place in two master narratives, one about the history of Australian photography,

and the other about the history of Australian modernism. In both, it was admired as a pared-down, elegant image of commonplace objects. Beginning with curator Gael Newton's book *Silver and Grey: Fifty years of Australian photography 1900–1950* (1980), it has been reproduced and exhibited numerous times within this double context of photography and modernism. In 1991, it was chosen by Australia Post as part of a series of four stamps commemorating the 150th anniversary of photography's arrival in Australia.[7] Art historian Mary Eagle included *Teacup ballet* in her book *Australian Modern Painting Between the Wars 1914–1939* (1992), as an exemplary modernist work, although she incorrectly referred to it as an advertisement. Art critic Joanna Mendelssohn was among those who provided positive commentary during the 1990s, writing that it 'so effortlessly summarises the elegance and domestic poetry of Art Deco'.[8] In 1995, it was selected by the National Library of Australia as the cover image for the book *Olive Cotton: Photographer*.

How strange it must have been for Olive herself to see what Moorhouse describes as a 'communal sensibility' take hold of *Teacup ballet*, and to realise that one of her earliest photographs, made at the age of twenty-four, had come to represent her whole oeuvre through no advocacy of her own. *Teacup ballet*'s elevated position is stranger still, given that it is so obviously atypical. Olive's engagement with objects or elements from the domestic environment, though intense and fruitful, was brief, because her primary and enduring attraction was to the organic and the animate. The pull of the natural world was already becoming very apparent in 1935, the year she made *Teacup ballet*.

Surrealism

As part of Olive's wide-ranging experimentation in the mid to late 1930s, she had a dalliance with what can be described as surrealist techniques, but there is nothing to suggest that she identified with either the philosophies or politics that underpinned the international surrealist movement.[1] Its iconoclasm and radicalism, as advocated by its French founder André Breton in his *Manifesto of Surrealism*, in 1924, were definitely not for her. Even those surrealist techniques she used briefly are the least interventionist, confined to double exposures and composite printing, rather than the more radical solarisation, photomontage and collage. And, it should be noted, composite printing did not actually come to her via surrealism. It was a standard pictorialist strategy, one she had been successfully applying for several years to obtain the sympathetic skies needed to complete select compositions. Consequently, *Sky submerged* (c.1937), often regarded as one of her most surrealist works (another is *Design for a mural*, undertaken during the war), has an ambiguous status. The image was produced by combining two separate negatives – one of the sky and one of the sea – neither of which she considered complete on its own. However, when she brought them together, they created 'a satisfying composition and the title suggested itself'.[2]

This account is revealing because it indicates Olive was not pursuing the kinds of violence, either in her imagery or process, that surrealists wrought through photography to deliberately disorient and provoke the viewer. Instead of radical discontinuity, she was characteristically seeking coherence and unity, as encapsulated in her

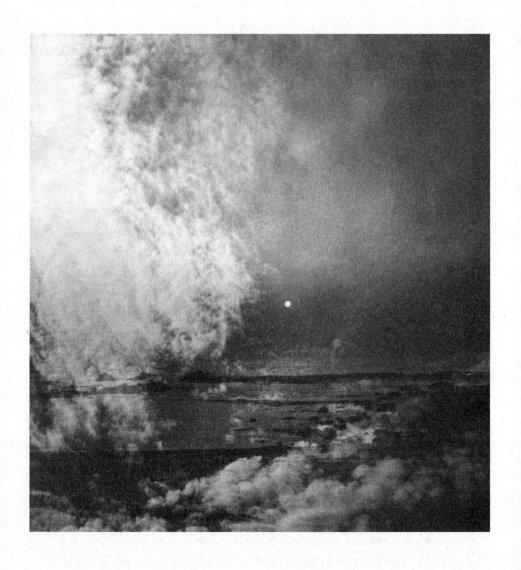

Sky submerged, 1937, National Gallery of Australia, purchased 1987

self-described 'satisfying composition'. *Sky submerged* can therefore be read in at least two ways: either as a pictorialist image indebted to pictorialist forms of manipulation practised by Harold Cazneaux, Frank Hurley and others, or as a surrealist image, with its fantastical scenario of inversion in which the sea has absorbed the sky. Then again, in less binary terms, it can be seen as both pictorialist and surrealist, an example of a photograph in which different styles and approaches are enfolded into each other.

Whatever the case, *Sky submerged* is unusual in Olive's oeuvre in its disruption of realism, and in that sense is the most extreme, least literal of her images. Others that could make a claim to a surrealist influence include *Surf's edge* and *The shell*, each of which introduces an uncanny effect through the use of extreme close-up and consequent loss of markers of scale. However, a survey of her negatives establishes these, too, are isolated examples.

Max's encounter with surrealism was of a different order and warrants elaboration as a contrast to Olive's. He was captivated by the work of American-born, Paris-based photographer Man Ray after Sydney Ure Smith asked him to review James Thrall Soby's monograph *Man Ray Photographs 1920–1934*[3] for *The Home* magazine. The invitation came at a crucial time, when Max was casting about for heroes in the arts whose attitudes resonated with his own romantic inclinations. The hope was that their work would help him conceptualise the transition from pictorialism to modernism in photography. His review of Soby's book began with the bold statement that Man Ray's importance 'in photography is analogous to that of Cézanne in painting, and it does not seem imprudent to prophesy his enjoyment of an equivalent greatness'.[4]

Aside from Man Ray's formal brilliance and virtuosity, Max was excited by his iconoclasm. As he wrote in 1976, 'Man Ray particularly appealed to my sense of the radical. Let's kick convention right up the arse and do a new thing.'[5] Years later he said, 'I was rebellious without Man Ray but he gave my every waywardness a terrific boost.'[6] Man Ray's liberal attitude to sex and sexuality was

also fundamentally important. His unabashedly erotic photographs of two of his lovers and muses – the artist's model and singer known as 'Kiki of Montparnasse', and American photographer Lee Miller – published in Soby's monograph, had no equivalents in Australian photographic practice of the period. Surrealist techniques were liberating for Max: freed from straight photography's ties to external reality, he could develop a new language of visual eroticism. The predominantly female models in his surrealist studies are usually not recognisable, their faces excluded or purposefully obscured in some way. *Jean with wire mesh* is a notable exception. In this elegant, erotically charged portrait, which was inspired by Man Ray, the model Jean Lorraine is identifiable in the image – provocatively so – and is named in the title.[7]

Olive, on the other hand, did not turn to surrealism as a way of exploring eroticism or the genre of the nude.

Between 1935 and 1938, Max energetically and systematically worked his way through Man Ray's techniques in both his commercial and art photography, experimenting with photomontage, multiple exposures, solarisations and photograms, replicating their effects. The results of his experimentation were published in a portfolio in the Christmas issue of *Art in Australia*, in 1935; the seven selected images included a surrealist still life and a portrait. Surrealist techniques were also ideal for creating eye-catching illustrations, and Max was quick to capitalise on the elements of novelty and surprise, juxtaposing unexpected props in his commercial work, for advertisements and commissioned portraits published in *The Home* and elsewhere.

Olive, through Max, was certainly familiar with Man Ray's work, and the couple was probably also aware of the International Surrealist Exhibition, which was organised by leading figures in English and French surrealism and held at the New Burlington Galleries in London in 1936. Man Ray was one of the members of the French organising committee and the show was opened by Breton. Salvador Dalí notoriously presented one of the public

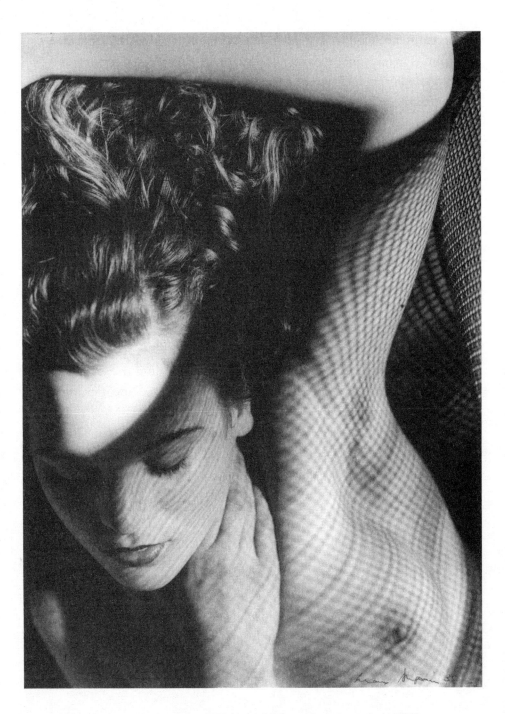

Max Dupain, *Jean with wire mesh*, c.1935, National Gallery of Australia, purchased 2006

lectures while wearing a deep-sea diving suit that nearly suffocated him. The exhibition was a landmark in surrealism's history and attracted press coverage in Australia, with the *Sydney Morning Herald* explaining to an uninitiated Australian audience that:

> surrealist art expresses subconscious dream pictures. Daydreams
> mainly balanced with a modicum of reality. In this newest
> form of art the exponents endeavour to interpret their waking
> dreams, conceptions by ear and eye, their thoughts into visible
> colourful reality on canvas.[8]

It wasn't until 1939 that examples of paintings by well-known surrealists arrived in Australia, in the Herald Exhibition of French and British Art, presented first in Adelaide, then in Melbourne, where 45,000 people saw it, and finally in Sydney at the David Jones Gallery. There is no evidence that Olive and Max attended the show but, given its profile, it is likely they did; their close friend, fellow photographer Damien Parer viewed it in Melbourne, mentioning it in a letter to them.

For Olive, the nod to surrealism during the years 1935–37 was cursory at best. The radicalism of the international surrealists, who wanted to bring about a cultural and, in some cases, political revolution, did not resonate with her approach to life or to photography. Nor did her brief encounter with surrealist imagery and techniques have any long-term impact on her work. As became increasingly clear from 1937 onwards, observation and experience were fundamental to her practice, and the experimentation seen in her still lifes and images such as *The shell* began to fall away. The surrealists may have revelled in ignoring external reality in favour of subconscious dreams, but she did not.

The shell

When I first saw this photograph – and it was a surprise, because it came late in my research – a single word kept running through my mind: 'animate'. There is only one concrete element in the image, a shell that fills the frame. Nothing could be simpler. But it's not the shell itself that brings the composition to life; it's the teardrop-shaped glowing white light that sculpts the shell from the inside – animating both it and the image.

The shell belongs in some ways to the still life experiments Olive conducted in the studio – where she removed objects such as teacups, ice-cream cones and cardboard from their usual settings and usage, decontextualising them for pictorial reasons. *The shell* continues with this exclusive focus, adopting a neutral, deliberately uninformative background that has no potential for distraction. But the photograph also differs from its counterparts in a fundamental way. Its subject matter is less immediately recognisable, and its treatment is more disorienting, part of the beguiling, animated effect.

Consider, for example, how scale is deployed. It is impossible to know exactly how big or how small the shell is. Ultimately, this doesn't matter because the image is purposefully scaleless. Of itself this is noteworthy because it challenges long-established compositional conventions in western art. Generally – in still life painting, for example – it's possible to tell the size of the things an artist has depicted and their correlation to what is familiar and known in our world. But Olive's shell has no external referents,

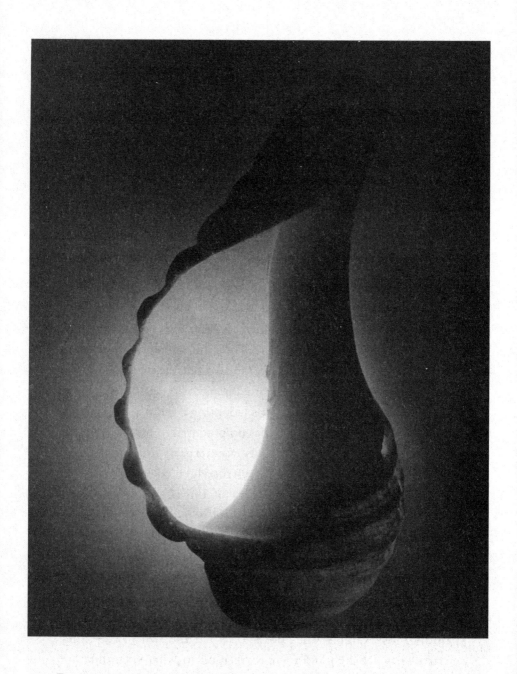

The shell, c.1935, National Gallery of Australia, purchased 2012

no context to anchor and define it. Her handling of it represents an instance where photography, especially modernist photography, with its predilection for various visual distortions, comes into its own.

Then there is the light, or, more specifically, the ambiguous nature of the actual light source. This shell may have been fashioned into a lamp, as suggested by the merest hint of an electrical cord that drops out of the shell and out of the lower section of the image. Shell lamps were in vogue during this period, often mounted on Bakelite bases for use on tables and desks in domestic settings. Lamps themselves were of interest to Olive, who designed lampshades that used photographs in repeated patterns as border designs.

And what about space – where does this shell sit within the composition? Even if the photograph is turned sideways, or rotated until it is upside down, it still doesn't make any sense spatially. The fact that the shell floats in an indeterminate field of light is significant, as it destabilises the viewer's standard, assumed viewing position. It makes us restless because, despite the simplicity of the composition, not everything can be apprehended at once. In keeping with Olive's ethos, this restlessness relates to being active – animated – rather than to being agitated, which was never a feature of her work.

The shell shows Olive in an experimental phase of her practice, but it also prompts an unexpected reading. In contrast to other prosaic items Olive photographed around the same time, such as spectacles and cardboard, the shell is less neutral. It is highly charged with symbolic value, traditionally being associated with representations of the feminine. Olive's treatment of her subject matter does not exclude such a reading. *The shell*, simultaneously animate and mysterious, is a rare instance in which she engaged both with form and with symbol.

Flower studies

'Flower studies', as Olive called them, emerged as an important theme in the mid to late 1930s, one that was uniquely hers. She did not photograph just any flower that came her way, but always made careful, purposeful choices. And she worked almost exclusively with non-natives, with exotics, rather than with Australian indigenous flowers. Max recognised how important flowers were to her and gave her a book on flower arranging, probably *The Art of Flower Arranging in Japan*, with a preface by Lionel Lindsay (1933).

By the time Olive began photographing flowers as subjects in their own right, in 1935 – *Shasta daisies* being the earliest resolved example – there had already been more than two decades of impassioned debate about the relative value of exotic and native flowers. This took place within the overlapping spheres of art, design, landscape architecture and gardening. The case for the greater appreciation and protection of native flora had gained ground as a result of the efforts of individual botanists; through groups such as the Field Naturalists' Society and the Australian Forest League; and through publications, especially Florence Sulman's influential two-volume work, *Popular Guide to the Wildflowers of New South Wales* (1914). High-profile individuals with a passion for native flora had also become involved in the 1910s and 1920s, including architects Walter Burley Griffin and Marion Mahony Griffin. In an essay on the Griffins, art historian Tim Bonyhady has pointed out that as early as 1918, Marion Mahony Griffin argued that native plants should be the dominant

plantings in suburban gardens (she advocated for a ratio of nine-tenths native to one-tenth exotic).[1]

By the 1920s, the position of native wildflowers across New South Wales was dire. Due to the voracious appetite for them as cut flowers, several species were on the brink of extinction. At Castlecrag, for example, the Griffins and other residents of the new estate there had to safeguard the bushland from the destructive actions of professional pickers who, Bonyhady writes, 'made a comfortable living supplying lorry-loads of waratahs, native roses and flannel flowers for sale every day at Paddy's market in the city'.[2] Christmas bush and Christmas bells were very popular, commanding high prices in the markets every December. Finally, in 1927, the New South Wales Government was compelled to respond to this widespread threat of extinction and passed the *Wild Flowers and Native Plants Protection Act.*

Advocacy for native plants came from artists, too, with Margaret Preston being the most prominent and most vocal. After returning to Australia from England in 1919 and settling in Sydney, she began to articulate her concept of a national art based on the use of uniquely Australian subject matter, not only native flora, but also native fauna and Aboriginal artefacts and patterns. In the 1920s, her prints and paintings featured Western Australian wildflowers, but after 1932, when she moved to Berowra, in the Hawkesbury region of New South Wales, she began using indigenous plants from that area – banksias, waratahs, gum blossoms and wheelflowers.

So how was Olive affected by this ongoing, very public discussion in the cultural and conservation sectors about the place of native flora? How did she position herself within it? Since childhood, she had been surrounded by unspoilt bushland in Hornsby and had spent extended periods of time at Newport and in the Pittwater area. In 1924, she photographed her family on a bush track that connected the ocean beach side of Newport to Pittwater. In the 1930s, she frequently went on bush picnics and camping trips with Max and friends in the hinterland of Sydney, and further afield along the coast and inland. All this points to a love of the bush, but Olive was not involved in

campaigns to protect native plants and wildflowers, in either her life or her art. As stated, she photographed exotics almost exclusively: shasta daisies, poppies, plum and quince blossom, windflowers, gerberas, lilies, agapanthus, Cherokee roses and sunflowers. There was, in other words, no polemic in her pictures and they had no part in the debates being passionately waged by botanists, conservationists and artists.

Another important point of differentiation is her ideas about flower arranging. In the 1920s, Sydney artists Thea Proctor and Margaret Preston both championed flower arranging as an art form. In an article, 'The gentle art of arranging flowers', to which they each contributed, Proctor declared that 'a flower arrangement should be a design' and continued:

> Flowers and leaves should be selected not only for their colour but
> for their form, and they should be chosen to suit the vase or bowl,
> the colour scheme of the room, and particularly of the walls.[3]

For these two artists, the distinction between exotics and natives was irrelevant in this design context.

Olive was certainly predisposed to exotics, but when it came to design, she clearly did not take her cue from the generation before her. The flowers she photographed from the mid-1930s onwards were not constituted as floral arrangements, or as elements in an interior design. The vase, if there was one at all, was barely visible, rendered irrelevant in the overall image. The focus was always on the flowers themselves, removed from domestic or other design environments and set against neutral backgrounds.

While these photographs do not relate to larger debates about natives versus exotics, or the art of flower arranging, they do signal the evolution of Olive's particular conceptual, aesthetic and technical concerns. She was clear about the reason for choosing the flowers she did – it was because of their form. As she explained in 1995, 'I prefer to photograph simple flowers because their form is more clearly defined.'[4] In her comments about photographing flowers, the

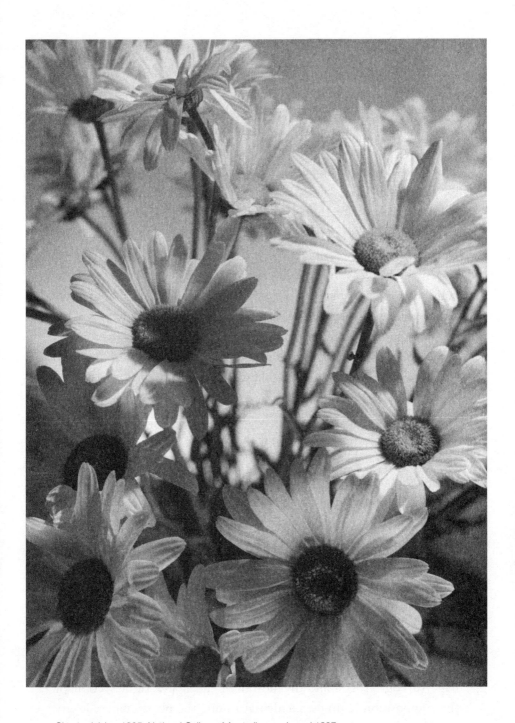

Shasta daisies, 1935, National Gallery of Australia, purchased 1987

words 'simple' and 'perfect' recur, underlining the way she saw the flowers as representing the perfection of the larger, natural world.

Her earliest success, *Shasta daisies*, was taken in the studio and is linked to her still lifes, demonstrating her ongoing experimentation with composition and different effects of studio lighting. It is an important, complex work. The intent was straightforward, expressing Olive's fondness for 'flowers with the simple daisy form'.[5] She chose to photograph the daisies in the studio rather than outdoors to maximise control of the lighting and background. However, even though the flowers were carefully arranged, she wanted them to look as natural as possible – 'to try and convey a feeling of out of doors'.[6] Lighting was therefore crucial, and *Shasta daisies* showed the continued development of her skills in this area. The photograph attracted immediate attention. It was selected for the Victorian Salon of Photography exhibition at the Athenaeum Gallery in Melbourne, in October 1937, and for the prestigious London Salon of Photography that same year, Cotton's second showing after *Teacup ballet*.

Shasta daisies is technically accomplished, but it also subtly introduced another key feature in Olive's oeuvre – egalitarianism. The group of daisies as a whole is the focus of attention, rather than any individual flower. In contrast to *Teacup ballet*'s composition, which works on diagonal lines, *Shasta daisies* takes the eye in a circular sweep that begins in the upper right of the composition and moves from daisy to daisy in a clockwise direction. The daisies function like the numbers on a clock face, with each flower being accorded equal value.

In the plant and flower studies Olive made in garden settings, rather than in the studio, the concern with egalitarianism is tied to her holistic view of nature and celebration of the interconnectedness of living things. This can be seen in the exemplary modernist works *Lily pond* and *Papyrus*, both 1938, and many other examples.

Lily pond is an adventurous composition that works actively from edge to edge; the single lily flower in the upper right section of the composition is almost incidental among the plants, whose leaves are splayed over the surface of the water. The gaps in between the

Papyrus, 1938, National Gallery of Australia, purchased 1987

plants introduce spatial depth and some intriguing visual ambiguity, amplified by the layered leaves, some of which are underwater, some not. Despite the flower's evident beauty, it isn't the centre of attention. Olive foregoes an interest in detail or use of close-up in favour of an overall view and an emphasis on the complex interweaving of the plants and their leaves. Nothing here is separate or represented in isolation, every single element is connected to another and another.

Aside from Olive's sophisticated use of the entire frame, or visual field, *Lily pond* also feels unusually languid due to the soft play of light on the leaves, a flickering effect that creates a sense of ceaseless, gentle movement. The subtle suggestion of flow, flux and change – in the patterns of light and movement of the water – is no small feat in a still photograph. It is integral to the image's meaning, as a reflection on the endless dynamism of the natural world.

For *Papyrus*, photographed on 'a breezy summer afternoon' at the Sydney Botanic Gardens, Olive adopted an unusually low vantage point known in progressive photography circles at the time as 'the worm's eye view'. One of the hallmarks of modernist photography, it was taken up by photographers who wished to break with tradition and explore new, more dynamic ways of picturing commonplace subject matter. Securing the image involved watching and waiting until, in Olive's own words, 'the wind blew a white cloud into place',[7] and provided a contrast with the papyrus's dark fronds. Using asymmetry and exploiting the interaction between still and moving elements creates dynamism; some fronds are depicted in sharp focus while others are blurred from the movement caused by the wind. This is one of her most exuberant images, joyfully teetering on the edge of legibility.

The flowers and plants Olive photographed may have been chosen for their simplicity of form but, seen in conjunction with her landscapes from the same period, they go beyond exercises in aesthetics to celebrate her vision of nature. That vision, developed in the mid-1930s, and consolidated by 1937, would not alter. Her flower studies from later decades stayed true to it.

'Harmonic perception'

At the same time Olive was working on flower studies, she branched out into landscape photography. This could not have happened without the purchase of her own professional camera, which she managed to do in early 1937, shortly before her twenty-sixth birthday. Her choice was the highly regarded German-made Rolleiflex, a medium format twin lens reflex camera popular with professional photographers across the world. Its attractions included the superior quality of its lenses, use of roll film, reliable mechanics, compactness, and relatively modest weight, especially when compared to Max's heavy Thornton Pickard camera. The Rolleiflex automat camera, which had an automatic film counter, would win the Grand Prix award at the Paris World Fair later in 1937.

Buying the camera was a tangible sign of her commitment and independence, but in more practical terms it meant she could now take high resolution photographs outdoors, and with unprecedented ease. Working outdoors with large format cameras and the associated paraphernalia of a tripod, dark cloth and dark slides, which hold the sheets of film, is notoriously difficult. A memorable car trip in autumn 1937 gave her the chance to work with her new lightweight camera in a concerted way.

> … I went with my father, my uncle Frank Cotton and his son
> Keith on a ten-day camping trip, going from Sydney up the
> north coast to Coffs Harbour, then across to the New England
> tableland and back to Sydney by the inland route. We travelled

in a 1918 Buick and (generally) slept in sleeping bags under the stars. I had just bought my first Rolleiflex, and my patient father kindly stopped whenever I wanted to take a photograph. This sometimes took quite a long time – waiting for the sun and clouds to be right, selecting a viewpoint and so on.[1]

Olive had made landscapes before – *Dusk* being a notable early example – but they were modest and constrained in comparison to those produced between 1937 and the outbreak of war in September 1939. The new body of work, which included *Winter willows* (see p.175), *New England landscape*, *Orchestration in light* and *Light and shade*, stood out for its style, subject matter and content. Greater ambition was evident in the experimentation with different vantage points and more complex compositions. The Rolleiflex camera introduced a square format negative and Olive began to favour medium- and long-distance views, which she had rarely explored before. However, what emerged most powerfully in her new landscape photography was her romantic sensibility, her deeply felt response to what she saw and felt, and what she could now picture.

Learning to use the Rolleiflex wasn't the only factor affecting this paradigm shift. The ten-day trip also seems to have been a transformative experience. Olive was not well travelled (and never would be). This was not at all unusual for the time. It applied equally to Max, who hadn't yet been outside New South Wales and who did not go interstate and overseas until the war. On the car trip with her relatives, Olive travelled further than she had ever been before – Coffs Harbour was an impressive 550 kilometres north of Sydney – and they passed through completely new landscapes that she was understandably keen to photograph.

On the trip, Olive particularly enjoyed her father's company, free of the pressures of their professional and family lives and the competing claims of her younger siblings, who were at home in the capable hands of Miss Reed. It is likely that Leo shared his

deep knowledge of geology and astronomy with his daughter – one night, through his binoculars, she was thrilled to see a crater on the moon – which in turn fed into her evolving conception of land and landscape. Certainly, the two of them pursued their compatible interests while travelling. She later described an incident when they stopped to examine a magnificent granite tor, which they both found 'irresistible', but for different reasons. They trespassed on private property to get closer to it: Leo's aim was to obtain a specimen of the rock and hers was to take a photograph of the tor from the best possible viewpoint. One of the negatives she exposed included the figure of her father, geological hammer in his hand, dwarfed by the huge rock formation that fills the composition. However, in the print she made back in Sydney, she decided to eliminate Leo, as she felt his tiny figure detracted from 'the atmosphere of brooding solitude' that was her rationale for the image. She left his hammer visible at the far right of the composition for what she described as 'sentiment's sake'.[2]

While travelling, Olive kept a journal, often writing in the car, as her higgledy piggledy handwriting attests. She filled two notebooks with entries that reveal her observational skills, noting changes in soil colour and quality, the effects of rainfall and fire, the different kinds of vegetation and patterns of land use. Her notes are incisive and sometimes very eloquent. She saw 'the sun looking like [the moon] through the morning haze', and remarked on the 'lovely morning – mist lying white along the valley in patches'.[3] Fires were everywhere – the 'Smell of burning wood [was] like incense'[4] – with farmers burning the vegetation and clearing land in readiness for grazing animals and sowing crops. She also recorded the activities of their little family group: making coffee in a muslin bag, washing the dishes in a bucket on the roof of the car, getting three flat tyres in one day, and coming across a young swaggie sitting by his camp fire and reading a newspaper.

The trip allowed Olive to master using her Rolleiflex, indulged by her father, whose years of intensive fieldwork had taught him

the patience that was also fundamental to her practice. Olive never worked quickly but by this stage she was sufficiently credentialed for Leo to have every confidence in her slow, deliberate approach. *Winter willows*, taken at Bendemeer, a small village on the New England tableland where they camped for a night or two, involved a characteristically lengthy process. Olive later explained:

> I spent a lot of time selecting the view for Winter Willows.
> I was very attracted to that great line of bare willows and I
> walked up and down, moving this way and that until finally
> the branching was right. It was very complicated, but finally I
> clicked.[5]

Other landscapes from this trip, including *Mountain air* and *Twilight*, introduce a grandeur not previously seen in her work. The scenes she photographed from elevated positions are expansive, with the natural world shown well beyond human scale. *New England landscape* is structured to emphasise this, its composition effectively divided into two equal parts, half land, half sky.

Olive's contact with new kinds of landscape heightened her senses and enlivened her. She wrote evocatively about camping in the Wollomombi Gorge on the New England tableland, an experience that gave rise to *Orchestration in light*, one of the images she most prized.

> We could hear dingoes calling in the distance all night. I
> awoke to this wonderful pale early morning sunlight gently
> touching the protruding rocks and higher levels of the gorge,
> and I could see the thin stream of a waterfall flowing down to
> be lost in dark pools in its far depths. There was such a great
> range of tones, from light through to darkness, that my mind
> translated it into orchestral sounds, from the high treble of
> piccolos to the deep sonorous notes of double bass instruments.[6]

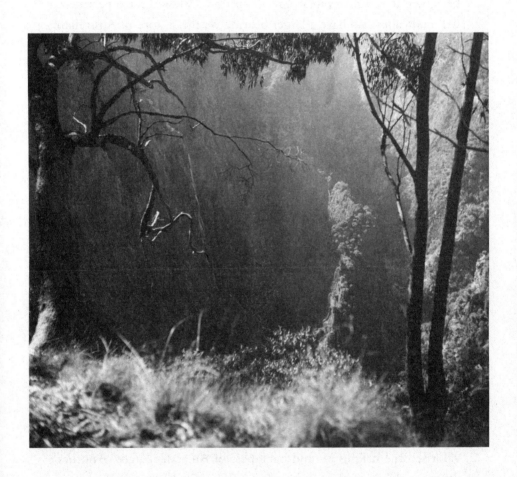

Orchestration in light, 1937, National Gallery of Australia, purchased with assistance from the Helen Ennis Fund

Here, in words, Olive evoked a sense of the landscape being alive with light, movement and sound, while the image itself conveys the experience of being fully immersed in the scene, enraptured by everything that she could hear and see.

As a result of the 1937 camping trip, landscape photography became one of Olive's main preoccupations. Viewed retrospectively, her landscapes also have a larger bearing on the history of Australian photography and Australian art. Representations of land and landscape are never neutral or innocent, or exclusively a matter of aesthetics; they carry social and political meanings as well. As Olive knew from her involvement in the Photographic Society of New South Wales, landscape had long held pride of place in Australian art photography and was championed by leading pictorialists Harold Cazneaux, J.B. Eaton, S.W. Eutrope and W.H. Moffitt and many others. Other categories and genres – still lifes, portraiture and character studies – were invariably considered less important. By concentrating on landscape photography, she entered into a larger debate.

The same year Olive travelled through New South Wales, Harold Cazneaux and his wife, Winifred, drove from their home in Sydney to the spectacular Flinders Ranges in South Australia. On this 1937 trip, he made some of the most famous images of his career, including studies of a gnarled old gum tree that later became known as *The spirit of endurance*. By this point, Cazneaux had decades of landscape photography behind him and remained committed to representing the specific qualities of Australian light and landscape. This went back to the founding, in 1916, of the Sydney Camera Circle, affectionately called the Sunshine School, which valorised the brightness and harshness of Australian light. Another distinctively Australian feature of pictorialist photography was a love of the pastoral landscape. The preference for untroubled scenes of settled, productive farmland ignored the history of colonisation and the violent, brutal dispossession of Indigenous Australians. Instead, it owed much to recent historical events, in particular the First World War and the desire to make a link between pictorial

harmony and national unity that followed its traumatic events. This was the period, as art historians Ian Burn and Geoffrey Batchen have argued, when the landscape was being conceptualised as a site of physical and spiritual sustenance.[7]

Olive's landscapes conformed to prevailing views in some ways, endorsing European occupation, but she did not consciously relate her photography to this nationalist agenda. The titles of her work alone indicate this. They rarely incorporate specific place names or make any reference to Australia as a place or as a qualifier (with, for example, generic titles like *An Australian scene, An Australian valley*). Instead, she favoured titles with literary and poetic allusions, which accorded with the elevated feeling of her landscape imagery and continued with pictorialist traditions.

On a superficial level, Olive's flower studies and landscapes can be grouped into separate categories, each displaying distinctive formal and technical investigations. The flower studies, for instance, are mostly close-ups, whereas the landscapes are predominantly medium- and long-distance views. However, the two groups are fundamentally connected. They are equally indebted to her understanding of scientific method, proceeding from sustained observation of natural elements and changing patterns of light. But there is no overriding concern with objective facts or information, and what emerges from them is not scientific knowledge. The flower studies and landscapes show Olive working successfully in a revelatory mode. This has nothing to do with seeing evidence of the divine in nature but stems from a profound appreciation of the workings of the natural world and its beauty, and a desire to express that pictorially.

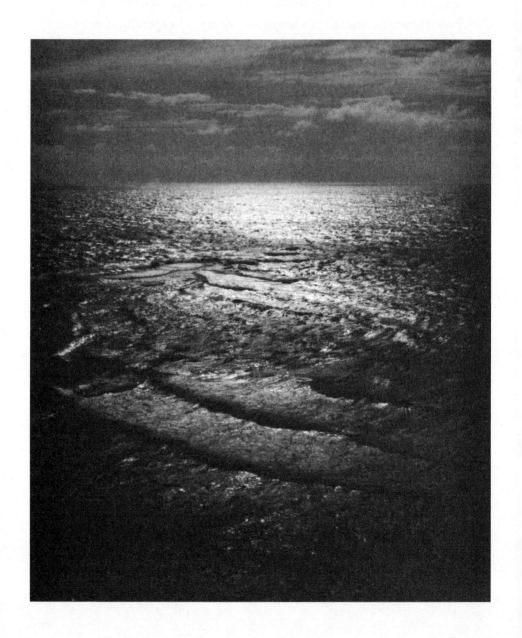

The sea's awakening, 1937, courtesy Cotton family and Josef Lebovic Gallery, Sydney

The sea's awakening

Sometime in 1937, one of the very best of years for Olive, she stood on the southern headland at Newport, watching a vast expanse of the Pacific Ocean with her camera at the ready. It was, she later recollected, 'early morning, before the sun rose and soft daylight accented every ripple of the water'.[1] The image she created is her only known seascape, a straightforward composition with three main components: the sky, sea and light. It observes a traditional pictorial convention, the rule of thirds, with two-thirds being devoted to the sea and one-third to the sky. No sign of human presence or activity is included and there is no extraneous detail.

The vintage print of *The sea's awakening* (the only one known is in the collection of the Art Gallery of New South Wales) is beautifully resolved with its rich, sonorous tones. Image and print show Olive Cotton at her most lyrical and sublime. The title, with its literary allusions, helps reinforce this effect. It is probably drawn from the poem 'Becalmed' by English poet Henry Wadsworth Longfellow, the final verse of which reads:

> Blow, breath of song! Until I feel
> The straining sail, the lifting keel
> The life of the awakening sea
> Its motion and its mystery.

The success of *The sea's awakening* comes from one crucial factor – a vantage point that hovers well above the scene. Unfixed, it appears

somehow indeterminate. Indeed, this image is predicated on an all-seeing vantage point, what is sometimes referred to as a 'God's eye' view. Nothing specific is included to attract the viewer's attention. Because the focus extends from the foreground to the distant horizon, we are led through the overall scene without being expected to pause and scrutinise any individual element. And yet within this vastness there is detail. As Olive revealed in her comment that 'soft daylight accented *every* ripple of the water' [my emphasis], detail is especially important. This reference to *every* ripple underscores another vital aspect of this photograph: its evocation of both a rapt way of seeing and a state of rapture.

The all-seeing vantage point Olive assumed is impersonal. There is no human narrative in the scene or even a suggestion of one; there is no literal point of identification, no way for the viewer to enter into it. This does not mean the image is devoid of action or narrative – there can be no mistaking sunrise as the central event, with sunlight energising the upper half of the composition and declaring the beginning of another day. Sea and sunrise are united in a wondrous relationship that is part of nature's cyclical rhythms, enacted daily, without any possibility of interruption or human intervention.

The picture edges in *The sea's awakening* have no hard limits but are fluid, open-ended. Olive chose to frame the view from the headland, without making any references to land, either in the foreground or on the sides. The implication is, of course, that the scene cannot be contained. It extends way beyond the edges of the frame, is beyond human scale and comprehension, and effectively has no end. The effect of monumentality achieved in this image has its corollary in other landscapes from the same year, especially *Orchestration in light* and *Light and shade*.

Dupain later took a photograph from a similar high vantage point at Newport, looking down to the sea, but he chose to include a human figure – a solitary male running along the water's edge. Though this man and his disappearing footsteps occupy only a

narrow strip of the composition, his inclusion adds scale and drama. For Olive, in contrast, human presence in a place such as this is irrelevant and would be nothing more than a distraction.

The sea's awakening also underlines Olive's growing interest in interiority and inner states of being. The sea is represented visually, not as a site for activity, whether swimming, surfing, fishing or boating, but rather as a field for contemplation.

'A break for independence'

It took an impressively short time to consolidate the reputation of the Bond Street studio – within three years it had become the go-to place for clients seeking imagery that was dynamic, contemporary and suitable for reproduction in the print media. Coincidentally, the relationship between Olive and Max also moved to a different level around this time, one that was more mature and presumably more physically intimate. The crucial factor behind this development was the expanding circle in which they moved; by the late 1930s, they found themselves surrounded by creative individuals, including friends, colleagues, clients and business associates. They often went out on assignment as a group, piling into Max's Chevrolet, nicknamed 'The Yellow Terror', and driving to their favourite beach locations at Cronulla and Newport to do fashion shoots. 'There was,' Olive said, 'often a little light-hearted action between shots,'[1] and her snapshots from this period convey a sense of the group's esprit de corps and love of life.

Olive also began spending occasional weekends away with Max and their friends, either at Newport or camping on the New South Wales south coast. Culburra Beach, 185 kilometres south of Sydney, was one of their favourite camping spots, as documented in a delightfully informal album of photographs owned by Max's friend Chris Vandyke (the album is in the State Library of New South Wales's collection).[2] At Newport, they stayed either at Lyeltya or Waioni and relished their freedom.

Their expanded friendship circle included some of the Ballets Russes dancers who were performing in Sydney; Max and Olive took them to Bondi Beach, shared meals with them in the studio and went out to dinner with them.[3] However, for Olive, the most important new friendship was with model Jean Lorraine, who helped her make what the worldlier Lorraine termed 'a break for independence'.[4]

One of Olive's roles at the studio was to find models for Max's professional and art photography, and she had originally contacted Lorraine after seeing a photograph of her in *Australian Women's Weekly* around 1935. Very quickly she became one of Max's favourite models during his early modernist phase. Lorraine outlined her circumstances at the time she met Olive and Max in her unpublished memoir, 'Chasing a breeze':

> I hadn't been able to find a job to save my soul, and so I went
> around all the art schools doing figure modelling. But I got
> tired of being taken home by the young painters to meet their
> mothers, who would give me a meal and try to persuade me
> to give up modelling. I was a little leery about working for a
> photographer so I asked friends if Max Dupain were reputable,
> and they said, 'Oh yes, he's only young but he has a lot of
> talent, he's well respected in the art world.'[5]

A spirited, adventurous and unconventional woman, Jean was actually a few years younger than Olive but already much more experienced in life. Born Winifred Audrey Wickens, her upbringing, initially in Perth, then Sydney, had been unsettled because of what she described as her father's 'secret life with horses', which led to great swings in the family's fortunes. He had been a horse trainer, an occupation he abandoned for a career in retail after marrying Jean's mother, but continued to gamble throughout his life (when he was semiconscious on his death-bed, in 1946, much to the consternation of his family, 'he kept calling the races').

After leaving high school, Jean attended business college and then worked in an office in Sydney. In 1934, at the age of seventeen, she married a young athlete and moved with him to Newcastle for a short time. 'That', she later wrote, 'was when I learned about love-making', believing that she could at least 'master this part of being a wife'.[6] The marriage didn't last. By the time Olive and Jean met, the teenage couple had separated and were in the process of a protracted divorce, which, as Lorraine put it, took five years 'to grind through the courts'.[7] Jean had taken up with a new lover, John McInerney, a country boy who was studying medicine at the University of Sydney. She described him as 'tall and beautiful' and 'gifted, if a little difficult', 'wild, tough', charming and very attractive to women.[8]

Jean Lorraine later recollected her first impressions of Olive, giving a rare first-hand account of what she was like in her twenties:

> Olive was pretty, almost shy with a soft beautifully modulated speaking voice. She complimented me on my slim figure … and remarked that she would like to lose a few pounds. I reassured her, 'You will, that's just puppy fat. I worried about that when I was about your age, but then I grew an inch or so taller and everything evened out.'
>
> She laughed. 'How old do you think I am?' she asked.
>
> 'Sixteen,' I answered positively. That's me, maybe wrong, never in doubt.
>
> 'I'm 26,' she told me.
>
> Apparently, that's how you make a friend for life. I did.[9]

On face value, theirs was an unlikely friendship due to their differences in age, background and life experience, but, Jean wrote, they were 'extremely compatible. We each had our own agenda and we could converse for hours without interrupting each other's train of thought.'[10] She treasured their friendship as 'a golden thread which ran through my late teens and twenties. We laughed together

often; cried together rarely, but did share each other's sorrows deeply.'[11]

It was through Jean that Olive was able to make the practical arrangements for leaving home, with Jean later detailing how the two women came to share her inner city flat:

> After my short first marriage, I lived alone for a while. I was eighteen years old and dumb as a stump. I had a small flat in King's Cross, a community with a very bad reputation. My friend, Olive Cotton came to share my flat for a while. She had been living in the suburbs with her widowed father, a housekeeper, and three siblings [it was actually four], and was wanting badly to make a break for independence ... Olive's father was a very unworldly professor ... He had always protected his children and in retrospect, I'm amazed that he allowed her to live in such a disreputable place with an artists' model. But he did put a three-month limit on her sabbatical.[12]

Living away from her family meant Olive could socialise more freely with Max, who still lived with his parents at Ashfield. Jean recollected that the three of them often met up after work and shared a meal together at her place. Although the flatting arrangement was temporary and Olive returned home as agreed – she was, Jean wrote, 'a woman of her word'[13] – it was a turning point in her relationship with both Max and her father. Leo appears to have accepted her need for greater autonomy, as she participated in group camping trips with Max and their friends.

* * *

Most in Olive and Max's tightknit community were young – in their twenties and at a stage in their lives when they were beginning to form romantic attachments and long-term relationships. Exceptions were the artist Douglas Annand and his wife, Maida, whom they

came to know through Ure Smith; a few years older than Olive and Max, they had married in Brisbane in 1928 and had already begun their family.

Although an involvement in the arts is conventionally associated with liberal social attitudes, within their little group there was no consensus about what comprised 'acceptable' sexual behaviour. Jean Lorraine and John McInerney were perhaps the most liberated: they became lovers well before the divorce from her first husband had been finalised. Both Jean and John appear to have had multiple affairs, which Jean referred to in her unpublished memoirs (not necessarily in positive terms). In contrast, Damien Parer, who joined the studio in 1938, was a devout Roman Catholic, and followed the church's teachings that premarital and extramarital sex were wrong. As his biographer has pointed out, Parer believed that 'any transgression led straight to Hell'.[14] He therefore did his best to keep a physical and emotional distance from any woman he felt attracted to: when courting Marie Cotter, he would make sure that they were never alone for long, fearful of creating a situation where he would find it impossible to resist 'temptation'. She later gave details of his excruciatingly awkward behaviour as he tried to keep her at bay.

In Australian society more generally, historians of sexuality have summed up the 1930s as a deeply conservative, moralistic period, with a relentless focus on heterosexuality. Women and men were expected to be sexually active only within marriage, and sex was assumed to be procreative, not recreational. Marriage was for life and divorce was exceptional: statistics show that, at the turn of the 20th century, only 4 per cent of marriages ended in divorce; numbers rose very slowly until the mid-1940s, when the rate increased as a consequence of hastily made, unsuitable wartime marriages. Access to information on sexuality and contraception was restricted (state and federal legislation banned the advertising and display of contraceptives),[15] sex education wasn't taught in schools, and marriage manuals were relied on for information about sexual relations between men and women.[16] Despite the regulation

of sexual behaviour by the state, church and the police, and the huge stigma associated with pregnancy outside marriage, premarital sex was common. Statistics for the period 1921–30, when Olive was growing up, reveal that more than 30 per cent of recorded confinements for women aged between fifteen and twenty-four were illegitimate.[17] Abortion, which was illegal and notoriously unsafe because of the risk of infection and haemorrhaging, was widely practised.

It is not possible to establish Olive and Max's respective views on sex and sexuality and indeed they may have been very different. Max implied that sexual activity was part of their group camping trips in the late 1930s, when he told his biographer Clare Brown that 'We all went camping with certain things in mind, particularly Chris Vandyke.'[18] He recalled being concerned that Marie Cotter's sister Doreen, 'a good Catholic', may not have realised this was the case when she accepted an invitation to join them on one particular trip. As it transpired, she 'wouldn't play ball'[19] – Max's words – and Vandyke treated her badly, so Max and Olive stepped into the breach and looked after her. Max said that he and Olive were married at the time, but if this incident dated from the trip to Culburra Beach documented in Vandyke's album, it was actually two years prior. In his memory, he and Olive were clearly a close couple at this point, acting in unison. The tempting conclusion is that they were not sleeping separately at this time but sharing a tent.

Olive and Max were definitely exposed to liberal views on sexual behaviour through other quarters. One of the most conspicuous was Max's association with physical educationalist and writer George Southern, who was close to Max's father, George.[20] Southern trained at the Dupain Institute (1928–30) and was a teacher there. Olive's contact was far more limited but she is known to have visited Southern and his wife at their home in Mosman with Max and his parents.[21]

Southern was author of the self-published book *Making Morality Modern*. It was intentionally provocative, text on the cover declaring

it to be 'a broadside attack on sexual morality, likely to make the wowsers yell and thinkers think'. Photography historian Isobel Crombie has pointed out in *Bodyculture: Max Dupain, photography and Australian culture 1919–1939* that Southern 'encouraged political, economic and sexual equality for men and women; the liberation of marriage from "Church and State tyranny"', as well as a eugenic approach to 'Race betterment', which George Dupain also advocated.[22] Southern was sympathetic to socialism and communism and opposed conventional sexual behaviour. According to Crombie, he and his wife, Lois, were in an open marriage, and he championed the nudist movement in Australia 'as a significant aspect of sexual and political freedom'.[23]

One can imagine that Olive's acquaintance with Southern and his publications, especially those to which Max contributed photographs, stimulated discussion. But nothing suggests she was committed to pursuing sexual freedom on an individual basis, or that she identified sexual liberation as being fundamental to transforming society through the kind of radical politics Southern espoused. Nor is it possible to conclusively determine, from the skerrick of evidence available, whether she and Max were among the more sexually active members of their circle and became lovers before they married. There is no doubt, however, that Olive believed in equality between women and men, and in the ideals of a companionate marriage in which that equality could be fully expressed.

Olive might not have been overtly rebellious when it came to challenging society's sexual mores, but she was certainly not one of the wowsers Southern set out to provoke, as her exploration of nude photography reveals. This was never a central part of her practice – in contrast to Max's – but it is significant that she modelled nude for him on several occasions between 1935 and 1939. In light of conventional morality that conflated nudity and sex, modelling nude was a very courageous thing to do. The prevailing assumption was that, if you either modelled nude or photographed nude subjects,

you were likely to be sexually promiscuous and disreputable. This was an age when, as Parer's biographer Neil McDonald reminds us, a woman was expected to wear gloves and a hat in public and not doing so was considered whorish.[24] It is therefore unlikely that Olive's family knew of her actions at the time: Leo, so often referred to as 'unworldly', would not have approved of such behaviour, and other family members were worried about Olive's reputation once they discovered she had been Max's nude model.

Jean Lorraine, on the other hand, was prepared to challenge conventions as a nude model, and did so with confidence. She later explained: 'I do not feel guilty about shedding my clothes and posing for a group of young artists. I know that my body is pretty and symmetrical and I am not self-conscious.'[25] She loved modelling for Max and enjoyed their rapport:

> I never categorised myself as his favourite model, but we always
> felt very comfortable working together. Compared to other
> photographers I posed for, his ideas were always more original.
> And he was great fun. He loved to laugh, and he loved to make
> me laugh.[26]

It should be noted, however, that Jean had to deal with the negative repercussions of posing nude. After they married, her husband John asked her not to continue but she ignored his request: 'I have promised to quit, but here I am. I will invent a scenario to cover my day's activities and then I will listen entranced to what he has to say. I am crazy about him, I do not ever want to hurt him. But I will lie. Everybody lies.'[27]

While Olive's involvement in nude photography was another tangible demonstration of her and Max's active collaboration, it may also have had a more minor, practical dimension – difficulties in finding models such as Lorraine, and the discretion required, meant that photographers' girlfriends and wives would sometimes fulfil the role. Olive's participation appears to have been based either

explicitly on an agreement with Max or at the very least on his understanding that she must not be identified in the image itself or in its title. His nude studies of Olive are therefore exceptionally discreet. She was photographed from the back, as in *Little nude* – the only instance in which she was publicly acknowledged as the model during her lifetime – with her hand or arm strategically covering her face or with her body truncated, as in *Torso in sun*.

There was also a crucial, larger context for Max's nude studies of Olive – his interests in body culture, sex and eroticism, that were deepened by his exposure to vitalist philosophy, especially the work of Nietzsche, D.H. Lawrence and the Powys brothers. He regarded his nude photography as a deliberate challenge to the status quo, but had few Australian examples to refer to or emulate. The only Australian precedent he could recall seeing was a nude study by Cecil Bostock, which was included in his portfolio of art photographs, published in 1917. Harold Cazneaux did not exhibit or publish nude studies at any point in his career, nor did other pictorialists, with the exception of William Buckle (his wife posed nude for him on a few occasions and he photographed other models as well). Max did not think Norman Lindsay influenced his decision, despite his familiarity with Lindsay's view of sex as 'the most vital of all issues', as outlined in his book *Creative Effort*, and that Lindsay's paintings and drawings were crammed with female nudes, often in allegorical guises. However, Max's knowledge of the genre expanded significantly once he began purchasing international photography magazines, such as *Das Deutsche Lichtbild*, which regularly published nude studies by Man Ray and others. The inclusion of a ten-page section of nude photographs in the English *Photography Year Book* (1938) was indicative of the proliferating international interest. American photographer Edward Weston's outstanding nudes – mostly of his lovers – would come later.

In contrast to Olive, Max did not have to countenance the possibility of parental disapproval about working with the nude. George Dupain was an advocate of nudism as part of the health

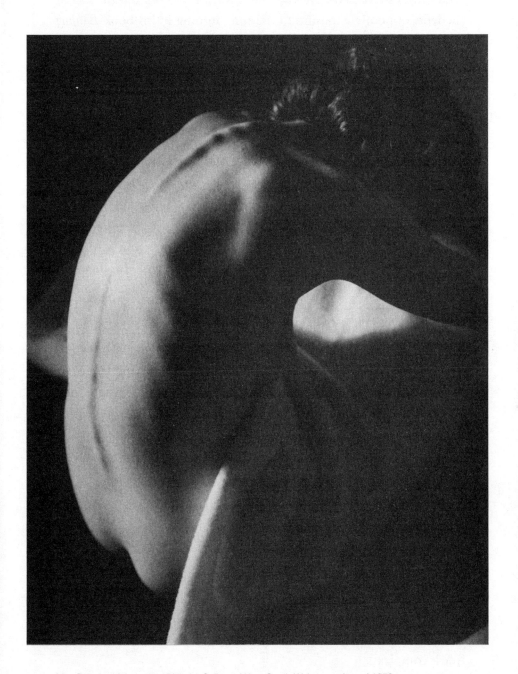

Max Dupain, *Little nude*, 1937, Art Gallery of New South Wales, purchased 1976

and fitness movement. He saw it as a way of maximising the health benefits of bodily exposure to the sun, arguing in his book *Battling Obesity* (1935) that:

> The modern 'nude cult' is an attempt to get more sunlight and is a thoroughly healthy reaction against the despoiling dangers of darkness. The truth is that the larger the body surface exposed to the action of sunlight, the greater the benefit to individual and racial health.[28]

Max Dupain did not belong to any nudist groups but his background meant that he could approach nudity in a relatively liberated way, producing images that were exceptionally frank at a time when the photographic nude was still relatively uncommon. His memoirs state that he first began investigating the genre in 1931, when he was aged twenty and in the early stages of his apprenticeship with Bostock. His earliest efforts were not very successful, in part because of the graceless, overly self-conscious poses his models adopted, sometimes lying awkwardly on sand (perhaps the sand dunes at Cronulla Beach). However, within four years, his nude studies had become highly accomplished and varied. What united them was his attraction to a particular kind of male and female body – youthful, strong and well built – and his celebration of vital, elemental forces and eroticism.

For Olive, exploration of the nude genre was confined to only a few known examples. Max appears to have been her sole male subject, and then, in her three known studies of him, he may not even have been naked (it is possible he was wearing bathers or shorts). Two photographs derive from the same outdoor session, probably at the beach, and are upper body shots that show him adopting athletic poses; his face is included and he is readily identifiable. The third, the photograph known as *Max after surfing* (c.1937–38), is by far the most complex.

Max after surfing

Max after surfing is a beguiling, erotic image of a male nude that is unlike anything else Olive produced. Indeed, it has no known equivalent in the history of Australian modernist photography. Its appeal is immediate and yet, paradoxically, the experience of viewing it is slowed down through Olive's masterly use of chiaroscuro, which achieves an effect equivalent to a filmic slow reveal of her apparently naked subject.

Probably because of its intensely private, intimate nature, *Max after surfing* was not exhibited at the time it was taken, and Olive kept it to herself. It only came to light in 1995, when she and her daughter Sally were assiduously working through the archive kept at Spring Forest, gathering information for use in the book *Olive Cotton: Photographer*, which was to be published later that year. This was when Olive gave the photograph the title by which it is now known, and when she settled on the date of 1939. She explained to Sally that Max had been out surfing, which was one of his favourite pastimes at Newport, and she photographed him after they returned to Waioni.

The seductive power of *Max after surfing* comes in part from the ambiguity of its narrative. It is not clear exactly what moment is being represented, whether Max is getting undressed or dressed after coming in from the surf. He is suspended in an eternal pause, with no action ever to be completed. Nor can the setting be conclusively identified. There is simply not enough detail to determine where he is, whether inside or outside in an in-between space, like a

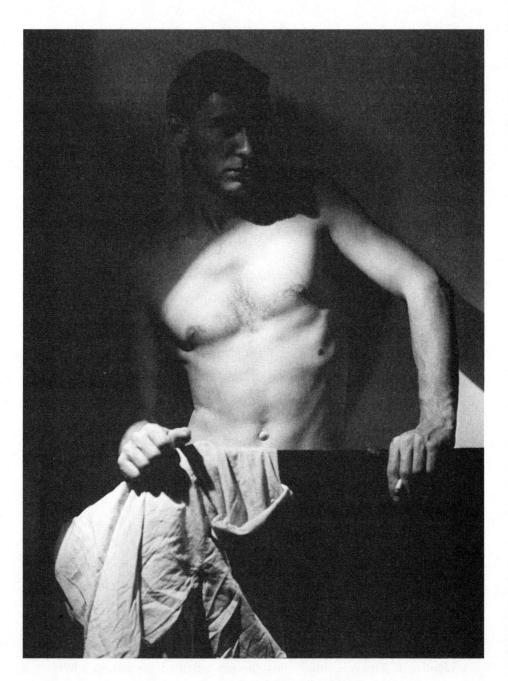

Max after surfing, 1937, courtesy Cotton family and Josef Lebovic Gallery, Sydney

porch or a shallow verandah. Nor can we be certain about what he stands behind so strategically; perhaps it is a low screen made for indoor use, or a flimsy balustrade. This lack of specific, anchored information contributes to the photograph's hermetic quality, and its dreamy otherworldliness.

Intriguingly, the vintage print Olive owned is not the only one that exists. A second quite different print subsequently emerged after hers was published in *Olive Cotton: Photographer*. It was in the collection of Jill White, Max Dupain's assistant, part of a group he gave her in the years before he died, in 1992. This print is from the same negative and is signed – not by Olive or Max – but by the eminent international photographer Baron George Hoyningen-Huene, who arrived in Sydney for a brief visit in December 1937. The existence of this print raises fascinating questions which, however, cannot be definitively answered, because of the lack of written or oral documentation about the circumstances of its production.

The second print (purchased for the National Gallery of Australia collection in 2006) differs from Olive's version in a number of key respects. Hers is small, measuring 22.3 x 17 centimetres, and it is unsigned. The version Max originally owned is much larger, at 38 x 30 centimetres, which is exhibition scale, is more tightly cropped, un-retouched, and has drawing-pin holes in all four corners. The inscription, written in pencil in a flamboyant cursive style on the lower right-hand corner of the print, reads, 'To Max / with friendship / from George.' A further inscription on the right-hand side, likely to be in Max's hand, relates to mount size and framing instructions, though whether the work was ever framed is not known.

The material differences between the two prints have a significant effect on our responses to the image and the feelings it generates. Size is a crucial factor here. So is the way the negative has been interpreted tonally. Olive's print is moodily dark and introspective, whereas Max's is considerably lighter and less discreet. When it comes to the named subject, Max himself, the emphasis is not the

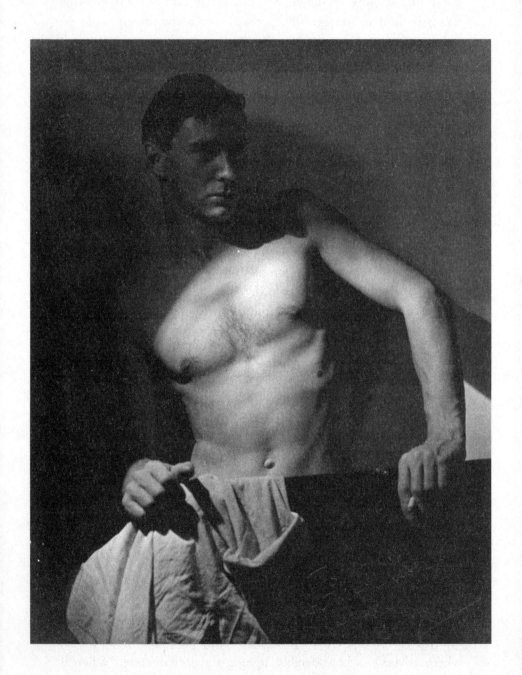

Max after surfing, 1937, National Gallery of Australia, purchased 2006

same either, with greater attention directed to his torso alone in one print and to both his torso and face in the other. In each, however, his virility is highlighted; he is shown to be lean and fit, and a tracing of dark chest hair is evident. His face is self-contained and still – Max doesn't look directly at the camera, he poses for it.

* * *

The Australian visit of Russian-born photographer George Hoyningen-Huene began on 5 December 1937, when he arrived in Sydney on the ocean liner SS *Nieuw Holland*, and ended five days later, on 10 December, when he boarded the SS *Monterey* bound for the United States.[1] At the time of his Australian sojourn, he was one of the most famous fashion photographers in the world; he had worked for Paris *Vogue* in the 1920s and early 1930s, and in 1935 had joined the influential American magazine *Harper's Bazaar*, whose art director was the legendary Alexey Brodovitch. Hoyningen-Huene was known for introducing movement into fashion photography and instilling it with a new vitality. His newsworthiness was such that the *Daily Telegraph* published a photograph of him in his cabin on the *Monterey* the day before it sailed. He also attracted the attention of the *Sydney Morning Herald* during his visit, not least because of his extraordinary style of dress. The paper reported that: 'This expert on women's clothes was himself immaculately dressed when he arrived here. A perfectly-tailored finely checked suit, combining brown and blue, a zephyr blue felt hat, brown suede shoes, and a blue shirt completed his outfit.'[2]

Interest in Hoyningen-Huene was not confined to fashion and beauty circles. Dupain knew his work through international magazines and greatly admired it, listing him in his pantheon of fashion photographers, along with American greats Margaret Bourke-White and Edward Steichen, and was determined to get everything he could out of Hoyningen-Huene's Sydney visit. He later wrote that:

I chased him all over town and eventually tracked him down in Ure Smith's office. He visited the studio often during his week's stay and twice I had the good fortune to assist him [in] operating [the camera]. He left stimulation and enthusiasm in his wake.[3]

In one amusing incident at the studio, Hoyningen-Huene struggled with the equipment they used to control the camera's shutter speed.

He could not get the hang of the bulb-squeezing system, particularly the thumb covering the hole. So we improvised with a wooden plug and inserted it into the hole. Of course the inevitable happened – when the bulb was squeezed hard, the plug flew out and whacked the fashion director in the ear! Great laughter all round.[4]

The visual record of Hoyningen-Huene's visit to the Dupain studio is limited, comprising a small group of photographs by Geoffrey Powell and by Dupain himself. Powell showed the two men in discussion, maybe about a photograph, Max listening intently to the older man's comments. Max made two known portraits during what appears to have been the same session in the studio. One is of a smiling and obviously very hot Hoyningen-Huene – it was summer, after all – casually dressed, shirt collar loosened, necktie undone (Olive also had a print of this in her personal collection, possibly a memento from his visit). The second shows Hoyningen-Huene looking closely at photographic prints, perhaps some of Max's recent efforts, which the two men may have been discussing. Hoyningen-Huene also made some portraits of Max[5] during his visit but unfortunately these have not yet been discovered.

The terms of Olive's engagement with Hoyningen-Huene were entirely different to Max's. Due to the gendered roles at the studio and her position as the assistant, she did not interact with him as a photographer in her own right and he may have barely noticed

her. Late in life, at the age of eighty-four, she recalled that she had decorated the studio with bunches of blue hydrangeas in anticipation of his visit, and remembered him photographing a model there, but nothing more than that.[6] Because Hoyningen-Huene's work was in fashion and portraiture, it did not have the same relevance to her as it did to Max. Nor would his glamorous Hollywood style have aligned with hers, as she was becoming increasingly enamoured of natural light by this point, working outdoors whenever she could, rather than in the studio.

Some examples of Hoyningen-Huene's Australian work were published during his short stopover. His fashion photographs for David Jones were featured in the *Sydney Morning Herald*, and others appeared in *The Home* magazine shortly after.[7] Capitalising on the topicality of his visit, the *Australian Women's Weekly* reproduced a selection of his stylish photographs that had previously been published in *Harper's Bazaar*.[8]

Because of his fame, the *Sydney Morning Herald* gave generous coverage to his views on fashion and beauty. One reporter asked for his opinion on the most beautiful woman in the world, and he wittily replied, 'I have not seen Greta Garbo.'[9] He was very complimentary about a type of woman he had discovered in Sydney who was 'Folies Bergere, Manet, and Mae West all rolled into one'[10] – high praise that ensured strong local interest. He claimed that Australian women were 'full of vitality', and went on flatteringly to say:

> ... there are more good-looking women here than there are in London ... They dress well and seem to be quite conscious of their own good looks and smartness. The English man is the best dressed in the world; but the English woman is the worst. Australian women are almost as smart as the American.[11]

Hoyningen-Huene's connection to the Dupain studio was not prearranged but is hardly surprising, given Max's up-and-coming reputation at the time and his own professional associations with

David Jones and Sydney Ure Smith. The studio's central location and excellent equipment would have been further attractions, enabling Hoyningen-Huene, or others on his behalf, to turn around his negatives and prints as quickly as possible.

* * *

By the time of Hoyningen-Huene's brief visit, Olive had attained a new level of assurance in her photography. She was now experienced in the use of the studio camera (the negative for *Max after surfing* is in the studio camera format, 7 x 5 inches, or 21 x 15 centimetres) and had acquired her Rolleiflex. *Max after surfing* continued her engagement with Max as a subject, which was inextricably tied to their shared life and photographic partnership. However, the portrait differs from others of him in its level of eroticism, sophistication and glamour. Reviewer Stephanie Holt enthused that it is 'a swoon-inducing portrait', writing that Dupain 'is here part matinee-idol profile, part Bruce Weber-esque muscles, part lovingly observed husband; at once cool, erotic and intimate'.[12] Another reviewer referred to it as 'sexually charged', with Dupain appearing 'semi-clad like an Adonis'.[13]

Which returns us to the matter of its date. The inscription from Hoyningen-Huene on Max's version of the photograph establishes that it could only have been taken either before or during his stay in Australia, in December 1937, not 1939, as was initially recorded.

When Olive and her daughter Sally first came across the photograph that Olive decided to call *Max after surfing*, Sally sensed her mother's reluctance to say too much about it. Olive was governed by a strong sense of propriety and sought to protect both her and Max's reputations, as well as the feelings of their respective spouses, Ross and Diana. This anxiety about how people might judge her relationship with Max can be contextualised within the religious conservatism of the 1930s and the taboo of premarital sex. Olive

and Max did not marry until 1939, the date she retrospectively gave to the image. A later dating moved it into a safe realm – the intimacy of marriage – where it could not be tainted by impolite speculation and innuendo. In reality, however, it was taken up to two years before she married, when she and Max were still living at home with their parents.

The photograph's eroticism was a very sensitive issue, not only for Olive, but also for her second husband, Ross, and other members of the Cotton family. In Ross's opinion, Olive would never have taken what he described as 'erotic photographs' of Max, and he believed that it was Max, not Olive, who set up *Max after surfing*.[14] Olive herself was anxious about public knowledge of the fact that she was the model for Max's coy and charmingly titled *Little nude* from 1937. (The 'little' is a likely reference to her physical stature.) She worried that people would think badly of her for modelling nude because it was not considered respectable behaviour. Perhaps she need not have been concerned. Frank Moorhouse's summation was that the image served as 'a perfect example of what Dupain strove for – the relegation of "subject" – where the light and composition and body form are very close to being "everything". The subject is almost secondary.'[15]

Little nude and *Max after surfing* are related as an example of Olive and Max posing in each other's photographs, but there is a crucial difference that is reliant on a larger context. *Little nude* was made for public consumption and was regularly exhibited and published during Max's lifetime, and *Max after surfing* was not. This is an important distinction because it has a fundamental bearing on the different affective qualities of the two versions of *Max after surfing*. Olive's small, intensely felt print can easily be read as emblematic of her desire for Max. In contrast, the print Max owned has nothing to hide. It operates in a different emotional register and was presumably Hoyningen-Huene's demonstration of his glamorous Hollywood style of printing to Dupain, authenticated by his personal inscription.

There is no information about how Max and Hoyningen-Huene might have laid claim to Olive's negative – I am assuming that they did – but the convergence of their interests in glamour portraiture and the nude are obvious.

Max had already been exploring the genre of the nude for several years, creating works that drew from his own background – especially the influence of his father – as well as broader social and cultural concerns with health, fitness and eugenics that were circulating in the interwar period. Isobel Crombie suggests that, in *Max after surfing*, the emphasis on his 'muscular, lean body' is more than an erotic portrait: it also reflects his strongly held 'belief that modern men and women should model their bodies on those of Greek and Roman statuary'.[16] It is therefore conceivable that, as a model, Max was keen to meld classical and contemporary references into a vision of the new man.

Although best known as a fashion photographer and portraitist, Hoyningen-Huene was also an outstanding photographer of the male nude. The best-known example is a 1931 photograph of a lover, the German-born, American-based photographer Horst P. Horst, which focuses on his torso and partially obscures his face. Hoyningen-Huene's interest in the male nude was confined to a particular type, one that was young and athletic. As a model, Max fitted the bill perfectly, the epitome of good health and male beauty. The cigarette he holds did not have negative health associations at that time and would have signified sophistication.

* * *

The circumstances that gave rise to the existence of the two versions of *Max after surfing* cannot be known with absolute certainty. But for Olive there was no question that the negative, the print and the narrative were hers, and hers alone. Despite the time that had passed, the photograph remained tightly woven into her memories, of Max, Newport and her own photographic practice involving

Max as a collaborator. She succeeded in creating an image of her husband-to-be which, through the consummate control of tone, speaks of intimacy, sensuality and inwardness.[17]

Hoyningen-Huene's involvement can, I think, be best understood as opportunistic. Seeing Olive's negative (or print) at the Dupain studio gave him the perfect opportunity to show off his style and printing prowess in rendering the male nude. He embellished the lighter, larger print he made with a personal inscription to Max and presented it to him as a gift. Olive was not part of this transaction, but she would have seen the outcome – Hoyningen-Huene's print was pinned up on the studio wall, to be scrutinised and admired by all.

Meanwhile, her own little print quietly disappeared from sight. It was incorporated into her personal archive, packed into her traveller's trunk and despatched to Spring Forest, where it remained vividly remembered, but hidden, for sixty years.

Lucille

In the mid-1930s, Olive had to contend with Max's flirtation with his first cousin, Lucille. She was the oldest daughter of his uncle, William Dupain, affectionately known as 'Bill', and his aunt, Muriel (née Morrisby). Bill Dupain worked for the Australian shipping line Burns, Philp & Company and was manager of the company's operations in Port Moresby, where the family lived for several years. By 1935, Muriel and her two daughters, Lucille and Diane, were back in Sydney, living at Double Bay, while Lucille attended Doone's finishing school at Edgecliff, in the eastern suburbs. This privately run school aimed to prepare girls for a life in high society through a curriculum delivering 'tuition in social graces', and prided itself on the achievements of its graduates. Its senior students, an article in the *Australian Women's Weekly* claimed, 'have since figured in romances … been presented at Court, associated with Royalty and visiting notabilities, become famous for their beauty and accomplishments'.[1] Harold Cazneaux photographed Lucille at Doone's, either as a private commission or in a session organised by the school, and the pretty young woman is shown adopting artful poses in a lovely garden setting.

Lucille remembered that, while living in Sydney, she would 'rush off' to see Max and Olive at the Bond Street studio whenever she could; it 'was tops … like a breath of fresh air'.[2] They would buy food and take it back to the studio, where they ate together, sometimes accompanying their meal with a drink of dry sherry. (She confided to Clare Brown in 1991 that it might have been cooking

sherry, and asked her not to mention this to Max, who would have denied it and been furious; she didn't say why she expected such a negative reaction, but it may have been because the drink was cheap and drinking it implied poverty and a lack of sophistication.)

Max welcomed the young woman, then in her late teens, back into his life and introduced her to activities ranging from the serious to the light-hearted. According to Lucille's later recollections, he took her to her first ballet, Stravinsky's *Firebird*, performed by the Ballets Russes in 1936–37. She described the experience as 'marvellous – I don't know whether it was [the performance], or whether it was because Max took me'.[3] Max read her extracts from books by D.H. Lawrence and Aldous Huxley that meant a great deal to him at the time, and which, she recalled, he was 'quite adamant' about.[4] They went together to the latest Noel Coward film, *The Scoundrel*, at the Savoy theatre in downtown Sydney, in May 1937, which she found so frightening they had to leave before it ended. When Max bought his first car, that stylish yellow Chevrolet, she shared the excitement: 'I was with him when he learned to drive it, I think – we took it over the [Sydney Harbour] bridge a few times, I was terrified – it was great fun.'[5]

Both cousins, Lucille and Diane, sat for Max for portraits published in *The Home*. The full-page portrait of Lucille, in the January 1937 issue, is particularly appealing. She adopts a dynamic pose, leaning diagonally into the frame, with her head angled in a subtly different spatial plane. An attractive dazzle of drops of light behind her enhances the glamorous effect. Her facial expression carries a suggestion of barely contained energy that is unusual in Dupain's society portraiture, where his female subjects typically appear more static, sometimes even inert. Possibly as a result of Dupain's connections, Lucille also modelled clothes for some of the fashion photography assignments he shot for David Jones. However, she drew the line at modelling nude, telling Clare Brown 'it would have been scandalous'[6] to have done so. She did recall Max showing her nude studies he had made of a pregnant woman, which

'shocked' her; these may have been for his montage, *The birth of Venus*, dating from 1939, the year she was back in Sydney in advance of her wedding. And she had heard that Olive was one of his nude models, which she didn't find surprising, because she associated the couple's involvement in the arts with more liberal attitudes. In her opinion, 'It wouldn't have worried Olive, modelling nude' (others disagreed).

For Lucille, there was no doubt that she and Max enjoyed 'an affinity', confidently asserting that he found her 'fun and relaxing'. She thought he was 'so good looking and the glamour type' and wanted him to join the air force because she felt he would have looked great in the blue uniform airmen wore (hence their nickname 'the blue angels'). She appreciated the fact that 'Max was so modern' and referred to him insightfully as 'a tomorrow man'.[7] Their mutual attraction apparently made the Dupain relatives 'quite nervous'; as she put it, 'they knew how taken I was by Max and they were worried I'd want to marry him, and I couldn't being first cousins and all.'[8] However, she claimed she had no such designs on him and was not interested in getting married at that time. She was, in fact, 'having too much fun' in her life as an in-demand young socialite.

Despite her youth and obvious impressionability, Lucille did have a big impact on Max, which he later acknowledged. In an interview with Clare Brown, he made the candid comment that he could have married Lucille, but unfortunately did not elaborate on why he felt this way. Nor did he ever explain how he reconciled his attraction to his cousin during these years when he and Olive were seriously involved as a couple and would soon marry.

While clearly smitten with Max, Lucille also held Olive in very high regard. In her assessment, she was 'a gentle woman. And strong. She took pictures of what she wanted to take pictures of. If Max didn't want her to do something, and she wanted to … Well, they were both very stubborn.'[9]

For Olive, watching Max and Lucille's flirtation and 'affinity' play out in front of her must have been extremely confronting. Her

feelings were sufficiently strong for her to take uncharacteristically duplicitous action on at least one occasion, which she recounted to her daughter decades later. Sally calls it Olive's 'only known act of deception'. Lucille had arranged a birthday party for Max to which Olive was not invited. Faced with this humiliating lack of regard, she told Max that she had already arranged a surprise birthday gathering for him. He cancelled the commitment with Lucille, and Olive hastily called her and Max's closest friends and invited them to a party. The fact that Olive still remembered, and relayed such detail about this incident, indicates its significance in her emotional life – it was not something she could forget.

The vividness of Olive's recollections also suggests there was a larger context for her response. Looking back over her life with Max, she may have seen his attraction to Lucille as a harbinger of future disloyalty and disappointments, which gave it an even stronger, more enduring resonance.

In September 1937, Lucille exited their lives in Sydney and moved to Cairns, where her father had recently been appointed local manager of Burns, Philp & Company. A photograph of her and her sister, Diane, was published in the 'Women's Pages' of the *Sydney Morning Herald* with details of their imminent departure. Lucille's next media appearance was nearly two years later, when a stylish portrait of her, taken by Dupain, accompanied the announcement of her engagement.[10] As part of the extended Dupain family, Olive and Max are likely to have been among the guests at her society wedding held three months later.

The Max Dupain Studio,
1937–39

By 1937, the Dupain studio was attracting an ever-expanding number of clients and their calibre was impressive.[1] Having been a two-person operation since its inception, with only Max and Olive working full-time, they were now ready to expand and bring in other staff. Geoffrey Powell joined them in April 1937 as an assistant and camera operator. Olive, meanwhile, continued in her role as studio assistant.

An article published in the New Zealand magazine *Monocle* gave a nicely observed description of the set-up. Its author, Kay Lester, wrote:

> The furnishing of [his reception room] reflects the character
> of Dupain; well-filled book-cases cover two walls – poetry,
> literature, modern design, modern painters and old masters.
> Curtains divide this reception-room from the studio. This
> latter is a spacious operating-room replete with large glass
> sliding-screen, which supplies most of his backgrounds together
> with many ingenious designs which have been cleverly evolved
> for scenic decoration. An elaborate system of spot lighting
> supplies the artificial lighting scheme.[2]

As Lester noted, it was Dupain's character that was solely in evidence. His domain encompassed both the studio and what the

article referred to as the reception room. Olive's professional sphere was confined to the reception area where she liaised with clients and models, attended to visitors, and did the paperwork associated with the business.

When Geoffrey Powell joined the studio, he was nineteen, seven years younger than Olive and Max. In Max's assessment, he was 'a forthright individual who would insist on growing a beard in a society that was not beard oriented'[3] – he, and many others, regarded him as a non-conformist and a rebel. Born in Hobart, Tasmania, in 1918, Powell moved with his family to Sydney in 1928, after his father's death. His aspirations for a naval career were dashed because of his colour blindness and he turned to photography instead, aided by Laurence Le Guay, a fellow student at North Sydney Intermediate Boys' High. The two boys had joined the Photographic Society of New South Wales in 1936 so that they could use their darkrooms: 'Using amidol developer because it made our nails black and we looked like pros!!'[4] It may have been at the society's meetings that Powell met Olive and Max, who had both been members since their late teens.

Powell came to Dupain with some professional experience, having worked as a general assistant at the Russell Roberts Studio in Sydney the previous year. But, more importantly, his position on photography aligned with both Max's and Olive's. He had already thrown himself into the growing debate about modern photography and was determined to challenge the so-called 'old bromide men' or 'artists of the blurred eye' – advocates of pictorialist photography. This was a time when convulsions in art photography circles were becoming extreme, because of the growing impact of modernist approaches. Years later, Powell recalled a memorable Photographic Society of New South Wales meeting in Sydney in 1936, when his work was at the centre of a 'ruckus':

And the wonderful night at the Photo Society meeting when
I put up a gloss b/w [black and white] print of mud on the

axle of an old Ford T-Model, and another of the inside of an umbrella, for criticism by the Metcalfs, Cazneaux, Mallards et al of bromoil fame. Oh la la, Got a par [paragraph] in the Sydney press … some columnist was there and talked of the ruckus and argument of 'the blurred eye v. the third eye'. Ask Laurie [Le Guay] if you see him, he should remember. Great stuff when you're 19 or so.[5]

Powell's photography was well received by fellow modernists, or 'third eyes', and despite his youth, he quickly developed a public profile through publications and exhibitions in Sydney and interstate. He participated in the annual competition for Colonial and Overseas Workers organised by *The Amateur Photographer and Cinematographer* journal in London, and his anti-war photomontage *Victory* was published in the illustrious international journal *Photographie* in 1938.

At the Dupain studio, Powell washed and glazed prints, and undertook some basic photography for advertisements that ran in newspapers and magazines, including *The Home* (October 1937) and *Wireless Weekly*. This mainly involved taking photographs of objects, 'simple things', such as a tennis racket, table lamp and radio. In July 1938, he took photographs for the labels of canned food, pasting printed samples of them into his scrapbooks that chronicled his professional achievements.[6] Powell's training was in accordance with Max's credo – the emphasis was firmly on versatility, on being an all-rounder.

There were two main ways Powell differed from others in the Dupain circle – his adventurousness that bordered on the foolhardy, and his evolving left-wing politics, to which he became increasingly committed in his late twenties. His employment ended because of his restlessness and desire for adventure, with Max giving a frank assessment of the young man's strengths and weaknesses in the reference letter he wrote on his departure.

To whom it may concern:

Geoff Powell has proved himself an industrious assistant to us
for some years. [In fact it was only one year.] His attitude to his
work is essentially objective and physical, his approach is direct
and at times reveals bright flashes of promise.

His immaturity is a handicap in so far as it is responsible for
his lack of intense concentration. On the other hand he has dug
well into the roots of his profession for a youth of 20 years.

Full of hope and enthusiasm he will 'do things' in
photography once he has mastered himself and realised that his
work matters more than all else.

Max Dupain[7]

Powell had been arrested and fined for climbing to the top arch
of the Sydney Harbour Bridge to photograph the sunset over Port
Jackson in July 1938, but his most notorious act occurred shortly
after leaving the studio. He managed to stow away on the yacht of
Count Felix von Luckner, a commander in the German navy in
the First World War and a suspected Nazi agent, who arrived in
Australia in May 1938. According to Powell, von Luckner offered
him a job on his yacht, *Seeteufel*, but then decided not to employ
him, much to Powell's annoyance. He subsequently made his way
north to Cairns and smuggled himself on board the *Seeteufel* while
it was berthed there; after being discovered, he was cast off on
Thursday Island 'with threepence'. The photographs he took during
this colourful encounter were published in *The Home* magazine in
November 1938, with the attention-grabbing headline, 'I stowed
away with Count von Luckner.'

Following Powell's departure, Max took on another
photographer, Damien Parer, but on an intermittent basis. Damien's
association with the studio, from October 1938 until December
1939, was relatively short but full of impact. He was only a year

younger than Max and Olive, and they immediately established a close relationship.

Damien was described by Ron Maslyn Williams, a pioneer in the Australian film industry, as 'a bright bloke with a very sharp dramatic Spanish face, big nose, tremendously intense eyes'.[8] War correspondent Osmar White found him equally memorable, writing that he:

> … was long, stooped, black-headed, sallow-faced, smiling. He had great piston-legs covered by a fuzz of black hair and ending in size-12 feet that looked as if they could crush the skull of a python … No one, however crusty, could remain within earshot of the bubbling bass hoot that served him for a laugh without wanting to laugh too.[9]

Born in Melbourne, in 1912, to a Spanish father and a mother of Irish ancestry, Damien was the youngest of eight children. His childhood dream was to enter the priesthood but like Max, Olive and Geoffrey Powell, he became enthralled by photography in his teens, and it took him down a different career path, though he would remain a devout Roman Catholic throughout his short life. After leaving high school, Damien was apprenticed to two leading studios in Melbourne – Spencer Shier's and then Arthur Dickinson's – which gave him a solid technical training.

By the mid-1930s, he was involved in the film-making industry in Sydney and worked as a cameraman on Charles Chauvel's *Forty Thousand Horsemen* (released in 1940). While film quickly became his first love, still photography remained a useful means of supplementing his income between film shoots. Max fully appreciated his friend's commitment to film, later saying that Damien's work with him 'was fill in stuff',[10] which he was more than happy to accommodate.

Olive and Max both adored Damien and the three of them spent a lot of time together. Olive treasured him as a friend, who had 'a

wonderful personality',[11] was good with people, could put a sitter at ease and create the right atmosphere for working with a model. When he was ill with a suspected duodenal ulcer, she plied him with malted milk drinks to help alleviate his symptoms.[12] Max also had an enduring affection for him, later writing: 'I'd be very content to say that Damien was the most lovable and sincere person I have known; he was totally honest and delightfully naïve.'[13] Elsewhere, he described him as 'A beaut bloke, the best of beaut blokes'.[14] Although Max did not share Damien's devout religious beliefs, he did not quibble with them: 'he was so thoroughly integrated with his faith that one did not question his deep-seated philosophy.'[15]

Their affection and respect was returned in abundance. In Damien's view, 'Maxie is the only photographer in the country worth a cracker … the only one who thinks, the only one who has perception and selective power and I like him.'[16] He was equally fond of Olive and, indicating his high professional regard, selected one of her photographs for use in the final credits of the short film *This Place Australia* (1938).

Damien had an intimate knowledge of contemporary developments in documentary film and photography, incorporating practical and theoretical perspectives. He was tough in his assessments of his own work, which mostly fell short of his high standards, and he scrutinised the work of both Australian practitioners and eminent international photographers published in magazines. All of this he shared openly, Max later writing:

He brought new thinking and photographic awareness to the studio. The words 'documentary' and 'factual' were being bandied about in the late 1930s and Damien would sound off at every opportunity about Robert Flaherty, Grierson and Lorentz, protagonists of the new theory and practice. His favourite quote was Grierson's assessment of the photographic document: 'The creative treatment of actuality'. It still rings in my ears.[17]

* * *

In addition to new colleagues and new influences, the studio gave Olive privileged access to the various musicians, dancers, writers and artists Max was commissioned to photograph for publicity for the theatre company J.C. Williamson, the Australian Broadcasting Commission (ABC), and Ure Smith's publications. Every now and then, Olive had an opportunity to photograph these celebrities herself, always for her own purposes. One of the most successful interactions was with Hélène Kirsova, the Danish-born prima ballerina, who performed with the Ballets Russes de Monte-Carlo, led by Colonel Wassily de Basil, which toured Australia in 1936–37. The Ballets Russes, which came to Australia three times before 1940, was world renowned, thanks to the innovative approach of its Russian founder, Serge Diaghilev. He fostered collaborative, radical experimentation between avant-garde practitioners in dance, music, and stage and costume design. The success of the company's tours was a concrete sign of Australia's growing cultural sophistication.

The photographs Olive took of Kirsova as the puppet ballerina in *Petrouchka* combined her dual interests in portraiture and dance. In them, she adopted the reductive style she favoured for portraiture in this period and kept studio props to a bare minimum. The spare setting was enlivened only by the play of the studio lighting and the shadows it cast. Kirsova's pose as the doll was, of course, a conceit, as she was not performing on stage but self-consciously re-enacting her role for the purpose of picture-making. Olive did not break into Kirsova's state of intense concentration by soliciting eye contact, indicative of her growing fascination with the interiorised state of her subjects.[18]

Olive's views of the ballet are not on public record, but those in her circle were greatly impressed by the dancers' abilities. Max later recalled Geoffrey Powell's feverish response to their presence in Sydney:

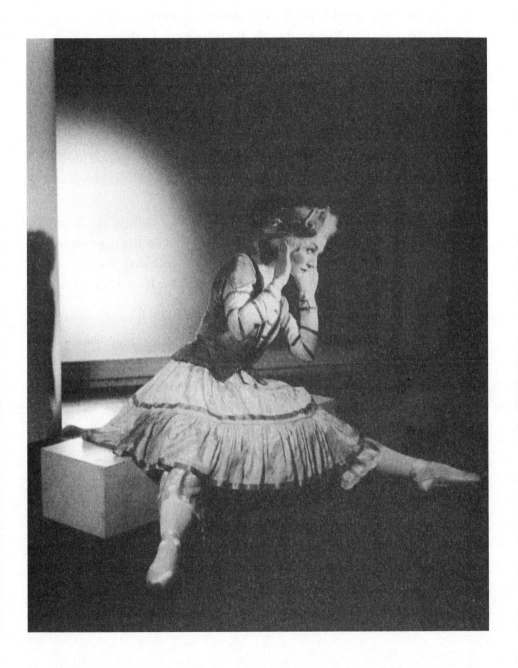

Hélène Kirsova as The Doll in Petrouchka, 1938, National Gallery of Australia, purchased 1987

Geoff fell heavily for the Russian ballet in 1938 and spent many extracurricular hours at rehearsals getting unique pictures. I remember him returning to the studio late one evening and bursting in on a small group of us, drinking coffee and arguing. He had made a feverish return from the theatre for film replenishment. In his breathless haste he had only one comment to make: 'I'm up in the flys!' before grabbing new stock and flying out again followed by much friendly laughter and banter. Great days![19]

* * *

When Kay Lester visited the studio and reported on the impressive set-up for *Monocle* magazine in 1937, Max enthused about the revolutionary possibilities of modern photography. He told her that:

> ... more than ever I now realise the breath-taking possibilities of this new machine. I believe in the creative effort of generations of artistic thought ... The camera could revolutionise the world's culture! With its feet once established in the soil of tradition, its head will look after itself in the clouds of futurity.[20]

Olive would have been equally positive, though her expression would have been less grandiose. She did not set out to revolutionise world culture, but she did aim to create contemporary photographic works and believed in photography's bright future.

The Budapest String Quartet

Group portraits are notoriously difficult to do well, because of the challenge of ensuring that every individual has been attended to sufficiently. The genre wasn't something that ever particularly interested Olive, but *The Budapest String Quartet* is a stand-out example. The famous group of European musicians – violinists Alexander Schneider and Josef Roismann, cellist Mischa Schneider, and violist Boris Kroyt – was invited by the ABC to give a series of concerts at the Sydney Conservatorium, in July 1937. It was a repeat visit for them, as they had originally performed in 1935, to great acclaim. The appreciative reception was a further sign of the growing sophistication of the music scene in Sydney, which Olive herself was enjoying. In her traveller's trunk was a program for a concert given a month later by famous Polish pianist Arthur Rubinstein, who performed works by Bach, Beethoven and Chopin.

Olive's contact with the quartet did not come about through her own doing. Max had been commissioned by the ABC to take the publicity shots for the promotion of their concerts, and she capitalised on their visit to the studio, photographing them while they prepared themselves for the 'official' session. As she later recounted:

While Max was arranging them for the official photograph,
I wandered about them with my Rolleiflex looking for
interesting viewpoints.
 And then they began a serenade by Tchaikovsky. This
was an exciting moment and I decided to get a shot of them

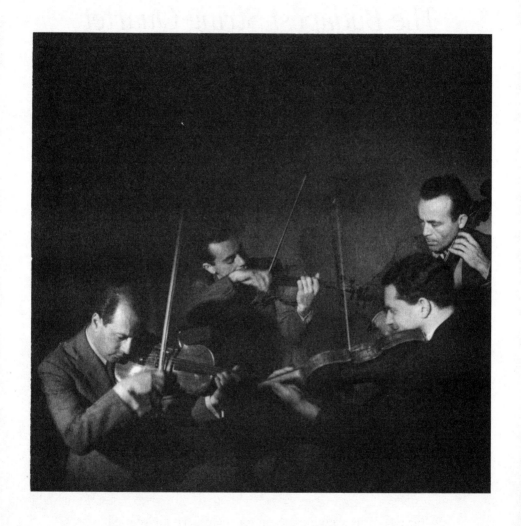

The Budapest String Quartet, 1937, National Gallery of Australia, purchased 1987

actually playing. This did not constrain me to show all their
faces clearly as for a publicity shot. I wanted to get the feeling
of a group making music they loved …[1]

This brief statement is revealing because it emphasises, once again,
that unlike Max, she was free to photograph as she wished. She
did not have to deal with a client's expectations or the conventions
relating to a particular commission – in this instance, a publicity
shot that would clearly show each musician's face. Even more
importantly, though, it gives an insight into the *raison d'être* of the
photograph, which, as she put it so succinctly, was 'to get the feeling
of a group making music they loved'. Olive's responsiveness to this
'feeling' came from her own love of music, as a pianist and as a
keen concert-goer. She was, therefore, particularly excited by the
quartet's visit, and attended their concerts, sitting near the front of
the concert hall, 'absolutely rapt', as they played music by Beethoven,
Debussy and Schubert.

Her photograph of the quartet has no documentary agenda, being
unconcerned with depicting the musicians either individually or as a
group. It was when they began playing – an 'exciting moment' – that
she realised she had something to photograph: the feeling of a group
immersed in their music-making. The quartet is linked together in
an elongated circle, each attending to his own instrument and to
the music. Everyone is totally absorbed, eyes shut, with no overt
acknowledgement of each other, Olive or indeed anything that might
have been occurring around them in the studio. The composition is
extremely simple, with the neutral setting eliminating any potentially
distracting background details. The musicians occupy the lower
half of the image, while three of their bows, enlivened with light,
reach upwards, providing strong vertical accents in an otherwise
horizontally aligned composition. Brighter light falls on the faces
of the cellist and violist at the right-hand side, but the internal
dynamism of the composition means that neither man is singled out
for attention. Our eyes swirl around the entire group.

The vintage print of *The Budapest String Quartet* demonstrates the full extent of Olive's technical accomplishments by this point. She controlled the dark and mid-range tones to evoke another world where the sensory and internalised experiences of playing and listening to music are far more important than any material reality. On her own terms, she judged the photograph a success, saying in 1995 that she could 'still hear the opening bars of the serenade'[2] whenever she looked at it. This is an apt comment for a photograph that is about music, not musicians.

Stepping into the dark

It is hard to imagine such a scenario today, but in the period from the mid to late 1930s, debates about old and new approaches to photography were impassioned. They were waged publicly through exhibitions and in commentary published in newspapers. Olive did not contribute materially to the public polemic but she held an important position in the debate for three main reasons: she practised a modern style in her art photography, was one of the few women modernist photographers, and was associated with Max, who had emerged as a leader in the modern photography movement during these years. The debate reached its zenith in 1938, with the mounting of two important exhibitions – and Olive was represented in both. The first, the Australian Commemorative Salon of Photography, was mounted as part of the official program of cultural activities for the sesquicentenary of European settlement, and the second exhibition was presented by the recently formed, curiously named Contemporary Camera Groupe. These shows were seen to embody divergent views about the state of contemporary photography.

The Australian Commemorative Salon of Photography was a hugely ambitious undertaking, organised by the peak bodies for photographic practice in New South Wales (the Photographic Society of New South Wales, the Sydney Camera Circle and the Professional Photographers' Association of New South Wales). Six hundred and twenty-two works were selected for display from more than sixteen hundred entries from professional and amateur photographers in

thirty-two countries. The Australian entrants read like a who's who in photography of the day, with all the big names represented, including John Kauffmann in Adelaide, Athol Shmith in Melbourne, and Monte Luke in Sydney. Different applications of photography – commercial, advertising, press, scientific, amateur – were showcased in the exhibition. Harold Cazneaux, one of the organisers, a selector and judge, celebrated the medium's potential as art:

> Critics who say that photography is only a mechanical means
> of producing a picture know little of artistic photographic
> technique. A first-class photographer who possesses depth
> of feeling, an eye for artistic selection and a creative mind
> can give lasting joy to the beholder of his work and elevate
> photography to the realm of true art.[1]

The exhibition's range may have been eclectic, but the gender balance was highly skewed, as was typical of the period. Of the eighty-three photographers in the Pictorial Section, only four were women: Miss Olive Cotton, Miss Nellie A. Leggett, Miss Helen Lupton and Mrs Rose Simmonds. Olive was a very successful competitor, with representation in three of the seven categories, Pictorial (with *Beach landscape*), Professional Portraiture (a portrait of her grandfather, Frank Cotton) and Commercial, Advertising and Press (with *Party frock* and *Fashion for children*). None of her photographs were priced in the catalogue, perhaps because she did not anticipate any sales or had decided she did not want to part with the prints she had entered. Max's photographs were priced significantly higher than those of fellow exhibitors, suggesting that he saw his work as exceptional and highly desirable to collectors. He was awarded a silver medal for one of his fashion illustrations in the Commercial section.

From Max's perspective, the show was retrograde in many respects, and he took issue with it publicly in a letter to the editor published in the *Sydney Morning Herald*, 30 March 1938. He objected

to the 'unanimous acclamation of ourselves by ourselves!' and remarked on the absence of work by eminent international modern photographers, such as Man Ray, Moholy-Nagy and Steichen. He passionately argued that:

> Great art has always been contemporary in spirit. Today we feel the surge along aesthetic lines, the social economic order impinging itself on art, the repudiation of 'truth to nature' criterion, and the galvanising of art and psychology. Our little collection if it were truly representative, would reflect these elements of modern adventure and research, but it is not; it is a flaccid thing, a gentle narcotic, something to soothe our tired nerves after a weary day at the office![2]

Several photographers leapt to the exhibition's defence in the pages of the *Sydney Morning Herald*. G.H. Wilson praised the catholicity of the selection, which embraced both modernist and traditional photography, and claimed that 'Mr Dupain's views are those of a minority, an enthusiastic minority.'[3] Pictorialist photographer Arthur Smith declared that: 'Ultra-modern photography, like ultra-modern art, is but the expression of mob revolution' and quoted Norman Lindsay to support his anti-modernist view that 'the ultra-modern cameraman produces photographs that have nonsense in them, and that no one can understand'.[4] Another pictorialist, W.H. Moffitt, attempted some kind of reconciliation, writing that: 'By all means let works of the type so extolled by Mr. Dupain be exhibited; my protest is only against his assumption that they are the only kind worth exhibiting.'[5] Cazneaux rejected Dupain's claim that work in the Commemorative Salon was not 'truly representative', and advocated a cautious approach to the embrace of contemporary trends. As he saw it:

> … if a few impetuous young workers, influenced by the champions of ultra-modern thought, choose that formula of

'aesthetic exploration along abstract lines', then real danger
lurks in the fact that 'exploration' is uncertain, and the ultimate
destination is unknown.[6]

The furore around the exhibition provoked action from Max
and other colleagues. They formed the Contemporary Camera
Groupe, its name alone declaring a break with the past, especially
with the photographic societies and salons that had dominated the
photography scene in Sydney and further afield for years. Cecil
Bostock, who was invited to design the exhibition catalogue,
was responsible for the addition of the 'e' to 'group' to give it a
French spelling, a decision Max considered 'perverse' (he said that
members referred to it as the 'groupie').[7] As well as Dupain and
Bostock, the Groupe's members included other photographers
William Buckle, Harold Cazneaux, George G. Morris, Laurence
Le Guay, Damien Parer and Russell Roberts, and graphic artists
Douglas Annand, A.E. Dodd and Louis Witt. Olive Cotton was
the only woman involved. Their exhibition, which opened at the
David Jones Exhibition Gallery in November, was accompanied by
a slender catalogue that used the highly charged, clipped language
more typical of a manifesto:

> We have built this little unit in order to strengthen the liaison
> between photography and the other arts.
> We hate the cliché, and would drive a wedge between
> stagnant orthodoxy and original thought of the living moment.
> At the same time, we do not take this step in the dark
> without reference to our masters whom we love.[8]

Olive was one of the few participants represented with the maximum
number of seven prints: two portraits, an urban study (*Over the city*),
landscapes and studies of nature, including the stunning modernist-
inspired *Papyrus* and *Lily pond*. In Cazneaux's copy of the catalogue
(in the National Gallery collection) he made a brief descriptive

notation alongside the entry for *Papyrus*, indicating it was one that attracted his attention. Max's selection of works concentrated on portraits and nude studies; his exclusion of landscapes was probably a rebellious move to provoke pictorialists, who revered landscape as the most serious genre in art photography.

The Contemporary Camera Groupe's 'missionary purpose' did not go unnoticed. A reviewer for the *Sydney Morning Herald* recognised their desire to 'strengthen the liaison between photography and the arts', but was unimpressed with the 'acutely self-conscious' nature of some of the work, noting that it 'is not sufficiently detached from personal motives of display'.[9] Cotton was commended for her landscapes, which were described 'as simple, sincere, and competently done', and Dupain's work was judged 'as sincere' and sometimes 'distinguished'.[10] In a surprising assessment, given his stature in photography, Cazneaux's pictorial techniques were considered wanting, seeming 'to dissolve some of his beautifully chosen landscapes into an etched effect that often loses vitality'.[11]

What is most curious about the Contemporary Camera Groupe, in its membership and the one and only exhibition it ever held, is the ambiguous nature of its much-vaunted challenge to 'stagnant orthodoxy'.[12] Despite the passionate rhetoric, it did not reject outright some of the older, well-established photographers. On the contrary, they were respectfully referred to in the catalogue as 'our masters whom we love'. How else to explain the participation of Cazneaux, who was so closely associated with the Australian Commemorative Salon, which Dupain had publicly critiqued, or the inclusion of other pictorialists, such as George Morris and William Buckle, whose styles were hardly revolutionary? The lines between new and old photography – between modernists and pictorialists – were not drawn as sharply or unequivocally as the exchange in the press seemed to suggest.

* * *

As an exhibitor in these two key shows, Olive achieved an impressive and unusual degree of visibility, but she was never a proselytiser and the highly charged rhetorical language of a manifesto was not naturally hers. Temperament was not the only reason she was not at the forefront of the debate; gender and her associated comparatively low professional standing were crucial factors, too. She was a studio assistant, whereas her male colleagues in the Contemporary Camera Groupe were camera operators, professional photographers with considerable autonomy.

For Olive, however, 1938 was an auspicious year, in which she outstripped the achievements of many of her fellow exhibitors. No other woman photographer was represented in the two most talked about exhibitions in the country, the Australian Commemorative Salon and the Contemporary Camera Groupe's show. Furthermore, she received substantial international endorsement with her second showing at the London Salon of Photography, which hung both *Shasta daisies* and *Winter willows*.

Even more significantly, *Winter willows* was published in *The Penrose Annual: Review of the graphic arts*, where it was discussed by Jan Gordon, art critic for the English newspaper *The Observer* and occasional reviewer for the annual. The highly regarded, beautifully produced *Penrose Annual*, published by Lund Humphries & Co, dealt with the latest developments in printing, design, advertising and photography, and featured articles by luminaries including Herbert Read, Nikolaus Pevsner, and artists Paul Nash and Moholy-Nagy. Sometimes, guest designers were commissioned, and the 1938 issue (volume 40) had the distinction of being designed by Jan Tschichold, the German-born pioneer in graphic design who had fled from Nazi Germany to Switzerland in 1933. Tschichold championed modernist design principles, especially in typography, and his effort for the annual, including text, binding, jacket and the advertisements, is now regarded as a highlight in the annual's history. He was especially admired for his reductive approach, which homed in on essentials.

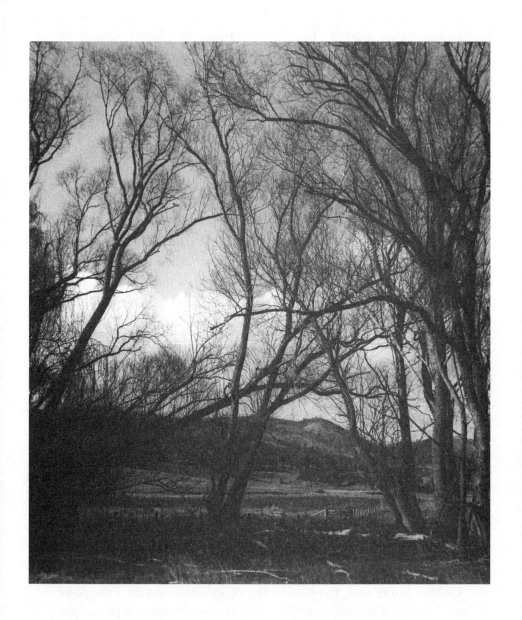

Winter willows, 1937, National Library of Australia, nla.obj-136352735

Gordon's review, 'Art in photography', for *The Penrose Annual*, was exceptional for its insightfulness and for its being the only contemporaneous instance where Olive's work was discussed in an international arena. The review established a larger framework for photography, introducing the idea of 'pictorial unity', and considered how a photographer might achieve it (recognising that the means involved were different to a painter's).[13] In Gordon's view, the successful artist photographer must be able to perceive harmony in art and nature, react emotionally to it and convey to the public similar or parallel emotions via their works. This appreciation of a highly self-conscious way of working, and the associated effort required before exposing the film, accorded with Olive's approach. As Gordon argued, the photographer:

> … can perceive harmony in Nature, and equally he can
> perceive it when imaged as pictorial reality on the focusing
> screen. At this stage he can criticize its parts, re-adjust them
> to his emotional purpose, and, within limits, manipulate them
> until they become adequately pictorial, and so on. All this
> undoubtedly requires intuitive, perceptive, and critical faculties
> of a high order. But, as is seen, they have to be exercised
> mostly before the picture is taken. In consequence, while the
> painter normally allows his perceptive faculties to look after
> themselves, the photographer must sensitize his, and cultivate
> them to the most acute pitch possible.[14]

In sum, Gordon believed 'The more sensitive and acute the perceptions are, the better the photograph.'[15]

How thrilling that *Winter willows* fitted the bill as an example of what Gordon poetically described as a 'feat of harmonic perception'. Gordon wrote that 'the possibilities of so very complex a tangle of movements, rhythms and spacing shown in "Winter Willows" by Olive Cotton' were proof of keen perception, 'recorded aptly with no hint of "artiness"'.[16] These comments demonstrate Gordon's

appreciation of the distinctive qualities of Olive's photography, as well as its modernist credentials. Equally gratifying was the publication of *Winter willows* alongside a work by F.J. Mortimer, one of the most influential English pictorialists of the day. He was renowned as a founding member of the London Salon, a member of the British Royal Photographic Society and of the Linked Ring Brotherhood, which was established in 1892 to defend photography as an art. He was also editor of *Photograms of the Year*, which Olive and Max read avidly.

Seeing her work appreciated in an international forum, and contextualised within the latest contemporary developments in art and design, must have been immensely satisfying to Olive. A demonstrable leap in confidence ensued.

* * *

The year 1938 also saw Olive receive broader public attention for the first time. In March, an article on her, 'The lady behind the lens', was published in the *Sydney Morning Herald*'s mid-weekly *Women's Supplement*.[17] Its subheading, 'Young Sydney artist discusses a hobby for women', trivialised women's participation in photography, presenting it as a hobby rather than a serious pursuit, but the content is very useful nonetheless. The unnamed reporter had interviewed Olive and quoted her extensively, giving a rare insight into her views on photography. The text was accompanied by an engaging studio portrait of her, taken by Max, and a selection of her photographs that indicate what she felt were her best works to date. Three of the five reproduced, *Plum blossom*, *Teacup ballet* and *The Budapest String Quartet*, remain well known.

The impetus for the article was her representation in the Australian Commemorative Salon of Photography exhibition, which had opened a few days earlier. Introduced to the readership as an 'amateur' photographer who had achieved international success, having twice exhibited at the London Salon of Photography, Olive

was described as 'an attractive young woman with a penchant for art in several forms and a firm belief in women expressing themselves through an art medium'.[18] The circumstances behind her adoption of photography were also publicly stated for the first time: 'She was precipitated into photography at thirteen years of age when she found that an inclination towards graphic art was in her case handicapped by an apparent lack of talent with brush and pencil.'[19] This was the explanation she would repeat several times in coming years, attributing the greater talent in drawing to her sister, Joyce.

What 'The lady behind the lens' communicates most strongly is Olive's view of photography as an ideal means of self-expression, 'a universal art form comprehensible to everyone, within reach of all',[20] and her advocacy for women's participation in photography. The author referred to Olive's observation that the situation for women was improving:

> The names of women are appearing more and more in the
> photographic annuals of the world, and some of the important
> Continental exhibitions have included the work of as many as a
> dozen amateur women photographers.[21]

Olive went further in her advocacy, saying 'that women are doing photographic work comparable with that of men'.

In her typically positive way, Olive expressed her confidence about the future. Using the example of landscape photography, she argued for expanded artistic possibilities for women working in what she termed the 'right spirit' – using the camera to express themselves 'rather than making tourist bureau records of beauty spots'.[22] She did not see options being confined to art and amateur photography, envisaging additional professional opportunities: 'I believe that photography will soon be used as a medium for design. It will provide a field for women who have mastered the technique of modern photography.'[23] This, surely, was applicable to her own

situation, given her command of photographic technique after years spent learning and perfecting it.

The article also gives an invaluable insight into Olive's belief in the value of an individual's distinct sensibility – or in her words, 'discernment and personality' – and the importance of technical mastery. Under the subheading 'Some advice' she outlined the array of options available to the creative photographer:

> 'ONE thing that women who wish to become good photographers should remember,' Miss Cotton continued, 'is that the camera can do more than merely record an unchanging picture of a subject. A landscape, for instance, is there for everyone to photograph – an apparently changeless combination of earth, and trees, and grass; but it can be photographed in a hundred different ways. The lighting, the relation of the various objects to the shape of the picture, and many other factors can be changed by the individual, and this is where discernment and personality come into the picture, as it were.'[24]

In the final section, headed 'In the dark room', Olive emphasised the importance of darkroom work and making one's own prints as an intrinsic part of the creative process.

> 'EVEN the casual hobbyist,' Miss Cotton declared, 'should develop and print her own pictures. Otherwise, it would be an expensive hobby and in any case, the treatment during these processes can always make or mar a picture. To become efficient at developing, printing and enlarging, experience over a number of years and constant practice are needed to make the most of one's opportunities.
>
> 'One of the commonest and most serious mistakes made by the inexperienced photographer is the tendency to take a dozen pictures of an object in the hope that one will be good.

I find it much more satisfactory and less expensive to take one carefully considered and planned picture.'[25]

This last sentence encapsulated her approach. Deliberation and purposefulness were fundamental. She imagined what the final image would look like in advance, a process known as previsualisation, which did away with the need for multiple exposures and waste of precious film.

The *Sydney Morning Herald* article is another pertinent reminder of the way gender framed her practice. Inclusion in the *Women's Supplement* was gratifying as evidence of public recognition and was a useful forum for advocacy, but it underlined the limited parameters within which she worked and within which her work was received.

It was as an art photographer and 'amateur' that Olive had begun to attain considerable success, becoming the most publicly visible woman practitioner of the period. This standing was reinforced with the continued publication of her photographs in the popular Commonwealth Bank staff magazine *Bank Notes*. The December 1938 issue reproduced her landscape *Mountain air*, taken on the trip with her father through New South Wales, and devoted a full page to *Papyrus*. Olive was in excellent company in the magazine: high-profile photographers J.B. Eaton and Harold Cazneaux were other regular contributors, mostly represented with landscapes. Olive's photographs were included not for informational and illustrative purposes, but for their aesthetic qualities. They introduced a decidedly modernist note into the magazine's design, in their choice of subject matter and their bold, adventurous compositions.

Marriage

Olive and Max grew ever closer during the late 1930s, spending most of their time together, and it cannot have been a surprise to anyone when, after such a protracted courtship, they finally decided to marry. They had known each other for fifteen years and he was her only love. As Max's surviving love letter reveals, they had begun imagining a future together as early as 1931, when they were both seventeen, so it is curious they waited so long. There was no notice in the Sydney newspapers announcing a formal engagement, which was common practice for newly engaged couples, and the date of the proposal is not known. However, Max is the one who proposed, Olive accepted, and they settled on 29 April 1939, in mid-autumn, as their wedding date.

Everyone must have thought they were perfectly matched, given their relatively privileged backgrounds and similar values and interests. Even more impressive, in terms of the prospects of a companionate marriage, was their shared passion for photography, which they had explored concurrently since their early teens, and which had already resulted in their working side-by-side for nearly five years.

Olive was Max's intimate, his friend, colleague and confidante, but no commentary from her about the person he had become by the time of their marriage has survived. All that is left is a handful of remarks from friends and family, including Damien Parer, Ernest Hyde, Joan Sample, Barbara Beck and Lucille Dupain. Among them, there is full agreement about his deep attachment to photography

and about fundamental aspects of his character. They all recognised, for instance, that Max's work mattered enormously to him and that he was a gifted, driven photographer, who often found it very hard to relax. He was not prepared to compromise his art photography, which consumed and captivated him; commercial photography was a distraction and a nuisance.

Max attracted the intense loyalty of his friends and colleagues. Damien Parer said he owed everything he ever learned about photography to him and was grateful that he had taken him on, and Ernest Hyde greatly admired his exceptional artistic ability. They appreciated his talent but also his generosity when it came to sharing knowledge, something Olive commented on as well.

Other remarks focused on Max's intensity – he was 'always intense' – and his inwardness, which often manifested as reserve and aloofness. He did not seek out company, and 'his idea of entertainment was a quiet party at home'.[1] Hyde said, 'he was not outgoing but inclined to find his own satisfactions within himself, looking inside to put meaning in his life.'[2]

His was a dominant personality, and although his friends didn't say so explicitly, it can be inferred that he was used to getting his own way. In Joan Sample's view, he was 'a very dynamic person to be with, he would inspire you with his energy. What Max wanted to do everybody wanted to do… [he] was a very competitive man.'[3] While he was serious, she remembered him as having 'a great sense of fun underneath it all'.[4] Barbara Beck, wife of his good friend, the English artist and graphic designer Richard Beck, felt that when he made up his mind he was unlikely to change it; she liked him but 'couldn't actually warm to him'.[5]

Close friends also identified contradictions in him. He was described as 'contrary', someone who, in Hyde's assessment, hid his kindness because he wanted to show he had control. Inferences are that he was one of those men who appear cool, detached and in charge of their emotions, but in reality are often struggling with the volatility and depth of their feelings, and unsure about how best to

express them. And, despite the considerable professional success he had already achieved and his outward air of confidence, no one felt he was easily pleased. He had 'an impatient air of striving after goals that were in his mind … so he was in a constant state of never being quite satisfied with what he was doing'.[6]

His restlessness was also remarked upon, as a man who was 'searching, seeking something'.[7] His cousin Lucille suggested that his photography represented a way of escaping from what was going on in the world, and that he was someone who, as she put it, was always 'searching'.[8]

* * *

At the time of their marriage, Olive was twenty-seven years old and Max had just turned twenty-eight. The average age for brides in this era was a little over twenty-five and for grooms, nearly twenty-nine, so they were very close to the statistical norm. Olive's sister, Joyce, who was three years younger, had already married.

In contrast to her cousins on the Channon side, Olive's wedding was a simple, unostentatious affair. It was held at the Cotton family home in Hornsby and conducted according to the rites of the Methodist Church. The event was noted in the 'Social and Personal' column of the *Sydney Morning Herald* on 1 May.

> The marriage was quietly celebrated on Saturday morning of
> Miss Olive Cotton, elder daughter of Professor L. A. Cotton,
> of Hornsby and of the late Mrs. Cotton, and Mr. Max Dupain,
> son of Mr. and Mrs. George Z. Dupain of Ashfield. The
> ceremony took place at the bride's home.

No photographs of the wedding were published in the paper or magazines of the day, but Olive kept a little snapshot of the smartly but simply dressed, smiling couple posed near a pergola. In it, Max looks directly at the camera and Olive has her head turned to the

side, her short-sleeved wedding dress and exuberant bouquet of flowers shown to their best advantage. They appear slightly self-conscious but happy.

For their honeymoon, they drove to Canberra in Max's roadster. It was Olive's first visit to the national capital, which was still very small, with a population of only around seven thousand people. On their return, they set up house together in rental properties, firstly in a flat at Balmoral on Sydney's lower North Shore, and then in a house on Longueville Road in Lane Cove, which gave easy access via ferry to the city and the studio.

* * *

What Olive expected from her marriage can only be surmised. There were, no doubt, the attractions of stability and respectability, and the possibility of having children. There may also have been relief at finally formalising their relationship after so many years, and giving it a future with a far more certain shape. However, negotiating the transition from single but attached status, to married – from Miss Cotton to Mrs Dupain – cannot have been straightforward. She stopped working at the studio for the first twelve months of their marriage, possibly in line with social convention (women were banned from working in the public service and other occupations in Australia after they married), as well as the standard division of labour in which the husband was expected to be the breadwinner and the wife the homemaker and child-bearer. This meant Olive was no longer fully immersed in the social and creative flux of studio life and was removed from the camaraderie and satisfaction that her work as the assistant had engendered. Ironically, she and Max no longer spent their days together; they were now artificially separated by their marital roles. She did, however, remain deeply attached to the business, and concerned about the vicissitudes that began to affect it as the possibility of war became more likely.

While it can be assumed Olive took on domestic responsibilities in her and Max's household, marriage and a temporary break from work commitments also gave her a chance to pursue her art photography. Capitalising on this newfound freedom and aided by the studio's excellent facilities and equipment, she went on to create some exceptional images. They showed her at the height of her maturity, confident in her choice of subject matter – it is so identifiably hers – experimental, technically astute and in full command of her visual language of evocation. The images from 1939 particularly have a heightened sensuousness and suggest a quietly ecstatic state of being. In one of these, *Grass at sundown*, this comes from being in tune with the natural world and being able to recognise meaningful patterns in nature, their delicacy and complexity. As she later said of the work and its significance to her: 'Each grass head outlined by a nimbus of light from the setting sun and the sun's rays themselves all create, for me, a magical atmosphere.'[9] Clearly, she was feeling very hopeful.

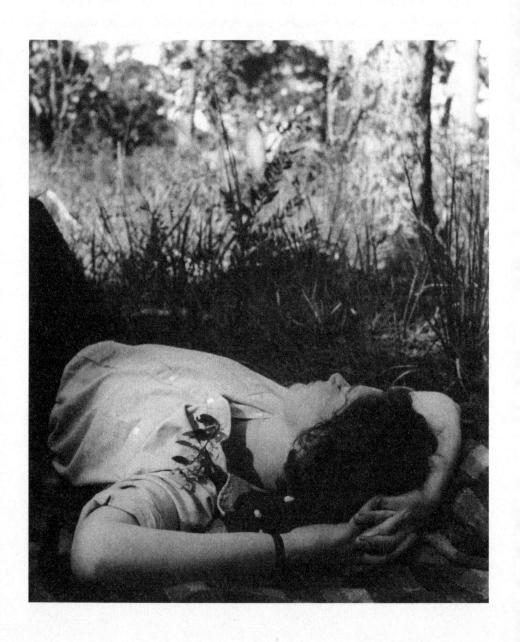

The sleeper, 1939, National Gallery of Australia, purchased 1987

Figures in the landscape

The way Olive approached photography in the late 1930s was far more organic and intuitive than programmatic. Nonetheless, by 1939 her work had cohered into two main interrelated categories – landscapes and flower studies – which incorporated considerable stylistic and technical variations. Her exploration of the figure in the landscape was confined to only a handful of photographs, but two of them, *The sleeper* and *Only to taste the warmth, the light, the wind*, count among the most memorable works of her entire career. Both date from 1939, the year of her marriage and the outbreak of the Second World War. Significantly, the figures in the landscapes are women.

As was characteristic of Olive's mature approach, *The sleeper* arose from the most personal and intimate circumstances. The sleeping subject was one of her closest friends, Olga Sharp, whom she met sometime in 1936 or 1937, when Olga was working in the advertising department of Amalgamated Wireless Australasia Limited, and Max was commissioned to photograph AWA radio sets for a series of advertisements. Olga was interested in the visual arts and studied at Sydney Technical College under sculptor Rayner Hoff; Olive appreciated her artistic talents and described her as 'a clever artist and a sculptress'.[1] Later, Olga had a photographic studio at Wahroonga (a suburb near Hornsby), where she photographed children; Olive considered her work to be 'very sensitive ... she had a lovely feeling for it'.[2]

In her recollections of the circumstances that led to *The sleeper*,

Olive stressed the union between her human subject and the natural environment:

> I took this photograph on a bush picnic; Olga stayed behind to rest while I went with the others for a walk. When we came back, there she was, sound asleep on a rug with a wildflower pinned to her blouse, her arms behind her head; and although she was in the shade, the tall grass behind her was brilliant with sunshine. She was a picture of complete relaxation and content in the bush setting which she loved.[3]

Olga lies on her back in a totally unselfconscious, open pose. Olive approached her quietly to ensure she did not disturb her, crouching down to assume an empathetic viewpoint. Think how different the effect would have been if she had positioned her camera higher above her sleeping friend and looked downwards at her. The sense of intimacy derives not only from the fact that Olga is asleep, and therefore unaware she is being photographed, but also from Olive's physical proximity to her subject. She is so close, she could have reached out and touched Olga, if she so desired.

There is an obvious comparison to be made between *The sleeper* and Max's *The sunbaker* (1938),[4] which also explores the theme of the figure in the landscape. This now famous image was taken while Max, Olive and their friends, including Englishman Harold Salvage, were camping at Culburra Beach on the New South Wales south coast. Max said: 'It was a simple affair ... one of my friends [Salvage] leapt out of the surf and slammed down onto the beach to have a sunbake – marvellous.'[5] Salvage lies on his front, with his head down on the sand, water droplets drying on his skin, alluding to his recent exertion in the surf. His pose is as casual as Olga Sharp's but, in contrast, he does not appear at all vulnerable. His body is taut, ready to spring into action; his monumental form and angular limbs dominate his surroundings.

Other differences are equally revealing. Unlike Max, Olive had no long-term interest in modernism's heroic vocabulary. For her,

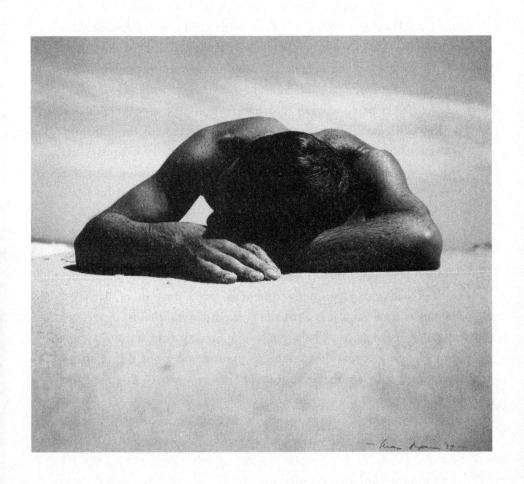

Max Dupain, *Sunbaker*, c.1938, National Gallery of Australia, gift of the Philip Morris Arts Grant 1982

maintaining a humanist perspective and a connection with her subject, which was expressed as a kind of honouring of whoever and whatever she photographed, was of the greatest importance. Although not individualised in the manner of a portrait, Olga Sharp is not abstracted in the way Salvage is. He has become form, an element in the landscape or, to extend this analysis further, his body is represented as landscape. Nor does *The sleeper* express what can be thought of as overt nationalist inclinations. Max's view of *The sunbaker* as an 'icon of the Australian way of life'[6] is not transferable to Olive's image, even though it also originated outdoors in an all-Australian setting of the bush.

The sleeper pairs woman and nature but exploring gender and dealing with qualities conventionally associated with the feminine are not Olive's concern here. *The sleeper* eloquently expresses her vision of a union with the natural world, externalising how she herself felt in nature. That Olga is asleep in the Australian bush is a secondary matter; being asleep in nature is what counts.

Only to taste the warmth, the light, the wind, one of her most sensuous images, took this immersion in nature even further. The woman in it was a model, Jenny Brereton, whom Max sometimes worked with on assignments, but it is not a portrait of her. Her identity is irrelevant; it is what she is experiencing that is important: pure sensory delight. The choice of a literary title reinforces this point, helping to gently nudge the photograph from the realm of portraiture into another category of imagery and to align it with other lyrical works, like *The sea's awakening.* The title is derived from a line in a poem, 'O summer sun', by English poet Robert Laurence Binyon, published in *Primavera: Poems by four authors,* in 1890.

O summer sun, O moving trees!
O cheerful human noise, O busy glittering street!
What hour shall Fate in all the future find,
Or what delights, ever to equal these:
Only to taste the warmth, the light, the wind,
Only to be alive, and feel that life is sweet?

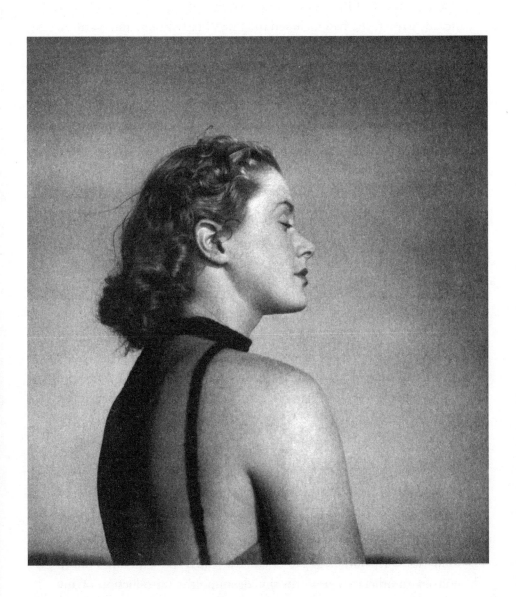

Only to taste the warmth, the light, the wind, c.1939, Art Gallery of New South Wales, purchased with funds provided by John Armati, 2006

Choosing Binyon affirmed Cotton's ongoing love of English poetry of the late Victorian period. This wasn't the first time she showed her enjoyment of his work. In her last few months at high school a decade earlier, she had included the line, 'I tasted rain, and warmth, and light and wind', in her poem, 'Farewell to seventeen'. The reference to 'O summer sun' on both occasions is unmistakable.

The literary title also signalled Olive's ambitiousness – this was an art photograph, first and foremost. The large print size, 33 x 30 centimetres, was a further indication that she intended it for public display.

Only to taste the warmth, the light, the wind had its origins in an ordinary and common run of events. Max had been commissioned to photograph the latest women's bathing suits for a David Jones advertising campaign and Olive accompanied him and the two models, Jenny Brereton and Phyl Riley, on the shoot at Bungan Beach, Newport. At some point, most likely after Max had secured the illustrative shots he needed, Olive began photographing the women, too, singly and together. Phyl Riley is shown lying on the sand in a bathing suit with a striking scallop pattern, and the two women are photographed together interacting a little awkwardly. But it was when she moved to focus on Jenny on her own that Olive achieved one of the greatest successes of her career. Showing no interest whatsoever in Jenny's costume (only its straps and upper edges are visible), she chose instead to photograph her subject from the back right-hand side, her face in full profile. The angle of the figure and her off-centre placement within the frame contribute to the dynamism of a remarkably spare composition. Only two elements, the figure and the sky, are involved, one solid, the other not. The tones of the subject's sun-kissed skin and the sky are so close, they almost merge. Olive didn't use a separate negative of clouds, which she sometimes did to enliven an otherwise uniform sky, deeming the introduction of any kind of external pictorial drama totally unnecessary.

In *Only to taste the warmth, the light, the wind* and its companion piece, *The sleeper*, the women are shown to be totally at ease within

the natural environment – the bush and the beach – and seemingly oblivious to the activities or potential disruptions of anyone around them. Both have their eyes closed. Olive's concern with representing states of interiority and self-absorption in photographs such as these does not mean, however, that the women depicted become ethereal figures. Each retains a very physical, grounded presence.

The two photographs have another unusual and important dimension: their basis in the understanding of, and intimacy between, women. The subjects are relaxed and the images of them are sensuous and celebratory, but not assertively erotic in intent. These qualities are evident in other photographs of women Olive would make during the war years, when female connections and companionship assumed an even greater role in her life.

The date of both photographs is pertinent for personal as well as larger historical reasons. They were probably taken during the first part of her twelve-month sojourn from the studio. While she was free to pursue her own creative interests at this time, it did not result in an expanded output, as might have been expected. The art photographs from this year were outstanding in many ways, but were far fewer in number than in the two years immediately before her marriage, which were exceptionally productive.

Depending on exactly which months in 1939 they date from, the backdrop was either impending war or actual war. Either way, as was typical of Olive's work, no current events were registered and no signs of foreboding or anxiousness were expressed. As always, Olive went towards the light, aspiring for a timeless quality in her photography. Given the date, however, her concerns can be seen in positive, even redemptive terms, as a sign of her determination to engage with beauty and provide an uplifting vision, when the international political situation was deteriorating – and everything in the world was about to change.

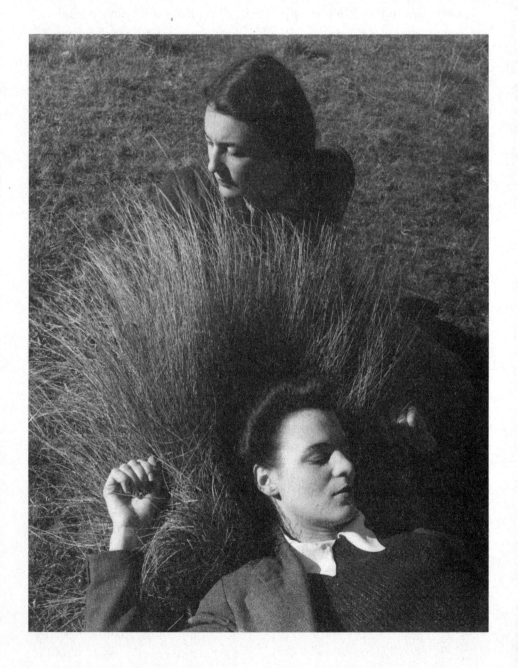

Max Dupain, *Two girls at Bowral*, 1939, National Gallery of Australia, purchased 1983

Two girls at Bowral

This is Olive's story, but there is one photograph by Max that impinges on it in a significant way because of what it suggests about their relationship. Also taken in 1939, it relates to the theme of the figure in the landscape, but intriguingly, and probably inadvertently, it has an unsettling psychological dimension that involves both Olive and Max. In contrast, the status of Jean Lorraine, who is Olive's companion in the image, is relatively straightforward. Max called the photograph *Two girls at Bowral*,[1] though the subjects are readily identifiable. It simultaneously articulates Max's perception of the differences between the two women (whether this was conscious or not is another matter), and expresses Olive's discomfort as a model and a subject.

The composition is divided into two parts that operate on a vertical axis; if Olive and Jean were photographed side by side, on a horizontal plane, the effect would have been less hierarchical. A vigorous tussock plant sprouting out of the paddock serves as a bizarre separation device between the two women. Jean lies on her back on the grass, arms above her at shoulder height, head resting on the tussock, her eyes closed and face relaxed. Olive, her body mostly concealed by the plant, is in a sitting position, with her torso and face angled diagonally in the composition. Alongside her stylish friend, she looks plain. Her hair is drawn sensibly back, possibly into a bun, and her clothes − or at least what we can see of them − have no immediate visual or sensory appeal, whereas Jean's accentuate her shapely figure. Jean was very interested in fashion, and, looking

at this photograph, one can assume she knew what suited her. She later good-humouredly described herself as 'the best dressed poor girl in Sydney', capitalising on the excellent dressmaking skills of an artist friend who would make her stylish outfits based on designs they saw in *Vogue* and *Harper's Bazaar*.[2] The same level of fashion and image consciousness does not apply to Olive.

At this stage of his career, Max had started to turn away from studio photography because of what he regarded as its fakery and inauthenticity.[3] This meant abandoning props, and working with his avowed new ally – sunlight. A trip to Bowral in the southern highlands gave him a welcome opportunity to take his camera outdoors into a natural setting. Equally importantly, this was when he was at the height of his romanticism, seeking truth, purity, the elemental and eternal. *Two girls at Bowral* explores these concerns. It is not a portrait of two individual women or a statement about their friendship, but a representation of a deeply conservative view of 'woman' more generally. Max's viewpoint is dualistic and essentially oppositional: the glamorous Jean is all body, at once sensuous and aware of her sensuality, whereas Olive, who is possibly now his wife, appears cerebral and disembodied. Their differences are underlined in their facial expressions as well. Each has her eyes closed, but in Olive's face there is a suggestion of tension. She is not relaxed, and her discomfort is palpable. Jean's expression is smooth and confident; she has given herself over to the occasion.

Jean's is the face of an experienced model who loves being photographed and is relishing her encounter with Max and his camera. We can assume there is accord between how he sees her and how she sees herself in this performance. But Max's view of Olive and her view of herself are patently not the same. She is familiar with Max's numerous photographs of Jean, his exceptional nude studies of her and beguiling portraits, and perhaps knows that her own presence in the image will be compromised. Before she even sees the print, she is fully aware it will not be in her favour.

The obvious differences between Jean and Olive did not inhibit their close friendship and may have been part of their attraction to each other and what Jean considered to be their extreme compatibility. As she said: 'We always managed to have conversations on parallel planes ... we both enjoyed the business of talking.'[4]

A year after this photograph was taken, Max selected a portrait of Jean for close analysis in a magazine article, 'My best picture and why'.[5] The full-page reproduction opposite his text presents a three-quarter length portrait of her, her long hair loose once again, tumbling over her shoulders and down her back. Her eyes are half-closed, her eyelids heavy with make-up and she wears a dark dress with a plunging V neck. It is a striking, sensuous image, though Max made no mention of this quality in his text. Instead, he used the occasion to rail against the 'unreal living' that his heroes Paul Gauguin and D.H. Lawrence had rejected decades earlier in their art and literature, and which he felt still pervaded contemporary studio photography. He aimed to avoid 'a posed subterfuge' and capture his subject's essence by not imposing his will upon the sitter, but giving hers 'full play'. His hope was that, 'This portrait may have mystery, or a mood – it may possess some eternal element in woman.'[6]

Despite counting his portraits and nude studies of Jean among his best work, Max was far from generous about their relationship, professional and otherwise, in later life. When asked about her, he replied that there was 'nothing remarkable about her ... she was very attractive in lots of ways, that's all I know.'[7] A disingenuous comment, given how close they had all been for a vital five-year period.

For Olive, there was never any equivocation. Her friendship with Jean was steadfast and enduring, and she would go on to make portraits of her that drew from their mutual intimate understanding, and which succeeded on that basis.

War

There was much cause for personal celebration in 1939, with Olive and Max's marriage. Jean Lorraine and John McInerney married earlier that year, too, on Black Saturday – 13 January – when, as Jean later wrote, 'The city was ringed by bush fires and the sky was ... dark with smoke and cinders.'[1] She wore a maize yellow linen dress a friend had made, and carried a bouquet of blood red roses, which were drooping as soon as she left the church. They kept their wedding secret from McInerney's parents, who wanted him to complete his medical studies before marrying.

As the months progressed, the political and social situation across Europe became increasingly unstable and Australian newspapers were filled with commentary and speculation about the possible outbreak of another world war. The fascists were in power in Germany under Adolf Hitler and in Italy under Benito Mussolini, and in Spain General Franco had recently established a military dictatorship following the Nationalists' victory in the Civil War. German military aggression was escalating at an alarming rate; the Germans had annexed Austria in March 1938, and widespread violence against Jewish businesses, synagogues and people occurred across Germany and Austria during Kristallnacht in November of that year. Following the German annexation of Sudetenland (the German-speaking area of what was then Czechoslovakia), agreed to as part of the Allied policy of appeasement, Hitler's troops invaded the rest of Czechoslovakia in March 1939. Fears about the expansion of communism were also growing, following Stalin's consolidation

of power and the USSR's strong industrial and economic growth. Australia's foreign policy response to the situation in Europe, as summed up by Australian historian Stuart Macintyre, was one of isolationism and appeasement.[2] Under the United Australia Party government, led by Prime Minister Joseph Lyons, criticism of the fascist dictators was censored and the number of refugees entering Australia, including Jewish victims fleeing Nazism, was limited.

Olive's and Max's awareness of the distressing, disruptive impact of events unfolding in Europe had a personal dimension through their friendship with dancers from the Ballets Russes company, many of whom came from countries either already occupied by German forces or under imminent threat of occupation. They were also fearful about what war would mean for them, their friends and family members who might be called on to serve in the forces. Olive's brothers Jim and Frank, for instance, were both aged in their early twenties and at that stage were single (Les was only in his early teens and so was not at immediate risk).

Against this backdrop, Max, who was a pacifist, joined the newly formed Sydney Camouflage Group, early in 1939. It was initiated by Sydney Ure Smith and Victor Tadgell and brought together scientists, military representatives, engineers, architects and artists who were concerned about what they saw as Australia's lack of preparedness for possible war in the Pacific region. The group considered knowledge of camouflage in Australia to be inadequate and were determined to ensure that it was adapted for Australian conditions.[3] Around April 1939, they began holding fortnightly meetings, sometimes in Ure Smith's offices, which were chaired by William Dakin, the University of Sydney's Professor of Zoology. Art historian Ann Elias has noted that Ure Smith's central role in the group accords with 'his reputation for activism, and his aspirations for industry, design and architecture to work together in developing a progressive and successful, if somewhat conservative, nation'.[4] Membership of the Camouflage Group was a wholly male affair and involved some of the most prominent artists working in

Sydney at the time. Architect John D. Moore was a member,[5] as was Frank Hinder, Adrian Feint, Douglas Annand, Peter Dodd, Robert E. Curtis, Frank Medworth and Arthur Murch. Max Dupain and Russell Roberts were the two photographers, who, along with Annand, had a close professional association with Ure Smith.

Great Britain and France declared war against Germany on 3 September 1939, after Hitler's troops invaded Poland. On the same day, Australia's conservative prime minister, Robert Menzies, announced that the country was also at war. According to Macintyre, 'Australia entered a second world war as it had entered the first, automatically.'[6]

In the Dupain circle, Damien Parer was the first to enlist, surprising both Max and Olive. He arrived at the studio in his new uniform one night, beaming, and announced that he was going to the war.

Max continued to run his business in increasingly difficult circumstances, as the war began to adversely affect the commercial photography scene, decreasing demand for advertising and illustration. However, it was Max's association with the Sydney Camouflage Group that would ultimately determine both the nature and timing of his involvement in the war effort.

* * *

In mid-1940, Olive returned to work in the studio, perhaps to fill the gap left by Damien. It may also have been an attempt to keep studio running costs down; if the business was stretched and they could not afford to pay an employee, they could at least adapt by decreasing their own salaries.

Early wartime commissions included the production of photographs for government campaigns, with John McInerney's youngest siblings, Haidee and Roger, used as the models. Haidee was the archetypal adorable, blonde, curly-haired child with great sentimental appeal, and her image was featured in an advertisement

for the government fundraising scheme Fourth Liberty Loan. Headlined 'PLEASE HELP BRING MY DADDY HOME', the text reads, 'He says he'll get home sooner, the more supplies and guns we can send him and his mates.' As part of the campaign for self-sufficiency and hard work on the home front, Roger was photographed in a vegetable garden, 'digging for victory', while Haidee appeared once again in an advertisement for victory stamps that was circulated as a poster.

As in the first few years, when they were establishing the business, Olive and Max were working together again, with no other employees. The key difference, now that they were married, was that they were fully in each other's company every day, working together and living together.

PART THREE

PART THREE

'The instability of everything'

War changed everything. As Damien Parer poignantly wrote from New Guinea in 1942, 'How this war has unsettled everything. I don't just mean the fear of bombs and sudden death, but the change in social life; the instability of everything'.[1] He was initially appointed to the Australian Department of Commerce film unit, which was soon after taken over by the newly established Commonwealth Department of Information. He left Sydney for Melbourne in December 1939 and, after his arrival, wrote a long letter to Max and Olive, thanking them for their kind thoughts and for the scones Olive had supplied him with for the train journey. Olive kept this letter, along with five more written when he was in the Middle East during 1940 and 1941, and one from 1942 that he wrote to her alone.[2] These letters, most of which are several pages long, map Damien's travels as a cameraman and his experiences in the early stages of the war.

At the outset, Damien expected to be in Melbourne only a short time before returning to Sydney to work on a film about the navy, with a script written by his colleague Ron Maslyn Williams. However, the Department of Information had other plans for him. On 10 January 1940, Damien sailed for Palestine in a new role as official film cameraman with the first contingent of the Second AIF. Along with famed Antarctic photographer and war photographer Captain Frank Hurley, and young New Zealand photographer George Silk, he was set to work covering the operations of Australian troops in the Middle East between 1940 and 1942. He filmed the

assaults on Bardia and Tobruk in Libya, both in January 1941, the Greek and Syrian campaigns, and also the siege of Tobruk, which lasted from April to November 1941. He accompanied soldiers in the AIF, with the aim of covering live action; this was the approach for which he became best known.

Damien's letters are invaluable documents that provide information on his wartime activities, his views on the war's progress and the relative worth of the efforts of the Allied and enemy forces. His impressions of Australian military life are also illuminating, and his attitude to Australian soldiers was extremely positive. But, of course, these letters are not detached historical or cultural records. They are personal and autobiographical, offering insights into Damien himself, his responses to totally new, alien environments (he hadn't travelled outside Australia before enlisting), his approach to his work, his motivations and feelings. He told Olive and Max that he particularly loved Greece, where he spent some time in 1940, captivated by the people, the place and the spring weather. He also enjoyed Haifa, in what was then Palestine, particularly the company there, plus 'a special cocktail we get at a café ... that has achieved a certain fame amongst our acquaintances'.[3] He later reassured the Dupains that he wasn't becoming a drunkard – his preferred beverages were wine and Ovaltine – and regarded 'festivity and good fellowship' as 'a fine Christian thing'.[4] What emerges from his writing is a fun-loving, highly motivated young man in his late twenties, who was desperate to make outstanding war documentaries. No wonder he was mortified when, at one point, Hurley, his superior, wanted him to remain in Palestine where, as Damien put it, 'all is peaceful ... It's a bloody Siberia as far as I'm concerned.'[5] He needed action.

The letters also reveal how close he was to Olive and Max, and how active their exchange was on artistic and cultural matters. Damien was a considerate, loving friend who sourced gifts for the Dupains on his travels through the Middle East: a beautifully shaped bowl suitable for soup or punch; a figurine of some sort; and some

perfume he hoped Olive would like. He told her: 'It is the essence of the oils or something ... got it at a bazaar in Cairo – where it is not too, too oriental.' He also sent them a length of beautiful brocade – 'the most lovely piece of cloth I have ever seen in my life – just gorgeous!'[6] – which he insisted they put to practical use as a backdrop in the studio or as a new jacket for Olive (a thoughtful suggestion when clothes rationing was coming into force). Another gift was a book of photographs, which he had purchased because he thought they would be intrigued by the photographer's interesting use of daylight in his portraiture.

Damien's interest in art was broad, encompassing photography, film, the visual arts more broadly, and classical and popular music, whether live or recorded. He enjoyed a concert of Tchaikovsky's music in Jerusalem, and told the Dupains that one of his colleagues played records of Beethoven's Fifth Symphony on a portable gramophone – 'It's pretty hot!' – knowing how much Max loved Beethoven.[7] Before being sent overseas, Damien had attended the Herald Exhibition of avant-garde art in Melbourne, but struggled with some of the works on display, singling out Salvador Dalí's painting, *L'homme fleur* (1932), as the most deplorable. However, it was his passion for film that shone through. He was captivated by the German Expressionist silent film classic *The Cabinet of Dr Caligari*, 'the most amazing idea I have ever seen on film', and was delighted that Olive had seen Pare Lorentz's ground-breaking documentary film *The River* (1937), which he hoped Max saw, too. He also recommended they go to *Babes in Arms*, 'a really good light entertaining show ... don't miss it – you'll probably have to force Max to see it Olive.'[8] Obviously, Olive was more interested in film than Max was and more amenable to social outings.

The exchange between the Dupains and Damien extended to personal commentary on each other's work. Feedback from Olive was meaningful and respectful, with Damien responding frankly on one occasion: 'I'm afraid Olive I don't agree with you about my work particularly the movie stuff. – I can't kid myself about it – it's

just so, so – and the stills are only fair – we must be honest. – It is awfully good of you to pick out a few shots and say they are all right, but I'm really not satisfied.'[9] In another letter, he expressed concern about Olive not giving her photography 'the attention it deserves', echoing Max's admonition years earlier that she must make her own photographic work a higher priority. She promised to send him examples of her recent work for his consideration.

Damien praised the work of both Olive and Max as a creative alternative to the kind of photography promoted by camera clubs, which he felt strangled any good ideas amateur photographers and film-makers might have had. He was well informed about the Australian art scene, especially as it affected his friends and colleagues, who sent him copies of the latest magazines and books. He was enthusiastic about the issue of the magazine *Australia* that published an article by their mutual friend Peter Dodd, along with recent photographs by Max. But, like Max, Damien was disappointed with Gert Sellheim's design of the book *Soul of a City* (1938–39), to which Max, Hal Missingham and other photographers had contributed. He thought the layout was a 'bloody mess', judged Sellheim's design of the first four pages as 'fair', and the rest as 'buggered'.[10]

Damien's letter-writing also provided an opportunity to articulate his evolving credo as a cameraman. In December 1940, he explained his three main aims were: 'to build a true picture of the Australian Soldier in movie and stills', 'to make good movie single reelers showing cause and effect' and 'to keep newspapers and newsreel supplied with really hot spectacular news'.[11] He believed that the soldier's credo of mateship was emblematic of the Australian spirit and championed this view of the digger as a national archetype in his films and writing.[12]

The intimacy of his friendship with Olive and Max meant Damien could confide in them on personal and professional matters. He gave a frank assessment of the capabilities and approaches of his colleagues at the Department of Information and was most critical of

his boss, Captain Frank Hurley, nicknamed 'Cap'. Damien regarded the fifty-five-year-old Hurley as uncollaborative, conservative and out of touch with what could be considered newsworthy for Australian audiences. He explained:

> I find working with Hurley difficult. He is a good bloke in himself, but unfortunately having worked so much on his own, he cannot tolerate another man doing a responsible job of work, – collaboration is not the order of the day at all. He must be no 1 on top all the time. So poor old Parer has been shoved in the back somewhere. – Also Hurley doesn't have much news-sense which is necessary to the job: he goes mad about bloody native boats, and mosques, & clouds (cumulous variety only), – while the War Correspondents lick us on the news stuff – I agree with you now Max that his stuff lacks design – he goes for big rugged scenery or things & worries about 'quality', and his imagination is limited, – don't think he could ever produce something fine.
>
> On the other hand, – his technical resource, – chemistry & exposures etc. is excellent, and his abounding energy & care of the cameras, is a great lesson for me I hope I profit by it – also his influence with Generals & things is most useful … [13]

Damien's letters also highlight the strength of his emotional connection to Olive and Max, which he was not afraid to express. In one letter, he tells Olive: 'You have been in my thoughts so often, & so many things happen that I would like you to see & talk about, – & on top of it all – your letter, Olive, arrived today & made me feel how much I like you & Marie [Cotter] …'[14] Moments of great poignancy flow from the extended dislocation and separation from friends and family he was experiencing: 'I hate to feel that I am losing touch with you, so even though you haven't been able to reply I want you to hear from me. – How are you both? How is the war affecting you, how is work, and what is your present outlook'.[15]

In the same letter, which is the most emotional of his among those in Olive's possession, he becomes momentarily melancholic:

> Oh Max – time is flying so quickly – it seems youth is slipping past – and nothing has been accomplished. – Already my hair is thinning out on top; – I'll be bald soon – and no work of importance done so far ...[16]

The Dupains

Among the few personal photographic items dating from the Dupains' married years is a lovely study of Olive in a pensive mood, probably taken at one of their family homes at Newport in 1940. This may well have been Max's last major portrait of her.[1] She leans on the window sill, upper body and head tilting towards the natural light, eyes looking into the distance. Her hands are crossed in a gentle, relaxed way and her simple wedding ring is visible. Max included this and other portraits of her in an album they compiled in late 1940 as a Christmas present for Damien Parer, who was then on the other side of the world at Bardia, Libya, with the 6th Division of the Australian Army.[2] Inscribed, 'A few shots from home for Damien Parer to look at occasionally', the album was the Dupains' playful, fond address to their much-loved, absent friend. It opened with a portrait of Olive, opposite which Max wrote an incomplete, suspenseful inscription, 'Fancy a sweet innocent thing like this marrying a – ', and was followed by Olive's portrait of him and the closing inscription, 'bastard like him!' Her portrait depicting an engaged Max sitting on the doorstep of their home is a study of relaxed intimacy.

The shots they assembled, forty-five in all, were mainly portraits: of Olive and Max photographed by each other, of people associated with the studio, and other mutual friends, including Jean Lorraine, Marie Cotter and Peter Dodd. One of Max's stylish, beguiling studio portraits of Marie – whom Damien would marry a few years later, in 1944 – was accompanied by the teasing comment, 'Boy! Oh Boy!'

An informal photograph of Jean and Olive carries a similarly playful caption, 'Nice girls!' Also included in the album was a photograph of Max's beloved Chevrolet with the caption, 'I still have it & it still goes', and some shots from a group camping trip Olive and Max had enjoyed on the King's Birthday long weekend a few months earlier. Other photographs were samples from recent commercial projects, including outdoor portraits of Paul Petrov and Tamara Toumanova, Ballets Russes dancers who had found themselves stranded in Sydney after war broke out. The overwhelming impression conveyed by the selection of photographs, and Max's inscriptions, is of an active, enjoyable social life and a strong sense of camaraderie shared with their friends.

Despite the positive sentiments expressed in the album, Max and Olive were facing considerable upheavals in their lives in this period. The drop in clients following the outbreak of war was making their financial situation precarious and they decided to amalgamate with Hartland & Hyde, a process engraving firm and leader in colour printing. It was run by Ernest Hyde, whom Max knew from primary school. Max later described the amalgamation in colourful terms:

> [In] early 1941, Hartland & Hyde were inducing the painful
> birth of colour photography in Sydney. It should have been a
> Caesarean, but instead it laboured on until natural resources
> dried up and a still birth seemed imminent. I was asked to
> apply whatever life-giving support I could and breathe fresh
> energy into the ailing infant.[2]

As a consequence, Max and Olive packed up the Bond Street studio and relocated to 49 Clarence Street (since demolished). Hartland & Hyde occupied two upper floors and the Dupain studio was located on the ground floor.

At the same time, Olive and Max's marriage was beginning to founder. It appears that Olive had begun to quietly turn away

from Max and gather herself. This withdrawal may have been slow enough and subtle enough at first that it was not discernible to their close friends. And it seems that Max himself did not register any significant change in Olive's feelings for him, as he was taken aback by the events that subsequently unfolded.

The 'bust-up'

The first obvious, outward indication that their marriage was quietly falling apart was Olive's decision, made independently of Max, to look for work outside the studio, on her own terms. She approached the University Appointments Board in New South Wales to see if any teaching positions were available. Frensham, a private progressive girls' school at Mittagong, in the southern highlands, 120 kilometres from Sydney, had a vacancy: as Olive remembered it, the 'maths mistress had left at the end of first term, I think because of illness, and they didn't have a replacement so I went up there.'[1] Olive joined the staff in the winter term, which began on 3 June 1941, lived in Mittagong during the week and, initially, for several weekends, returned home to Max.

These were radical actions to make early in her marriage – moving away from Sydney, from her husband and the home they had set up together a little over two years earlier. Frensham was, however, a very congenial environment for her to retreat to, not only because of its location in a beautiful semi-rural setting, but also because of the school's values, its championing of creative expression and commitment to developing a strong community. Olive had the additional benefit of inspirational companions among the women who worked there. Frensham proved to be the perfect place for her to establish some autonomy in her life and reflect on the inner tumult she was experiencing in her relationship with Max.

During her tenure, the school had fewer than 150 students, both boarders and day students. However, despite its small size, it was a

very dynamic environment, with a clear philosophy developed and articulated by Englishwoman Winifred West, who, with Australian teacher Phyllis Clubbe, had established Frensham in 1913. A deeply spiritual woman and committed Anglican, West believed that education should aim to develop the complete human being, one who can identify what is worthy in life and what is not.

Frensham's grounds and buildings were also sensitively planned in relation to one another, thanks to West's inspired partnership with her friend, artist and architect John D. Moore, who designed several buildings as the school began to outgrow its original accommodation. In 1937, the school's West Wing, which Moore collaborated on with Sydney architect V.L. Dowling, won the Australian Institute of Architects' Sulman Prize for excellence in architecture. Moore was committed to a rational approach that related to Australian conditions; he favoured clean lines and minimal adornment, which accorded with Olive's modernist views. The simplicity and elegance of his buildings appealed to her.

As a new staff member Olive must have been impressed by the diverse array of sporting, cultural and community activities on offer, which included gardening, hockey, music and the performing arts. There was a performance by the Polish Australian Ballet, a puppet show, and students performed Oscar Wilde's *The Importance of Being Earnest*, which was presented earlier in the day than usual to accommodate visitors who had to travel from Sydney by train rather than car because of petrol rationing. The Sydney String Quartette gave a concert, and recitals of classical and contemporary music were held during the term, beginning with Bach and Handel, and followed a few weeks later by the works of unspecified 'Modern Composers'. On a special visit to the school, the Bishop-Elect of Singapore conducted the morning service one day; and dignitaries and former pupils were among the numerous other visitors listed in the school's magazine, *Frensham Chronicle*. Staff and students were also preoccupied with the war effort, knitting various items of clothing – mostly balaclavas, pullovers, socks and gloves – to send to

soldiers serving overseas, and raising money for the Red Cross and YWCA War Appeal.

One of the extracurricular activities Olive immediately became involved with was the Photography Club, with a note in the *Frensham Chronicle* tacitly acknowledging her photogfaphy career:

> This year the activities of the Club have been mainly connected
> with war work. Several members have developed films and
> others have sold negatives to raise money for war funds. We are
> very lucky to have Mrs Dupain with us this term.[2]

Frensham was also a place in which wide-ranging, substantial and topical ideas were freely discussed among staff members and the broader community. Olive's time at the school coincided with its twenty-eighth birthday celebrations and an evening of rousing speeches on democracy. The choice of topic related to the rise of fascism in Europe and Hitler's military aggression. In her oratory, Ruth Ainsworth, the printmaker, whose role was Art Mistress, said that:

> There are two fundamentally different ways of regarding
> the world. One views life as a mechanical system. The other
> finds evidence of a creative process bringing life forwards
> towards an ideally distant goal ... According to this view there
> is an ultimate spiritual reality and man's freedom consists in
> the degree to which he becomes conscious of this reality and
> brings it to expression in his life.[3]

Ruth Ainsworth, who was a well-connected artist, and a friend of painter Grace Cossington Smith and ceramicist Anne Dangar, underlined Frensham's moral – and experimental – underpinnings. She exhorted the community to take action to ensure that the influence of those with 'higher standards and a better sense of values' would be felt, instead of allowing 'a thoughtless majority to give

the direction to life'.[4] Ainsworth believed that the school provided a role model for larger society: 'we are making an experiment in living together and our measure of success has a wider significance than for our own happiness.'[5]

The headmistress, Miss Phyllis Bryant, who had succeeded Winifred West after her retirement in 1938, was similarly motivated. She declared that 'the learning and memorising of fact is really of very much less importance than the cultivation of an alert and enquiring mind, which is eager to receive new ideas and impressions'.[6] She told her audience that they were faced with two choices for the future: 'You can be a machine-minder, or you can be an artist.'[7]

Olive had already made her choice.

* * *

The fact that Olive returned to Max on weekends during the months of June and July suggests that at the outset she may not have planned to leave the marriage. Perhaps, at first, she wanted time on her own to think about things, or to develop a plan to put to Max, in an attempt to improve their failing relationship. Perhaps she had already tried to initiate change over the previous year or two and was feeling that she had exhausted all possibilities. Then again, there may have been an incident that prompted her to take decisive action. Whatever the situation was, within a few weeks, she determined that leaving Max was her only option and she told him she would not be coming home again. He was apparently very shocked by her decision. At this point, according to his deposition in the divorce proceedings two years later, 'she took her belongings, most of them, and subsequently she came back and took the balance.' The end of August 1941, less than three months after starting at Frensham, was therefore the date when Olive 'officially' left Max.

Damien Parer, who was still in the Middle East, was distressed to receive news of their separation. He wrote to Max saying:

I was bloody sorry about you and Olive having a bust up –
the combination was such a cracker one – and I like you both
so much – I feel it can't be permanent – don't think I am an
interfering bastard when I say that.[8]

'Cracker combination' or not, the bust-up proved permanent, and
for reasons that can never be fully known by outsiders.

As English writer Hermione Lee remarked in her biography of
Virginia Woolf, every marriage is a mystery, and Olive and Max's
was no exception. They were also both extremely discreet about
their private lives and did not enter into public commentary on what
transpired between them. This, combined with the fact that the great
majority of their friends and peers are no longer living, means there
is no possibility of obtaining any insights on the dynamics of their
relationship from those who were closest to them. But there are a
few snippets – comments, anecdotes, rumours – which suggest that,
despite Damien's positive assessment of the couple's compatibility,
there were deep-seated issues from the start. Barbara Beck, who
socialised with the couple in Sydney, felt that Max treated Olive
'like a piece of furniture'.[9] She stressed that they had known each
other for 'a very, very long time' before finally marrying, implying
that they were so familiar with each other, there was no romance
left and the relationship had already run its course.

Olive herself made only two public statements that give any
inkling of possible reasons for their break-up. One is enigmatic:
'Things alter when you become a wife', she told journalist Susan
Chenery in 1995, but did not elaborate on what 'things' she was
referring to.[10] The other is more specific and far more revealing.
In an interview towards the end of her life, she said that by 1941,
the year she left, she'd 'had enough of Max paying rather too much
attention to pretty models'.[11] This concern about Max's attraction to
other women is reiterated in a poignant anecdote recounted by her
friend Nancy Hyde, the wife of Ernest Hyde, who ran the business
Hartland & Hyde. Olive confided in Nancy that she would rush

over to the window when Max left the Clarence Street studio, ostensibly to visit a client, and look down into the street to see which way he turned. The direction he chose indicated whether he was heading off for work, as he had told her, or whether he was on his way to visit a girlfriend, as she surmised. It is not hard to imagine Olive, face pressed against the windowpane, heart in her mouth as she watched him go.

Remarks about Max Dupain's physical attractiveness and appeal to women are common in interviews with friends and associates. Playwright Betty Roland said he was 'very good looking' and Barbara Beck described him as 'extremely handsome and obsessed with physical fitness'.[12] Jill White, Max's later long-term assistant, commented that 'he was devastatingly good-looking till the day he died'.[13] Ernest Hyde remembered him around the time of his marriage to Olive as being 'very energetic ... dynamic', telling Clare Brown that Max 'was very conscious of his inner strength ... and women sensed it very strongly ... there was certainly a very strong sexual urge in Max'.[14] Hyde reported women saying to him, 'Max is so virile.' He concluded that 'Max's sexuality was vitally important'[15] to him but did not know, or wish to speculate about, how this might have played out in his private life.

What exactly Olive meant by Max 'paying rather too much attention to pretty models' was never specified. Whether he was simply flirtatious, or whether he entered into liaisons and affairs with other women, either before or during their marriage, cannot be known. However, because she and Max worked together in the studio every day, and she often accompanied him on fashion shoots, she saw first-hand the way he interacted with models, and would have registered his degree of interest in any particular woman, who would probably have been someone she also knew. While she wouldn't have been privy to details of any assignations Max may have made, she certainly would have felt his inattention. She was also in the unusual and sometimes confronting situation of being continually faced with photographs of the beautiful

women Max photographed, and his numerous nude studies of them.

Max told Clare Brown in 1990 that his work, especially fashion photography, brought him into constant contact with 'the opposite sex', and went on to make the following vague statement:

> Of course there was a quid pro quo sexually … [but] it is important … under such circumstances, you do one of two things, that's your job, or you muck about, I don't think you can mix them … I was most concerned with the progress of my own work, making a living out of photography. That was even more basic than the sex bit.[16]

Despite not spelling out what he meant by 'quid pro quo', the implication is that he valued his work, his photography, more than sex. This viewpoint is corroborated by Jill White, who stated: 'a lot of photographers are very gregarious and real playboys, but Max wasn't like that. I asked one of the girls who modelled nude for him what was he like [to model for], and she said he was always very formal and correct, even shy.'[17] Barbara Beck also commented on his formality and distance. Perhaps Max approached photography as a means of sublimating his desire for other women, because of his prior and ongoing attachment to Olive.

For Olive, however, Max's behaviour, whatever exactly it constituted, was unacceptable. As with her response to his flirtation with his cousin Lucille, she initially attempted to take control of the recurring circumstances presented to her. According to Marie Cotter's sister Doreen, Olive did everything she could to keep women away from Max.[18] There is also no doubt that her relationship with Max became increasingly painful, and the attendant emotional disruption made it difficult for her to work. The years 1940–41 saw a sudden drop in her output, and she was not able to produce any photographs of significance. Working in the studio and darkroom alongside Max may have proved too distressing, and relocating to

Frensham brought an end to the ready access to facilities she had long enjoyed.

Almost certainly, other factors were involved in her decision to leave the marriage. Max himself speculated that he may have unwittingly constrained Olive's creativity and her ability to pursue her photography, when he later reflected that: 'She had talent. I could have been a repressing influence because in those days when you are extremely young the world is out there to be conquered, nothing stands in your way.'[19] His driving ambition and conquering attitude are likely to have affected much more than Olive's ability to continue working. Ernest Hyde's insights into his character suggest that he would have been very difficult to live with. While greatly admiring his talents as a photographer, he considered him 'a rather unbending person', someone who was 'not prepared to compromise'.[20] He told Brown that 'Max could be difficult to talk to unless you happened to be on the same line of thinking … Conversations had to be around where Max was.'[21]

The Cotton family's friend Jean Cook felt that Olive's and Max's views of marriage and domesticity were also incompatible. She believed that Max's expectations were conventional and he grew tired of what he felt were Olive's 'casual ways', which, in Cook's words, included 'not darning socks, not putting dinner on the table'.[22] Barbara Beck agreed, saying that Max 'expected … everything to be done for him', and felt that the marriage must have been difficult for Olive.[23] Max may have had the example of his own parents' happy marriage uppermost in his mind, which was dependent on Ena's selfless devotion to her husband. Olive herself later suggested to an interviewer that the fact she 'didn't like domesticity' was a factor in her unhappiness.[24] For someone committed to the ideals of a companionate marriage, such an unfair division of household chores and a preoccupation with minor housekeeping matters would have been loathsome.

The outcome was unequivocal. Within a short time of marrying Max, Olive discovered that there was not enough space in the

marriage for her and what she valued most. There also wasn't enough regard, consideration or affection, it seems, and she suffered multiple humiliations and betrayals, large and small, which she decided not to bear any longer. Perhaps Ernest Hyde summed up the situation best, when he told me in 1995 that 'Max was a very demanding person and Olive was a very giving person.'

* * *

The decision to break completely with Max was the second audacious and conspicuous step Olive had made in her adult life – the first having come at the end of 1933 when she joined the Dupain studio, instead of training as a teacher. Leaving Max was of a different magnitude altogether, though, not least because of the potentially public nature of their split and the stigma associated with divorce at that time. However, Olive did not prevaricate or compromise. She wanted to live according to her principles and was determined to act of her own accord, despite what others might think or advocate in the hope that she could be persuaded to change her mind.

The company of women

At some stage during the hugely consequential year of 1941, when Olive and Max's marriage was unravelling, a young woman approached Olive with an unusual request. Her name was Joan Baines and she and Olive were acquaintances, a very significant fact because the collaboration they were about to embark on involved a large amount of trust. It resulted in a small group of remarkable nude studies, taken for Joan's husband, Alan, which have no equivalent in either Olive's body of work or that of any other Australian photographer of the period I have yet encountered.

Joan Baines (née Matthews) commissioned the photographs as a gift for Alan, who was serving in the AIF in Palestine. According to a newspaper article, he left Australia soon after their wedding in December 1939, and so, like many other couples married during the war, they had spent very little time together. While the photographs belonged in the first instance to Joan and Alan Baines, they were also Olive Cotton's, signed and dated by her and thus claimed in an authorial sense.

The studies of Max in which he may have been nude (their discreet nature makes it impossible to be definitive) can retrospectively be brought into play here as they and the studies of Joan share a crucial link. Neither was made for public view – they were emphatically private.

Joan's desire to be photographed nude in a conservative and puritanical era in Australian society was daring. Given that no instant imaging technologies were available in 1941 (the Polaroid

process was two decades away), the only option for a young woman like Joan was to find an open-minded photographer whom she could trust. The fact that she already knew Olive meant matters of privacy and discretion were nuanced by familiarity.

Olive may have had limited experience with the genre of the nude herself but was intimately acquainted with the conventions of nude photography and especially with Max's efforts in this area. She was also already experienced as a portraitist, especially of women. Her photographs of her sister, Joyce, and her friends Olga Sharp, Gwynneth Stone and Jean Lorraine are distinguished by the subjects' self-possession and the sensuousness of the depictions. Nothing about them, however, was as bold as the collaboration with Joan.

The three strongest images of Joan were taken outdoors by the water, probably at Nielsen Park, Vaucluse, and the fourth is an interior shot set in an empty or sparsely furnished room (this might be at Lyeltya, Newport, where the women could have worked undisturbed). In the outdoor shots, Olive's vantage points and Joan's poses vary in order to present multiple views of her. There is a striking full-frontal nude, a study of her in a half-seated position, and a remarkable close-up of her lying on the rocks, photographed from the waist upwards with her arms behind her head. In all three shots, she looks at the camera and, by implication, her husband, Alan. This directness of address is antithetical to the conventions of nude photography of the period, where subjects did not directly acknowledge either the camera or the viewer.

Nor is the level of documentary or descriptive detail typical. Olive represents Joan literally as she is, without any of the allegorical or mythological trappings that were commonplace in nude studies by men in this era – for example, in the work of Geoffrey Powell, Laurence Le Guay and Keast Burke.[1] Nor do Olive's photographs of Joan display the detached formalism of many of Max's female nudes. Given the private and intimate nature of the commission, specific detail and veracity were crucial, the means by which Joan

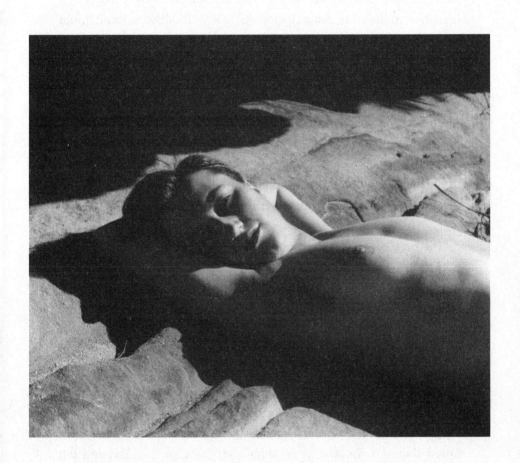

Untitled nude, 1941, Art Gallery of New South Wales, gift of Joan Baines 2000

revealed her individuality, herself. The photographs also differ from their public counterparts by male photographers in the way Joan unabashedly declares that she is a sexual being in control of her own performance and her own body. This is a more complex matter than it might first appear, because the photographs are not confined to an expression of sexuality. They go further than this to assert that Joan is a multi-dimensional subject, whose intelligence and inner and erotic lives are all evoked simultaneously.

While Joan's desire to send photographs of herself to her new husband was the motivation behind the commission, what was it, aside from their acquaintanceship, that enabled the two women to embark on such an adventurous collaboration? They belonged to the same generation, with only a four-year age difference (Olive was older), were university graduates (Joan had a Bachelor of Science), and were professional women who had capitalised on the employment opportunities that became available during the war.

In their professional lives, they were women of consequence with unusual careers. That they stood out from their peers, albeit for different reasons, is indicated by the fact that they each attracted newspaper coverage, Olive as a photographer and Joan as a pathology technician. As reported by the *Sydney Morning Herald*, Joan was formerly a biochemist on the staff of the Children's Hospital and became 'a pathology technician with the army holding the full rank of sergeant'.[2] The article was accompanied by a photograph of her at the pathology department of the Engineers' Depot at Moore Park, in Sydney. Another, longer piece in a Brisbane newspaper noted that she was the only female sergeant in the AIF and felt no embarrassment whatsoever about holding this responsible position. Joan is quoted as saying: 'I love the work. We make about 300 blood group classifications here daily … and we don't make any mistakes. One mistake would mean a human life.'[3] For the reporter, however, appearance and apparel were of equal interest to her professional activities. Joan was said to be 'an attractive

brunette, who wears a boyish hair crop' and her sergeant's army uniform was described in detail.[4]

Olive and Joan were atypical in their backgrounds and in the impressive degree of autonomy and self-assurance they displayed. However, it was also their unconventionality and liberal thinking that made the creation of the photographs possible. Joan's commission was both a bride's gift to her new husband and a manifestation of a socially and sexually liberated viewpoint.

In addition to the purposefully erotic and sexual representations of Joan's naked body, the photographs deal with the complex matter of reciprocal desire – not only Joan's desire for Alan, but also his desire for her. In effect, she is trying to present herself to him in the most direct way possible, fully naked rather than nude; she is trying to imagine and anticipate what it is about her, in her, that makes him desirous of her. She invokes this narrative of desire through her performance to the camera and makes it tangible to Alan through the presentation of photographic prints he can touch, hold and look at in her absence.

When seen together as a group, it is obvious that the four photographs work in different modes, ranging from the specific to the more imaginary. The full-frontal view is charged with momentum, as if Joan is about to move forward and, with lips slightly parted, smile or speak to her absent partner. The close-up of her in a reclining position, which mirrors the pose of Olga Sharp in *The sleeper*, is the most emphatically modern, employing a radical perspective and a play with abstraction. The dark shadows that fall across Joan's upper torso and face, and the upper section of the composition, are powerful forces. This, however, is also the dreamiest image. With her eyes half-closed, the directness of expression seen in the full-frontal version is abandoned and Joan adopts a pose that is open, vulnerable and unabashedly intimate.

Joan Baines's photographs were a promise to her husband for their future life together, made during wartime when they could not know when, or even if, he would return. Fortunately, he came

home safely in 1945, bringing the group of photographs with him, which the couple treasured throughout their marriage. While Olive's photographs speak explicitly of the relationship between Joan and Alan Baines, and of the performance and representation of her desire for her husband, at the same time they invoke a collaborative relationship. The two women worked together trustingly for an agreed effect.

Transition

When Olive left Max, she must have decided to proceed with divorce as quickly as possible. No extended conversations, no wavering, no trial separation, no second chances. And, even though they had been at the centre of each other's lives for so many years, from August 1941 onwards they hardly had any contact. But there was still one significant legal hurdle to negotiate early in their estrangement: the grounds for divorce. This was an era in which fault, such as adultery or desertion, had to be established. If Max had indeed been involved with other women, Olive could have identified adultery as the cause of their break-up; she didn't, and they proceeded on the basis that she had deserted Max. This doesn't mean there was no adultery, merely that proving desertion was more straightforward and less scandalous. The onus was therefore on Max to take the matter forward. Over the next few months, under instruction from his solicitors, he had to gather evidence that would prove he had done everything he could to induce Olive to come back to him, and that his efforts had been unsuccessful. The long, drawn-out process was demeaning and distressing for them both, framed within the context of either the denial or restitution of Max's 'conjugal rights', which were a legal entitlement of marriage. For the Judge in the Supreme Court of New South Wales Matrimonial Causes Jurisdiction, the eventual question to resolve was:

WHETHER the Respondent [Cotton] has withdrawn from cohabitation with the Petitioner [Dupain] and has kept and

continued away from him without any just cause whatsoever
and without any such cause has refused and still refuses to
render to him conjugal rights?

For Olive, going down this path was a brave decision at a time
when the instances of divorce were still relatively few across
Australia – around 3000 per annum – and the associated stigma
was considerable. There is no doubt that her family, especially
Leo, was deeply shaken by the prospect of the divorce proceedings,
knowing full well that fault would have to be established and in
public no less. A high-profile case such as theirs was certain to
attract press coverage. Furthermore, as a divorcee, Olive would
face an uncertain future due to the entrenched disadvantage
divorced women experienced, socially and financially. This was a
situation she had to confront almost immediately. After only two
successful terms teaching maths at Frensham – all the girls she
taught having passed their Leaving Certificate, which she found
'very pleasing' – she felt she had no choice but to give up her
position, because, as Jean Lorraine commented, 'she did not want
to "bring discredit to the school"' through the scandal associated
with divorce. This meant foregoing the financial security and
independence the position gave her, a supportive, stimulating
work environment and the companionship of a group of inspiring
women. In actuality, she need not have worried about leaving.
Miss West, the school's founder and principal, held progressive
views and would have supported her regardless. Olive did not
realise this until many years later when by chance she met Miss
West in Sydney:

We all went for coffee and she asked why I had left. It was
because my divorce case was coming up the following year
and I didn't think it would be good for the school. 'It wouldn't
have made any difference,' she said. Miss West was a wonderful
woman.[1]

At the end of the teaching year, on 11 December, Olive left Frensham and returned to Sydney, probably to Wirruna, which she had left two and a half years before to marry Max. Then, in 1942, she moved with Leo, Lilian and Leslie to the house Leo had bought in Artarmon, a charming Californian bungalow, which was much closer to the university and the city. Earning an income and attempting to maintain some independence from her family was her highest priority. She worked briefly as a draughtswoman and then at microfilming documents for use by government departments, before receiving a totally unexpected offer – Ernest Hyde asked if she would like to run the Dupain studio while Max was away working as a camouflage officer for the Department of Home Security.

Due to the now fraught relationship between Olive and Max, Hyde brokered the employment arrangements without them having to meet. Olive was to receive a salary of £4/10s a week, and a share of the business profits. When she had left the studio the previous June, she had assumed it would be forever. However, returning in greatly changed circumstances suited her, with the collaborative arrangement especially to her liking, as she later explained:

> I thought, 'Oh well, I'll be on my own', so I went back ...
> which was really nice because I could do all the practical work
> and I didn't have to worry about the accounts. Hartland &
> Hyde looked after that part of it ... I had my little reception
> room [that] also housed their switch girl and switchboard for
> the whole set up and she was my receptionist too.[2]

Olive's new role coincided with the dramatic escalation in the war that occurred after the catastrophic Japanese bombing of the American naval base at Pearl Harbor, in December 1941. More and more friends were joining the war effort. Max began his camoufleur training at the Royal Australian Air Foce (RAAF) aerodrome at Bankstown, in Sydney, in January 1942. He was

part of the venture led by Professor William Dakin, whom Max knew from the Sydney Camouflage Group; Dakin's book *The Art of Camouflage*, with photographs by Max and others, had been published the year before. Although a pacifist who 'scorned the heroics' of war 'and despised the negativism created by brute force',[3] Max may have been prompted to contribute as a non-combatant once events began overwhelming the Allied forces. He spent several months in Darwin in 1942, designing and building camouflage screens for the oil tanks that replaced those destroyed in Japanese bombing raids earlier that year. Other artists who were original members of the Sydney Camouflage Group, Max's close friend Douglas Annand included, also became camoufleurs and were sent overseas. Ernest Hyde left Sydney, too, and was away for more than three years; he trained with the RAF in Canada and was then deployed as a navigator, flying in Lancaster bombers. During his absence, Hartland & Hyde was run by his father, E.J. Hyde, founder of the company.

With most of the men absent for extended periods, Olive could throw herself into working as a professional photographer for the first time. The newfound focus was welcome, given the increasing worry associated with the war, which was now engulfing the Pacific.

* * *

On a far more personal and immediate front, Olive was dealing with the divorce and its attendant emotional disruption. Evidence that it was advancing came in the form of a one-page letter from Max, which he signed 'Maxie', a nickname used only by his closest friends, such as Damien Parer. Its contents and slight ring of inauthenticity indicate that it was a small, purposefully constructed piece of theatre that had to be enacted in order for the couple to successfully move through the legal process.

(10 May 1942)

158 Parramatta Rd.
Ashfield
Sydney

Dear Olive,

It was so good to see you again on Tuesday after so many months – you fairly shone in your new blue frock and buff coat.

The difference this strange separation has made to me is so apparent: just that life has never really been the same since you left me. It has lost its fullness completely. I do want you to come back.

Dick & Rosie [mutual friends] were over last week end – they, too, missed you and your funny little ways – not to mention the intense interest you used to have in them and all their activities.

Couldn't you come home, say, next Thursday? I'll pick you up in the car at Maida's [Annand] house about 6.30 p.m. Give me a ring if this hour is convenient for you.

Yours,
Maxie.

As was to be expected, Olive did not reply. Max informed the Supreme Court in a sworn statement several weeks later that:

I have never received any written reply to the letter ... but about the last week in June I was speaking to my wife on the telephone and she informed me she had taken legal advice and been advised not to send any answer to the letter.

He added the crucial information that: 'She has not in fact returned to me in response to the said letter nor have I had any communication from her indicating her attention to do so.' This was the necessary proof that she had failed to 'render [Dupain's] conjugal rights', as required. As a consequence, they could now advance to the next stage of the process and its inevitable conclusion.

Shared problems in photography

Olive and Max's estrangement in mid-1941 not only meant the break-up of their marriage, it also spelled the end of their partnership in photography. It therefore provides a convenient date marker at which to consider what they achieved jointly when together.[1] This involves acknowledging the wrench that came from so suddenly having to disentangle love, work and a shared creative ethos that had nourished each of them for many years and enriched their respective photographic practices.

Because Olive and Max met as youngsters they developed their approaches alongside each other. At first their activities were shared, rather than fully collaborative.[2] While they often photographed each other, providing an engaging visual record of their growing up, these early opportunities for portraiture, whether formal or informal, appear to have had as much to do with happenstance – with where they were at a particular time – than any concerted campaign. By late 1934, however, once they were in their mid-twenties and Olive was settling into 'the Bond Street operation', the nature of their interactions in and through photography deepened. The next six years, until 1940, were their most intense. This was when their preoccupations in art photography sometimes overlapped – still life being one example – and when they explored the genre of the nude together, which required a heightened degree of deliberation and reciprocity.

The common assumption is that Max's position as a photographer with his own studio and very public profile in the commercial and

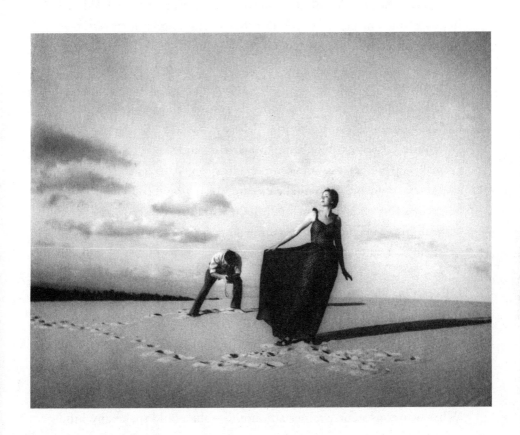

Fashion shot, Cronulla sandhills, 1937, National Gallery of Australia, purchased 1988

art worlds meant that he was the principal agent in their exchanges in photography. In reality, however, the situation was far more nuanced and subtle.

Perhaps the clearest visual statement about their respective roles is contained in Olive's *Fashion shot, Cronulla sandhills*, which shows Max at work photographing Noreen Hallard, whom Olive regarded as a particularly graceful and photogenic model. Olive considered her own role on the day to be 'just the general dogs-body assistant'.[3] She explained how the photograph came about:

> In the late 1930s it was becoming common practice to take fashion photographs out of doors. We would all go in Max's small car to a favourite location where he would take the required shots, my role being to help the models with their make-up and changes of costume. However, I always took my camera and would often take pictures for my own enjoyment, such as this one. Here on sandhills at Cronulla, we see Max with his Rolleiflex photographing an evening dress for his client, David Jones.[4]

Olive typically made the most of her 'free' time, working with purpose before being called on again by Max or the model to assist in some capacity. In these small intervals, she found a space for herself and her photography, one that was freer than Max's and more open creatively because, during her first stint at the studio at least, she was not governed by professional obligations and expectations. What was consistent was her autonomy – she could make any kind of photograph she wanted to, the aim being to satisfy herself, not a prospective client.

During another of these intervals or in-between times, which also occurred at the beach, she took the now well-known *Girl with mirror* (1938). The model was waiting, Olive explained, 'for her turn to be photographed by Max, whose camera tripod casts the stronger long slanting lines of shadow in the top left-hand corner'.[5] Olive thus

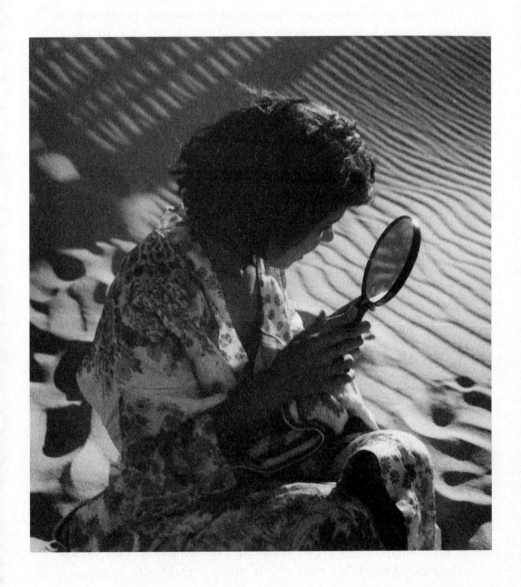

Girl with mirror 1938, National Gallery of Australia, purchased 1987

transformed the inactivity of waiting into a pictorial opportunity, in which the unnamed model scrutinises her appearance in a hand mirror. Intriguingly, Olive did not focus on her as an individual and chose not to show her face. The angle of the woman's profile is such that it gives minimal information, preventing any easy identification of her. Rather than being a portrait or figure study, the main concern is with conveying the subject's state of self-absorption. Olive's own presence as a photographer is not acknowledged and can be regarded as irrelevant in reading the image. The setting in the sand dunes also provided Olive with the dynamic shadows and play of textures she loved, and which, by the late 1930s, were a well-established, immediately recognisable feature of her visual vocabulary.

A crucial statement by Max towards the end of his life indicates that he saw himself and Olive as equal partners – we *'shared* the problems of photography', he said (my emphasis).[6] He did not specify what the problems were but did make an intriguing statement that he and Olive were united in their interest 'in another, more intangible world'.[7] He felt they had this in common with Geoffrey Powell and Damien Parer, their co-workers at the studio. The 'intangible world' may refer to the 'spirit' of modernity, with which, inspired by the likes of Saxon Mills and Man Ray, Max aligned himself. From his perspective, operating within an essentialist, modernist framework, contemporary photographers such as himself and Olive had a responsibility to express this spirit in their work.[8]

* * *

Creative partnerships between wives and husbands, and between lovers, were not uncommon in the visual arts in the early to mid-20th century.[9] High-profile international examples include painter Georgia O'Keeffe and American photographer Alfred Stieglitz, American photographers Tina Modotti and Edward Weston, and Europeans Hannah Höch and Raoul Hausmann, Gerda Taro and Robert Capa, and Lucia Moholy and László Moholy-Nagy, all of

whose lives together have been dealt with in various art historical texts, biographies and autobiographies, and exhibitions.

Lucia Moholy wrote frankly about the nine years she and Moholy-Nagy were together in her deliberately small-format book, *Mohoy-Nagy, Marginal Notes* (1972), motivated by her desire to correct any errors that had crept into the scholarship on the life and work of her former husband. She didn't sentimentalise or sensationalise any aspect of their life together, and focused on their working arrangements, writing that they were:

> ... unusually close, the wealth and value of the artist's ideas
> gaining momentum ... from the symbiotic alliance of two
> diverging temperaments. Innate boldness and passionate
> fervour on the one hand, restraint of approach on the other,
> had each ... a part to play in the outcome, initiative and
> implementation remaining the artist's birthright.[10]

What passed between them was private knowledge of course: Moholy later realised that none of their friends and colleagues could have realised the extent and manner of the collaboration. She sought to amend this and make it known she faced the dilemma of a woman who had been involved in a relationship with a man far more famous than she was. Later, during her life review phase, she found herself literally writing from and in the margins.

In Australian art, conspicuous examples of modern couples who shared their life and work include painters Joy Hester and Albert Tucker, sculptor Inge King and printmaker Grahame King, and painters Helen Maudsley and John Brack. But in the field of photography, Olive Cotton and Max Dupain stand out as exceptions. In some ways, Olive's situation was comparable to Lucia Moholy's, but she publicly disclosed very little about her and Max's collaborative enterprises. She did make a playful nod to their relationship in a double portrait, not circulated at the time but printed decades later.[11] It is a hand-held shot in which Max, lying

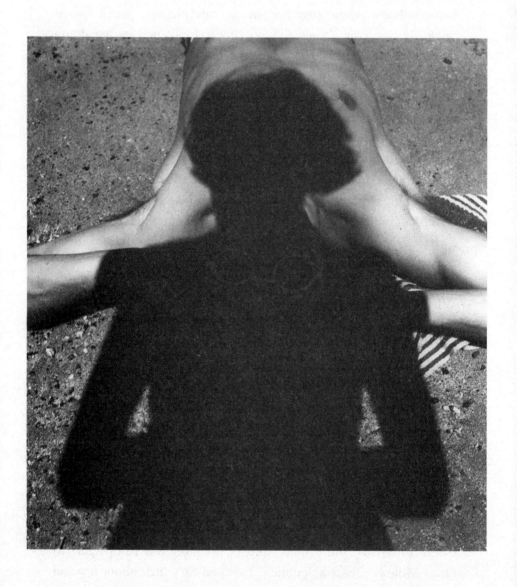

The photographer's shadow, 1935, courtesy Cotton family and Josef Lebovic Gallery, Sydney

on his back in the sun, is the willing participant, his mouth open in feigned surprise as Olive's shadow looms over him. This is an image of the two of them, twinned in the triangular patterns of their arms and elliptical shapes of their heads, interacting in a relaxed way.

Olive did not see herself as Max's collaborator or equal across the spectrum of photographic practice. She made it clear that, in the professional realm, she wasn't his competitor and always deferred to his expertise and excellence. She was unfailingly respectful of his ownership of the studio and his achievements across the board, and never made a case for the significance of her involvement in, or impact on, his practice and never claimed credit for anything relating to the studio's output during the years they worked together. One of the few to make any overt comment about the respective merits of their photography – though privately – was Geoffrey Powell. He was wary of the widespread view that Max was the superior practitioner, stressing that 'Olive inspired Max and did some beautiful work.'[12] He reiterated his position a few years later, writing that Olive 'did some really marvellous work in her day (and let's face it, was a great inspiration to another photographer better I leave un-named!)'.[13] Max was, of course, who he meant. An acquaintance, Joan Brown, who knew Olive and Max before they married, felt that Olive 'always stayed in the background and let Max show his stuff more'. Brown's aunt, Olga Sharp, a close friend of Olive's, repeatedly told her that Olive's work was 'superior to Max's'.[14]

Olive's acceptance of, and response to, Max's domination of the field of professional photography resonates with a statement by Russian-born modernist artist Sonia Delaunay, who was married to French artist Robert Delaunay. It is only recently that her textile practice has received serious scholarly attention, whereas his work has long been the subject of prominent exhibitions and publications. Sonia Delaunay said that: 'From the day we started living together, I played second fiddle ... Robert had brilliance, the flair of genius. As for myself, I lived in greater depth.'[15] This reference to 'greater depth' is highly significant, alluding to a rich inner life, which is

pertinent to Olive's situation. Arguably a 'greater depth' informed her photography and helps distinguish it from Max's – not only his professional photography, but his art photography as well.

When it came to her art photography, Olive's autonomy and authority were paramount, exercised through the decisions and judgements she made independently. When asked directly whether she was influenced by Max, she replied bluntly: 'Not in the least. No. I'm sure there's nothing similar at all about our styles.'[16] Of *Shasta daisies*, she recalled that Max thought she was wasting her time when he saw what she was doing in the studio, but, in her view, 'it turned out quite well'.[17] This is a huge understatement – the photograph was selected from a very competitive field and hung at the London Salon of Photography. In another comment that may obliquely refer to Max, she said that: 'you feel that you've considered everything before you present the final print, it's your idea. [If] anybody else wants to impose their ideas, I don't like it.'[18]

Late in life, she spoke of two incidents that provide further evidence of her creative self-confidence and quiet determination. When a male friend made a patronising comment about a recently completed print, which she was pleased with, she silently dismissed it.[19] She elaborated in more detail on the second exchange with another unnamed male friend, which also carried an element of condescension.

I don't like people interfering with what I do. Somebody we
knew quite well, an artist who had come over from England
just before the war [possibly Richard Beck], asked for a print.
I had a photograph of a rather twisted tree, the light was nice
in it, and I'd made the print very carefully. I felt that was the
right print for it. This fellow was a very good black and white
artist, and a very sensitive, kind sort of person. He looked at
the photograph and said, 'Oh, you can make me one of those
but when you do just darken this corner a bit more.' I didn't say
anything but he didn't get his print.[20]

Olive knew her own mind and would not brook any interference in her image-making process. She created photographs on her own terms – they were hers and hers alone.

This brings us back to the 'shared problems' Max referred to and the nature of the couple's creative partnership. While their approaches were different, stemming from their own philosophical and gendered positions, they were both controlled, purposeful rather than spontaneous photographers, and had a keen sense of compositional rigour. Most notable, however, is that the affective qualities of their work for the crucial years from 1934–40 are dissimilar. Olive's photographs are generally more sensuous in appearance than Max's, due to her use of softer tones and less pure black. His, in comparison, are harder, harsher and have greater tonal contrasts. These differences, which relate to their unique individual responses to light, are important but ultimately do not detract from their shared fundamental concern with forging a modern photographic language. But, with the end of their marriage, this became a separate, rather than interconnected, endeavour.

'Really great years'

Olive's decision to run the Dupain studio in 1942, although a very personal one, was framed by events completely outside her control. The outbreak of the Second World War instigated a dramatic reorganisation of work and the workforce across Australia. In December 1941, Labor Prime Minister John Curtin told the Australian people that his cabinet had decided 'to approve of the principle of the extensive employment of women in industries where men were not available in sufficient numbers to attain the scale of production approved as a war objective'. The *National Security Act 1939* determined which industries were 'essential', which important occupations were 'reserved', and which other industries and occupations were to be phased out. As more and more men became involved in the war effort, women's participation in the workforce increased, rising from 664,000 in 1939, the year war was declared, to 855,000 in 1944. As well as taking up civilian employment, women had the option of joining women's services in the army, navy and air force. This was very different from the situation during the First World War, where women at home in Australia were primarily involved in providing material support for the troops serving overseas and in fundraising activities. Curtin made it clear, however, that the high participation of women in the workforce was a temporary phenomenon, confined to the duration of the war. He stated that he would ensure that those women involved in traditional 'men's jobs' would be replaced by men as soon as it became possible.

The photographic industry was also being reshaped during this time, with gender continuing to be a crucial, though often unacknowledged, determinant of work roles. The men who had dominated professional photography temporarily left the studios and went into other areas of photographic practice connected to the war effort, both at home and abroad. This applied to Max Dupain, Damien Parer, Geoffrey Powell, Edward Cranstone and others, with the Commonwealth Government's Department of Information becoming a major employer of male photographers and film-makers, the DOI having been established a few days after the outbreak of the war to coordinate the production of visual material for government use. With the men away, Olive was presented with unprecedented opportunities in the professional photography sector.

Her stint running the Dupain studio in Clarence Street was relatively short, less than four years, from early 1942 to late 1945, but extremely consequential. In Olive's own assessment, these were 'really great years', and she relished her new responsibilities and newfound independence.[1] For the first time in her life, she was in charge, running the business with which she had been intimately associated since its inception, but in which her public status had always been relatively minor. Now, not only was she the manager, she was the chief photographer as well, a role previously held by Max and other male colleagues. Ordering the stamp declaring her new status – 'Olive Cotton, Max Dupain Studios' – must have been very satisfying.

Damien Parer was in North Queensland when he received the news, and wrote from New Guinea to wish her well:

My dear Olive,
Betty Hurst – in her letter – says that you have now taken over Max's Studio. Good show! – She also says how sure she is that you will make a good job of it, and I am too.

245

He added: 'I do hope you like working at Hartland & Hyde's as chief cameraman – that's not quite the title but I hope you do like it', and sent his love.[2]

Not surprisingly, war led to a drop in business for the big photography studios. Russell Roberts's studio, the largest in Sydney at the time, was among those forced to reduce staff numbers. Demand for fashion, social and celebrity photography, and illustrative and advertising photography, which had burgeoned in the pre-war years, rapidly contracted once war broke out. Both *The Home* magazine and *Art in Australia*, which Sydney Ure Smith sold to Australian Consolidated Press in 1939, ceased publication in 1942, following a decline in circulation. These magazines had always given a high profile to photography and were sorely missed. Ure Smith's new venture, *Australia National Journal* (1938–47), which was devoted to art, architecture and industry, continued his support of photography but the journal was much smaller and individual photographs didn't have the same visual impact as in his earlier publications. Wartime restrictions on paper and inks compromised the journal's presentation as well.[3] Olive did not regard her occasional work for *Australia National Journal* as 'creative', but nevertheless it gave her 'great satisfaction turning out a good job and showing subtleties of light and shade' in the photographs she contributed.[4]

Olive was the sole photographer in a business that, at its peak in the late 1930s, had supported Max and one other photographer – Powell or Parer – and her as an assistant. However, despite the overall difficult and unpredictable economic climate, the war years opened up a greatly expanded range of possibilities for her practice. Her output was no longer limited to the art photography she pursued on her own initiative and she began tackling a large variety of assignments for commercial, private and government clients. In her own words, she photographed 'anything that came. And I never turned anything down.'[5]

The most ambitious commission was a large-scale photographic mural of a ballet scene for the interior of a new house in Sydney's

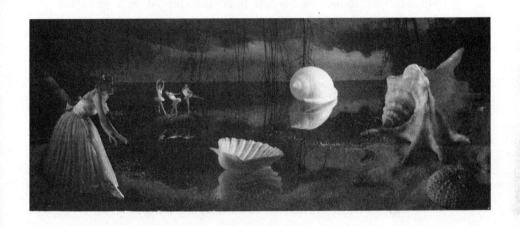

Design for a mural, 1942, National Gallery of Australia, purchased 1983

eastern suburbs, for architect Samuel Lipson. It was an imaginative and technical feat in which Olive took great pride. Photographic murals had come into vogue following the success of Russell Roberts's impressive mural installation at the Australian pavilion at the New York World Fair in 1939; the installation was designed by Olive's friend Douglas Annand, and she would have seen the installation shots in the magazine *Australia*. Lipson's stipulation that the mural should contain ballet dancers was indicative of the popular taste for ballet that had grown in the wake of tours by the Ballets Russes companies, which, of course, Olive knew intimately through Max's publicity photography of the late 1930s.

Although the ballet mural has been interpreted as a surrealist work by art historians, there is no evidence that Olive considered it as such. She wanted to make an eye-catching image on a ballet theme that would please its owners and resolve the technical challenges presented by the size (183 x 76 centimetres). In 1995, she explained the production process in detail:

> I engaged a charming young model who was also a ballet
> dancer to come and pose for me, with two changes of costume.
> I took many shots of her in various traditional ballet poses,
> from which I chose four. Then I had to devise an appropriate
> setting for the dancers. I wanted to give a sense of depth to
> my picture. Eventually I made a large negative of willow
> streamers reflected in a highly polished stainless steel sheet with
> a miniature setting of stones, sand and shells in the foreground.
> I made a second large negative with the dancers reduced to a
> suitable scale, set in a clear film background, and then put these
> two together to make the final composite negative. One of
> the images was reversed, since I put the sensitised sides of the
> negatives together for maximum sharpness.
>
> The 6 feet of photographic paper was obtained in one roll,
> and I enlisted someone to help me pull it to and fro through
> the chemicals in a very large wooden dish on the darkroom

floor. We rolled and unrolled it through baths of developer, water, hypo [a chemical mix used to stabilise the image] and more water. Then my helper went home and the print was transferred to more water in the long darkroom sink. It had to be thoroughly washed (there was no hypo clearing agent in those days), so I stayed all night at the studio to change the water in the sink every hour.[6]

A measure of the mural's success was its longevity. Apparently, it remained on an interior wall of the house for more than forty years.

Other notable successes during the first years of her stint at the studio were photographs for Hartland & Hyde's advertisements published in *Australia National Journal* in 1943 and 1944. They comprised a child study, a portrait of Jean Lorraine and two other portraits of unidentified women, one of whom wears a headscarf. The advertisements' layouts are simple and hierarchical – Olive's images have primacy and text plays a minor role, simply stating the company's name, specialisation and address. The visual impact is immediate, due to the clarity of the compositions, the energy that flows from simple gestures, such as the slight incline of a head, and the asymmetry achieved when, for example, a face is framed slightly off-centre. Olive also positioned her subjects well forward in the picture plane, a strategy that presses us, reader and viewer, into a relationship with them. There is, however, nothing confrontational in the 'exchange', which is mediated by the elegance of the images and the inwardness of the women's expressions. Olive may have photographed the women in close-up and looking out of the frame – at her, at us – but this does not mean they are attainable. Characteristically of Olive, something about their dreaminess and self-possession keeps them in their own world, distanced from ours.

The Dupain diary

American essayist Janet Malcolm famously likened the biographer to 'the professional burglar' who rifles through people's intimate belongings and extracts the most valuable.[1] I felt like that on reading a diary Max Dupain kept during 1942–43 and which, fifty years later, he gave to his biographer, Clare Brown, to transcribe.[2] It is a private document that exposes Max's innermost thoughts and feelings during a tumultuous period in his life. And it is where, in a hurt, often volatile state, he tried to make sense of his break-up with Olive, in the process saying things about her and the Cotton family that are negative and difficult. The diary presents another problem biographically. Olive left so little, nothing comparable in substance or depth to Max's diary, compounding her lack of presence in the narrative of their separation and divorce. That said, Max's diary is invaluable for his insights into what he felt went wrong between them.

In February 1942, six months after Olive left him, Max decided to begin a diary, apparently for the first time in his life. As he explained in the first entry, written on 2 February 1942, he conceived his 'diary' not in what he described as 'the academic sense of the word', but as something akin to French artist Paul Gauguin's *Intimate Journals*, which were written more in the form 'of an adventure than a series of objective incidents'. Gauguin was one of his heroes, a romantic artist who reacted against mainstream society and bourgeois values.[3]

Whether or not the diary fulfilled its original purpose as a creative adventure is of little consequence for Olive's story, but as

a document showing how he felt about her and their break-up it is extraordinarily important. More than anything else from the time, it gives a raw, powerful sense of the man Olive had married, his character and temperament, his interests, his views and his obsessions. This was a time when Max was experiencing profound feelings of instability and anxiety about the future: not only was his marriage ending, but the war was omnipresent and the potential for disaster and death never far away. Richard Beck, for example, had just left for New Caledonia – Max photographed him on the day of his departure – prompting the poignant comment: 'All the wrenches in life nearly pull the heart out of a man.'[4]

Max used his diary-writing in part to espouse his views on life, as on 3 February, when he stated in his typically heroic, charged language that:

> Life is a vast battle against greater odds. Against disease,
> starvation, ill health, hereditary qualities, the will of the
> masses, the will of your friends, against myself; in fact
> the little embryo yet unborn is brought to life in a great
> involuntary motion and is pitted against the whole world
> before it even starts life.

A few days later, he elaborated further on his philosophy, beginning with a quote from the British writer Llewelyn Powys, another of his inspirations, whose rejection of Christianity and advocacy of sexual freedom appealed to him:

> 'The absence of moral order unconnected with human
> manners is certain. We must be prepared to take our bearings
> without a compass and with the slippery deck of our life vessel
> sliding away from under our feet.' Llewelyn Powys
> What could be more appropriate as a working philosophy
> for contemporary life? We are sure of nothing, we are baffled
> by the absurd paradoxes in human nature, we cannot trust

each other, we skin before we get skinned; in short we are afraid. Science and commerce have started us in the race of competition. We are scared of losing our material gains. Life is complex instead of being simple. I do not believe the human heart will regain happiness until people develop an aesthetic response to life. This is about the one thing I am certain of.

It is reported that the Japanese are killing old women and children in conquered territories and raping the young girls. I caught the rat that eats my bread last night and this morning, before the body is cold, the ants are scavenging its flesh! Civilisation![5]

The position Max articulates here is a romantic one. He saw himself as an outsider in Australian society, at odds with mainstream values and the banalities of a conventional life; he believed that his understanding of the fundamental nature of 'an aesthetic response to life', and his championing of it, set him apart from other people. On 3 March, for instance, he expressed his love for poetry, which had been a constant in his and Olive's lives since their teens, and his disdain for a routine existence built around work and its obligations. He consistently damned those who, in his view, did not understand the value of creative endeavour, fervently expressing his outrage about the state of modern aesthetics after a visit to a local shopping centre at Hurstville, in southern Sydney:

What a dead hole! Vulgarity! The quintessence of it. I was waiting for my client ... and took a stroll around the shopping centre, what an appalling sight. I looked in vain for something with a spark of aesthetic value, but all I could see was as ugly as sin from the architecture to the foul goods in the windows and the people that bought 'em.[6]

And Olive? She, and other members of the Cotton family, flicker in and out of the narrative, attracting the greatest amount of his

attention in February and being mentioned for the last time four months later, in June 1942. Sometimes he is distressed, hurt and defensive, sometimes perplexed and conflicted, and at other times quite clear-eyed about his situation. While expressing what he described as a 'brotherly' concern for Olive and her wellbeing, he tells himself that he is no longer in love with her. Over a span of four months he attempts to explain how this sad, painful situation has come about. Two days into the diary, Olive makes her first appearance in a reflective entry about their life together and what he regarded as her shortcomings:

> I think of Olive sometimes in the mornings. I can remember the same table set with a neat cloth, flowers maybe, and places set for two. We would be laughing and joking about things some mornings and maybe I would be sullen others. Olive was nearly always noncommittal, somewhat even tempered but invariably reticent. Roberta [Yardley] told me once that Olive's reticence was indicative of her depth of feeling. But when you look for other avenues expressing this depth they don't exist ... her music, her photography, her general response to aesthetic matters.[7]

This is a damning assessment in which he concluded that Olive's 'noncommittal' attitude and 'reticence' − or what I interpret as a lack of outward display of her feelings − have impacted disastrously not only on their relationship, but on all aspects of her creative life. Yet music, photography and aesthetic matters were what she cared about most.

Shortly after this entry, he became energised after talking with their mutual friend Olga Sharp, who, as he put it, was 'a sort of go between Olive & myself'. He was fond of 'Old Sharpie', as he called her, who he felt was 'the essence of kindness itself', and he respected her views. Olga had recently seen Olive and:

... says she is looking very thin and worn and is quite worried about her. S says she wants somebody on her tail all the time making sure she gets this and that at regular intervals. 'Well, Sharpie, she can't have her cake and eat it, I feel worried about her too, I'd hate anything to happen to my sister!'[8]

This declaration of brotherly regard sounds straightforward, confident and assertive, but other evidence suggests that he was troubled by this account of Olive. His emotional instability and vulnerability are exposed in the very next paragraph, where he tellingly describes being taken over by 'a queer feeling' that strikes at the core of his being, 'the centre of me'. The way he dealt with this nervous flux was through physical action, fleeing into the sun (it was the height of summer) in an attempt to regain his equilibrium.

Suddenly I find myself at the Olympic pool!!! It's half past one and the sun is shining brightly and strongly as I write this I feel it warming into my very marrow. I've got a queer feeling in the pit of my stomach today; in the centre of me; right in my nervous system. I don't know what it is, maybe it's just upset nerves or something. I wish I could feel something stable somewhere.

The diary also introduces Olive's grandfather Frank and her Aunt Ethel and what appear to be his conflicted feelings about them. His descriptions of their meetings shed some light on his relationships with the Cotton family, as well as their views on the break-up with Olive. An unexpected visit from Ethel unsettles him because she relays news that his grandfather-in-law, Frank, would like to see him; this was only a few months before Frank died and there is no question that he was distressed by the couple's separation and intention to divorce.

Meeting people of varying characteristics makes for tolerance. I feel this after a visit from Olive's Aunt Ethel. Dear old

soul, I guess she means well, but heck! a little knowledge is a dangerous thing! She came to tell me (very nervous) that by a chance remark made by Olive a week or so ago, it was apparent that my political outlook was screwy and that grand'papa wanted to have a talk with me about it. Nice work, but I don't believe it – there's something else in the wind. The old bastard will start ragging me about Olive. He once said that if his wife left him he would drag her back from any corner of the earth, whether she wanted to come back or not apparently. The dear old romantic – the fact remains, his wife didn't leave him!! If he starts that racket I'll shut him up . . . quick and lively! In fact I'm rather looking forward to it! There I go again. That's all life is a battle of wills. The will to live and survive, my will against his.[9]

The next day, still mulling over his exchange with Ethel, he reiterated his philosophy of life based on notions of heroic individualism and the valorisation of creative and aesthetic forces.

... I've got Ethel on my brain again – she said to me 'do you realize what life would be if Nazi Germany won the war?' I answer 'I haven't the faintest idea what it would be like.' Her statement betrays her fear, she is scared stiff she'd have to work in a factory making do dads for little Nazis or something. In other words she's fallen for the popular slogans about Nazi Germany and she's scared stiff.

I think one must be brave enough to accept life in whatever form it comes. Fear is a warning, like pain. All is animal really. Ethel's self defence rises with her fear. We huddle together in fear, or we hunt in packs. Hunger and love, two interests underneath all others.

I think Grandpa Cotton is probably a wholesome morsel of humanity but is not cynical enough for his generation. Old Ethel tells me about some working class families she knows

very hard up and living on the dole – 'and you'd be surprised
what they get out of life.' … She tells me 'my dear boy you've
got a lot to learn yet' and 'just learn a little history', Ha! Dear
old Soul!! The argument boiled down to this – she believes
in humanity and thinks the new social consciousness … will
develop into a world order and man for the first time in his
hazardous career will 'love his neighbour as himself'. So far
it's taken 2000 years to do it!! For my part I don't believe in
humanity much. I believe in the individual and his capacity
to rise superior to the masses and create his own world. As
an artist I can see no other world worth a cracker save that of
Debussy, DH Lawrence, Daumier, Beethoven, Chris Brennan,
Leonardo, Mestrovic, and all the great creative minds that I …
[have] made slight contact with. It is the aesthetic in life that
means that life's worth living. Blast this social consciousness.
It's only a fake anyhow, the result of some propaganda
complex … We are all parasites no doubt, but some more
than others! New slogan for the masses 'Skin or get skinned.'
Ha! Ha! Ha![10]

A letter from Ethel fails to appease him and he still feels rankled by
their opposing views on contemporary politics and, more broadly,
on human nature. In response, he writes an intense monologue,
which suggests that there was no-one around with whom he could
discuss his feelings; close friends like Damien Parer were all away.

Old Ethel wrote to me yesterday! I half expected a letter
because I'm sure I made her feel a bit small on Wednesday. She
was half apologetic and somewhat pathetic in her attitude of
semi submission. She says, after me, 'All is not jungle law' and
there she goes straight away trying to save her own skin and
down me! All is jungle law, by God it is. As Powys says, It is
the most common of all instincts for a man to strive to make all
other men believe as he believes.[11]

The diary also foregrounds the importance of his parents in his life. Shortly after Ethel Cotton's surprise visit, his doting 'Ma' and 'Pop' offer their perspectives on the situation. Not surprisingly, they side with him and want to protect him from any further grief caused by the impending divorce.

> Ma has her new teeth in and is very cocky about them. Makes excuses to laugh and show them off sort of thing. There is something very stable in that home: the old man has pursued a philosophy of reason ever since I can remember and there he stays approaching everyone and everything with a rational and analytical outlook. I often wonder where I get my romanticism – there is no bloody doubt about it I am a romantic …
>
> Ma & Pa were very concerned about old Ethel's visit to me, especially Ma! 'I wouldn't go near them' said she 'you can bet your life they're after something!' Woman's intuition you know – yes, you know! Pop says, 'I think they have one or two motives they wish to see you about, one – to try and induce you to recapture Olive, or two – to collect evidence against you and try preventing your divorce!' Nice work Pop, but you can bet your life they'll get a good flea in their ear if they start that racket![12]

These comments reveal the Dupains' belief that, in spite of Olive's feelings and autonomous decisions, the Cottons did not want the divorce to proceed; they were convinced that Olive's relatives would do whatever they could to prevent it happening. The inference is that, in contrast to the Cottons, they saw no possibility of reconciliation and had already accepted the outcome.

* * *

Three weeks later, Max was in a particularly reflective mood. This was due to his emotional reaction to two events, discussed in

reverse chronological order: a meeting with Olive, which by then was rare, and a drive in his car, which was infrequent because of petrol rationing.

When in it [his car] I always remember some of the long drives I have made through the country and down the coast. Peace time and life was comparatively free of worries. I recall the ten mile stretch of concrete road to Canberra just past the little town of Collector. Banjo Paterson has written about it. I think of the great wide spaces, the fertile plains and the parched areas. Dead trees in acres and acres. The great belt of green pasture land at Lake George, the mirage and the white healthy sheep. Canberra, the little fairy town. I've seen Canberra twice now – with my mother and with Olive on our honeymoon. That makes me sense something that is dead – my relationship with Olive. Real love is evocative of joy and rapture. When I meet Olive now I feel pity for her and [a] sense of brotherly sorrow. I could never be happy with her again. We shall get a divorce and … for me anyway, will start afresh. I shall probably have to lose everything (like the British Empire) in order to put my house in order again & gather together all the broken fragments that Olive has shattered …[13]

Following this melodramatic comparison between his losses and those of the British Empire, he changes register and grapples with his feelings for Olive and reasons for their break-up. This is the closest he gets in the diary to explaining to himself what has happened and why.

On Monday I had lunch with Olive. It was a very sad meeting, so impotent and futile. I felt that she still cares for me but is too proud and detached to say so. She is an unimpassioned creature and I feel very strongly that something has gone wrong deep down somewhere. I pity her helplessness from the bottom of my

heart, her worst enemy is undoubtably [sic] herself. There is so much to say and think about this affair that I feel perplexed and nonplussed when I start to jot down a record of it.

When I go back and try to dig up a satisfactory reason for her leaving me, everything seems to fail me including memory. It is as though a malignant growth set in at some stage and time saw the inevitable happen. What the malignant growth is I can only guess. It might be Oedipus complex on her part [what did he mean by that?] or a realisation on my part that I did not love her at all but was carried ... [along] as a man of habit and customary circumstances.

It's now 7.30 p.m. and as I write the gramophone thunders the chorus of Beethoven's first symphony. It rejoices me and makes me feel a tremendous response to life – just life itself and the thought that art will go on after my own flesh and bones are rotting in the earth. This great urge to survive. I look at the pot plants on my sill and notice their eager lean to the sun, how splendid in their struggle for life, to survive & to procreate ... I hear the distant thud-thud of Ak-Ak again and again; it scares me a little as the hour is perfect for a raid. So we will kill to survive, do anything to justify the existence of our little dot of consciousness.

Who knows how much Olive and Max said to each other while they were together about what they saw as their respective failings? Or indeed, whether they said anything at all about such matters? Perhaps, as sometimes happens, the dynamic of their relationship excluded such intense frank exchanges. Did Olive ever know that Max came to view her as 'an unimpassioned creature' and 'detached', while he saw himself as impassioned and engaged? Crucially, he also suggests that their marriage was based on the 'habit and customary circumstances' that had formed over the many years of their relationship, including six years spent working together, rather than on 'joy and rapture'. Max's assessment was extremely

harsh, but it was made in a private diary, where he wrestled with his innermost feelings, never expecting his emotional outpourings would be exposed to any other reader.

Olive wasn't mentioned again until 12 June 1942. After an evening spent at the pub with companions from the army, which he clearly did not enjoy, a train journey gave Max time on his own and a rare opportunity to reflect:

> ... I'm overjoyed at leaving and curl up into the train seat,
> at long last alone, to contemplate the lowering skies and the
> strange acts of war.
> I watch the melancholy of the dusk amongst the distant
> purple hills and think of the ... Pathétique [Beethoven's piano
> sonata]. I pass Mittagong and glimpse Frensham through dark
> fern trees and I falter in my thoughts as some of my past life
> rips open my memory. Mostly I don't inwardly cave in now
> when I think of her. At times I feel glad and almost prepared to
> laugh it off with her.

Reading Max's diary entries in the sequence they were written, when he could not know how things would turn out, reveals that for a few months he was still sometimes conflicted in his feelings for Olive, probably because of the shock of her decision to leave him. He is relieved that he no longer caves in when thinking of her, but, as the above diary entry goes on to reveal, he is also excited about the future, writing: 'A strange elation comes over me at the recollection of lost love like the phoenix rising again from the ashes. Diana's love overwhelms all that I do and all [that] I am ... at the moment.'

* * *

Max encountered his new love, Diana Illingworth, on the Lane Cove ferry to Circular Quay, which he took to work each day when

he and Olive were still together. He had watched Diana, fascinated, for several weeks or possibly even a few months before eventually approaching her. She was an eighteen-year-old student at the National Art School at the time; her mother was Rita Palmer and her father was Nelson Illingworth, a professional singer who was briefly Professor of Singing at Sydney Conservatorium (1916–21), by then living in the United States. Her grandfather was English sculptor Nelson Illingworth senior, and was known in Sydney as a notable bohemian.[14]

The dates leading up to Max's first exchange with Diana are critical. Olive started teaching at Frensham on Tuesday, 3 June 1941, and had made her decision to look for work away from the studio several weeks earlier. Perhaps Max had confided in her about his growing attraction to the beautiful young stranger on the ferry he'd noticed reading art books on the trip into town. Perhaps, as partners so often do, Olive sensed his disloyalty without him even having to say a word. She had known him so long and so well that even a slight, subtle turning away would have been sufficient for her to notice. Whatever the case, Max's preoccupation with Diana may have been the catalyst for Olive's realisation that she was not happy in their marriage and was unlikely to ever find contentment with Max as her husband. He had not given her what she had wanted and ardently hoped for, and he could not.

Olive's departure for Frensham, probably on the weekend before the commencement of term, may have been the impetus for Max to finally approach Diana. On Monday, 2 June 1941, when, as he later put it, he was living on his own and was 'susceptible', he spoke to her for the first time.[15] Diana usually caught the ferry with a girlfriend, but on this day her friend was ill and so, unusually, she was alone. Within weeks of their first exchange, while Olive was away, Max and Diana began a relationship. Its positive effect on him did not go unnoticed by his friends. In the first entry in his diary, he wrote the following account of an exchange with Olga Sharp, or Sharpie:

We had a cup of coffee in the dark room and talked about
the war and things generally. Women are more intuitive than
men. They rely on their emotional and intuitive grasp of life to
answer things rather than their reason. They 'feel' where a man
'weighs the evidence'. She told me I had been pretty intolerant
for a whole year not only towards Olive but everyone. I make
excuses, which is the wrong thing to do I know, but I make
them just the same and talk about the move from my old
studio, business going bad, Olive's lack of response to certain
material deficiencies in our lives, my general irritability over
the whole affair. 'But,' says Sharpie, 'you've changed a lot in
the past six months, Diana has done something to you that
none of us could do.' I keep very still when I hear this and a
glow comes over me. I know it's true and I know I love Diana
and she loves me and this is the reason for the change in me.
Nothing more, nothing less.[16]

Photographic evidence of Max's feelings for Diana was forthcoming
almost immediately after they met. Two beautiful studies of her
entitled *'Twixt waking – and sleeping* were published in *The Home*
on 1 July 1941, less than a month after Olive took up her teaching
position. Damien Parer, writing from the Middle East several
months later, found the images captivating.

Ron [Maslyn Williams] and I feel that the portrait on page 19
of July's Home is Diana – it seems to answer your description –
it is a most fascinating picture[. W]ho is the girl on the other
page – or is it the same girl …[17]

Both portraits are exceptionally tender. Taken in close-up, Diana's
face is barely visible, her eyes are closed in one and open in the
other. The compositions have no backgrounds, no details, and are
filled with swirling darkness, which invokes a sense of mystery. The
evocative titles, whether chosen by Max or the magazine's designer,

respond to the eroticised state in between waking and sleeping, when a person is not fully conscious.

And how did Olive feel when she saw these photographs, with Max's attraction to Diana now in full public view in a widely circulated magazine? All we have to go by are the dates from the divorce papers, establishing the rapid sequence of events that culminated in their separation: Olive went home to Max for the first few weekends of June and July and left him in August, only a few weeks after the publication of Diana's portraits. Clearly, they marked an end point for Olive – veritable proof that their marriage could not be salvaged.

* * *

On 2 June 1942, Max wrote a highly self-conscious entry to mark the one-year anniversary of his first conversation with Diana. He reflected on the significance of their meeting and their growing, passionate involvement with each other. This, he feels sure, is love, the likes of which he had never experienced before.

> This day makes it a year since I spoke to Diana on the Lane
> Cove Ferry. I often think of the hour and moment and the
> stirring that ran between us. We have been terribly happy and
> our life together has been the whole world to us. I love her,
> there is no doubt about it. I love her with all my heart and
> body and mind.
>
> It has been all so very romantic, she is young and beautiful
> and full of womanly grace and charms – I just fell for her,
> naturally and without thought of anything else, the moment
> I saw her. I remember the stirring expectant moments [when]
> I saw her in the ferry before speaking to her and how my
> day was full of her image even though not a word had passed
> between us. I now feel bound to her forever and forever,
> because for the first time, I'm in love.

In his ardour for Diana, his love of Olive is eclipsed and obliterated, categorised as something else – brotherly – and by implication as something less. Max confided the depth of his newfound feelings in a letter to Damien, himself 'a firm believer in idyllic love'. Damien wrote back warmly: 'You write lyrically of Diana … I envy anyone so lifted from themselves – to be in love …'[18]

Divorce

How Olive felt about the divorce can only be imagined, because of the lack of any written or recorded oral documentation. But Max gave a telling account of his feelings in his diary entry of 17 February 1943, after the start of proceedings in the New South Wales Divorce Court. In it, his emotional distress is clear – it is the most disorganised and one of the most charged passages in the entire diary.

Life moves too fast and we are unconscious of half of it. Just a general statement to be taken at face value maybe it has a lot of real truth maybe it's all … [sentence is not completed] A court of law would want me to prove what half it was we were unconscious of and if that was the half that did the other half constitutes of and why I'm buggered if I know or care. This soliloquy evolved from my contemplating the fact which I had to utter in the divorce court today about Olive – she said to me 'I don't think I will come down for any more weekends because I don't love you anymore!' The last sentence she said without knowing – I mean knowing in the real sense of being completely conscious of it just as [D.H.] Lawrence was completely conscious of the phoenix within himself. She just said it only half knowing she had no time to stop and consider the consequences, life was moving too fast. 'I don't love you' so glib and without conviction or background or foresight. They don't understand either. They are too smart and so educated to a most excruciating point that

the really deep finer feelings are filed down like the edge of a razor after it [has] been cutting cardboard.

What a vile atmosphere exists in the court. Damien was right – by God was he ever!

'What you say shall be the truth and nothing but the truth so help me God' and a bible is thrust into your right hand mechanically by an old tw[e]rp who has been doing the same thing for the term of his natural life. Probably his father did it too. He didn't stop to think what the truth really is or whether I believe in a God. Life moves too fast for him to think so I take my oath by a God I believe does not exist.

Fantastic! Life moves too fast.

Smart wiley little Little the barrister. I was afraid of him then but now I have him on my own plane and I feel like twisting his crooked nose. Why do I say that when he did me a good turn? Just my ego I suppose – don't want to be beaten. I must admire his scholarship though, I guess he'd take me for an ignorant bastard. He speaks Spanish, Italian & French. Maybe he has just a retentive memory. Scholarship [versus] poetry and art. I suppose we cling desperately to whatever straw we catch onto first.

There is no universal law. Each being is, at his purest, a law unto himself, single, unique, a Godhead, a fountain from the unknown!

Divorce! Divorce! The whole place stinks of it. All over the papers – everything laid bare for the sweet understanding public! They would publish photographs of actual intercourse if it increased their sales and if they were allowed. Why are they allowed just a little and not all, just enough to goad the public … I hate it all: privacy is one of the elements of freedom of living which we are supposed to be fighting for. Christ! What hypocrisy!

I become anaesthetic [anaesthetised]. I close up to it all and refuse to receive the psychological impact of it all. This is the only way I can survive it.

Max did not write anything again for five weeks. On 25 March 1943, he mentioned that he was packing up his belongings at the army camp in Bankstown, and preparing for a trip to northern Queensland. A few days later, having been farewelled early in the morning by his mother at Central Station, he was on the *Newcastle Flyer*, destined for an air force base at Cairns, where he would spend the next few weeks in his capacity as a camouflage officer. He knew he would not be seeing Diana again for some time. He wrote:

> I feel queer about life these days nervy & unsettled – I
> somehow want to get away from it all for a while by myself
> and try to solve all my problems once and for all. I feel
> shattered and shot up all inside me. Life has become a series
> of psychological impacts, a sequence of shocks and subsequent
> mental aberrations. However I must learn control of these
> things and keep my survival instinct uppermost.

When the train stopped at Hornsby station he was stirred to reminisce about his past with Olive:

> Olive lived here once. I feel the old ache deep down inside me
> again. A flood of memories to be stifled like the breath of a
> drowning man ... I once believed in the free spirit and careless
> laughter in the face of all things, heightened awareness, the
> virility of life that Rubens [the Flemish painter] had. But they
> are a bit of a mockery now.

This was the last time Olive was mentioned in Max's diary.

* * *

As they must have feared, the Dupains' high profile was such that they attracted the attention of the weekly tabloid *Truth*, and they had to suffer the humiliation of having their private lives publicly

exposed. A week after their case was heard, the paper published an article about it, on 21 February 1943. Sandwiched between advertisements and headlined, 'Business as usual: But not on home front', it read in full:

> A strange state of affairs in the matrimonial lives of Maxwell Spencer Dupain ... well-known Sydney photographer, of 49 Clarence Street, and his pretty wife, Olive Edith Dupain ... was revealed in the Divorce Court last week, when Dupain sought a decree for restitution of conjugal rights. Dupain, who is at present engaged in defence work, told Mr. Justice Edwards that although Mrs. Dupain has left him and refuses to return, she is managing his studio and, in addition to a fixed salary, is receiving a share of profits.
>
> 'I don't love you any more,' his wife said to him when she walked out on him in August 1941, Dupain declared.
>
> Mrs Dupain, daughter of Sydney University Geology Professor L. A. Cotton was married to Dupain at the home of her father at Hornsby in April, 1939.
>
> **Job in Country**
>
> Dupain said that before he married her Mrs. Dupain was employed at his studio. After 12 months of married life she returned to her old job at the studio, but six months later she told him she wanted to live an independent life and get a job in the country.
>
> Despite his protests she took a position as mathematics mistress at a country school. For some time she came home at weekends, but in August, 1941, she told him she did not propose to come home for any more weekends.
>
> 'Please don't do that,' he appealed to her.
>
> 'I am afraid I must do it. I don't love you any more,' she replied.

Telling of repeated but unsuccessful efforts to induce his wife to return, Dupain said that in May, 1942, he wrote to her … He received no reply to the letter, but one day he met her by appointment and took her to lunch. She was very friendly towards him, but rejected all his entreaties to return home.

Mr. Justice Edwards ordered Mrs. Dupain to return to her husband within 21 days.[1]

'A reasonable sum'

After their case had been heard, Olive received a visitor at the Clarence Street studio on 3 March 1943. It was the stenographer who worked for Max's solicitor, and her task was to serve Olive with three official documents.[1] The first was the 'Decree for Restitution of Conjugal Rights', and the second was a written notice 'of the consequences of failure to comply with the said Decree'. The third document contained the address of the home she was to return to in accordance with the decree – number 158 Parramatta Road, Ashfield, Max's parents' place, where he stayed on breaks from his work for the Department of Home Security.

Justice Edwards had also determined that 'a reasonable sum be tendered to the respondent for expenses to enable her to return to the petitioner's home'. The agreed sum was £1, which the stenographer gave to her. The instructions for what was required next were unequivocal: now that Olive had confirmation of Max's address and enough money to cover her bus fare to Ashfield, there could be no excuse for failing to 'render to his conjugal rights'. She signed a receipt for the documents served, and 'accepted the said sum'. However, she had no intention of acting on the decree, and Max did not have any expectation that she would. Both were certain that their marriage was over.

Two and a half months later, Max requested an early hearing of the divorce suit on 22 May 1943, on the grounds that his departure from Sydney was imminent. He had been notified by the Deputy Director of Camouflage that he would 'shortly be required to leave

New South Wales for a remote part of Australia', and that 'unless something unforeseen occurs', would be absent from Sydney for at least six months. The application was successful. Less than a fortnight later, on 3 June 1943, the Dupain versus Dupain 'Decree for Restitution of Conjugal Rights' was heard in the Supreme Court of New South Wales. Max was represented by his solicitor, but Olive was not represented and did not appear. She was found guilty of desertion without reasonable cause by Judge Edwards. He granted a decree nisi, which meant that the couple had to wait a further six months to be sure there was no contestation. If none ensued, the decree absolute would be granted. This eventually occurred on 8 February 1944, less than five years after they married.

'The boy next door'

As I have mentioned, Olive did not leave any diaries, letters or oral accounts that might have outlined how she felt about the break-up, but there is one important contemporaneous source. It is an interview with a woman called Joan Rose, which Max's biographer, Clare Brown, recorded in Sydney, on 30 November 1993, the year after Max's death. Rose (née Sample) had met Max when she modelled for David Jones in the mid-1930s and was one of his good friends. She also knew Olive, though not very well. After Olive left him, Max spent three months living with Joan and her husband, George. During this time, Joan and Max apparently had numerous heart-to-heart conversations, details of which she recalled for Brown fifty years later. The following extract is from Brown's transcription of the interview and, although undoubtedly affected by the workings of Joan's memory and her preferences (she was Max's friend, not Olive's), it gives an insider's view of Olive's perspective on the end of her marriage

> Joan: I was married in [19]39 and Max was an usher at our
> wedding and he later became godfather to my daughter, and
> when we came back, we were back for a few months, he
> said, 'Joan, Olive and I are going to get married', and I said,
> 'Oh that's very nice Max, are you sure about this?' 'Yes,' he
> said, 'Well I've known her for 17 [15] years, we've lived next
> door to each other.' 'That really doesn't make marriageable
> material does it?' 'Oh', he said, 'Of course it does, we know

each other very, very well.' So anyway, they married, and after two years, they found it was absolutely impossible, and I asked, 'Whatever went wrong?' Max came to me and he said, 'Olive is leaving me.' I said, 'Whatever for? What have you done?' He said, 'Apparently it's what I haven't done.' I said, 'Oh Max, I'm terribly sorry.' He asked, 'Will you have a talk to her?' So I rang Olive and we had lunch and we talked, and I said 'What went wrong Olive?' And she said, 'Well I think Joan, the way I can describe it, I expected him to turn into a knight in shining armour when we got married ... and he was still the boy next door.' I told this to Max and he said, 'I can't be a knight in shining armour, she's still the girl next door to me.' He said, 'I can't feel all that romantic business that she wants.' You've met Olive, do you understand?

Clare: I guess I had a sense that because she was independent-thinking and strong willed and wanted to do photography of her own, that may have been a big part of it.

Joan: I don't think that was the problem, no, because Max came to live with us for three months after they broke up, and we had lots of talks. I said, 'It's a lot of give and take in a marriage Max', here I was at the fine old age of 23, 24, giving this advice, and he said – 'Give and take?' I said, 'Well one person can't be doing all the giving and the other all the taking all the time.' And he said, 'It's just not going to work out', they decided that maybe they should get divorced ...

Clare: Do you think that part of the problem with Olive was that he was dedicating so much of his energy to photography and that required everything he had?

Joan: Yes, yes, he didn't think it was necessary to devote time to her, because they knew each other so well ...

Clare: So it was a practical decision?

Joan: Yes.

Clare: And how do you think Olive felt about him?

Joan: She said that she wanted him to change when they married. She wanted him to change and become the man of her dreams. I don't know why she married him in the first place really. He convinced her that they should marry …

Clare: Would the impending war have anything to do with it?

Joan: No. I think he felt that George and I had married, and he and Olive may as well get married. … I don't think at any time there was any deep emotional thing …

Clare: Do you remember the scandal of the divorce because it would have been unusual, divorce in those days?

Joan: … I do remember a bit of it, but Olive chose not to be close to me after they separated … I think, she became quite introverted for a while, and she's not an introverted type as you know. You wouldn't classify her as introverted would you?

Clare: I would say that she is reserved with emotion.

Joan: Yes, with emotion, yes, she was always reserved with emotion …

Clare: I would say that she was confident, and strong in herself.

Joan: Oh, yes, a very strong person, and she's doing beautiful photography now.

Clare: Were you aware of her photography at the time, of her ability as a photographer?

Joan: No, Max never spoke about her photography. I think she would go to his studio sometimes, it never occurred to me that she was taking it seriously. Yet during the war she ran the studio.[1]

Joan Rose's account relates to an unpublished, cryptic comment Olive made in an interview in 1983 when asked directly about the break-up with Max: 'You grow up together but that's fine, good friends. But marriage doesn't work.'[2]

PART FOUR

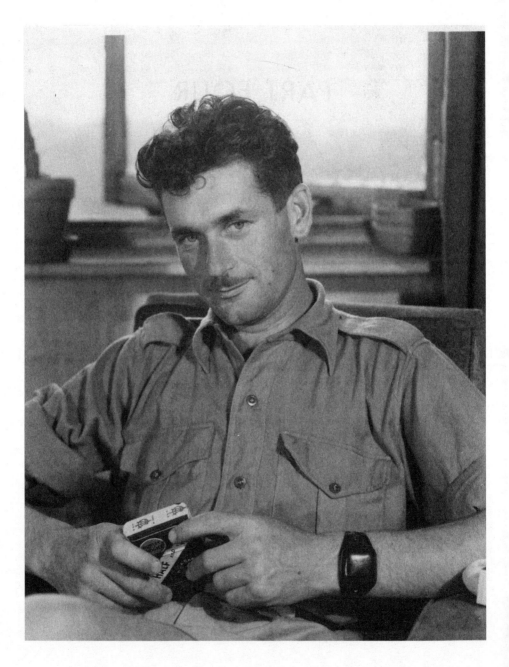

Ross McInerney, 1942, National Gallery of Australia, gift of the artist 1987

Meeting Ross

In the midst of running the studio and going through her divorce, Olive found herself in an entirely unexpected situation. She fell in love with Ross McInerney, whom she met through Jean Lorraine – he was the younger brother of Jean's husband, John. Olive's daughter, Sally, once told me that she had seen something Olive wrote to Ross, thanking him for bringing her back to life. I haven't come across that revealing statement yet, but there is something I think of as its visual equivalent: Olive's portrait of Ross taken at the Dupain studio in mid-1942, probably in June. Olive later gave a short explanation of how her relationship with Ross began.

> Ross ... called in to the studio on brief leave from the army training camp at Bonegilla [in New South Wales], and I suggested that I should take his photograph just as he sat there at the window, to give to his parents. After that we saw more of each other whenever possible during the war years, and we married about two-and-a-half years later.[1]

The portrait, one of Olive's best, rewards close examination. In it, the relaxed, fit young man, dressed in his army uniform, is looking at Olive as she takes the photograph. He is half-smiling in a way that might be interpreted as being slightly self-conscious but intimate nonetheless. The lower section of the composition is dominated by his bare forearms and hands, while at the bottom left, his thigh, which extends out of the frame, is rendered out of

focus by the proximity of the camera. Olive is almost pressing up against him, eliminating any physical distance between the two of them, and compressing the pictorial space. Although she said that she initiated the portrait as a gift for Ross's parents, it is an erotically charged image that speaks of her and Ross's mutual attraction and their emergent relationship. This impression is confirmed in another portrait, possibly from the same session, where she moved closer still, creating a head-and-shoulders view of her handsome subject with his hazel eyes and thick, wavy brown hair.

These portraits of the man who would become her second husband invite comparison with *Max after surfing*, because of their erotic power. The differences are telling. Olive photographed Ross with no coyness or obfuscation and his eye contact introduces a directness that is absent from the elaborate set-up with Max.

* * *

Like Olive, Ross came from a strong family but one that was different in a great many respects: they were Irish, not English; Catholic, not Methodist; and lived in the country, not the city. The McInerneys had a deep, ongoing connection to land in central western New South Wales – Wiradjuri country. Ross's Irish-born grandfather, John McInerney, settled there in 1863, only forty years after the European invasion, which led to violent frontier conflict, and dispossession, disease and starvation in the Wiradjuri population. McInerney was among the wave of new settlers who established themselves as farmers. He owned a large property at Cucumgilliga, near Koorawatha, which he named Bally Calla, after a town in his home county in Ireland, and successfully farmed sheep.[2]

Bally Calla was subdivided into smaller farms in the mid-1920s, which were farmed by John McInerney's descendants, including Ross's father, Daniel. Ross's mother, Blanch Beryl Thompson, known as Beryl and nicknamed 'Tommy', also of Irish extraction, grew up in Glebe, in Sydney, and met Daniel at Cowra when she

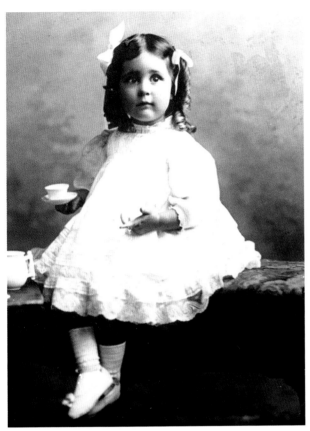

Olive Cotton, age two. The first of five children born to Florence and Leo Cotton, Olive was a clever, bright-eyed child whose beautiful clothes reflect her well to-do upbringing in Hornsby, on Sydney's North Shore. *(Courtesy Sally McInerney)*

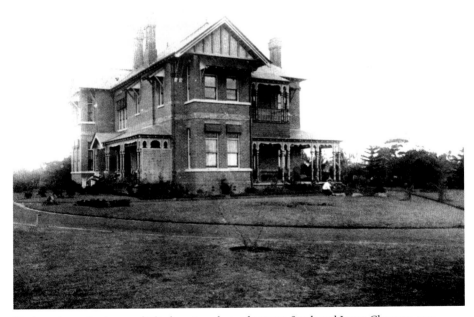

The large imposing home of Olive's maternal grandparents, Sarah and James Channon, was called Pakenham. It was on the site now occupied by the Westfield shopping centre on the Pacific Highway in Hornsby. *(Courtesy Sally McInerney)*

Wirruna, Olive's family home in Hornsby, was designed by her parents and situated on twenty acres of bushland. She and her siblings enjoyed a tennis court, a turf cricket pitch and a rock pool where they swam in summer. *(Helen Ennis)*

In 1937, Olive went on a camping trip with (from left to right) her cousin Keith, her uncle Frank Cotton and her father, Leo. They travelled up the coast of New South Wales to Coffs Harbour and returned to Sydney via an inland route. Olive used the trip to trial her new Rolleiflex camera. *(Courtesy Sally McInerney)*

Olive Cotton and Max Dupain on their wedding day in 1939, photographed at her family's home. She was twenty-seven, he had just turned twenty-eight; they had been romantically involved for eleven years and working together at the Max Dupain Studio for five years. *(Courtesy Sally McInerney)*

Olive and Max regularly took photographs of each other during their teens and twenties. This photograph from 1939 was taken at the home they shared after their marriage and is a study of relaxed intimacy. *(National Library of Australia, nla.obj-136348086; detail)*

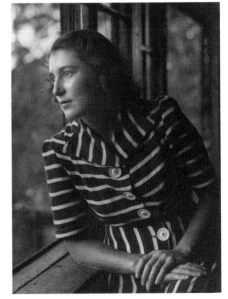

Probably taken at Newport, this is one of Max's most tender portraits of Olive. It dates from 1940, the second year of their marriage, which ended early in the following year. *(National Gallery of Australia, Canberra, purchased 1982; detail)*

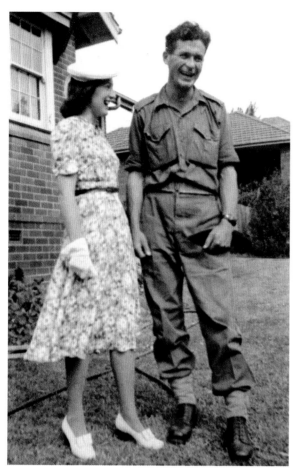

Ross McInerney's war service, which was mainly interstate, made planning for a wedding difficult, so he and Olive seized a short period of leave in December 1945 for a hastily organised ceremony. Olive's youngest sibling, Leslie, photographed the smiling couple. *(Courtesy Sally McInerney)*

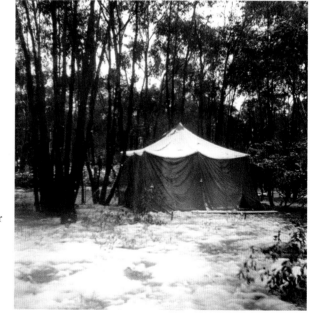

Olive and Ross began their married life in a tent, pitched on land owned by Ross's parents in a remote setting near Koorawatha in central western New South Wales. Without access to electricity or running water, processing negatives and prints was impossible. *(Courtesy Sally McInerney)*

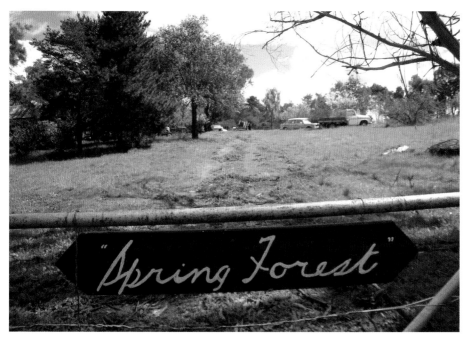

Spring Forest, 2010. Olive and Ross purchased this 500-acre property near Koorawatha in 1949 and lived here for over fifty years. Their first house was on the left; the 'new house' is at the top of the driveway. The 400 acres of uncleared bush remain a haven for birds. *(Ben Ennis Butler)*

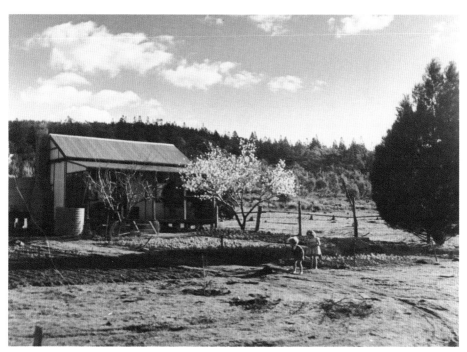

The family's first house was a two-room weatherboard cottage built in the early twentieth century. They lived here until 1973, the children attending the one-room school nearby. *(National Library of Australia, nla.obj-136350962)*

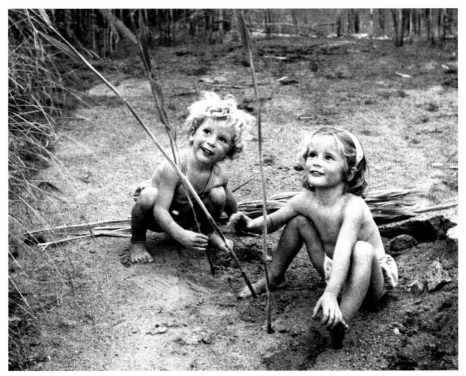

During the first eighteen years she lived in the country, Olive kept taking photographs, mainly of her children, Peter and Sally, who had all the advantages of growing up in nature, with what Olive referred to as 'space and freedom'. *(Courtesy Sally McInerney)*

Olive always excelled as a portraitist, and particularly favoured working outdoors with natural light. As evident in this portrait of her daughter, Sally, taken in 1959, the aim was to avoid any artifice and let her subjects reveal something of themselves. *(Courtesy Sally McInerney)*

In 1964, Olive opened her modest studio in the Calare Building in Cowra's main street. It housed a reception area, a space for portraiture and a small darkroom. (*Helen Ennis*)

The interior of Olive's studio. On its walls, Olive pinned up some of her photographs from her years at the Max Dupain Studio in Sydney, including the now famous *Teacup ballet* from 1935. (*Sally McInerney*)

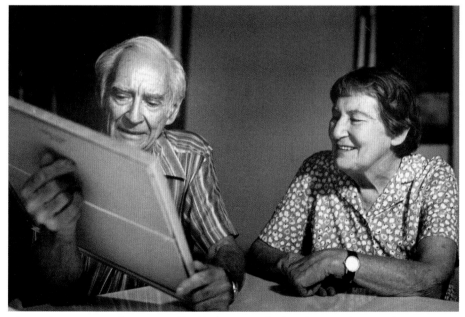

Olive and Max separated in 1941 and had little contact for decades. Jill White, Max's assistant, photographed them in his studio in Artarmon, in Sydney, in 1990, when they were both nearly eighty. (*National Library of Australia, nla.obj-146281759; detail*)

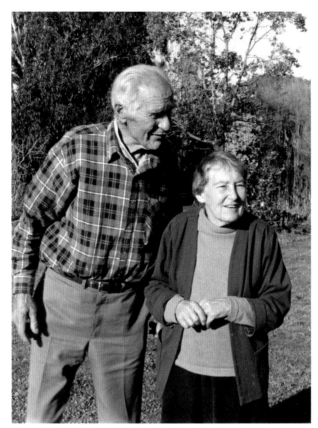

New Zealand artist Robin White was one of many visitors welcomed to Spring Forest in the 1980s and 1990s, when Olive's reputation as a major modernist photographer was growing. She took this photograph of Ross and Olive in 1995. *(Robin White)*

The door to Olive's room, with its original Dymo label. *(Ben Ennis Butler)*

Seen here in 2010, the 'new house', where Olive and Ross lived for thirty years, comprised two barracks that originally accommodated construction workers. In the front yard were seventeen abandoned cars and other household and farm paraphernalia. Olive's bedroom was at the centre, behind the tree. *(Ben Ennis Butler)*

was working there as a schoolteacher. They married at Sacred Heart Church in Darlinghurst, Sydney, on 21 January 1915, and had a large family of seven children born over a seventeen-year period: John, Ross, Bryce, Barry, Gavan, Roger and the only girl, Haidee.[3]

Ross grew up at Bally Calla and in Cowra, where his family had a house in Lachlan Street, a few doors up from the Catholic primary school he attended. For his high school education, he boarded at St Patrick's College in the regional New South Wales town of Goulburn, which was the McInerneys' choice for their four oldest sons. St Pat's was a stronghold of Catholicism and Irishness, founded by the Christian Brothers in 1874 (and is now closed). Most students came from farming families who weren't wealthy but wanted their sons to get a good education and religious instruction in the Catholic faith.

St Pat's had a strong emphasis on sport, which suited Ross, who played football and tennis, and took up running. In 1935, after completing his Leaving Certificate, he returned to Bally Calla to work with his father on the farm.

A few years before Olive met Ross, his family had suffered a devastating reversal of fortune, which no doubt she knew about from John McInerney. Financial difficulties forced the McInerneys to leave Bally Calla in 1938 after decades of farming, which had included periods of prosperity. In its heyday seventeen men were employed on the property, which was widely known for producing high-quality wool. In 1916, for example, *The Sydney Wool and Stock Journal* noted that Ross's father, Daniel, had achieved the highest prices in the area for his wool. When Daniel started losing money during the Depression, after the value of wool slumped, he didn't tell anyone, not even his wife, because 'he was so ashamed' about what was happening. Sally writes:

Then one day he broke the news that the family would have to start packing and leave their home immediately – the bank was

reclaiming it at the end of the week. It was a terrible shock for
Tommy (Ross's mother) ... They retreated to their remaining
land, a rocky bush stronghold in the hills, known as 'Blackett's'.
There John, Ross and Bryce built a hut whose walls were
sheets of stringybark and corrugated iron, and this became the
family's new home.[4]

Further disruption was to come, however. With no savings and
no prospect of earning a living locally, Tommy moved to Sydney
in 1939, with the two youngest children, Roger and Haidee, and
ran a restaurant and cake shop at 681 Military Road, in Mosman,
until 1951. Daniel continued farming at Blackett's, but the family's
overall income was greatly reduced and never fully recovered. He
remained deeply attached to the local area and served as a councillor
for the Waugoola Shire for a fifteen-year period from 1925.

The McInerneys' separate, long-distance living arrangements
affected their marriage. Ross's sister, Haidee, later commented that
by the time Tommy returned home, the couple had 'grown apart.
They were still good mates, but they were different.'[5] Ross was
deeply distressed by the loss of Bally Calla and the destabilisation it
caused, saying decades later, in 1998, that he was still living with its
reverberations and thought about it every day.

* * *

Haidee remembered Olive and Ross's courtship as 'a real love
match, romantic, sure of itself'.[6] And yet, in many ways, they were
a curious pair. Ross had not yet established his line of work, in
part because of the disruptions of war – he enlisted in December
1941 and was in the 6th Australian Armoured Car Regiment when
he and Olive met. He was also considerably younger: when they
began their relationship, he was nearly twenty-four, and she had
already turned thirty-one. In further contrast, Olive was from an
eminent Sydney family, and had substantial professional experience;

she had also been married to a high-profile man and was soon to be divorced. Her attraction to Ross, however, can be easily explained.

At the time they began their relationship, Ross had a promising future. In the General Remarks of the Army School's Confidential Report it was noted that he was 'of officer material'. The report described him as a 'Manly type. Intelligent. Capable of hard work. Keen and confident.'[7] He was just over 180 centimetres tall, very handsome, with frequently remarked upon movie-star good looks. Olive's portrait of him prompted one journalist to exclaim that he 'looks startlingly like a young Clark Gable'.[8] Ross was strong, with an excellent physique that was the result of his country upbringing and years of physical work, and he could be extremely charming.

Olive's and Ross's political beliefs were also closely aligned – they both voted for the Australian Labor Party, and had the same social values.

Nonetheless, Olive took some wooing. She was still distracted by the break-up with Max and apparently had no intention of committing to anyone else. In one of her letters, written several weeks after she and Ross had married, she commended his persistence in courting her. This indicates that early on he had seen a future in their relationship when she had not.

> I remember you coming to the flat another time though. I'm afraid I couldn't have been very good company then as I was so pre-occupied with my own 'woes'. I shall always wonder – and be thankful, Darling – that you persisted in seeing me for as long as you did. You must have had more patience and understanding than I ever guessed; my darling Husband, I love you so very much.[9]

In the same letter, she singled out Ross's dependability as a quality that especially impressed her and set him apart from other men she knew; Max's shortcomings in this respect were obviously still at the top of her mind.

… Darling, I do appreciate the way in which you spend your free time, not like a lot of the boys. But then, I always knew that I could depend on you; somehow I knew that from the very first, I didn't have to have it proved to me in time. You know that's one of the qualities that I love in you …[10]

After taking her (perhaps unconsciously) erotically charged portrait of Ross, the couple began corresponding and, a little over a year later, were writing on an almost daily basis. They saw each other whenever Ross was on leave and could return to Sydney, but his stays never lasted more than a few days. Ross's two surviving letters from September 1943, written during his brief stint in the air force, show they were already deeply in love by then and had committed to a future together. Ross told Olive: 'I would willingly forego a lot of things if this war were to end and allow us to live again as ordinary beings – not that you and I are ordinary, Darling. In some point of fact I'm extraordinarily fortunate in having you to love me.'[11] While full of passion, both letters are still relatively chaste in tone, suggesting that they may not have yet embarked on a physical relationship. Olive's letters from this time no longer exist; she asked Ross to burn them to ensure that no-one else would read them. He did so, very reluctantly.

For Olive, the year 1942 was a turning point both professionally and personally. Even though the unpleasantness of the divorce was still looming, she had begun feeling positive about her life, enjoying more control over her circumstances than she had experienced in a long time.

* * *

In the first six months of 1942, the war escalated further, fatalities and casualties mounted, and the conflict, which Olive monitored as best she could through radio and newspaper reports, came closer and closer to home. Singapore fell to the Japanese on 14 February,

when the British commander, General Arthur Percival, surrendered. More than 100,000 British, Indian and Australian troops became prisoners of war and, along with European civilians, were forced into internment camps. On 19 February 1942, Darwin was unexpectedly attacked by Japanese aircraft; at least 240 people were killed and hundreds were injured, although, because of government censorship, Australian newspapers reported only fifteen fatalities. It took decades for the full extent of the death and devastation that occurred to become widely known. Destructive air raids took place in Australia's north, northwest and northeast over the next six months: Darwin, Townsville, Mossman, Katherine, Broome, Wyndham and Port Hedland were all targeted by the Japanese air force; Horn Island in the Torres Strait was also attacked. At sea, Australian losses continued to climb: the sinking of the cruiser HMAS *Perth* in February and the sloop HMAS *Yarra* in March killed hundreds of men. By the end of March, Japanese forces occupied great swathes of Southeast Asia and the Pacific. In a matter of months, they had invaded Hong Kong, Malaya, Burma and Thailand, and were in Timor and New Guinea, with every possibility that they would take complete control of the Pacific region. In the first week of May, the Battle of the Coral Sea was fought between the Imperial Japanese Navy and American and Australian naval and air forces, resulting in further massive losses of life. The prospect of Ross being sent into the conflict zone was all too real.

Just a week or two before Ross sat for his portrait in the Dupain studio, the war encroached even on Sydneysiders. On 31 May, three Japanese midget submarines entered Sydney Harbour and unsuccessfully attacked the American warship USS *Chicago*, but the Australian naval depot ship HMAS *Kuttabul*, which was moored at Garden Island, was hit by either a Japanese torpedo or a shell from USS *Chicago* and sank, resulting in twenty-one fatalities. Two of the Japanese submarines were destroyed and retrieved, while the whereabouts of the third were unknown until decades later. Japanese submarines continued to attack Australian ships in the following

days, sinking an Australian coaster, *Iron Chieftain*, southeast of Newcastle, causing further fatalities. The coastal suburbs of Sydney and Newcastle were shelled on 8 June, fortunately without causing casualties or any significant damage, but the attacks did generate widespread fear among residents.

American troops had begun flowing into Australia after General Douglas MacArthur was made Supreme Commander of all Allied forces in the Southwest Pacific in March 1942. Substantial gains were, however, yet to be achieved.

As with her fellow citizens, Olive's access to information about the progress of the war was often frustratingly limited, confined to reports in the media and anecdotal accounts from servicemen on leave from the battlefronts. This meant that her involvement with Ross, though full of hope and promise, was framed by a far larger sense of anxiety and instability – which would prevail until the war finally ended.

Prescience

The signs of what would become established patterns in Olive and Ross's relationship were there early, taking shape in the wartime letters they wrote. The most revealing of these date from late 1943, when, in Olive's words, they had been 'seeing each other for more than a year'. They were in the midst of one of the most highly charged periods in a relationship, negotiating the terms of their love and trying to establish (probably silently and subtly) whether they would have a future together. This was not straightforward because of the war: they could not control Ross's leave arrangements, had little or no access to the telephone, and were dependent on letters to learn more and feel more for each other. Both come across as being fully committed to what was already a marriage in their eyes, but their different personalities and temperaments are clearly marked. What the letters also show forming is the unique dynamic between them, the core of their relationship that would slowly become concrete as they established themselves as a couple.

Olive was consistently and overwhelmingly positive – about Ross, their relationship and their current circumstances, despite the difficulties, which she never dwells on. She reveals that while Ross was persistent in their courtship, so was she. Most importantly, her letters indicate what Ross represented to her and what she prized most in him – his sexual fidelity and dependability. As a passage in a key letter implies, this was something Max lacked.

You tried hard to 'shake me off', but you couldn't get rid of me, could you Darling. I think you didn't really want to get rid of me, because you knew there was one sure way of doing it, and you didn't try that. Do you remember my asking you if you would still want to marry me supposing I had an accident, and lost an arm or a leg, or was disfigured in some way? You teased me for a while about it, but you don't know how extra much I loved you when you finally re-assured me. You see, I had asked someone else the same question years before, and got a very evasive answer which hurt rather – I should have been warned by that, shouldn't I.[1]

The idea of disfigurement she introduced is metaphoric, suggestive of a measure, an extreme, a way of asking Ross, exactly how much do you love me? It harks back to the strange dream she had written about as a teenager, when she felt anxious about her hold on Max and whether he loved her more than his photography. Now, however, she is confident that she won't be disappointed: Ross has already passed the test. In contrast to Max, who did try that 'one sure way' of disappointing her – presumably by either a serious flirtation or a liaison – she feels sure Ross will stand by her no matter what might happen in the future.

In his letters, Ross's self-doubt and lack of confidence are on full display. So is his strong tendency towards negativity. In one letter, he found himself wanting in a comparison with his brother John, whom he mostly called Jack, concluding with a rhetorical question: 'I have frequently remarked that I do not possess the same qualities, good or bad, as Jack, haven't I?'[2] He wondered if he was actually good enough for Olive, who, as he had recently explained to a friend, was the personification of his 'ideal woman', the one he wanted to marry as soon as he could.

… Of course that is if you don't suddenly change your mind, Darling. Anyhow I trust you and am pretty sure that you

won't. Of course if you did happen to change your mind it would be, as I have so often said, wholly to your advantage and my great disadvantage.[3]

Ross reiterates his need for Olive and her good opinion of him, confiding that: 'I'm glad that you have confidence in me, Darling. I really feel that I can do the things I speak of and I hope I have the chance to prove your trust.'[4] In a similar vein, two days later, he thanks her again and reassures her that he won't ever take anything for granted. Olive's confidence in him and her faith that he will not fail her help him believe in himself, lift him up and propel him forwards. His dependency was already profound: he needed her in order to become a better person.

Cordiality

Max and Olive initially had only very limited interactions while she was running the studio and their divorce was proceeding. They had more contact, though still infrequent, when Max briefly returned from the field to the studio to print (he usually processed his negatives in situ). On these occasions, they exchanged information about their personal lives. Both were now fully absorbed and content in their new relationships and were planning to marry as soon as circumstances permitted.

Olive reassured Ross that he didn't have anything to worry about in relation to Max. In her characteristically diplomatic fashion, she gave Max full credit for his gift to Ross of some prized American tobacco. Given his sensitivity about Max, neither the gesture nor the gift were likely to have given Ross much pleasure, but Olive good-humouredly urged him to think kindly of her ex-husband.

> Will you be surprised when I tell you that it was Max who
> gave me that tin of tobacco for you? – the American stuff.
> Owing to subtle propaganda on my part, he has a high opinion
> of you; so I rather hope, if you ever meet him, that you will let
> bygones be bygones and refrain from throwing him down the
> stairs![1]

Olive kept a newsy, engaging but unfortunately incomplete letter Max sent her from the RAAF base in Townsville in April 1944, two months after their divorce was finalised.[2] He was in good

health, managing to escape the dreaded dengue fever, typhus and malaria, and was working hard, explaining that:

> For the last two months I have been tossed around & about
> 3000 miles of jungle & am fed up to the back teeth with
> packing my kit, unpacking it … & mosquito net etc … & have
> made somewhere in the vicinity of 500 exposures; these have
> all been processed, classified & annotated & sent south for
> demonstration purposes. I have about 100 negatives that I am
> keeping for my own exhibition work & am aching to get them
> into the projector.[3]

He admired the American forces 'tremendously' and was sure they 'will crush Japan like a nut & in a short while too'. In his view, they were more organised, better equipped and far more ambitious than their Australian counterparts:

> After being with the RAAF for so long I felt that in contrast
> we are playing at war; all we have are brave men criminally
> short of equipment. One bloke said to me the other day 'Don't
> worry the Yanks will win the war in spite of the RAAF!' That
> is the general feeling of the men here; they are fed up with
> their impotency & want to get home & grow food to feed the
> Yanks![4]

Because the last page is missing, it can only be guessed how he chose to sign off, whether it was with love and affection or a more formal expression. However, what is very noticeable is the brotherly tone – he does not mention their past life together and addresses Olive as an equal.

The gift

Due to his disenchantment with the way his film footage was used by the Department of Information, Damien Parer resigned his position at the end of August 1943 and joined the American film company Paramount, as a cameraman. In March 1944, he returned to Australia on a brief visit. His biographer, Frank Legg, outlines what transpired:

> He arrived on the morning of Thursday March 16 … [and] learnt from a friend that Elizabeth Marie Cotter, a girl he had known for eight years, was arriving that evening by train from Canberra, where she worked in the Attorney-General's Department. She was coming to Sydney for her mother's birthday, the following day. Parer met her at the train that Thursday evening. On the Friday they were engaged. The Thursday after that they married. There was a brief honeymoon, during which Damien dragged his wife to film after film until her vehement protests stopped him.[1]

Two weeks later, Damien told his friend George Silk, the New Zealand photographer, the good news about his marriage: 'I'm very pleased about the whole thing, it's about time I did something about it, she is perhaps the only girl who could put up with my idiosyncrasies. Anyway, she's marvellous.'[2] His return address – 'C/ Postmaster, San Fran' – revealed that he had already left Australia to resume his coverage of American operations in the Pacific for

his new employer. Damien would never get to meet his son, who was conceived during the short time he and Marie had together.

On 17 September 1944, Damien was killed by Japanese machine-gun fire while filming the American marine landings on Peleliu Island, Palau, on the second day of the American invasion. Olive kept a newspaper cutting outlining the circumstances of his death. It was written by *The Bulletin*'s war correspondent John Brennan, who was with Damien when he was killed. Brennan noted that Damien 'minded not what risks he ran if he believed he would thus get "good pictures"', and wanted to emphasise 'the human factor – the emotions, reactions and living conditions of the men involved', which most newsreels overlooked. His strategy was therefore to follow the troops into battle. Brennan reported on his friend's final movements:

> Parer went in with the squad behind the first tank. I followed with the next. I saw him halfway across the isthmus – for the last time.
>
> The attackers pushed on. In the later afternoon I returned to the neck of the crossing. Damien did not come, but that gave no cause for worry; I knew that if he had been getting good pictures he would stay for the night. I remained there the night. Next morning I went in to look for him.
>
> No one remembered seeing him since the attack started the previous afternoon. He was not on the beach.
>
> His body was found later when the promontory was 'secure.' It lay a little ahead of a pillbox not a hundred yards from where I had last seen him. He had been caught in a burst of machine-gun fire, and obviously had been killed instantly.[3]

Brennan mourned the loss of 'a sincere artist, with the artist's absorbing interest in his work ... a deeply-religious man, a fine and engaging companion, a lovable friend'.

* * *

Five months after Parer's death, his son, whom Marie named Damien, was born. Despite the brevity of their marriage, Marie Parer confided in Damien senior's biographer twenty-five years later: 'I would give the whole of my life for another five minutes with Damien.'[4] Her enduring love for her late husband was well known, with Max commenting that she was still madly in love with Damien more than forty years later.

It is not known if Olive was able to see Damien on his last short visit home or whether she attended his and Marie's hastily arranged wedding. What is certain is that his devastating death placed her in a doubly difficult situation: she was grieving the loss of a dear friend and at the same time supporting Marie, who was facing the complications of motherhood overshadowed by tragedy. That space – of friendship and grief – was one I expect she entered into gently and compassionately. In her letters to Ross, she mentioned being in touch with Marie, passing on news to him of her progress and the birth of her son, writing in one of them:

> The baby now weighs 10lbs and I shall go and see them both one evening next week. I had been wondering what I could give her for the baby and asked if she'd like a 'cuddleseat' – have you seen one? They are like a sling that goes over the shoulder and supports the baby when carrying it, thus taking all the strain off the arms. Marie said she'd like one very much as it would be very useful when young Damien is a little older. So I shall get one and will give it to her from both of us, if you'd like that Darling.[5]

That 'cuddleseat' purchased in 1945 disappeared decades ago, but Olive's solicitousness did leave a tiny trace. It can be found in the 'Parer family papers ca. 1941–2004', which Marie Parer deposited in the Mitchell Library at the State Library of New South Wales before

her death.[6] In addition to official correspondence and documents relating to Damien's life and work, there are personal family items Marie lodged for safekeeping. Among them is a folder containing cards from well-wishers on the occasion of Damien junior's birth, including one with Olive's simple handwritten inscription, 'To young Damien / With love and all / best wishes from / Olive and Ross'.

Finding this modest gift card is the kind of event biographers long for, when the yawning expanse of time that separates you from your biographical subject collapses in an instant. Holding Olive's little card, secure in its Mylar sleeve, meant I was almost touching something that had been in her hands seventy years ago. But this has no bearing on the card's ultimate importance: as a token in a crucial exchange it speaks of the trade in care and support between women living with the absence of their husbands, male friends and men in their families. Marie was surrounded by women like Olive whose partners were away and who, like Damien, might never come home.

Absent Without Leave

When Olive and Ross started their relationship, Ross had been in the military for around six months; he was part of an armoured car regiment, undergoing training and doing well. He had successfully completed a course for potential officers and received a very favourable report, which appears on his Defence file in the National Archives. The course instructor concluded that, 'Considering lack of previous infantry experience [McInerney] displayed a good standard of general knowledge and ability. Shows initiative and resourcefulness. Of officer material.'[1] His official records state that he remained with the armoured car regiment until 11 April 1943, when he left to join the RAAF as a 'leading aircraftman'.[2] Nine months later, he left the air force, and on 15 January 1944, joined the infantry (Unit 14), which was his last move.

Ross may have been a reluctant recruit. In the early years of the war, all around him young men from country towns and properties in central western New South Wales were enlisting. Within his own family there may have been an expectation that he should enlist, too, given that two of his brothers, John and Bryce, were already serving (the other brothers were still too young to contribute). Ross definitely did not share Bryce's zeal. Bryce had enlisted as soon as he could, joining up at the age of eighteen in November 1939 and serving with 2/6th Division Cavalry Regiment in the Syrian campaign. John was fully immersed in his role as a medical officer in New Guinea. Ross may also have felt torn knowing that his father would find farming even more

difficult if his three oldest sons were away and he could not call on them for help.

Regardless of how he felt about enlisting, Ross had little appetite for military life, except for the arduous physical training in which he could excel. His letters reported on his physical achievements and prowess at length and Olive responded with pride. In contrast, he found the daily routines and endless waiting for mobilisation tedious, frequently scrapping with other soldiers and those in authority. He also experienced failures and disappointments, though none were spelled out in any detail in public or private records of the time. His brother John alluded to his lack of success in the air force and other endeavours in a diary he kept while in New Guinea in 1943: 'Ross apparently has been wiped off as a pilot – a long list of such disappointments will do him no good.'[3] His failings in the air force were noted in an official document, too, with his supervisors stating that he was 'not likely to become an efficient aircrew'.[4] Unfortunately, they did not elaborate on the reasons for this negative conclusion.

But what intrigued me most about Ross's experiences during the war was the unexpected information that he was court-martialled. Papers on his Defence file establish that on 23 November 1944, he was tried for being Absent Without Leave (AWOL), having been held 'in close arrest' for sixteen days. He entered a plea of not guilty but was found guilty for being AWOL for 135 days, from 23 June to 7 November that year, and was fined £15. The evidence presented at his trial noted that up until then his service record had been 'clean'.

In reality, Ross's absence without leave was not as dishonourable as it sounds and did not involve a shirking of all his responsibilities. It was a reflection of his own priorities and a practical demonstration of what mattered to him most – family and farming. He didn't go missing during these four and a half months; he went home to Blackett's, to work. His father, Daniel, was on his own, struggling to manage the property during an extreme drought and a destructive rabbit plague. If the authorities had wanted to, they could easily have found Ross; he had made no secret of where he was or what

he was doing. In fact, he had attempted to get leave in early June, so he could assist his father, and dryly stated at his court-martial trial, 'I spent a lot of time applying for leave', any kind of leave – special leave, compassionate leave, emergency leave and seasonal leave.[5] All his attempts were unsuccessful and he was informed that refusal was based on the grounds that he was 'A1', which apparently meant he was too good to let go. He therefore felt his only option was to take matters into his own hands.

The account of the courtmartial on Ross's Defence file is only four typewritten pages long but, despite its brevity, the exchange with the authorities is illuminating. It says a great deal about the impact of war on a typical rural family, in physical, social and emotional terms, not to mention on their other intimate relationships. The McInerney family was widely dispersed by this stage of the war, with parents and children all having to endure separation from one another in Australia and overseas: only Ross's mother and youngest siblings, Haidee and Roger, were able to be together, living in Sydney.

A severe drought, which was devastating large tracts of farmland and creating huge dust storms, was making life even more difficult. On 16 October, just a few weeks before Ross's court martial, Sydney was subjected to a major dust storm during which thousands of tons of topsoil blew in across the city from drought-stricken pastures in inland New South Wales. The wind and water erosion that was afflicting the state was predicted to have dire consequences. Olive referred to the awful dust and heat in a letter to Ross while he was in detention waiting for trial:

> Yesterday was terribly hot though fortunately it was a dry heat
> and at one stage of the morning the smoke and dust was so
> thick that I could hardly see ... from the studio windows. On
> my way to the train I saw a dead baby bird on the footpath,
> it hadn't grown any feathers even – and I wondered if it had
> dropped out of the tree or had died from the heat first. I
> remembered a time when you painted a very lurid picture of

the country when it could be so hot that the birds dropped
dead from the trees.[6]

As part of the formal proceedings of the court martial, Private Ross
McInerney was questioned by the prosecution about his activities
since going AWOL in June 1944. His responses revealed the extreme
situation for those attempting to eke out a living from farming.

Q. Where did you go?

A. I went home that night and I stopped there until I was
apprehended.

Q. Were you ever away from the property?

A. I was never away from it.

…

Q. What did you do there?

A. I was working all the time for 135 days.

Q. What were you doing?

A. I was trying to obtain water for the stock and for domestic
purposes, feeding the stock and doing various essential
duties like that.

Q. You were feeding sheep?

A. Yes, and slaughtering sheep and doing general work that my
father could not do.

Q. This is very difficult country?

A. Yes, it is in the hills … it is fairly level itself but there is a
lot of timber on it and the rabbits are bad. I suppose they
are dead now because of the drought. This is the worst year
they have had since they have been taking rainfall records in
the district.

Q. And that is one of the reason [sic] why you felt your father
could not cope with the work?

A. I felt that to be the matter for a long time.

Q. Were you in uniform all the time?

A. All the time.

Q. And your intention was what as far as the army was
concerned?

A. I was going to return as soon as circumstances permitted.

Q. When?

A. When he got feed or the drought broke.

Q. This is the correct story?

A. That is the true story.

Q. That is the only story?

A. Yes.[7]

The first witness called for the defence was Ross's father, Daniel.
He stated that, because of the awful conditions and impossibility of
finding workers, they had drastically reduced the number of sheep
on their property. Even if labour had been available, he could not
afford to pay for it. It was Ross who had come to his father's aid and
worked incredibly hard for the entire time he was missing from his
unit. The exchange between the defence and Daniel McInerney
went as follows.

Q. What was he [Ross] doing on the property?

A. He was sinking for water for a good portion of the time. He
sunk about three wells. Then the stock had to be driven to
water.

Q. How far approximately?

A. I would say about three miles and they had to be brought
back again and the same applied to the horses.

Q. And he was attending to the rabbits?

A. Yes, the rabbits were in a pretty bad way.

Q. He was on the property the whole time?

A. Yes.

Q. And he was in his uniform?

A. Well, if shorts constitute army uniform he was.

Q. Khaki shorts?

A. Yes.

Q. And you felt you could not carry on without his assistance?

A. At this particular time there had been no change and realising the state of the country at the present time – it has been an unusual season ... I did.[8]

After the court martial, Ross waited anxiously for confirmation of the amount he would be fined and what he referred to as 'the promulgation'. In the interim, he was allocated menial duties in the mess at the camp in Cowra – greasy, filthy work – which he detested and railed against. He confided to Olive that he was feeling 'disgusted and forlorn', and was being pushed to breaking point.

> The feeling of frustration is very strong, almost overpowering and often nearly drives me to tears or temper ... It's a beggar of a life, Darling; the mental effect on me is severe and it does not take long for me to lose my spirits.[9]

He argued with the cook – not for the first time – and could not find solace anywhere bar 'the few brief hours' he spent in bed. Desperate for relief, he told Olive that the only possible solution was to apply for discharge from the army. The application he submitted was denied and so he was left with no alternative but to stay where he was.

* * *

Ross was far removed from any war zone while AWOL, but his time at Blackett's coincided with one of Australia's most dramatic events of the war. Around forty kilometres from the McInerneys' property, what is now known as the 'Cowra breakout' took place. More than 300 Japanese prisoners of war, who had been incarcerated in the large detention camp on the outskirts of the town, staged a mass breakout on 5 August 1944. In the process, 250 prisoners died – many by committing suicide – and more than a hundred

were wounded. Four Australians were killed in the mayhem. The prisoners of war who managed to escape into the surrounding countryside were all quickly recaptured within a fifty-kilometre radius of the camp and re-interned until the war was over.

A talisman

While Ross was AWOL, living at Blackett's, Olive visited him at least once, in October 1944. It was a joyous occasion for them both but underpinned by the knowledge that his situation was precarious and unlikely to continue for long. A couple of weeks after her visit, he was detained and any further opportunities for time together evaporated.

As instructed by Olive, during the war years Ross usually burned her letters shortly after receiving them. The few he kept and sent back to her, for safekeeping presumably, had special significance: a small selection from late 1943; from November and December 1944, while he was under open arrest; and from 1945, after they were married. Perhaps they were the ones that touched him most deeply. Living with her family in Artarmon, Olive's situation was, of course, entirely different and she could keep as many of Ross's letters as she wanted to. There was no shortage of supply. He was such a prolific correspondent that she sometimes felt overwhelmed and guilty because work and other commitments made it impossible for her to fully reciprocate.

The couple's letters from early November to mid-December 1944, immediately before and after his court martial, are direct and passionate, revealing that they had probably been lovers for some time. The 'brief, sweet time' they spent together at Blackett's was precious, and physically and emotionally draining. Ross reassured Olive that their lives would become more balanced when they were really married: 'I repeat that I hope that that time will not be very far away.'[1]

Each was mindful that censors could be reading their intimate exchanges, and the authorities certainly did intervene in their correspondence: an official stamp on the envelope of one of Ross's letters stated that it had passed scrutiny, and the couple noticed other instances of their silent inspections.

Once Ross was detained, Olive understandably felt very worried, not only about the resolution of his predicament – she was relieved to hear that he was being treated decently and was well fed – but also about his deteriorating state of mind in the lead-up to his trial. She urged him to look at the night sky for 'old Scorpion ... when I find him I feel that I have a kind of talisman for you and me.'[2]

Dismissing Ross's anxiety that she might think less of him because of his situation and its associated dishonour, she reassures him about his primacy in her life: 'of course, I'll keep on writing to you; – I don't consider there's anything humiliating about writing to, or even visiting anyone in your position.' Her letters are long, newsy, and mostly upbeat, openly expressing her love and constancy. Importantly, she also offered Ross a vision of a wonderful future together, confidently declaring in one letter, 'we'll show the world how to live!' They freely discuss their plans to marry, which are dependent on Ross being granted sufficient leave to return to Sydney and enough forewarning so that Olive can organise the legal formalities. He hopes that they will manage to get married before Max and Diana.

Because of the paucity of personal archival material, Olive's letters are vitally important for their insights into her innermost feelings, motivations and aspirations. They make her character real and coherent, and bring her voice into the present. As her most direct form of expression, they introduce her cadence of speech and tone, which cannot be known any other way. And so, to create a space in which Olive can speak, some of her wartime letters are presented here. The voice is an intimate one, the voice of a woman writing to her prospective husband whose safe return is far

from certain. Damien Parer's death a few months before gave their situation added poignancy.

These letters are also important for their cumulative effect. Read together, they are perfect examples of the autobiographical documents Janet Malcolm writes about so compellingly in her essay 'A House of One's Own' – that is, documents 'that reveal inner life and compel the sort of helpless empathy that fiction compels'.[3] It is through Olive's letters to Ross that she emerges most vividly as an individual and as a character in her own evolving narrative.

* * *

Artarmon
Sunday, 12 November [1944], 10 p.m.

My Darling
As you see I'm home again after spending actually only 24 hours at Newport. However, in that time I've had a good sleep and a good swim and a good sunbake, and feel quite refreshed.

I've read your last letter over and over again. I've been like a miser with a secret hoard of treasure, waiting for opportunities of being alone so that I can look at it all again; for I too look on your letters as something just between ourselves. I've missed you a lot this week end, probably because I've been able to think about you without so many distractions; – and yet, in a way I haven't really missed you because it seemed that sometimes you were thinking the same things as I was, and that made you seem close to me Darling.

It's good to hear you 'sing your own praises' sometimes; – though I don't consider that a form of conceit (!), and if you didn't tell me some of the nice things people say I wouldn't hear about them at all. And I do like to know that my own opinion about you is confirmed so heartily by others. (There

are some matters that I wouldn't appreciate confirmation of though, you know what I mean!) Anyway, it's a welcome change from those forlorn letters that said you were no good for anything ... remember?

I love you more than ever ...

That last line is getting to be like a chorus ... I hope you won't tire of hearing it repeated over and over again.

...

Please don't drive Sulkie over tree stumps any more. One day you might land on your head instead of neatly on your feet, and I don't like the idea at all. I did like the picture of the proud fifteen-year old boy when he first got Dancer though. Maybe there'll be another proud boy one day, just like you. You'd like that, wouldn't you; I would too. I remember that he has to have at least one brother or sister too.

I mentioned to Daddy that the spring at Fraser's had just about dried up for the first time in history. He asked if they are going to sink a well near it, as there should still be underground water there, but it has probably fallen to a lower level.

...

Are you all right still Darling. Have you any idea yet of what is likely to happen? I hate to think of you being in such a little space when you're used to having the whole horizon as your only boundary. Can you see the old Scorpion from there? I look for him in the sky at night and when I find him I feel that I have a kind of talisman for you and me. Do I sound very foolish?

...

I'll go to sleep now and write some more to-morrow. I must find out when the mails go to Cowra ... and post my letter accordingly.

Good night Darling. Somehow I feel that some good is going to come out of all this trouble of yours, because there is

something about you... I don't think I'm just being optimistic
either. I love you very much ... Darling, and feel so confident
that we'll be happy together, ever after, as all good fairytales
say. Ours won't be a fairytale though, it is going to be 'real'.
I'm going to think about you hard until I fall asleep ...

Monday 10 p.m.
I got home about 6.45 to-night. Quite a change for me. It has
been very hot and dusty and windy to-day. I expect this is the
dust you had in Cowra a week ago.

Leslie starts the Leaving exams to-morrow – English in the
morning.

Last Sunday week Miss Reed went to church and the parson
gave a long and doleful sermon on the evils of lotteries. She
was so annoyed that she promptly bought a ticket, and to-day
she won a 5 pound prize. She's very pleased with herself. But I
doubt there's a moral to this story.

After tea I thought I'd do a little sewing, and turned my red
and white striped skirt into a kind of 'pinafore' frock, which
I can wear with a blouse in the studio. It looks much neater
now, – Daddy was most impressed! This is it [small sketch].
Now that I've drawn it, it doesn't look so good, but you'll be
able to judge for yourself ... soon I hope.

I haven't got my sheets from Jean [Lorraine] yet. In fact
she has been so unhappy that I haven't bothered her. I don't
know what she and John [McInerney] are going to do at all.
There's a long and involved story of the last week with me
caught up between them, as it were, and trying my hardest
to be the peacemaker, because I really like them both. That
sounds as if I've been fussily interfering, but I haven't been
like that. Maybe I shouldn't discuss them at all as it's their
business entirely; only telling you all this isn't like gossiping; I
suppose I need you to share it with me, because it has weighed
so much on my mind.

Did you see in yesterday's paper that the *Shropshire* [an Australian cruiser] sank a Japanese battleship during the operations off Leyte [the Gulf of Leyte in the Philippines]? Just as well she got the range first, or the battleship could have blown her to smithereens. I guess Frank [Olive's brother] had a hand in that, as his action station is behind ... the big guns. It will be good to have him back again, safe and sound.

In one of your recent letters you spoke about writing to some man who usually had good dogs, because you wanted one. Was there time for him to reply before you left? I would so like to give you a dog, only you must do the choosing yourself, because I don't know anything about that. It would be nice to go with you though when you do choose it. You see, I'm mentally skipping the present period to some happy time in the future. But I don't forget you for a moment Darling, and keep wondering how you are spending your time, and how you are feeling, – and I keep hoping hard that you don't get despondent and unhappy again.

Maybe there will be a letter from you to-morrow, telling me how you've been faring.

I posted you a *Reader's Digest* on Saturday, and bought another copy for myself, so that I could read the same things as you. I liked the paragraphs about instinctive actions of wild animals, and I liked the condensed version of 'No life for a lady'; – I found myself thinking of it in terms of Australia, and casting you in the role of Ray!

Good night once more Darling. I wish I could say good-night, in person, every night.

I love you so much.

Olive

'We'll show the world how to live!'

Ross's fine of £15 – roughly equivalent to three weeks' wages – was a hit to their savings, but there were no other obvious external consequences of the court-martial verdict. Olive did ruminate whether the outcome would affect Ross's chances for promotion, and it may have.

At the end of December 1944, Ross was granted a few days' leave and joined Olive in Sydney with time enough for them to marry. They had a civil ceremony at the District Registrar's Office at Chatswood, on Sydney's North Shore, on 30 December. Only at the last minute did they realise that they needed witnesses, and Olive's good friends Douglas Annand and Una Dodd, wife of artist Peter Dodd, obliged. On the marriage certificate, Olive's occupation is stated as 'photographer'; Ross is described as a 'grazier', which is an interesting choice of word, grander than 'farmer' in its implication of large-scale grazing activity and land ownership. Olive's age is listed as thirty-three, and Ross's as thirty-two, whereas he was actually twenty-six. The age difference was a sensitive matter, because it was very unusual for women to marry younger men. Understandably, they wanted to keep their seven-year age gap to themselves, but the extent of the difference made some of their friends curious. A few weeks after they were married, Ross referred to the matter in one of his letters:

We have them tricked – and probably convinced too – about my age, haven't we, Darling? Of course, I don't mind being younger than you – that does not matter at all; I always knew that you were older – but I always liked to be a little older.[1]

It seems that because of the sudden, impromptu nature of their decision to marry, not everyone in the Cotton and McInerney families was told until afterwards. Olive's brother Les photographed the couple on their wedding day. His charming snapshot shows both Olive and Ross laughing out loud, appearing relaxed and happy. Ross is wearing his army uniform and Olive looks very smart in a floral dress, light-coloured gloves and hat, and new shoes. The elegance of her outfit represents a significant feat, given that Sydneysiders were in the grip of wartime rationing that affected supplies of new clothing and footwear.

The Annands' wedding present to them was a watercolour of a blue-eyed zebra, painted by Douglas (it hung on the living room wall of the new house at Spring Forest until the end); Olga Sharp gave them a tiny Chinese porcelain vase, which Olive described as 'exquisite', telling Ross that she was worried about how much Olga had spent buying it for them; and publisher Sydney Ure Smith was among those who wished her 'all the best' for her marriage. A few years later, Leo Cotton made an extravagant but practical gesture, giving the couple a second-hand Buick, whose remains still rest in the front yard at Spring Forest, marooned forever between the old cottage and the new house.

Ross's parents heard the news of their marriage separately. In one letter, Ross told Olive that his father, 'remarked favourably on our being married and said I would have "a different outlook now." Perhaps I shall have to adopt one anyway.'[2] Possibly because Ross's relationship with his mother was strained, Olive relayed the details of their wedding. It prompted Ross's question, 'What does mother think of our being married? Did she say?'[3] The news impelled Tommy to write directly to Ross with some sage advice,

presumably learned from her own marriage: 'It takes a long time for one to get to understand one's partner; in fact he might never attain this fully and the best course is to take for granted that whatever is said or done is with the best interest.'[4]

The newlyweds spent a week together – 'a lovely week', Olive told Ross afterwards, 'every single thing that happened was good' – before he returned to duty in the AIF. Olive missed him hugely as soon as he had gone, and her first letters to her new husband, 'my own husband', were filled with intense longing and delight that they were now married.

> See what thoughts and longings you have woken in me. I do love you so very, very much. I look at my wedding ring a thousand times a day and give it an affectionate little squeeze because it means that I belong to you, my husband, Darling.[5]

'My sweetheart husband'

Newport
Jan 14th [1945]
9.30 p.m. Sunday

My Dearest Darling,

It's now over a week since we said good-bye, and it seems ever so much longer. Thank you for your telegram, and the letter-card, Darling. I am going to Artarmon to-morrow morning in Daddy's car, early, to see if there is a letter from you: then I shall know what address to put on this letter.

Oh Darling, I love you more than ever, – I'm so proud and happy to belong to you, my husband. I can't tell you how glad I am, and I can't tell you how forlorn I felt that Saturday you went away. I spent the morning tidying up the house [at Artarmon] and then I slept for two hours, between 12 and 2, – (somehow I felt that you might have gone away while I was asleep) – and then I packed a few things and left at about 4 p.m. for Newport. I hope you didn't ring again after I'd gone Darling; I felt it was unlikely that you would and I couldn't bear being alone in the house much longer that day. Before I went, I took one pillow away from our bed – I couldn't come back to find two pillows there still, it would have only made me feel more lonely. Just the same, that little room is full of your presence Darling. I've tried to pretend that you are only

a hand's breadth away when I go to sleep, – but I'm not very good at pretending ... I love you so much, my husband.

I don't want to sound as if I'm 'w[h]ingeing' Darling. I knew you would have to go away some time, – and we were lucky to have a whole week anyway. It was a lovely week – every single thing that happened was good (except that I hope you managed to catch up on some sleep!). It was so very dear of you to come and meet my friends: – they all like you very much, and I feel so proud ...

Nancy [Hyde] has finally had a conciliatory cable from [husband] Ernest and feels much better about things.

John rang on Friday night to see if you'd left yet. He was supposed to leave Richmond yesterday, and intended to see Jean before going away. Also, I'm to photograph that nice W.A.A.A.F. on Tuesday ...

I didn't do very much last week. I went back to the studio on Monday, but can't say that my heart has been in my work. I've been home early every night, cooked myself some tea, and got to bed at a reasonable hour. I've slept and slept. Olga came to tea on Wednesday. She brought me a little parcel, for both of us, and I unwrapped it and found an exquisite little vase; it is only about 4 inches high but is a piece of genuine Chinese pottery, with seven tiny figures modelled round it, and each one is hand-painted – there are many colours. I told Olga if she spent her money like that she would never save up for more equipment for her studio, but she said she wanted to give us something. It is rather different from a 'buzz-saw', Darling, but it will be nice to have things like this too. It reminds me of the day we went into the Museum at Bathurst, and admired the engines, and the polished panels of wood, and the fine pottery and lace.

Jean stayed with me one night last week, – otherwise I've been alone. I've thought of writing to you lots of times, but somehow all I could do was fall asleep; I expect you've felt much the same, Darling.

The watch-strap you ordered arrived on Monday. It's just the right width, and looks very neat. Thank you Darling. I'll always keep it, even when it's worn out, just for sentiment's sake. I'm going to keep the letter-card too, because it's the first thing you've written my new name on. I get a nice feeling of belonging to you every time I read it.

I hope you are well, and have had no more trouble with that leg. Take care of yourself – oh Darling, I pray that you'll come back safely and gladly, and that then we can start life together for always. No matter what happens to you, don't stay away Darling, thinking that you might not be able to work very hard. We'll always be able to manage somehow, and never forget that more than anything in the world I need your love, because I love you so much.

Good night, my own husband, Dearest … I love you.
Olive

Artarmon:
Monday 9.30 p.m.
 …
I'll go to sleep now, – the zebra keeps a blue eye on me while you're away. I love you so very much Darling.
Olive

* * *

In the year after they married, Olive and Ross continued their regular and now even more ardent correspondence. She wrote in any free time she had, usually at the beginnings and ends of days, before or after work, when she had finished all her chores, and on weekends, when she was either at home in Artarmon or at Lyeltya in Newport. Ross wrote whenever he could, too, and Olive kept the great majority of his correspondence. The bulk of her surviving letters date from this period. Tucked inside their envelopes, they

were arranged with Ross's in rough chronological order and stored in a wooden box, which was kept at Spring Forest.

So how did she present herself to Ross during the first year of their marriage and their final year apart? We learn that she is hard-working and conscientious, that she is very family-minded and already well integrated into the McInerney family. She visits Ross's mother and two youngest siblings in Mosman whenever she can; and John McInerney often drops in to the studio for conversation. Olive is disciplined and careful, but every now and then has fun – going to a film, to Maida Annand's parties, the zoo, and to a bar in the city – but feels guilty enjoying herself when she knows Ross isn't happy.

She tells Ross that her desire for their life in the country is to start without any debt or obligations, and that she has embarked on a concerted savings plan, reporting by the end of the year that they have the considerable sum of £200 (approximately $14,400 today) in the bank. She outlines the practical measures she is taking to ensure they will be well set up when the time comes, buying tools and books and getting interested in making compost. She is keen to learn how to cook, make jam, preserve fruit and so on; she has bought a cookbook published by the British Food Board, which she expects to be useful, and watches Maida Annand cook as part of her preparations for a very different life. One assumes that her inexperience in domestic matters was due to Miss Reed's services; she would have done all the cooking for the Cotton family, and Olive's repertoire had obviously not expanded much when married to Dupain.

Throughout her correspondence, she is invariably good-humoured and positive. This is in line with Department of Information instructions that those on the home front write in a cheerful way to their loved ones in the military, but is also consistent with how she related to Ross. Keeping up his morale and spirits was a priority for her: it would have been selfish to behave otherwise, to 'whinge' when his circumstances were so much harder and more dangerous than hers.

Hardly ever did Olive overtly express any anxiety about their separation and circumstances. The first time was less than three weeks after they married: she was missing Ross acutely after their passionate few days together and made a heartfelt, very direct comment, one which is uncharacteristically full of doubt: 'There is so much of your life during war time that I can have no part in, isn't there ... – I sometimes wonder if I can be of any use to you at all.'[1] Several weeks later, she notes that the regular contact they have enjoyed may be over, with Ross now based interstate, and in a stoic response, tells him: 'I'll just have to get used to it, I guess.'[2] There was no other choice.

Her unspoken anxiety about how their relationship will fare long-term is evident in comments about other couples close to her: Nancy and Ernest Hyde; her brother Frank and his wife, Marie (they had married in December 1942); and Ross's brother John McInerney and Jean Lorraine, who were in the process of separating. Olive saw the unravelling of Jean and John's marriage first-hand, heard both sides, and found the whole emotionally charged, destructive saga distressing. On a brighter note, she was delighted to see how happy Nancy and Ernest were, once reunited: 'it's obvious that they've just picked up the threads where they left off two and a half years ago.'[3] The implications are obvious – she was thinking about her own reunion with Ross.

The letters are also interesting for what Olive chose not to mention in detail, about the progress of the war or what was happening in Australian politics. This is not at all surprising. Both she and Ross stayed mindful of the censors and continued referring to them. Olive reported that, 'The censor also had a look at your latest letter, and I wonder what he thought of your comments on censors in general';[4] and Ross noted on one occasion that the censor had been busy: 'Were any of my letters cut about? I can see no reason why they should be.'[5] However, she did refer to the impact of war on her daily life, with rationing and shortages of food, film, cigarettes and clothing, and the endless comings and goings of serving family

members and friends. At one point, she was thrown by a request to report to the manpower office and sought the help of Mr Hyde senior, nicknamed 'Daddy Hyde', who successfully intervened on her behalf, explaining to the authorities there was already an agreement that managing the studio on her own exempted her from being called up to participate in the war effort.[6]

There was one event that brought the horror of war into her personal sphere, via her aunts Ethel and Janet, and she provided Ross with an extended account of it. She had met an English family who had been taken prisoners of war during the Japanese invasion of Borneo, were finally liberated, and were now living temporarily in her aunts' cottage at Newport. Ethel and Janet had lent their home to the traumatised family so that they could continue their physical and psychological recovery in a congenial environment by the sea.

While Olive didn't engage explicitly with politics or comment on the war, her letters do contain coded exchanges in which she attempted to work out where Ross was and where he was likely to be deployed in the near future. In the last year of the war, on 14 February 1945, for example, she noted that he would probably be in New Guinea soon, and five weeks later was wondering whether he would be going much further than his 'supposed destination', without specifying what that destination might be.[7] She assiduously read the newspapers to try to glean information about where he could be stationed and when he might be coming home.[8]

Versatility

Running the studio developed Olive's versatility and her achievements were very significant. She took on diverse commissions: reproduction photography of works of art; film stills for *The Overlanders*, a hugely popular film directed by Harry Watt, one of the leaders of the British documentary movement; and ballet and theatre photography (one of her photographs was published in Peter Bellew's book *Pioneering Ballet in Australia*, in 1945).

Advertising photography became another important area of her practice, for products ranging from knitting patterns to processed food. Ross's sister, Haidee, was the very photogenic model in an advertisement for 'Mum's Jelly' – and Jean Lorraine helped out by making the jelly for the shoot. Olive also branched out into documentary photography, depicting fire damage to a Berger's paint factory caused by a lightning strike, and the installation of AWA amplifiers at St Andrew's Cathedral in George Street, Sydney.[1] Where she worked varied – at the studio, in people's homes, and at locations around the city – and the conditions were often technically challenging, especially when it came to lighting. An assignment for the Minerva Theatre in Kings Cross posed a physical challenge as she had to climb up above the stage to secure her shots.

Fortunately, the Dupain studio was already well established before the war and kept attracting some of the same loyal clients. One of the most important was Sydney Ure Smith, for whom she undertook reproduction photography and portraiture. It was largely through him that she could maintain the studio's connections to the

arts, which Max had initiated years earlier. Ure Smith commissioned her to photograph the artworks for the Australian Society of Artists' Annuals his firm published, and for his book *Present Day Art in Australia* (1945). Among the artists she photographed for him were Joshua Smith and Douglas Annand (though his portrait is erroneously attributed to Dupain in the *Australia National Journal*, August 1943).[2]

When prominent artist Margaret Preston wanted a photographic portrait, it was Olive she approached, relaying in a handwritten note, in 1944, that Ure Smith had said 'you are the one and only photographer,' asking her, 'Will you do some of me? I want a dozen – have run out of photographs so must have some.'[3] It was a note that Olive proudly kept.

Author Eleanor Dark wrote to Olive from her home, Varuna, at Katoomba, in the Blue Mountains, explaining that Ure Smith needed a portrait of her, perhaps to promote her recently published novel, *The Little Company* (1945). The two women greatly enjoyed the portraiture session, discovering links between their families, as the novelist's father and Olive's grandfather, Frank Cotton, were close friends. Olive's respect for Dark is obvious in a portrait that conveys a strong sense of the author's lively intelligence.

Another art-related commission was the reproduction photography for Bernard Smith's ground-breaking book on Australian art, *Place, Taste and Tradition*, which required access to the Art Gallery of New South Wales's collection. She told Ross:

> I was down at the art gallery again to-day, to see a set of
> pictures I have to photograph for a book that is coming out
> on the history of Australian Art. I went down into some dusty
> store-rooms in the basement to see some of them, and also into
> the air raid shelter where their most valuable pictures have been
> stored in case of an air raid ...[4]

She was back at the gallery a few weeks later photographing the entries in the Archibald Prize for 1945. They included Sir

William Dargie's prize-winning portrait of Lieutenant-General the Honourable Sir Edmund Herring, who had played a crucial role in the Australian military campaign in New Guinea. A year later, Olive herself was the subject of an entry in the prize, in a painting by Sydney artist Joy Ewart.

The war years also gave Olive a public presence and an audience she had not had before, due to the circulation of her work in a variety of publications. Two photographs of workers published as illustrations in Clive Turnbull's book on the RAAF, *Wings of Tomorrow* (1945), are particularly fine examples. One shows instrument mechanics working on a compass for the RAAF, and in the other, aircraft mechanics are rebuilding the power cells unit of a Royal Netherlands East Indies Air Force Douglas C47 at the de Haviland factory. Both photographs were full-page reproductions and have an immediate presence, with a warmth and humanity that distinguishes them from other illustrations in the book. Olive depicted the three workers in *Aircraft mechanics* in situ, seemingly oblivious to her and her camera. Although the poses appear natural, they are likely to have been determined by her, with instructions given to eschew eye contact, which would otherwise have turned the image into a more straightforward group portrait, rather than a study of them and their work. The men are not reduced to types or one-dimensional forms of propaganda; Olive chose to humanise them, rather than abstract and heroicise them. She brought her camera relatively close, so that they hold their own in the frame and yet can be seen in relation to the work that engrosses them. *Aircraft mechanics* is built around repeating semicircular and circular accents, and the aircraft engine that fills the lower section of the composition is like a big body the men are carefully attending to, their hands disappearing into its inner reaches. In Olive's vision, humans are not subordinated to machines, and engineering and technology are made organic.

Despite increased visibility, Olive was not as connected to other photographers or the photography scene as she had been during the

Aircraft mechanics, 1945, National Gallery of Australia, purchased 1983

pre-war years. The only other female professional photographer she was aware of was Margaret Michaelis, an Austrian-born Jewish émigré who had fled fascism in Europe and arrived in Sydney in September 1939. Michaelis set up her business, which she named Photo-studio, in Castlereagh Street, a short distance from Dupain's studio in Clarence Street. Michaelis specialised in portraiture and dance photography, and Olive admired the 'very individual, sensitive small portraits' that she displayed in her showcase at street level. However, the two women never met.

Olive Cotton and Michaelis actually had a lot in common – both were portrait specialists, were concerned with photography as an art form, and valued high print quality. They were also working long hours on their own, with Michaelis reporting that she kept her studio open from nine in the morning until seven at night. Additionally, both had to contend with rationing and intermittent shortages of photographic supplies. But there were also important differences in their situations that revealed the biases of the photographic industry and larger political and social forces in play at the time. The Australian-born Olive enjoyed all the advantages of being well connected and relatively well known. Michaelis, on the other hand, was faced with multiple restrictions that flowed from her status as an émigré, then as an émigré alien and finally as an enemy alien. Her professional activities were monitored by the authorities and she did not have the same freedom to practise her art as Olive. Her cameras could be confiscated at any point and she required a permit, issued under Section 3 of the Alien Control Order, to allow her to photograph members of the forces when they were 'included in bona fide wedding groups, parties etc., in the company of civilians and not on or in any defence property or establishment'.[5] The location of her studio caused concern because, as police noted, from the seventh floor window she had a good view of the harbour and movement of large vessels. Nor was Olive subject to any of the regulations governing place of residence, personal mobility and ownership of such things as radios and binoculars that affected

Michaelis. Olive was free to travel across Sydney, whereas Michaelis couldn't even sing in a choir she had joined without first obtaining a travel permit to attend practice sessions in a nearby suburb.

Throughout the war years, Olive's primary focus was her professional work, but whenever she could she photographed for her own pleasure. Without a car or even access to one – everyone was affected by petrol rationing – she didn't travel far. Landscape photography, which had been predominant in her oeuvre before the war, was now out of the question. Confined to the city and to the Clarence Street studio, she adapted to her changed circumstances and made a number of cityscapes, the only time in her career when she focused on this theme. Her technical experimentation also came to an end. It was as though the war called for a different kind of photographic language and Olive, like many, decided to respond by working as a straight photographer. She printed from a single negative, rather than using multiple negatives to make composite prints, as she had often done previously.

The Clarence Street building gave her a new perspective on the city, an elevated vantage point, which she made the most of visually.[6] From one window she could look towards the Town Hall nestled among the city buildings; and from another she could see part of the harbour and wharves – the view she enjoyed most. From the rooftop, she took *City rooftops* (1942), which brings together modern metropolis (its low-level skyline virtually unrecognisable today) and cloud-filled sky, uniting human and natural elements. In her cityscapes, Olive was always attentive to sky, clouds and effects of sunlight on urban structures. Smoke, emitted by ferries on the harbour and factory chimneys inland, was exploited as an additional softening device. As in a couple of earlier views of the city, *Escape* (1937) and *Sesquicentenary procession, Sydney* (1938), Olive is the detached observer, rather than a participant in the city's human life or ephemeral flow of energy.

* * *

City rooftops, 1942, National Gallery of Australia, purchased 1987

Portraiture was an area in which Cotton always excelled, although it comprised only a small part of her independent output during the Sydney years. Before the war, with none of the pressure associated with commissions, her portraits were mainly of those closest to her – Max, her friends, and members of her family, including her sister, Joyce, and grandfather Frank Cotton. These subjects understood her and her work, were sympathetic to what she was trying to achieve, and were fully engaged in the portraiture process. They were, in fact, ideal subjects, collaborators rather than sitters merely responding to a professional photographer's instructions. Although some of these early portraits are the antithesis of snapshots in their formality and level of control, they aspired to some of the same values, namely authenticity and honesty. They aimed to be 'true'. In them, Olive tried to capture something essential about her subject and convey a very real sense of them, of what modernists commonly referred to as their individual 'essence'. Olive's demands of portraiture were, therefore, ambitious and exacting.

Turning to portraiture during the war years was pragmatic in some ways, because it meant she could always find a subject. She continued working with her intimate circle, including friends Gwynneth Stone and Jean Lorraine, whose portraits display a new level of confidence and sensuousness. Each woman faced the camera in an assertive, knowing way. Their self-possession is familiar from portraits and self-portraits made by such artists as Margaret Preston and Nora Heysen several years earlier. Jean's extensive experience as an artist's model was particularly beneficial, as the consummate *Portrait by candlelight* (1943) reveals. Of the portrait, Olive wrote:

> For a long time I had wanted to take a portrait by the light of one candle, thinking that its gentle luminosity and soft shadows would be ideal for that purpose. I asked Jean Lorraine if she would come to the studio after work, and we waited until daylight was gone so that we could have complete darkness. I used the studio portrait camera, which had a shutter controlled

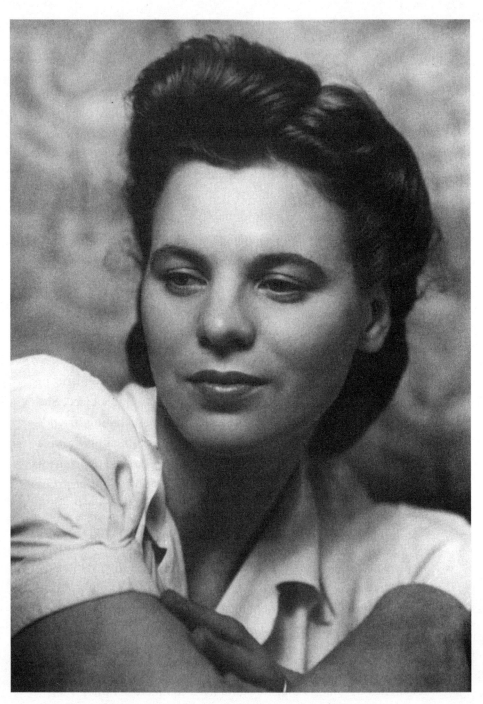

Portrait by candlelight, 1943, National Gallery of Australia, purchased 1987

by pressure on a squeeze-bulb, attached to the camera by a long thin piece of rubber tubing.

Jean took a relaxed pose which she would be able to hold comfortably, and then with all the lights out I lit a candle.

With one hand holding it aloft and the other gripping the squeeze-bulb, I opened the shutter to expose the film for a carefully calculated ninety seconds. (I knew the strength in candlepower of the lights that we used for portraits, and had calculated the exposure needed for a single candle.)

Jean was the ideal person for this experiment – she did not make the slightest movement, and we were both pleased with the result.[7]

Around the time of this session, Jean and John McInerney's marriage had reached what Jean described as 'breaking point', with both involved in extramarital affairs. John was back in Sydney from New Guinea once again and was involved with a woman Jean dubbed 'The Frowzy Floozy'.[8] John was convinced Jean also had a new lover; 'he is right', she later wrote, 'but I won't tell him he is. I have had an earth shaking one-week, whirlwind affair with Bill, an American paratrooper officer who ultimately will be my third and last husband … It's a mess.'[9] This personal tumult is of no consequence to the portrait.

Hardly any of Olive's art photographs from the early 1940s were shown contemporaneously, because of the disruptions to established exhibiting practices brought about by the war. Photographic societies initially directed their attention to fundraising. Members of the Victorian Salon of Photography and the Photographic Society of New South Wales held a fundraising exhibition at the Society of Arts Gallery in Adelaide, in July 1941, to raise money for the Red Cross; three hundred photographs were offered for sale. The Sydney Camera Circle, however, suspended its activities in 1941 and did not resume them again until 1945. It was only towards the end of 1945 that art photography began to reappear on any significant scale. In September 1945, well-known photographer Monte Luke

organised an exhibition of work by members of the Photographic Society of New South Wales, Sydney Camera Circle and Miniature Camera Group, which traced the development of photography from the daguerreotype up to the present.[10] At the same time, on the other side of the country, an exhibition at the Kodak Salon in Perth flagged Max Dupain's return to the scene with a selection that included a portrait of Damien Parer he had taken in Sydney.

Max had spent the years 1942–44 working for the Department of Home Security, researching and reporting on the camouflage work of American and Australian forces in Australia, Papua and New Guinea. In William Dakin's assessment, Max made an outstanding contribution, which he summarised in his Camouflage Report 1939–1945 (1947). Dupain was a 'Special photographer' who, Dakin continued:

> Possesses a strong creative imaginative mind & makes excellent contacts with all men. Is energetic & keen on his work, expresses himself clearly at all times. Has good construction sense. Capable & qualified to undertake general camouflage design & supervision.[11]

Max resigned from the Department of Home Security in late 1944 and, with a recommendation from Ron Maslyn Williams, director of motion picture photography in the Department of Information, was offered a job as a photographer there. Somewhat surprisingly, his earlier application for a position as a war photographer had not been successful. In his new role at the Department of Information, Max travelled extensively around the country documenting aspects of an Australian way of life for a publicity campaign targeting potential immigrants in the United Kingdom. Once this work was completed and he returned to Sydney, Olive's tenure in the studio came to an end.

Olive's last important commission also involved Max. In 1945, Helen Blaxland, a conservationist, approached the now divorced

photographers to work on her book *Flower Pieces*, published the following year (it was also issued in a miniature version). It was one of the few occasions where their photographs appeared together. Blaxland thanked them both 'for all the time, patience and unfailing good humour they have expended on these photographs, and for the high standard of technical excellence they have attained'.[12]

The book was structured according to the seasons and showed a sequence of photographs taken across a twelve-month period. Blaxland's aim was to present flower arrangements 'in their actual settings – on a mantelpiece, beneath a picture, in the corner of a room',[13] as she believed that the relationship between flowers and their surroundings, which she regarded as crucial, had been neglected in previous publications on flower arranging. She gave a wealth of practical advice about the appropriate flowers to use (gladiolas were definitely out of fashion); how to make them last (keep them out of the draught, fill their vases daily); and elaborated on the principles of arranging. The latter included directions governing proportion: 'always arrange flowers on the level at which they will eventually be placed'; for a tall vase, flowers should be 'one-and-a-half times its height', whereas for a low vase they should be 'one-and-a-half times the width'.[14] Blaxland's other concern was to debunk some of the 'sheerest poppycock'[15] about the arrangement and treatment of flowers.

This was an ideal commission. It built on Olive's longstanding love of flowers and the flower studies she had been making for years. The eleven photographs she contributed to the publication are assured and consistent in quality, ranging from close-ups of individual arrangements to shots of the room where an arrangement can be seen in relation to other design elements. The formality of the interior settings in the photographs is probably the result of Blaxland's art direction: a dish is strategically positioned next to a vase as a counterpoint in size and colour; a single rose lies on the mantelpiece next to a vase full of roses. In each case, the vase, with its manufacturer identified by Blaxland in her captions as Spode,

Mantlepiece, c.1945, National Gallery of Australia, purchased 1983

Belleek and so on, functions as an integral aspect of the overall arrangement.

Even within the strict confines of the commission, the differences in Olive's and Max's photography are unmistakable. Max employed theatrical lighting and strong shadows to create moody images, whereas Olive favoured holistic views, creating images that are light–filled and airy.

* * *

For Olive, the years running the Dupain studio were extremely demanding, due to the long hours and unrelenting pressure of deadlines. She carried out all the photography and darkroom work herself, processing film, making prints and then retouching them. Olive confided in Ross that it was very tiring being 'out on the job all the time'[16] and she was sometimes frustrated with 'this mad rushing about to get things done to an exacting timetable. That sounds as if I want to be lazy, but I don't want to be idle, only to work without having to rush everything.'[17] Despite the hectic schedule and pressure, she loved the whole experience. Jean Lorraine summed up this intense, vital period of her friend's life in photography by emphasising its personal benefits, saying that Olive had 'blossomed with independence and freedom'.[18] It would be nearly twenty years before Olive Cotton found herself in a studio again, but this time it would be her own.

End of war

The war ended in Europe in May 1945, but it would be three months before the Allied forces could declare victory in the Pacific. This came soon after the United States dropped atomic bombs on Hiroshima and Nagasaki, on 6 and 9 August respectively, killing more than a hundred thousand civilians and wounding tens of thousands of others. Japan formally surrendered on 15 August. That day, in downtown Sydney, hundreds of thousands of people thronged the streets to celebrate the restoration of peace – perhaps Olive, her friends and family were among them.

While the war officially ended on 2 September, the men in Olive's personal circle had slowly been returning home – each time increasing the heartbreak of the loss of Damien Parer the previous year. Those who were back included Olive's two brothers Frank and Jim, who had joined up in 1942 and 1943 respectively. Ross's younger brother Bryce was also home. He had been stationed in the Northern Territory before being discharged on 3 October 1944. In the last two months of 1945, the pace of returns quickened. John McInerney arrived in Sydney by train from Brisbane in November but was not in the best of health due to malaria he had contracted in New Guinea. Ernest Hyde returned from England. The camoufleurs were also flowing back after working at various military bases in northern Australia, New Guinea and on other islands. Max Dupain was in this group; after stints in Papua and New Guinea during 1943–44, taking aerial photographs of camouflage schemes, he spent four months on Goodenough Island at the Department of Home Security headquarters, at the Allied

military base there, in 1944. Max and Olive's friend Richard Beck, who served in the AIF, was discharged on 4 December 1945. Ross, unfortunately, was one of the last to come home.

After hostilities ended, the Australian military still had a great deal of work to do. In September, Ross was one of a 1000-strong Australian contingent that was sent to take control of the island of Ambon in Indonesia, which Japanese troops had invaded in January–February 1942, taking Australian, American and Dutch soldiers as prisoners of war. The Australian POWs, a group of more than 500 men, had suffered a 75 per cent death rate, one of the highest for any Australians in captivity. The 123 emaciated survivors from Ambon were rescued by Royal Australian Navy personnel on 10 September and given medical attention and food. Those well enough to travel were sent on to Australia by sea and air, and were among the nearly 15,000 ex-POWs who arrived home during the months of September and October.

Ross sent Olive an official Air Mail Letter Card informing her of his impending departure from Australia. This appears to be his only surviving letter from this time.

Pte. McInerney, R.G.,
Tues., 18 Sep. 45 64 Aust. Inf. Bn.,
Ambon

Dearest Darling
This is the new address.

I am to leave with A Coy. [Company], the first to leave, on Friday and should reach Ambon on Sunday. It is about 500 mls by sea and we are to travel in naval sloops and frigates.

Ambon is practically south of Morotai and just off the South coast of Serang, off the western tip of New Guinea. The maps often show the island as Ambonio but that is the town.

A naval and supply base and the Japanese equivalent of Morotai Ambon I believe contains 18,000 or so Japs.

However, they are expected to be quite amenable and are supposed to provide transport for us – we are taking only a few jeeps – and also to provide camping facilities for the thousand[s] of us.

Some of the remainder of the bn. [battalion] are to leave on Thursday in several small Jap. Supply ships – very small in fact – and the others in the 'Westralia' on Monday.

...

I shall go now, Sweetheart; I love you very, very much, my Darling wife.

Love

Ross

In Olive's letters to Ross while he was in Ambon, five of which are extant, the change in tone is palpable. There is a strong sense of excitement as she waits for news of his return – nearly driving 'everyone mad asking if the postman has been three times a day!' She hopes he will be home for Christmas, her only anxiety being that she might not recognise his footsteps coming up the path at her father's home in Artarmon, where she was living. The letters are full of information about her interactions with family and friends, crammed with the detail of daily life, which he will soon be immersed in again. And she is full of hope that they will soon be able to start their family with, as she had foreshadowed to Ross some months earlier, at least two children. She writes:

Oh Darling, I'm just longing for us to start our life together. It will be wonderful when we can talk to each other again, and make plans, and just be together. I hope it will all be very soon now Darling. You don't know how very happy and excited I feel at the prospect of it all.

All my love, for always, my sweetheart husband.

Olive

Sturt

On a visit to Frensham School and what is now the Sturt craft and design centre, it is not difficult to see the past in the buildings or their setting. The original buildings that house Frensham's classrooms and offices are well maintained, and the English-style gardens with their winding sandstone paths are well tended. In the cool, wet climate of the New South Wales southern highlands, the azaleas and camellias planted in the 1930s have grown well, with hydrangeas among them, and agapanthus and irises on the gardens' borders. This is an environment in tune with nature, the formal gardens around the buildings giving way to paddocks and native vegetation dominated by stands of tall eucalypts. No wonder Olive loved it there.

* * *

In October 1945, Olive returned to Frensham at the invitation of former principal Winifred West. Circumstances were very different to those in mid-1941, when she was dealing with the break-up with Max and a stage of the war in which Allied victory seemed far from certain. Four years later, the war was over, her stint running the studio was coming to an end, and she was now Mrs McInerney, not Mrs Dupain, as she had been when teaching at Frensham. Even though Ross was still away, the end to hostilities meant that she could enjoy relative peace of mind, expecting him to be safe and to be home soon. There was, in every respect, so much to look forward to.

Her return – to take photographs for the book *Sturt and the Children's Library* – had a pleasing circularity to it. After all, the opening of the Sturt workshops was one of the major events that had taken place while she was teaching at Frensham, and she would have been caught up in the excitement and enthusiasm for West's latest visionary educational venture. As West had explained in the *Frensham Chronicle* in 1941, Sturt would be an alternative new school for local girls who were not well served by a conventional high school education. The plan was to start out by teaching classes in 'weaving and spinning, English, appreciation of art and music, divinity, dietetics and such other subjects as may seem desirable', with the aim of developing 'the girls' individual talents and personalities'.[1]

West had not known how Sturt would fare – whether it would 'just go phut!' – but by the time of Olive's visit in 1945 it was beginning to thrive. In her introduction to *Sturt and the Children's Library*, West noted with pride that the pupils' ages ranged from three to seventy-seven, and that they had successfully created 'a happy meeting place for people young and old who love beauty and good craftsmanship'.[2]

Sturt and the Children's Library was West's second book to use photography to promote and further the aims of the educational endeavours she led. The first was *The Frensham Book: 100 pictures by Cazneaux of an Australian school*, published by Art in Australia, in 1934. Harold Cazneaux and his wife, Winifred, spent several weeks at the school in 1933, during which Cazneaux took nearly four hundred photographs of the buildings, grounds and school activities involving staff and students.[3] His photographs of the gardens and beautiful bush setting emphasise the importance of the natural world in the school's ethos. Other images document the girls' well-rounded education, showing them gardening, beekeeping, sewing, making lino-cuts, singing carols, reading, juicing fruit and so on.[4]

Commissioning Cazneaux was an inspired move, as was approaching Olive twelve years later, not least because of her prior

involvement with the school and obvious sympathy for its emphasis on a creative approach to life and active engagement with the arts. Olive also had the benefit of a deep interest in the education of children, which had been fostered by her aunts. A few years earlier, Ethel Cotton had asked her to take a series of informal photographs of children attending the Woolloomooloo Free Kindergarten, located in an impoverished area of Sydney, and Olive had assumed the role of a detached but sympathetic observer; she later wrote that she sensed 'a happy understanding between the children and the fully-trained staff'.[5]

West had kept in touch with Olive after her reluctant departure from Frensham, and Olive later explained how the commission came about:

> When they wanted the book on Sturt she [Winifred West]
> asked me to do the photographs of the school and grounds. I
> went up one October holiday weekend and stayed with one of
> the staff in a cottage. I really enjoyed doing that job.[6]

Winifred West was delighted with the photographs Olive took and expressed her appreciation in a letter, writing: 'You are an angel to send the prints so quickly – they are lovely … it's all most exciting.'[7] However, publication was delayed by what West referred to as 'insuperable difficulties'. These may have been related to the impact of the war on the printing industry, which faced shortages of paper and inks. This may explain the low-grade quality of the paper eventually used in the book, which meant the reproductions suffer from some flatness of tone and lack of definition. Early in 1946, a few months after receiving Olive's photographs, West wrote to a friend about the book's progress, outlining its contents and structure:

> There will be about 50 photographs divided into sections: –
> The Garden; The House; Spinning; Dyeing; Weaving;

Flowers; Carpenters; Other People; Children's Library &
we are now trying to find suitable quotations to put at the
beginning of each section.[8]

As with *The Frensham Book*, West's *Sturt* begins with a tribute
to nature. In the first section, titled 'The garden', Olive's finely
observed and quietly exuberant springtime photographs show
lavender, roses and daisies in abundant flower. This is the strongest
sequence of images and concludes with a photograph of two girls
in school uniform working cut flowers into an arrangement. In
later sections, students are equally intent on their activities, whether
carpentry, spinning, dyeing and weaving, conducted both inside
the school buildings and outdoors. Students are mostly shown in
small groups, with Olive choosing not to single out any individual
student or teacher. Throughout the visual narrative, Olive is an
unobtrusive presence. Students and teachers generally don't register
that she is there, so there is little posing or self-conscious display
for the camera's benefit. Her mostly non-hierarchical and informal
compositions create an impression of naturalness and a sense of
purpose shared by the Sturt community.

Olga Sharp, who published the book for Winifred West,
contributed two photographs herself. Though not credited in the
book, it can be assumed that Sharp was responsible for the design,
which is modern in all aspects, from typeface to layout. Considerable
care is evident in the selection of the textured card for the hard
cover, papers of different weights and textures, the use of coloured
end papers, and the varied placement of illustrations, with some
images bled to the edges. The simplicity of the overall design is also
in keeping with the values Sturt espoused.

Olive regarded this commission as one of the most enjoyable of
her career, presenting a perfect combination of elements she held
especially dear – children, education and immersion in the natural
world. However, its significance extends further than that. It was
the last major body of photographs she produced at the studio before

Max's return, and the first time that a publication was given over to her photographs; until then they had appeared alongside those by other photographers, including Max. It was also the first, and only, time professionally that she went by her married name. The book summed up her photographic career to that point and anticipated her future as Olive McInerney.

Homecoming

The exact date of Ross's arrival in Sydney is not known, but hopefully Olive heard his 'footsteps coming up the path' at her father's house at Artarmon for their long-awaited reunion. Finally, after all the stops and starts since beginning their courtship in mid-1942, they could begin life as a married couple and put into action the plans they had developed over the previous months and years. They had already agreed to some matters of fundamental importance: the first was that Olive would leave Sydney and they would move to the country, and the second was that they would start a family as soon as they could. Olive had thought she was pregnant in the year before they married, and they were disappointed when it transpired that she was not – this is a further indication that she was prepared to reject convention and have a baby outside marriage. However, there was no discussion in their letters about where they would live, or how they would earn money in the future. Because such details were far more likely to have been worked out in intimate conversations when they were together, rather than through correspondence, they are now opaque.

Olive's letters reveal that she was initially hesitant about the prospect of moving to the country. Ross had assumed she would prefer to stay in Sydney and did not pressure her to change her mind. He was concerned that marrying him would mean having 'to give up all these things, just when you have made a name for yourself ... Indeed I feel that you are being asked too much.'[1] At some point, however, she became convinced that country living

would suit her best and became enthusiastic about such a move. Within a few weeks of their marriage, she told Ross:

> Oh Darling, I do look forward to the time when we can start our living to-gether. Apart from the great joy of being with you I shall honestly be very glad to live in the country. I've just about had enough of city life, anyway. I believe I'm going to feel far more at home in the country – I must inherit the liking for it from Grandad!
>
> When I think of those early days when I knew you, I can hardly believe that I thought it would be hard to leave the city, Darling.[2]

Ross concurred. A few days later, he replied: 'I'm glad that you seem to be sure that you are going to like the "bush", Darling. We shall do our best to make things happy for us both.'[3]

The positive sentiments Olive expressed about her relocation were qualified in public reminiscences she made decades later, at the age of seventy-six:

> Years later Ross McInerney told me that he had never expected me to want to leave the city, and he'd been planning ... [to] get a job in Sydney, but he'd have been miserable there. It didn't occur to me not to go with him, and he has always been very supportive of my work.[4]

That said, leaving Sydney represented another dramatic turning point in Olive's life. Only her sister lived away; the rest of her family, Ross's mother and his youngest siblings were all living in Sydney. Once again, a big decision Olive made on her own terms propelled her life forward in a new direction.

The wait for Ross to be formally discharged from the army gave Olive time to prepare herself and her belongings for the move. Her precious photographic negatives, prints and books were packed into

the green traveller's trunk and sent not on an exotic sea voyage overseas, but to country New South Wales. It was decided to leave her piano at her father's place until they had their own home and somewhere suitable to put it. By April 1946, if not earlier, Olive and Ross were installed at Blackett's and she was pregnant with their first child, Sally.

The year 1946 saw a milestone of another sort with the release of *Flower Pieces* and *Sturt and the Children's Library*. The following year, Olive was included in a major publication, the generously illustrated yearbook *Australian Photography*, edited by Oswald Ziegler. This was an ambitious venture, a public statement about the future of Australian photography in the post-war period, which aimed for national coverage. Established practitioners were represented, along with some of the newer arrivals to Australia, notably Axel Poignant, Wolfgang Sievers and Margaret Michaelis. The selection committee chose 'those photographs that unmistakably pronounce themselves as PHOTOGRAPHS', although a smattering of soft, pictorialist-inspired imagery was still in evidence. The Dupain circle was well represented with photographs by Max himself, Powell, Le Guay and Olga Sharp. Only one of Olive's photographs was selected (she may not have submitted more): a portrait of a young child named Mary Yardley, which does not have the strong connection between subject and photographer that characterises her best portraiture. However, its naturalness is appealing; taken outdoors in natural light, it avoids the stiffness and artificiality of a studio setting.

Inclusion in these publications was a substantial achievement, but it unintentionally marked another landmark event – the end to her life and work in Sydney. Little else of Olive Cotton's photography would appear in public, in either publications or exhibitions, for the next three decades.

A new marriage

When Olive's youngest brother, Leslie, turned twenty-one, Miss Reed's childrearing work was effectively done. All five children had grown up and become independent. Joyce was married and living in Armidale; Frank and Jim were dentists, living in Sydney with their respective wives, Marie and Edna. Olive had begun her new life in the country with Ross.

With her services shrinking to housekeeping, Miss Reed apparently began thinking about returning home to England. Neither she nor Leo thought it proper for her to remain living in the house alone with him. The solution to this potentially destabilising situation surprised the family – Leo proposed marriage. It was a course of action that demonstrated he was not concerned with the disparities between Lilian and himself in terms of class, education and social standing, or with people's gossip about a professor marrying his housekeeper. (Rumour had it that he was interested in a geologist at the university, and the family thought that she might have been a prospective wife.) From his point of view, marrying Lilian was the right thing to do. It fulfilled his sense of obligation to a woman whose long-term dedication to caring for his family entailed separation from her own family on the other side of the world. More specifically, it acknowledged her loyalty to him. She had been a stable presence in Leo's life in the decade and a half since Florence's death; she knew his habits intimately, and by running the household so smoothly had enabled him to continue his work. The arrangement they came to was, according to family members,

'quite comfortable for them both', and appears to have been based on 'genuine affection' and companionship.

The couple were married at their home in Artarmon on 9 November 1946. The two witnesses were Olive's brothers Jim and Frank. Leo's oldest grandchild, Pat Harrison, was in attendance and remembered it as 'a simple ceremony with few guests'.[1] Leo's children now had to reorient their thinking about Miss Reed's role – she was no longer the family 'help', but their new stepmother. They continued to call her 'Reedy', however, as they had done for years.

Further change came two years later, in 1948, when Leo retired from his position at the University of Sydney. As he no longer needed to be close to the city, he and Lilian moved permanently to Lyeltya. Joyce and her husband, Philip, bought the block next door and built a holiday house on it. From that point onwards, Newport was the focus for gatherings of the Cotton family during school holidays and especially at Christmas. Leo introduced his visiting grandchildren to his passion for geology, using Newport as their laboratory and showing them plants fossilised in the shale rock around the cliffs.[2]

Post-war photography

War affected individual photographers in very different ways. For Olive, the disruptions and deprivations she experienced did not lead to any noticeable changes in her perspective on photography. Certainly, she had expanded her repertoire and had used documentary photography for relevant commissions while running the Dupain studio, but she did not reconceptualise her own approach or views on photography's role in contemporary society more generally. Nor did she offer any public commentary. In the few months after the war ended, she continued working in a predominantly straight way, with a minimum of darkroom manipulation, and the overall impression conveyed by her work from this brief time is its positivity.

Max's experiences as a camoufleur were life-changing and he returned to civilian life determined to make a conscious break with his pre-war work. As he later explained:

> The unstable wartime years, the grudging adaptation to ever-changing surroundings, the thousands of impressions both good and bad of varying environments, all added up to long-term shock. I just needed a settled emotional life for a while in order to get my life and work into a new perspective. I did not want to go back to the 'cosmetic lie' of fashion photography or advertising illustration. I had seen too much of another kind of reality which probed deeper and demanded unequivocal attention ...[1]

He wanted to find a new direction for his own work and to help define a uniquely Australian form of photography that was appropriate for the post-war era. He decided that the crux was to work outdoors, using sunlight and striving for effects of naturalness and spontaneity. In 1947 he put forward his newly formulated views in a piece for the magazine *Contemporary Photography*, edited by Laurence Le Guay (who had served as a photographer with the RAAF and had himself only recently returned to Sydney):

> It is so necessary to learn from other countries but forever keeping in mind that a national photography will contribute greatly to Australian culture. Let one see and photograph Australia's way of life as it is, not as one would wish it to be. It is wasting the dynamic recording capacity of the camera to work otherwise.[2]

Max resolved his personal dilemma by wholeheartedly embracing documentary photography, in response to his wartime experiences, his current state of mind, and as a way of honouring Damien Parer. In their formative years, Damien had argued passionately for a documentary approach and had died in his unwavering commitment to it. Max's famous photograph of women queuing to buy rationed meat exemplified his changed direction. It was a scene that occurred independently of him; he did not set it up for the camera or issue any instructions to the women. As he saw it, his responsibility was to be alert to pictorial possibilities, which, in this case, came from the ripple of energy generated by the women as one of them pushed into the orderly queue; the women's uncompromising facial expressions and sober attire reinforced the grim effect. In the following months and years, Max produced numerous images of prosaic, typically Australian scenes as he continued to refine his views on a national photography. In the longer term, he devoted himself to architectural photography.

His photographs for the monograph *Max Dupain*, published by Sydney Ure Smith in 1948, reflected his new orientation, as it concentrated on straight and documentary images. Many of them dated from his time with Olive and she would have known them intimately – the nude study *Torso in sun* was of her. The book was dedicated to Ure Smith, Diana Dupain and Max's parents. In his foreword, Hal Missingham, then Director of the Art Gallery of New South Wales, praised Dupain's approach for its objectivity and clarity, and 'penetration into the essentials'.[3] In his accompanying essay, Max described photography 'as the art medium of the machine age' and stressed the values of objectivity and realism, claiming that 'selection' was the 'only personal prerogative'.[4] The book noted Dupain's growing reputation internationally, which culminated in the selection of his photographs of New Guinea for the exhibition New Photographers at the Museum of Modern Art, New York, in 1946.

Olive and Max's colleague Geoffrey Powell also turned his attention to the possibilities of post-war photography and, like Max, concluded that a realist approach was the key to the future. He believed it was time to champion a much more politically and socially oriented use of photography, and called on the 'progressive working class' to make sure that 'the conditions of the working man' were documented by the best possible photographers working in Australia. He argued that the contemporary photographer must respond to 'the world's current problems' and produce 'pictures which really mean something'.[5] This is where Powell's vision differed significantly from Max's: both men envisaged photography as having contemporary importance and a moral purpose, but for different ends. Powell's viewpoint was informed by Marxism and his introduction to communism in 1945 – it was directed towards producing concrete outcomes in society.[6] He argued that the contemporary photographer was one who 'will pick up his lenses and films for the more constructive purpose of helping mankind.'[7] Max had no such direct political agenda. He mostly felt at odds

with humankind; his politics and political action evolved out of modernism and were directed towards advocacy for what he regarded as a progressive form of photography.

The post-war scene in photography was also being changed by the participation of European-trained émigrés who had fled fascism and persecution in Europe, and arrived in Australia in the years either immediately before or during the war. They came in highly varied circumstances. Wolfgang Sievers, for example, whose migration from Germany was sponsored, was able to despatch his equipment and personal belongings in advance, but then had to flee Berlin after being called up to serve in the German Luftwaffe. Margaret Michaelis arrived with nothing (her photographic equipment was not shipped from Marseilles to Sydney until later). Helmut Newton (originally Neustaedter), who had trained as a photographer in Berlin, had different circumstances again. Having made his way from Germany to Singapore, he was interned by British authorities; he was then sent to Australia on the repurposed ship the *Queen Mary* as one of six thousand 'refugee aliens' Australia agreed to accept as internees. Newton spent his first sixteen months of exile in an internment camp in regional Victoria, before setting up a business in Melbourne. He was later joined by another German-born photographer, Henry Talbot, who had fled Germany only to be interned in England as a German national. Talbot arrived in Australia on the British ship the *Dunera*, infamous for its maltreatment of 'enemy aliens', including Jewish refugees. Like Newton, Talbot began his new life in Australia as an internee. Collectively, these European-born and trained photographers brought an impressive level of experience, confidence and sophistication to the local scene. Sievers, who became friends with Max, would go on to specialise in industrial and architectural photography, Michaelis in portraiture, and Newton and Talbot in fashion photography.

Due to her marriage and desire to have children, Olive was not among those who continued in the arena of professional photography

after the war. In her art photography, her approach was more aligned with Harold Cazneaux's than Max's or Powell's. In an essay on the role of photography in the post-war era, published in *Australian Photography 1947*, in which Olive was represented, Cazneaux argued that pictorial landscape photography could still be a vital force. As he saw it, the 'new worker' must not become 'caught up in the new "speed up" of life, with all the new cults and ideas, and the so-called modern art movement'. He posited another, more enduring alternative that was likely to have appealed to Olive, especially now that she was living in the bush. Cazneaux wrote:

> In our grand open spaces will still be found the beauty of sunshine and shadow, the waving grasses on the hillsides, the winding stream, the towering gum. Sincere art comes from the heart and mind, and we will find such inspiration in the work of yesterday even if we are all involved in this super progress of so-called modern life and art.[8]

PART FIVE

A canvas home

When I initially learned that Olive and Ross's first home was a large canvas tent in the Illunie Range, in central western New South Wales, I didn't think much more about it. This changed in a flash when their daughter, Sally, sent me a black and white photograph of the tent surrounded by snow. More than anything I had read or been told by relatives, the snapshot brought home the reality of Olive's situation when she and Ross moved to the country; it is impossible not to contrast it with photographs of Wirruna where Olive grew up. Because they could not yet afford to buy their own land, the McInerneys moved to Blackett's and pitched their ex-army tent in a cleared area of the bush near Ross's parents' bark hut. Daniel and Tommy were not happy with the primitive living arrangements Olive had to contend with; neither was Leo. The tent originally had a dirt floor – though at some point Ross built a wooden one – and they cooked and socialised at the hut in the evenings, and got used to living without running water, electricity or the telephone.

But Olive didn't live here continuously. In fact, what is striking – and this can only be established through the surviving correspondence between her and Ross – is how much time they spent apart in this period. The most extended separation was during her pregnancy, in 1946, when she stayed either at Lyeltya, in Newport, or in Sydney with the Annands, or with Olga Sharp and her parents. Ross remained at Blackett's whenever she was away, looking after things and picking up whatever work he could on farms in the district. By

9 November 1946, Olive was in Sydney, living at the Sharps' home at 30 Woonona Avenue, Wahroonga, in readiness for Sally's birth. She explained years later that she chose to have her baby in Sydney for practical reasons. The drive from Blackett's to Cowra hospital was thirty-five kilometres on rough dirt roads, far from ideal if an emergency were to arise during labour.

> I wanted to be near [a] hospital for the birth of my first child, and had been invited down from my country home to stay with my friend Olga Sharp and her kind elderly parents at Wahroonga. (The hospital was a large converted house at Hornsby, which had once been the home of my maternal grandparents. Now a shopping mall stands upon its site.)[1]

How discreet Olive is, referring to the tent as her 'country home'! On another occasion, she described it in similarly non-judgemental terms as her 'canvas home'.

Once again circumstances meant that she and Ross had to write letters to keep in touch. He was a prolific correspondent. On one day alone, Olive received three letters from him. They make for curious reading, in many respects (two from November and five from December are extant). They are loving – opening and closing with endearments – but not once does he mention Olive's pregnancy or ask how she is feeling, either emotionally or physically, as the birth of their first child approaches. Nor does he enquire about what she is doing, respond in any detail to what she tells him in her letters (unfortunately none of hers from this two-month period have survived), or ask after her family and the close friends she was seeing, some of whom he knew well. Instead, he is preoccupied with his work and a multitude of problems. His letter written on Christmas Day does not refer to the imminent birth, or the far smaller matter of Christmas, when the Cotton family enjoyed low-key celebrations at Newport. Five days later, on 30 December 1946, Sally was born at St Kilda Hospital in Hornsby. John McInerney

responded to the joyful occasion with a very generous gift of £50, obviously recognising that Olive sorely needed money. George and Ena Dupain sent their love in a congratulatory telegram, indicating that ties between them had not been broken after Olive and Max's divorce.

After Sally's birth, Olive went back home to Blackett's for a few weeks at most. At the end of March 1947, Ross was writing to her again at Lyeltya, where she and Sally stayed until the end of June. Her next stint at Blackett's, in the depths of winter, was similarly brief, lasting only the month of July. She returned to Sydney with Sally in early August, spent a couple of weeks at the Annands' home at 5 Princes Road, Lindfield, and then relocated to Lyeltya until the end of September. The absence of letters for October and November suggests that they were probably back in the country during these pleasant springtime months. Not for long, however. Ross's correspondence resumed in early December and continued uninterrupted through the summer until the end of February 1948. What this means is that, in the first eighteen months of their marriage, they spent no more than four months together at Blackett's, and probably enjoyed only a few extra days on the odd occasion when Ross could get away and join them either in Sydney or Newport.

In keeping with the pattern established before Sally's birth, Ross's correspondence remained full of copious detail about the hard, physical work he was doing, loading and carting hay to earn money. He also outlined the seemingly endless mechanical troubles he, his brother Bryce and their neighbours were having with their trucks, which were likely to have been old and difficult to fix, with spare parts still hard to come by immediately after the war. As before, he did not express any curiosity about Olive's life and, even more surprisingly, asked nothing about their new daughter. Another worrying element re-emerged, as his now familiar tone of complaint started tipping towards self-loathing and self-pity. In April 1947, when he was unsure whether or not Olive had written to him, he responded:

Perhaps you think there's not much point in writing anyway. Shall send you some cash as soon as I get some. I know I'm wrong but I'm damned if I know how I can manage. God knows *I'll* [crossed out] I might always be too damned poor to keep myself alone even – that 'myself alone' is appropriate.[2]

In a postscript to the same letter he went further in expressing his negativity:

I would like you to mention in your letters what you'd prefer to do in the matter of coming up here to live, staying down there, or what. Perhaps by staying down there you would be best off. For my part I am frequently heartily sick of being here – no doubt it is really a feeling of disgust with myself. It should be.[3]

Olive remained characteristically upbeat, reiterating how glad she was to be with Ross and to have married him. After admiring the 'youthful bloom' of her brother Les's female friends who were all dressed up for a party, she felt 'a bit ancient', but for Ross's benefit pointedly remarked: 'Still, I wouldn't want to be that age again, I'm well content to have the past behind me and very very happy to have you and Sally, Darling.'[4] With Sally now six months old, and Olive about to turn thirty-six, she was keen to get pregnant again, telling Ross: 'I'd really like some more children Darling, it would be well worth all the effort.'[5] The initiative, it seems, was hers and perhaps he needed persuading.

The letters also shed light on the couple's financial difficulties, as they tried hard to establish themselves as farmers. In a particularly important letter written in September, Olive reflected on their situation and effectively took charge, trying to galvanise Ross into action.

I was glad to know that all the picking up was finished, but the weather has certainly been against you. It is discouraging to

realise that most of your cheque will have to pay off debts, but
still, Darling, we'll be on the right side of the ledger, and there
are lots of people who seem to live on an overdraft all the time
and who would give anything to be in our position. I think
it will save us a lot of worry if we could learn to 'budget' our
expenditure. I don't really think we've ever been extravagant
(except for those walnuts!) and the things we've bought have
been worth the money and are really necessary. But some
things are more necessary than others: I suppose groceries
would come first on the list and then transport expenses –
petrol etc. If we could estimate how much those two items
would cost us for, say, three months, and build up a reserve
of that amount in the bank, then when everything else had
been spent we'd know we were really down to 'bedrock'. That
way we'd have three months warning that we must go very
carefully and enough time in which to find ways of earning
more money, and we'd know we couldn't spend money on
anything but the bare essentials until the reserve had been
built up again. When we have a fair sum of money in hand
it's terribly difficult to keep a sense of perspective, and it's all
gone before we know where we are! This sounds a bit grim I
suppose, and it's going to be very hard to build up that reserve
in the first place, but I think it would be worth it for the worry
it would save us. What do you think anyway, Darling? By the
way, I'm convinced that tobacco is one of the essentials to the
man on the land – it's part of the 'groceries'!

If the old Rural Bank could arrange for us to draw the
'Diggers' Dole' I think we could save something. Would it hurt
to tell them when you see them that you had to spend most of
your capital on your wife's medical expenses and have delayed
seeing them <u>until</u> you'd saved up enough money again?

... I do feel that until we are living on a place of our own
and are quite independent of anyone else that our finance
will always be in a muddle: – we just can't help it because we

haven't full control of things under present conditions. Am I talking like a penny-pinching financier Darling? I'm not really, and I know that I have the most generous of husbands. I'm just trying to think of a way for us to build up some feeling of financial security. I hope you understand, Darling; and if you disagree with me, say so, I won't be hurt, for I think that discussions often lead to the best ideas of all.

Oh Darling, I do miss you, and want us all to be together again for always. I love you so very very much.[6]

Along with a strong sense of Olive's energy, drive and practicality, this letter gives a hint of the complexities of Ross's character, and how she was learning to deal with them. She tries to ameliorate his worries with a positive attitude and lavish praise, telling him he is the 'most generous of husbands'. A few days later, she and Sally had left Lyeltya and were back at Blackett's for another short stay. This ongoing to-ing and fro-ing suggests that her best way of coping both with life in a tent and with Ross was by removing herself whenever she could.

* * *

By December 1947, Olive had returned to Lyeltya once again, and was in the early stages of her as yet unmentioned pregnancy with their second child, Peter. She managed to convince Ross, for a short time at least, that the future would be better. In one letter, written three days after another Christmas apart, he empathised with her and sounded marginally less despondent:

Dearest Sweetheart Darling
It was good to hear you today [presumably they had booked a phone call] and to feel that you've not decided to abandon me even now. I mean Darling that after all you've been through it would not be surprising if you did because you must be tired of all this waiting and uncertainty.[7]

Olive's letters over the next few months continued to be extremely loving and filled with endearments: 'My Dearest Sweetheart Darling', 'I send you all my love and hugs and kisses and everything, always. Take care of yourself, won't you sweetheart. I do love you, Olive.' She cautioned him to look after himself: 'Don't lift loads that are too heavy just because you are so strong, Darling ... All my love, my sweetheart Husband and hugs and kisses and everything, always. I love you, Olive.'[8] She was anxious about trouble Ross was having with their '"mad" or quarrelsome neighbours', but confident he could handle it. And she continued to reassure him that she had no regrets about marrying him, adopting a tone that was diplomatic, solicitous and affirming. 'My Dearest Sweetheart,' she wrote, a little over two years after they had married:

> Yes, of course I'm glad, so very glad, that I met and married you. And I'm just as homesick for you Darling, as you are for Sally and me. You say you hope I find some good in you, – I guess it's time I did sit on your knee again, by the firelight, and told you all the things I love you for. It would take a long time, Darling, and the list would never be complete because you're always giving me some new reasons for loving you.[9]

How much he needed this kind of energy from her, which, over time, transmuted into selflessness on her part. And how exhausting her endless, often fruitless negotiations with him must have been. She was convinced, however, that they would find 'a way out', presumably of their penury, without jeopardising his wellbeing and forcing him 'to live in circumstances which would make you unhappy'.[10] If he was the most generous of husbands, then surely she was the most obliging of wives.

* * *

When Olive moved to the country, the effects of war were still very present in Australian society. The names of the young men who had been killed were being added to existing or newly erected war memorials in the little towns spread across the district. In Boorowa, the details for Ross's friend Ned Leake were recorded on a plaque on the memorial's external wall. Ross would have known many of the men on these honour rolls, and their families; the McInerneys could count themselves lucky that all three sons had survived and returned home uninjured. The Labor Government was in power federally, led by Prime Minister Ben Chifley after John Curtin had died in office in 1945. Rationing of meat and clothing finally ended in 1948, the same year that the first Holden car was produced (the sedan cost £760 when the basic weekly wage was £5/19s), and artist William Dobell, whom Olive had met a few years earlier, won both the Archibald Prize for portraiture and the Wynne Prize for landscape painting. The following year, the Australian population reached eight million, and in the federal election the Liberal-Country Party formed a coalition government with Robert Menzies as prime minister, a position he would hold until 1966.

Much about Olive's post-war experience was standard for women of her generation. Once the men returned from war service and took up their old jobs, women's participation in the workforce shrank and they were expected to devote themselves exclusively to the roles of wife, mother and homemaker. But, as the snapshot of the tent at Blackett's makes clear, her circumstances were highly unusual and extreme. They were also dramatically different from the relatively privileged urban life she had previously enjoyed, with her family and with Max. According to Olive's daughter, Sally, there was a precedent for Olive's revocation of a comfortable material life for love and idealism, which she may have taken to heart. Olive was well aware that her grandmother Evangeline had begun her married life with Frank Cotton in a hut in a timber camp, in regional New South Wales.

For me, the image of the tent is both sobering and poignant. This is not simply because it documents Olive's changed material circumstances – after all, people made all sorts of sacrifices in order to establish or re-establish themselves in the post-war period. Nor is it because of the raft of pressing practical issues it brings to mind: how to deal with excessively hot summers, and winters that were so cold they even brought snow; how to do the washing for your family and where to dry it on rainy days; where to put your belongings, clothes and books, when space was so limited? Instead, it is what the tent represents for Olive's photographic practice. Living like this obviously meant that, for the time being at least, her pursuit of art photography would be difficult, if not impossible.

* * *

The tent was the family's first home. Their second was a tiny rented cottage on a property near Koorawatha, where they moved towards the end of 1947. Perhaps the charged emotional exchange between Olive and Ross in April that year, and his uncertainty about whether or not she would return home to him, spurred some decisive action. Though very modest, the cottage dramatically improved their material circumstances.

Over the next few months, Olive and Sally continued to spend extended periods away at Lyeltya. In her letters to Ross, Olive tried to weave connections between the two of them, their daughter and their respective families. She was proud of what they had already managed to achieve in their new garden and ever optimistic about what she felt they would accomplish together.

> I like to hear about the hollyhocks and cornflowers (they're
> wonderful flowers to keep on blooming like this!), and
> geraniums and our special wattles. It makes me feel that we
> have the beginnings of our garden and home already.[11]

The young almond trees were yielding a good harvest and she had obtained some cape gooseberries from Olga Sharp, which she planned to use for seed in their garden. Olive praised Ross for saving fruit from being wasted by making jam, and listed the winners of the White Leghorn poultry sections at the Royal Agricultural Show in Sydney, in case any of the names were familiar to him. Her news of Sally was positive. She was teething, playing, standing up in her cot, and charming her grandmother Tommy, who thought her first grandchild was very pretty: 'I don't think I've ever seen Tommy so spontaneous in her praise about anything before.' Sally had received her first diphtheria injection – 'She cried a bit I'm afraid, poor little girl' – and behaved well when her Aunt Edna looked after her so that Olive could have some precious time to herself. Olive reported that Sally 'didn't make a fuss, and played quite happily all day. I'm glad that I can leave her like that now, because it would be bad for her to become too dependent on me alone.'[12]

Understandably, however, her main preoccupation in early 1948 was her pregnancy and arrangements for the birth of her second child. She considered having the baby in Sydney, where she could call on friends and family for support and care of Sally, but in the end Peter was born at Cowra Hospital, on 2 August 1948.

Olive had wanted children for many years and her family was now complete. On the other side of the world, living in Panama with her husband, Bill Bailey, Jean Lorraine was also embarking on motherhood and confided in Olive about the joy it brought her: 'Isn't it wonderful having children, Olive? Even though they take everything, they're the most wonderful things in the world. I think we are very very lucky.'[13]

From Sally's perspective, her and Peter's early childhood was a wonderfully rich amalgam of the natural and familial worlds. She wrote:

We lived in a tent in a clearing, surrounded by palisades of stringybark trees and very tall men. Gang [her grandfather

Daniel McInerney] and Tommy's bark hut stood close by and
I was their first grandchild. There were old steam engines like
rusting elephants amongst the wattle trees, crowds of birds, a
white cat called Snowdrop, a one-legged white cockatoo, and
there was a lot of talking by the fireplace in the hut at night.
Gang's peacocks gave their lonely cries from the roof of the hut
where they roosted away from foxes, and Tommy kept their
feathers in a vase instead of flowers.

　… My brother and I played with the marvellous basic
materials of nature. Ducklings, pups and kangaroos were
sometimes our companions.[14]

There were attractions in living close to nature, but there were
also major worries. Olive's greatest fear, her sister-in-law Haidee
remembered, was that the children might wander off into the bush
and get lost. The unstated anxiety was: what would happen to her
photography?

Trying hard

Olive knew what she wanted from her new life in the country – to be with Ross, have children and create a family, live productively on the land and continue leading a creative life that encompassed photography, modern art and design, and music. She believed that, together with her new husband, she could make things happen and was determined, very determined, to do so. I am certain that she was not imagining, or even entertaining, the possibility of renouncing her former life as a photographer, as articles in the print media would erroneously assume when she and her work came back into public view decades later.

In the first months and years, she made a valiant effort to stay connected to the art and design scene in Sydney. She stayed with the Annands often and enjoyed their creative household. On one occasion, she went to see Professor George Korody and Miss Elsie Segaert, advocates of modern design and founders of the influential Artes Studios, whom she first met through the Dupain studio. She was very taken with their well-designed, stylish furniture, demonstrating her appreciation of a highly refined, European modernist aesthetic. She hoped that she and Ross would be able to purchase some chairs in the future – 'After the tractor and the Renault and a good few other things of course!'[1] She attended to the care of her piano, which they had left at her father's place, putting some naphthalene flakes inside it and washing off the mildew that had appeared on the keys. Her expectation was that she and Ross would soon be able to accommodate it and she

would then resume her playing. 'It is horribly out of tune, but that's nothing to worry about.'[2]

On other visits to Sydney, she helped Olga Sharp with some printing (because Olga's sight was deteriorating, she couldn't check the sharpness of her prints), and at her brother Franks's place did some printing of her own recently exposed negatives using an enlarger he had made for her. In keeping with the Cotton family's creative streak, Frank, an inventor as well as a dentist, fashioned the enlarger out of recycled and low-cost materials. Olive explained to Ross:

> Its chief ingredients are the lens and bellows of an old vest pocket Kodak, and a tin the size of a medium billy. It has its limitations, of course, and is no good for dense negatives, but, as you see, one can get a fair enough result with it. It is much more compact and easy to handle than Les' contraption, and Frank tells me I can keep it! I'm quite thrilled about that. He's had a few more ideas about improving it to-day, too.[3]

She was happy with photographs she had taken of Sally and sent some of them to Ross.

However, the colour and energy associated with her photographic practice during her years in Sydney evaporated quickly. There were no more encounters with the creative people who were the studio's clients: the likes of artists Margaret Preston, William Dobell and Arthur Murch, Ballets Russes ballerina Hélène Kirsova, publisher Sydney Ure Smith and writers such as Eleanor Dark. Contact with them, whether formal or informal, had stimulated her and nourished her creativity. Leaving her professional life meant that she effectively disappeared from the public sphere she had occupied through her photography since first exhibiting her work in 1932. Moving to a remote area of central western New South Wales inaugurated another kind of disappearance in an increasingly urbanised culture that showed little interest in what was happening in the regions.

There is no question that Olive's desire to take photographs was as strong as ever, and with her characteristic resourcefulness, adaptiveness and optimism she worked out a way of continuing a practice of sorts. At the age of eighty-seven she explained that in these early years in the country: 'I still kept taking photographs with my old Rolleiflex camera and had the negatives developed at the town chemist, always with the thought that one day I might get a darkroom of my own and be able to print my negatives.'[4] Photography seemed to be ideal for her circumstances because of the way it can be broken down into its constituent parts, akin to making a drawing for a painting, a matrix for a print or a maquette for a sculpture. Each part of the process – exposing a negative, processing it, and making a print – is self-contained and can be separated from the next stage for as long as necessary. This meant that, as a mother with two small children, Olive could continue to act creatively as a photographer, seeing the world in her photographic way and committing her vision to film. Photography itself enabled her to persist.

Spring Forest

The purchase of Spring Forest in 1949, a 500-acre property with a two-room cottage, made possible with a combination of their savings and a mortgage, was a great relief to them both. Olive was at Lyeltya when she received the news in a telegram from Ross, and she responded immediately: 'needless to say I'm very happy about it all.'[1] The protracted uncertainty about where they would live was finally over and at last they could think for the long term. The closest settlement to Spring Forest is Koorawatha, once a thriving town, situated on the Olympic Highway between Cowra and Young, 340 kilometres from Sydney. The property's previous owners, the Hickey family, had bestowed on the property its poetic name; after Mr Hickey's death in 1946, his widow decided to sell up and live in town.

The McInerneys moved to Spring Forest around August, Sally and Peter now aged four and two. Their new home was a cottage sited on the gentle slope that rises from the creek at the bottom of the property. From its front verandah, there is a view of the dirt road that curves around a bend and leads to the Lachlan Valley Way, half a kilometre away. Built in 1912, the cottage is in the classic Australian vernacular style: raw timber weatherboards, corrugated iron roof, a centrally placed front door with a room on either side (there was no hallway), a small kitchen behind the main rooms, and deep verandahs at the front and back. The children slept in an addition at the back built of corrugated iron and unlined. There was a fireplace in the main room, which served as the living and

dining room. It 'had a warm lived-in feel, with a bookcase and books about birds ... a settee, a small table and a car seat from an old Morris with a sheepskin draped over it – Ross's favourite armchair'.[2] The cottage wasn't painted outside or in, the wooden floorboards were uncovered, and there was no insulation, running water or electricity. It was left as it was for the twenty or so years they lived there.

Olive and Ross didn't share a bedroom in the cottage. She slept in her own room, the one opposite the living room. Her piano, moved down from Sydney after she had saved the money for its transportation, was kept there and she played it when she could. Ross slept outside on the front verandah, his narrow single bed tucked into the corner for some protection from the weather.

As with Blackett's, the setting at Spring Forest was remote. Olive later said, 'We were very isolated. We had to walk a mile before we could even see another house anywhere at all. And when he was young, if we had a visitor, Peter would hide behind a tree, he was so unused to other people. He can't believe it now.'[3] Socialising revolved around their families, with some of Ross's siblings and their expanding families living nearby. They rarely entertained their neighbours or local people; Ross's sister, Haidee, recalled that Olive did not have friends in the area but was not fazed by this. They did not have a car for the first few years and Olive did not learn to drive until the 1960s. She relied on Ross for trips into town, which were for grocery shopping, rather than socialising. A shared phone line, known as a party line, was installed at the cottage in the late 1950s, but Olive also continued writing letters to keep in touch with friends and family in Sydney. Members of the Cotton family made occasional visits: Leo and Lilian would stay at a hotel in Cowra, while others camped on the property. And there were annual trips to Newport to look forward to; Olive and the children routinely spent their summer holidays there, staying at Leo and Lilian's. Ross would drive them down but could only stay a day or two because the livestock, chooks and garden needed tending.

Money remained in short supply. Ross earned small amounts – cutting timber, fencing, raising sheep and cattle, and, later on, selling honey extracted from hives he kept on the property – but it was only ever enough to cover their basic needs. Leo was not in a position to help them out because of his own reduced income, as he explained to Olive in a letter written on New Year's Day, 1950:

> It has been a bit of a financial strain last year as my income dropped by 1100 pounds a year, and we [he and Lilian] spent all our ready cash in furnishing and extending our home [Lyeltya, in Newport].
>
> Living costs have increased enormously … last year food alone cost us 3 pound per head per week – and costs are still rising. … income has shrivelled to about half its normal yield. However we have come through by using capital from land sales.[4]

Aunts Ethel and Janet were sympathetic to the family's difficulties and sent them blankets and second-hand clothes to ease the financial pressure. This enraged Ross – 'Send something decent!' he is reported to have said – but they kept the items and put them to good use.

In the yard behind the cottage, Ross erected a chook run and established a productive vegetable garden, which he cultivated. Sometimes, though, food was short. Haidee remembered the family at one point having to rely on crumbed rabbit and pumpkin pie for several weeks; rabbits were never in short supply and Ross shot them not only for food, but to supplement their income by selling the skins. The Cowra district had a thriving rabbit trapping industry until the 1950s and local workers could make more from rabbit skins than from raising sheep for wool or from manual labour. When working as a shearer's cook for his brother Bryce, whose farm was a few kilometres away, Ross would sometimes bring home a sack of

leftovers – a cornucopia of damper, bread and scones. Olive cooked the standard fare of Anglo-Australian households in the fifties, with dinners consisting of meat and vegetables; cooking was not something she ever particularly enjoyed and she was known for regularly burning the saucepans. Ross was the better cook, having gained considerable experience in the army, but he insisted that she continue to prepare their meals.

Tensions in the marriage were increasing. During the summer holidays of December 1952, when Olive and the children were in Newport for their usual five-week break, Ross was feeling contrite about his behaviour. He apologised to Olive and vowed to improve:

> Darling, although it's only a week since you all left me [to go
> to Newport] it seems an age. I hope the next few won't seem
> as long. I know now how to appreciate you and all you have to
> do here in the way of work – and I won't ever leave the wood
> again.

A day later he apologised once again for not helping her:

> Goodnight my Darling wife. I love you very, very much. (I
> sound all right in a letter don't I?) Anyhow, Darling, I shall
> strive to help you (for instance by doing some of the chores,
> which I *should* do) and to be not quite such a beast – only in
> some ways though mind you.
>
> Good night, Darling. All my love (for what it's worth, I
> suppose), Ross.[5]

Their difficulties persisted. A year later, with the family again installed at Newport for the summer holidays, Ross tried to assure Olive that he did not take her for granted, and sought an affirmation about her feelings for him. He was afraid that she might have stopped writing to him and was unusually reflective about their situation:

Goodness Sweetheart, how glad I am that it's you I married (hypocrite, you say?). No darling, I mean that and sometimes even I'm glad that I am just me and I hope that you think that sometimes too.

The trouble with me is that I don't see enough people, often enough, to remind me that there is none like you, Darling. People don't like comparisons but I have often consciously or semi-consciously compared you with the person I've just spoken to ... I'm not making these things up Darling (I haven't the imagination for that) but I suppose I should tell you.[6]

When they moved to Spring Forest, Ross was thirty-one and Olive was just two years away from turning forty. Her expectation was that they would clear land and begin to farm, earning money from livestock and crops. Her letters, both during the war and in the immediate post-war years, made that very clear. The land they had bought, as they well knew through the McInerneys' long association with the area, was not prime farming or agricultural land and drought was an all too common phenomenon in the central west of New South Wales. But the creek flats at the bottom of the property had good soil, and the sprinkling of successful farms around them proved that earning a reasonable living from grazing and cropping was possible. Haidee and her husband, Ray Turner, made a go of it at the farm adjacent to Spring Forest, which they moved to in 1966 with Haidee's children from her previous marriage. They raised sheep and cattle and improved the pasture with fertiliser, which, Haidee recalled, led to a problem for them: because of Ross's inaction kangaroos slept at Spring Forest without disturbance during the day and grazed in her paddocks at night, competing with her stock for valuable feed. She was the one who had to shoot the kangaroos.

Somewhere along the way, Ross decided not to work the land. This was probably not a sudden decision tied to a revelatory event. It is more likely to have evolved slowly, even subconsciously. The

1950s were when Ross grew into himself – in a complicated sort of way. Older and more experienced in life, Olive also had the benefit of an even temperament and positive outlook. She knew who she was and what she wanted. How did she feel when Ross abandoned what she must have assumed was a shared dream and agreed plan? When it became obvious Spring Forest would never be a working farm and Ross would never be a conventional farmer?

In Haidee's view, Ross had been side-tracked by the war. His course in life might have been very different otherwise – he was clever, very capable with his hands and adept at all things mechanical, and was very good with animals. She felt he wasted his mind and his time talking too much and having too many cups of tea. Despite her sisterly love and sustained efforts to understand his motivations, she 'couldn't fathom him'.[7] She also suspected things would have been different if Olive had been stricter with Ross from the beginning of their relationship and had trained him better as a husband and father. Haidee thought that Olive indulged him and shouldn't have, as it made his behaviour worse. What she felt he needed was 'a good kick in the trousers'.[8]

The lingering effects of the war on the McInerney men manifested themselves in various ways. Of the three brothers, John, Ross and Bryce, Sally wrote that they 'had come back with no visible wounds from the war, though it had taken them to terrible places; to a child they seemed immensely tall, mercurial men who had fought an enormous bushfire somewhere.'[9] Growing up immersed in Ross's extended family, Sally realised that 'the war still pervaded everything' in both a psychological and physical sense. Military relics lay around their properties and were put to practical use: horses wore ex-army headstalls, and army overcoats were repurposed as extra blankets on their beds. Neither Ross nor John participated in war commemoration rituals, including those organised by the RSL – the Returned and Services League – in Cowra and Sydney. From John's perspective, nothing was to be gained by such activity. On Anzac Day in 1947 he noted in his diary: 'I attended none of the functions

[in Sydney]. The deaths of so many have achieved so little – but many bludgers keep the day (with beer) sacred.'[10]

Within a few years, it would have become obvious to all that Spring Forest would not be developed as a productive farm and the McInerneys' lives would not be conventional.

Much of the property was uncleared native bush, which, in contrast to his neighbours, Ross decided to leave alone. Whether this was due to disaffection or laziness – his 'lack of application', as one relative put it – or whether it was a result of his evolving conservationist views is contested. From Sally's perspective, her father was 'a conservationist far ahead of his time … He felt that humans were only transients on the land and so he never cleared it to sow large crops or to run as many livestock as the place might hold.'[11] Only a small area of land closest to the cottage was turned over to production, and only for the family's needs. Instead, Ross began directing his efforts to propagating native trees, especially ironbarks, to regenerate the forest as a haven for birds and wildlife. The Australian poet Geoffrey Lehmann – who, for a time, was Olive and Ross's son-in-law – later wrote the poem 'Menindee' with Ross in mind:

> Myself I wage no cosmic wars,
> I travel light
> with my five hundred acres,
> half of it uncleared, kangaroo country
> because no one wants
> what it would grow.
> With my bees and yellow jonquils
> and journeys with a carload of calves,
> trading in a small way,
> I survive.

The choices they made meant that they would remain poor, sometimes desperately so, and the task of supporting them financially would increasingly fall to Olive, not Ross.

Her behaviour was non-conformist, too. She did not define herself as a farmer's wife and was firm about what she would and would not do, as Sally later eloquently explained:

> Olive was not much like other mothers; she never had her hair permed in the style of the times, never joined any rural groups or associations and did not surpass herself at primary school picnic days when tables groaned with a dazzling display of cakes and biscuits (she once laughingly referred to 'the awful labour of making a sponge cake') …
>
> Though she loved the bush and the countryside, Olive always preferred animals to be in their natural state and at a distance: rather a difficult viewpoint for a farmer's wife. Ross, however, could charm birds out of trees and calm injured animals while he doctored their wounds. Olive never learned, or wished to learn, to ride a horse or milk a cow, and the behaviour of dogs was distasteful to her; nor did she feel motherly towards the intemperately bleating 'poddy' lambs, brought in beside the fire in winter, that kept scrambling out of their cardboard boxes and getting under her feet while she was trying to prepare dinner. She had been on (rather than 'ridden') a horse on only three occasions, all of them un-salutary…[12]

What Olive most appreciated about living at Spring Forest were the alternatives it gave her – more than anything else, she loved 'the space and freedom'.[13]

* * *

Most of Olive's time during the 1950s was consumed with caring for her young children. Sally began her education in a correspondence school program, which her mother oversaw, but in 1954 she and Peter, who was now of school age, began attending the local one-room school four kilometres away at Cucumgilliga. Olive was

keenly interested in her children's education and sympathetic to progressive ideas as a result of her own liberal upbringing, her professional experience at Frensham and familiarity with her aunts' enlightened views. Aunt Ethel continued to publish influential primers on spelling and maths. Her last book, *The 'Cotton' primary speller* (1955), came with an endorsement from the New South Wales Inspector of Schools, who wrote that Ethel's speller 'has been indispensable in Lower Primary Classes for years. Its author has a genius for handling spelling in all its aspects.'[14] The primers Ethel wrote were prized items in the McInerney household.

* * *

At Spring Forest, options for Olive's photography continued to be minimal. So far as biography goes, this raises some fundamental issues. For me, her primary attraction as a subject is her art photography, that which represents an invested, sustained investigation of the aesthetic and expressive possibilities of her chosen medium. But, for eighteen years, from 1946 until 1964, for very understandable reasons, there are few photographs to consider. There is also a dearth of biographical material that might give an insight into the workings of Olive's inner life. It was in these years that she was at her most remote and her life became almost irretrievably private.

In addition to the demands of marriage and motherhood, practical matters impeded her photography: there was no electricity to run a studio or darkroom and no running water, which were both essential for processing and printing. Also, the land around Spring Forest did not lend itself to her landscape photography. It lacks suitable natural features – gently undulating in some areas, flat in others, it is mostly given over to farming. Her best strategy for securing some pictorial interest was to home in on an individual tree, or a small group of trees, rather than a larger scene, which was intrinsically bland.

However, Olive did not stop taking photographs. As in the war years, her pragmatism came to the fore: if it was not possible to progress her art photography in ways she might have hoped, then at the very least she could continue by photographing whatever she could, whatever was close at hand. During the 1950s, her main subjects were her children and the unremarkable aspects of family life. She later said: 'I always carried my camera with me on fine days when I took the children out to a favourite playing place', and every year chose one of the resultant photographs for a homemade Christmas card for family and friends.[15]

Photographing her young children also had an aspirational dimension. Olive had in mind a project extending beyond the familial realm – a book on childhood in the country. It would build on the very rewarding work she had done for Winifred West in *Sturt and the Children's Library*, and would comprise a narrative combining her photographs and stories written by Jean Lorraine. Jean was living with her husband in the United States and the two women kept in touch through letters. Because of her isolated and complex circumstances, Olive could not develop the project, but she never entirely let it go, still hopeful in her eighties that a version of it would come to fruition.

I do not want to belittle the photography Olive did produce in this period because it is valuable in its own right. Her shots of her children, Sally and Peter, are thoughtful and warm, and their naturalness is appealing. As Olive said of a snapshot from this time – showing Ross drying a nappy over an open fire – 'It's not an aesthetic photograph, but it's part of the story'.[16] This helps explain the significance of another photograph she simply and evocatively titled *Children's garden* (c.1952), which she singled out to represent the first phase in her life and work at Spring Forest and which is now her most frequently circulated image from the 1950s. Years later, she explained what lay behind it:

A magnificent flowering plum tree in a neighbour's orchard attracted me to the spot where my children and their friends

Children's garden, 1953, National Gallery of Australia, purchased 1987

were all absorbed in their pursuits on this beautiful spring day. It seemed a paradise garden where children could do as they pleased.[17]

The composition is non-hierarchical and dispersed. Different elements – young children, a sheep, blossom trees – are all treated equally and are interwoven and interdependent in compositional terms. But, while this photograph of a self-declared 'paradise garden' presents an idyllic scene symbolising harmony and freedom, it ultimately lacks the aesthetic resolution of Olive's most memorable Sydney work. It is nonetheless 'part of the story'.

Olive's accounts of her early photography from the Spring Forest years were invariably straightforward and free of emotion. However, on one rare occasion, she expressed her frustration at not having been able to process her own negatives and prints, telling a journalist:

They'd take ages to come back and then out would come these horrid little square prints which I kept for reference for the day when I could finally print them up properly.[18]

The lack of her own darkroom was only one impediment; the cost of film and processing was another. At Spring Forest, the interval between the taking and making of a photograph, between exposing the film, developing and printing, became more and more extended, and Olive had to contend with perpetual uncertainty about when she could finally complete the act of photography. What was lost in this drawn-out process was any chance of analysis. She could not enter into the crucial process of assessing, judging and decision-making about what worked visually, and what did not, before progressing onto her next photographs and potentially a new phase in her practice. This should not have been a luxury, but it became one, and had a severe impact upon her creative expression.

Because the first eighteen years Olive spent at Spring Forest are mostly inaccessible to conventional biographical method, it is

necessary to rely on other kinds of evidence – anecdotes, gossip, memories and reminiscences – to give some sense of her. It is an odd but productive mix, which also serves as a reminder that during this decade a life was well lived – privately. This is the period when the idea of 'the long littleness of female life' seems particularly apt.[19]

On flying and other personal matters

Once, on a very memorable occasion, Olive had a chance to fly with Ross's brother John, who was visiting from New Guinea, where he was working as a medical officer for the Sepik district. They took off in his small Auster plane from a makeshift runway in a paddock near Spring Forest and, as they ascended, she photographed their property from the air. One of these aerial views was published in the ornithological magazine *Emu*, identifying the habitat of the Gilbert whistler, a species of bird discovered by Ross, who is referred to in the article as 'a most reliable local observer.'[1] Olive enjoyed her experience but in her photographic practice she never celebrated a love of speed or the forms of transportation, such as aeroplanes and cars, typically associated with modernism. Her photography came not out of movement but its exact opposite. For years it had been dependent on her capacity for stillness, watching and waiting. Being airborne in a noisy little plane would have given her a new sense of space and extent, stretching the personal bonds of connection as her home and the figures of her family grew smaller and smaller, and correspondingly less legible and more abstract. As air travellers know well, such an experience of detachment and disembodiment – celebrated by artists from the early 20th century onwards, when aerial photographs began to be widely circulated – can be both disorienting and exhilarating.

For Olive, seeing the world from the air would also have been affirming, due to the way an aerial view draws attention to the smallness of humans and human activity in a larger geological and physical landscape. This is something the daughter of a geologist would certainly have appreciated.

For the McInerneys, however, flying became associated with personal tragedy. On 16 March 1953, John McInerney's plane crashed into the sea after taking off from the small town of Vanimo in New Guinea. The two passengers survived but John did not. His death devastated his family and friends and had enduring ramifications. A short time afterwards, a stranger, a grieving woman by the name of Ree Rawling, turned up at Spring Forest unexpectedly. She was John's fiancée and was waiting in Sydney for him to return to her and her two children from an earlier marriage. Olive recalled that she brought with her 'a suitcase full of white shirts for him [John], all pressed and laundered, because he'd been about to come back from New Guinea, and now she just didn't know what to do with them'.[2]

John McInerney was an adventurous man who had travelled in China and Borneo and been taught to fly by Bobby Gibbes, a Second World War fighter pilot. As a doctor in New Guinea, McInerney was much admired, flying into remote areas along the Sepik River to assist seriously ill patients who had no access to medical services. A friend from the army, Paddy Kenneally, remembered him as 'a wild, tough boyo: there wasn't a mountain, a river or a swamp that would prevent "The Doc" getting to a man needing his attention'.[3] Ross recounted how, on one occasion, John 'delivered a woman of twins in the plane, while he was flying it'.

While he was admirable in many respects, John McInerney's behaviour was also unpredictable, with some regarding it as risky and potentially self-destructive. Friends worried about the direction his life was taking and the dangerous combination of his drinking and flying.[4]

Born two years apart, Ross and Jack (as Ross called him) were especially close. During the war years they were linked together

even more tightly by the time they spent together in Sydney. Geoffrey Lehmann's poem 'Jack' (published in the collection *Spring Forest*, 1992), expresses a younger brother's adulation of his charismatic older sibling:

> I was Jack's audience,
> the younger farming brother.
> Jack,
> fatal for girls, fatal for himself,
> my mentor and guardian in the city
> of wartime parties, floating populations.

Jack and Ross looked alike and their voices, as sometimes happens with siblings, were virtually indistinguishable. Lehmann wrote of this, too. His poem 'The future of the past' evokes an incident that occurred during the war when Ross was mistaken for his brother.

> Talking in a tent during the war
> I heard a stranger in the dark
> shout from another tent,
> 'Hello! Jack, you old bastard!'
> (Jack and I had the same voice)

Some say that Jack's death sowed a seed of fatalism in Ross, which grew slowly, but everything suggests he was well along that path by then. Everyone agrees that he never fully recovered from losing his brother. Reflecting on Jack's death decades later, Ross said: 'I think about him a lot, but it's hard to talk about what I think.'[5]

* * *

There were other sadnesses and difficulties to deal with, exacerbated by Olive's distance from Sydney. In 1951, her friend Maida Annand suffered a debilitating stroke in her forties. Douglas Annand had to

contend not only with Maida's ill-health, but also with a scandal that engulfed him in December the following year and generated widespread media coverage. He was arrested at a block of public toilets in Chatswood, charged with soliciting an undercover policeman 'for an immoral purpose', and found guilty on the basis of fabricated evidence.[6] It took a year for his appeal against his conviction to be heard and upheld. The judge who heard the appeal described the police evidence against Annand as 'a wicked and dastardly lie' and praised Annand's credibility. No conviction was recorded but the emotional toll of the wrongful arrest, protracted legal process and media attention was enormous. Worse was to come with Maida's death on 10 April 1954.

* * *

Still, life at Spring Forest had its lighter moments. Peter recalled how, in the lead-up to the Olympic Games in Melbourne in 1956, Olive and her Aunt Janet wrote a song for a music competition that offered a cash prize. Olive wrote the music and Janet the rousing, patriotic lyrics. Peter remembered his mother banging away on her piano night after night to get the score right, and both he and Sally still know the words off by heart. The cash would have been a windfall for the family but their submission was not successful.

Money-making schemes also preoccupied aunts Ethel and Janet, who worried about their niece's impoverished material circumstances. They encouraged Olive to develop her writing skills in the hope that she could earn money from publishing non-fiction stories, and were hopeful that Jean Lorraine could assist with advice on which American magazines might be interested in Australian material. Janet was full of practical suggestions for Olive:

... store up all your feelings, sensations, impressions,
difficulties, bits of humour and they will all contribute to the
fabric of your writing when the time comes. Regard every

experience as something impartial that may contribute to
a story and feel the reaction in an impersonal way yet in a
human enough way that you could express it for other women
who must have felt the same things but are inarticulate. You
have brains and ability and write well so store all experiences
carefully until the day comes when you have time to write
them.[7]

She was confident that if Olive made quick notes of 'anything human
or interesting in the day's happenings for even twenty minutes' she
would have the basis for stories she could develop later on, when
more time became available. However, no publications eventuated
and the McInerneys' money troubles continued to escalate.

Janet's correspondence is further evidence of how important the
support of women and family always were in Olive's life. There is
no doubt that Olive gained strength from her aunts' unbounded
love and unwavering faith in her. Tellingly, this exchange between
them did not acknowledge Ross in any way. An extant letter from
Janet in 1953 affectionately addressed Olive as 'Honey Child', and
ended by extending 'Hugs and kisses to the children and our love
to your dear self'.

Anecdote

When it came to gathering anecdotes about Olive and Ross, there were marked differences in people's responses. They offered relatively few stories about Olive and invariably used a uniform vocabulary to describe her. The dominant words were, in no particular order:

kind	saintly; 'a saint for putting
humble	up with Ross'
modest	quiet
self-effacing	reserved
warm	sensitive
gentle	caring
patient	hospitable.

Joan Brown, who met her in the 1930s, considered her to be 'a very nice woman, a special woman really'.[1] Haidee agreed with Ross on Olive's non-judgemental attitude, saying that she never made derogatory or uncharitable comments about anyone and always looked for the good in people.[2] She was, some told me, 'extremely smart', 'a brilliant sort of person'.[3]

While Olive's unanimously agreed goodness functioned like a screen hiding her from view, the situation with Ross could not have been more different. Through all manner of stories and remarks, he flared into life. His 'movie star looks' drew frequent comment; he and his older brother John were referred to as the best-looking McInerneys, each possessing 'a fatal charm' that governed their

relationships with women. The language people chose to describe Ross was highly charged, strong, and polarised views were glaringly obvious. He was:

domineering	generous
dominant	cruel
charming	smart
tyrannical	a ratbag
savage	lazy.
cultured	

One person passed on something Ross's father, Daniel, apparently used to say: summoning up the image of an imaginary tennis match, he wryly noted that Ross wasn't happy unless appearing on centre court. A nephew, Bill Johnson, recounted how Ross fell out with almost everyone at some point in his life, including his siblings and closest family members across the generations; he said that Ross had 'a terrible way of turning good things into bad' and was an 'example of a powerful mind not being fully engaged and turning on itself'.[4] One of Ross's granddaughters, Lucy Lehmann, wrote that he was 'jealous, bitter, bad-tempered – the list goes on until it ends with "strangely charismatic"'.[5]

People told me they 'didn't like him'. Some thought he was lazy, others felt he was misunderstood and could work very hard if he wanted to, was clever, had 'a good brain, wild, active'. A common observation was that he did not follow through on activities, abandoning them because he got bored or couldn't see the sense of them. He was also described as being 'uncompromising almost to his own detriment'.[6]

A neighbour, Jean Cook, who had lived near the Cottons in Hornsby, confided that some in Olive's family considered Ross to be 'a no-hoper' and worried about her living conditions at Spring Forest. They didn't think her situation was fair and were frustrated that Ross did nothing to ameliorate it when he could easily have

done so. Jean could not understand, for example, why he never fixed the wobbly brick steps into the new house.[7]

On the dynamic between Olive and Ross, the same divergence of opinion was immediately apparent. In Ross's favour, it was acknowledged that he spent a lot of time at home with Olive; in contrast to other farmers in the district, he had no interest in going to the pub and drinking with his friends (he had stopped drinking as soon as they were married). Other comments were negative, and sometimes painful to hear. Ross, I was told, 'was often quite rude to Olive, would interrupt her and get short with her', whereas she was always kind and concerned with making peace: 'Olive was always there but Ross was the dominant one.'[8] Geoffrey Lehmann, who visited Spring Forest regularly after he and Sally married in 1969, observed that 'Olive, unlike Ross, rarely expressed her opinion.'[9]

The comment that surprised me most came out of the blue during a short, illuminating conversation with a family member. Olive, I was told, was 'meek'. In line with the dictionary definition, I took this to mean that she was unwilling to argue or express herself forcefully, was resigned, submissive, compliant, deferential. At the time, I was unsure whether this perception applied specifically to her behaviour with Ross, or to her character more generally. Now, I feel convinced that it pertained to her dealings with Ross. Meekness was one of her responses. There were others that came and went, resistance and flight among them.

Leaving Ross, one

Among the most compelling stories I have been told was one about Olive leaving Ross in 1954, taking the children with her. Sally was not yet eight years old and Peter was six or so. Sally remembers the incident that prompted Olive's decision – Ross's reaction to the breakfast she had made them all that morning. It was a meal they often ate – white bread in milk sweetened with sugar and heated in a billy – but Olive apparently served it 'once too often'. Ross flung the billy into the garden and some of its contents may have splashed Olive as he did so. Sheepish and chastened after his outburst, he sat watching as Olive packed a suitcase and made preparations for them to leave Spring Forest, unsure about what would happen, whether they would really go. She and the children left on foot. They kept walking until a neighbour came across them, picked them up and drove them to Cowra railway station. They caught the train to Central Station, in Sydney, and for the final leg of their journey, took the bus to Newport, to Leo and Lilian's. Arriving at Lyeltya unannounced, Olive told the children to wait outside while she went in, presumably to explain their predicament. A few moments later, she re-emerged, ushering Sally and Peter into what would become their home for the next six months. Both children attended the local primary school at Newport.

From this anecdote, recounted with the vividness and indeterminacy peculiar to memory – Sally's memory – one unstated fact stands out: the sheer physical distances involved and the difficulties in traversing them. Olive did not drive at that time, and

the spontaneous nature of her decision meant there was no time to make any travel plans. Spring Forest is around thirty kilometres from Cowra. Olive set out with two small children, a suitcase filled with their belongings and no way of knowing exactly how they would get to town, the first and crucial stage of their journey. This alone indicates her determination to be gone and to be gone quickly. There is another telling detail. Sally remembers her mother changing her clothes before they left. She put on her smartest outfit, a chic linen suit that came from her days running the Max Dupain Studio. The A-line skirt and tailored jacket in off-white with light purple stripes still hangs in Olive's wardrobe in her room at Spring Forest.

Newport, like Frensham, gave her time to think. From her experience with Max she knew how bruising and public divorce could be, but then she had at least the advantage of being a working woman with some financial independence. In her marriage to Ross, her difficulties were greatly amplified: he was a domineering man whom the evidence suggests was becoming increasingly inflexible and set in his ways; she had two young children, no work, no state support, no financial security. All this made the prospect of a new start quite formidable. And then there were her father's wishes to consider. Family lore has it that the quietly spoken and possibly bewildered Leo eventually told his daughter that it would 'take ten years off his life' if she didn't go back to Ross – apparently not because he had conservative values and opposed divorce, but because he was pained at the prospect of her going through the process a second time and having to face an insecure future.

Olive may have been hoping in the early years of her marriage that the process of negotiation, of give and take, would lead her and Ross to the kind of midway, liveable compromise some couples successfully achieve together. The possibility of capitulating to Ross's will would have been repugnant. Perhaps, during her separation from him, she was able to devise an alternative strategy of accommodation, turning to the refuge of the inner life, hiding the deepest part of herself, making it secret and inaccessible.

After six months, Olive went back to Ross; whether because she wanted to or felt she needed to, there is no way of knowing. Her and the children's return trip to Spring Forest was made in much less dramatic circumstances than their departure. The family resumed their life in their weatherboard cottage, with the children's schooling governing their daily routine. After completing their primary education at Cucumgilliga Primary School, Sally and Peter went on to Cowra High School. Olive and the children kept up their annual ritual of staying at Newport for two weeks over Christmas, relishing a break from the baking summer heat of the central west.

Cowra High School

The severe financial stress the McInerneys were under was eased in 1959, when for the first time in their marriage, they finally had a regular income. Olive took a job teaching maths at Cowra High School. It had been eighteen years since she had taught at Frensham School and thirteen years since she had been in the workforce. Olive explained how her return to work came about, in an interview in 1991:

> When Sally was to go to high school, it turned out that a maths teacher had left. Sally's primary school teacher asked whether I'd be willing to take on the job. They were waiving the need for the Dip Ed [Diploma of Education] because maths teachers were so scarce. I took a deep breath and said 'yes'. Before the term started I got all the back issues of the Leaving Certificate exam papers that I could and worked through them to get my brain working mathematically again. The new maths master said, 'there are a whole lot of youngsters we haven't sorted out yet in the assembly hall, can you go and give them a lesson to keep them quiet.' There was this crowd of kids sizing me up. I said, 'Do you all know about tangents?' Some did, some didn't, and we managed to fill in time that way.[1]

Cowra High was a government school and the only high school in town; prosperous local families still preferred sending their children to boarding schools, mostly in Sydney. The students attending

Cowra High came from the town and surrounding rural area, from a mixed socio-economic demographic. There were also Indigenous students from the local Aboriginal community who lived on the Erambie Mission two and a half kilometres from the town centre. The school's curriculum was standard for the day, organised into academic and vocational streams as determined by the New South Wales Education Department. Gender divisions in the electives offered were clear, with girls studying needlecraft and home economics, and boys studying metalwork and woodwork. There was a range of academic, art, cultural and sporting activities, which created a lively environment that Olive enjoyed.

Returning to teaching was in many ways a daunting prospect, but Olive was totally committed to doing the best job possible. Former colleagues remember her with great respect and affection as a 'lovely, lovely person', someone who was 'extremely caring and had an excellent sense of humour', 'very gentle', 'shy', 'gentle but determined'. She was older than many other members of staff and was regarded as being slightly old-fashioned in her dress. No-one was aware of her former life as a photographer in Sydney, except perhaps the art teacher, but it was common knowledge that the McInerneys badly needed money and lived in what some colleagues thought were 'shocking' conditions. Olive's frugality left an enduring impression on her fellow teachers. She came into town on the bus with Sally and Peter, and ate a modest breakfast and cut lunch in the staff room. Apparently, her pride in Ross, who stood for the position of a shire councillor in this period, was evident; it was clear to everyone that 'she adored him'.

Accounts about how she fared vary. Teachers recalled that the principal treated her poorly. He bypassed her for the role of the girls' supervisor despite her being well qualified for it and the obvious choice as a senior member of staff. He asked another younger, less experienced teacher to take on the role instead. The same principal became obsequious when he discovered through an article published in the local paper that Olive's father was Professor Leo

Cotton and had been on Shackleton's expedition to Antarctica, but his disinterest in Olive's earlier life and her achievements persisted. The mathematics master was similarly unsupportive, invariably allocating Olive the junior level classes, which were notoriously difficult to teach. Olive later recalled the difficulties she faced but expressed pride in her own achievements:

> The maths master was quite tough. He kept the leaving
> Certificate classes to himself, but I always asked for one. Finally
> he gave me a group of twelve, maybe it was sixteen, for Maths
> 3. 'You won't do any good with them,' he said. 'Those kids
> will never pass. You'll never get them to talk, they're dumb.'
> And they were dumb. Not a word for the first fortnight, they
> just sat there. Their teacher the year before was a very sarcastic
> man. My son Peter was in his class once and came to hate
> maths. Peter has a very good brain indeed, but he didn't pass
> maths in the Leaving.
>
> As it turned out, I found the smaller group an ideal way
> to teach. You could give the theory and examples to work
> through and then go round the class and give each one a bit of
> individual attention. And they all passed. I thought, well, I am
> a good teacher.[2]

While Olive – 'Mrs Mac', as many students called her – was effective with small groups, she struggled to maintain order in larger classes. One former student described the situation as 'bedlam', because the boys played up so much and would not listen to her instruction. Another student, Frank Walker, had a far more positive experience; he considered her to be 'a remarkable woman', and 'an inspirational teacher' who fostered a love of maths and ensured that those who had previously suffered from inadequate tuition went on to complete their Leaving Certificate. He acknowledged her enduring influence on him, later writing that Mrs Mac was one of those teachers who changed his life.[3]

Despite the often challenging environment, Olive clearly enjoyed the intellectual stimulation of engaging with maths after a long break. In January 1961, she attended professional development classes in Sydney, organised by the New South Wales Education Department, telling Ross, who was at home at Spring Forest, that the 'lectures are first class. The maths lectures in particular are so good and so packed with helpful hints and methods, and accompanied by reams of printed-off notes.'[4] A few days later, on 18 January, she communicated her pride in her achievements in the classes:

I'm writing this in the lunch hour, and numbers and
geometrical figures still seem to be floating in front of my eyes
after the usual solid morning of maths.
 I've just had two assignments back from this lecturer with
'Excellent work indeed Mrs McInerney' and 'Fine work
Mrs McInerney – very good work', 'Well done, well set out' on
them – most encouraging. I slipped in my proof of Pythagoras
for him to see and he was most impressed and made a note of
it himself for future use! Anyway these lectures continue to be
very good indeed.

At the end of 1963, however, Olive's employment at Cowra High was terminated after a Diploma of Education became a mandatory teaching qualification at the school. This caused her considerable grief – personally, professionally and financially. The sudden loss of her salary would have been devastating, as Ross was earning a minuscule amount and both their children were still dependents, studying at high school and living at home.

Olive did everything she could to have the decision overturned and, in a letter to Ross a few weeks later, relayed the steps she had taken: she had approached the Teachers' Federation (the union) and they had spoken to a Mr Stephens on her behalf; and she had contacted Miss Doris Wallint, a maths inspector she knew, explained her situation and expressed the hope that she could still be of some

use to the New South Wales Department of Education.[5] To support her case, she had outlined her qualifications and noted that the maths students she had taught had passed the Leaving Certificate. She had also asked if she could submit her alternate proof of Pythagoras's theorem for possible publication in the *Maths Bulletin*; this was additional evidence of her credentials and commitment to her field. Lastly, she explained to Ross that, although she had not specifically requested Miss Wallint to intervene, she was confident that she had given her sufficient background information for her to take up Olive's cause if she saw fit to do so: 'So that really let her know the situation. I didn't ask her to do anything but if she thinks I'm worth keeping she can speak to Mr Stephens for me. I think she will. If not, she's really under no obligation to answer my letter.'

Olive's colleagues at the school also took action, with twenty-five members of staff signing a letter asking that the decision be reconsidered.

While still hopeful that she would either regain her position or secure other work with the Education Department, Olive was developing a plan B in case neither eventuated. By January 1964, she was contemplating a return to professional photography and was gathering as much information as she could on cameras and studio equipment, mounting and framing and on running a business, which she had never done before – at the Dupain studio, Hartland & Hyde had taken care of the accounts. Writing from Sydney, she told Ross:

> I've also been to the Taxation department to find out about
> sales tax, and to see the manager of Kodak's wholesale
> department, and to Swains to get specifications of all kinds of
> mounting boards and paper ...

The shortage of money in the McInerney household meant that purchasing any new equipment was out of the question, so she outlined to Ross alternatives she was considering. She hoped that

the Rolleiflex camera she had purchased in 1937 could be adapted to take an electronic flash, but her most pressing concern was with obtaining a suitable enlarger, an essential piece of equipment for making prints.

> I've found out a fair bit about enlargers, and about prices
> charged for child studies. It doesn't seem worthwhile getting
> a second-hand enlarger. Most of them are rather clumsy. It
> would be better to borrow something from Frank [her brother]
> (as he offered over the phone before going away for his holiday)
> and to get a really efficient one. Of course, if I go back to
> teaching I might be able to buy one on terms.

This letter displays Olive's initiative, practicality and clear-headedness. It also establishes that the task of solving their pressing financial problems was hers. From Ross, she asked nothing. The tone of her letters was especially loving and used the intimate mode of address, 'Dearest Darling', which she had favoured in the 1940s when they were separated during his war service. She signed off lovingly, 'I love you very much my Darling, Olive.'

Despite Olive's best efforts, Cowra High School did not re-employ her and she did not teach again. Opening a studio and resuming her practice as a photographer became the only viable option. With the assistance of family and friends, she began to take the necessary steps to put plan B into place.

The Cowra studio

Once Olive had made the decision to establish her business, the first task was to find suitable premises to rent – affordable and big enough to accommodate a studio, office space and a darkroom. She and Ross secured space in the Calare Building in Kendal Street, the main street of Cowra, well situated for local people wanting to book a portrait or wedding session, have their passport photographs taken, or pick up prints as soon as they were ready. Off the shared corridor were offices for surveyors and the local radio station. Ross and his brother-in-law Ray Turner did the fit-out, using mostly second-hand materials to keep costs down, and Olive retrieved from the green traveller's trunk some of her vintage prints from her Sydney years and pinned them up for clients to admire. *Teacup ballet* was one of those prominently displayed. This was the first public showing she had mounted since leaving the Dupain studio eighteen years earlier.

The eponymous naming of her business – 'Olive Cotton' – was loaded with significance. To Cowra residents, staff and students at Cowra High School and the extended community, she was Mrs McInerney, or 'Mrs Mac'. Very few actually knew who Olive Cotton was. But here she was reasserting herself by reaching back into her past and reviving her working name and identity as a photographer. The hand-painted sign above her door was not in a businesslike font but replicated her signature, the one she always used to sign her prints.

The studio and darkroom spaces were extremely modest and so was Olive's equipment. She was nowhere near as well set up as she

had been at the Dupain studio, with its high-quality equipment and range of different format cameras. Fortunately, however, photographic technology and processes had been relatively stable while she was not active and so she was not greatly disadvantaged by her basic equipment, or by her knowledge and skills acquired decades earlier. Her Rolleiflex camera, though nearly thirty years old, was good quality, with an excellent lens, and black and white photography in which she excelled was still predominant in the commercial sector. Colour photography did not become widespread until the 1970s and was an area Olive went into reluctantly and only peripherally.

Cowra was a small town with a population of five and a half thousand residents in 1966. This did not include local Wiradjuri people, living at the Erambie Mission, as Aboriginal people deemed to have more than 50 per cent Aboriginal blood were excluded from official population figures until 1971. The town's citizens were not particularly prosperous, but since the 1940s they had supported a local photographic business, known as Pardey Studios, which occupied prominent premises in the main street. Olive nevertheless found her own niche. Her workbooks establish that she attracted a steady stream of clients and made a modest income for the first few years, but one that was still well below the teacher's salary they had previously relied on. Their finances did receive a small temporary boost in 1964, the year after Leo's death, when Olive was granted her share of the Channon part of his estate, the surprisingly small sum of £130. Lilian Reed was the principal beneficiary of Leo's will and a portion of the money she was left went to her relatives in England.

As Cowra's newest professional photographer, Olive took passport photographs, portraits of single subjects and groups, and wedding photographs. Portraiture was her undisputed preference, especially when she could work one-on-one with a subject, something she had always enjoyed. Weddings were her least favourite assignments, because of the associated stress – if something went wrong technically with her photography, the wedding and its

rituals could not be repeated, and the appalling prospect of having failed her clients made her anxious. Ross accompanied her on wedding shoots, driving her to the location (their fee included a charge for petrol), carrying her tripod and gear and helping her set up. Although she never said as much, the formality of weddings was also likely to have been off-putting.

The business was a one-person operation, with Olive responsible for the front of house operations, taking the photographs, processing and printing them, ordering supplies and keeping the books. She initially offered black and white prints, or sepia-toned prints, or prints hand-coloured in oils, and different print sizes, with prices graded accordingly. For child studies, a sitting fee and a set of proofs cost £2/2s; three passport photographs, unmounted, cost £1/1s. The largest print size she made was 14 x 11 inches. By 1976, the weekly running costs were approximately $18.50 (the currency had by then been decimalised), with rent and materials the biggest expenses.

In the early years, she was open five days a week. She had obtained her driver's licence but was never a confident driver, and the poor mechanical state of their successive cars and high possibility of breakdowns was a concern. Ross usually drove her into town and at the end of the day returned to collect her. Sometimes Sally and Peter would go home with them too, rather than on the school bus.

The commercial work Olive produced at Cowra presents a challenge to the understanding and appreciation of her photography output overall. In contrast to her art photography, it did not assume the conventional shape of a body of work – what we think of in art historical terms as an oeuvre. Certainly, there was a large group of negatives, but there were no prints; these were immediately dispersed to clients and did not appear in public forums, in either exhibitions or publications. The Cowra works did not belong to Olive as such, but to the subjects of the photographs and those who commissioned them for personal and private reasons. To the photography world, therefore, the bulk of Olive's commercial

photography from the mid-1960s to late 1970s was invisible and remained so until 2002, when Australian ceramicist and long-term Cowra resident Greg Daly set about curating an exhibition of her Cowra work for the town's art gallery. He asked local residents to bring in any of their photographs Olive had taken; from the dozens they submitted, he made a selection for the very popular exhibition titled Olive Cotton: The Unseen Collection.

The photographs Daly chose provided a sampling of Cotton's commercial work and of something much larger as well. Through the exhibition, the people of Cowra – babies, young children, debutantes, engaged couples, bridal couples and family groups – came face-to-face with a catalogue of themselves from a brief historical moment, the second half of the 1960s, when Olive was photographing them. Olive brought to her portraiture her unique mix of engagement and detachment, with each of her subjects treated very respectfully. The success of the photographs pivots on this, on the quality of attention extended to those she photographed. Throughout her Cowra work, the emphasis was on naturalness, which, in the tradition of humanist photography, is equated with authenticity and genuineness. Any suggestion of fakery or contrivance was avoided because, in accordance with her modernist ethos, Olive believed that it was possible to convey more than a physical likeness in portraiture. She expected that her subjects, and those who knew them well, would recognise the individual's character in the portraits.

Stylistically, Olive showed herself to be very consistent, foregoing drama and any hint of excessive behaviour in favour of what might be considered as 'repose', that moment when the subject is stilled and, in being still, reveals something of themselves. The photographs in the exhibition demonstrated her control of her medium after a long absence: the compositions are well organised and the way she used mostly natural light added dynamism and delicacy.

Daly's selection also revealed Olive as a great photographer of children. There are precedents to this work, of course. At the

turn of the century, Harold Cazneaux, in Sydney, made numerous studies of his own children, especially his two oldest daughters, Rainbow and Jean, which are very appealing. Ruth Hollick, in Melbourne, was well known for her stylish, charming photographs of children taken during the interwar period. Olive's photography was unusual because she generally did not photograph children in the studio, preferring to photograph them out of doors at their own homes. She wanted her young subjects to be at ease and as natural as possible, even though they were being photographed and were often dressed in smart clothes in honour of the special occasion. For one commission, she followed 'this active little boy around his garden for what seemed like hours, until finally he threw himself down on the grass, looking up at me for a couple of seconds and announcing, "I'm a whale"'.[1] The boy's announcement represented his imaginative and playful projection and was the instant she made her exposure.

The exhibition, in its modest venue at the Cowra Regional Art Gallery, attracted national attention. Writing for the national paper *Australian Financial Review* in January 2003, art critic John McDonald declared that Olive Cotton: The Unseen Collection was 'one of the most wonderful exhibitions of the previous year'.[2] He remarked that, 'There is an edge to her work ... that sets her apart from the photographic odd-job artists – a quality of vision that distinguishes artist from artisan.'[3] And he elaborated on what he saw as the measure of Olive's artistry, writing that 'anybody can take a photo, but only a great photographer can consistently distil something beautiful and profound from the stuff of everyday life'.[4] In addition, McDonald made the perceptive comment that 'almost everything in this exhibition has been deliberately staged but nothing seems forced or unnatural'.[5]

For Olive, each Cowra commission was made on an individual basis and she could not have envisaged how all the photographs would look when brought together into one big group. For me, seeing the exhibition was a touching, poignant experience. This was

not simply because of the quality of her photography, or because of Cowra residents' obvious delight in seeing their interconnectedness and common past made visible. It was also because of something less specific that is intrinsic to photography – its relation to time. You do not need to know any of the subjects or indeed anything about them to sense their presence; they appear so definite, so particular, so 'there'. They are brave somehow and exquisitely vulnerable at the same time, not knowing what lies ahead, how the future will touch them.

* * *

In Olive's living room at Spring Forest, there was always a flower, sprig or leaf on display, something she had found close at hand, picked and placed in a little glass bottle. I remember once it was nothing more than a fallen leaf, red with autumn colour. Hers were the simplest of displays – you could not call them arrangements, as that implies far too much formality – sometimes just a single specimen shown to its best advantage without any artifice or encumbrance. In her selection, there was visible purpose and intent. The small marvel she had chosen was a modest reminder not only of the presence of the natural world but also of its perfection.

Given the depth of her longstanding interest in flowers, it is not at all surprising that she turned to them as a photographic subject as soon as she could. Opening the studio and darkroom meant she could at last pick up where she had left off in Sydney. The new flower studies were compelling evidence of her persistence and also highlighted her self-containment, as she created them for herself, rather than for public display.

The first, in 1964, was a sensuous study of one of her all-time favourites, a Cherokee rose, which she described as 'a five-petalled rose with a central mass of decorative stamens'.[6] She used 'a floodlight to control the placing of the light and emphasize the gentle convolution of the petals and the subtle gradations of tone'.

As with most of her earlier flower studies from the second half of the 1930s, no external context was supplied; removed from its original, natural setting, the rose was in its own perfect world. *Skeleton leaf* from the same year follows the same principles, offering an intense focus on a natural – and perfect – specimen. The leaf, its intricate tracery of veins illuminated by natural light, fills the upper half of the composition. It is the absolute centre of attention. Probably unconsciously, this image also harks back to her photograph of gum blossoms, taken when she was a girl.

Olive's re-immersion in her art photography went largely unnoticed. She was invited to contribute to an exhibition, Creative Vision, held at the Workshop Arts Centre in Willoughby, Sydney, in 1964,[7] but nothing further for the next sixteen or so years. Her submission combined photographs from the past – notably *Winter willows* and *The Budapest String Quartet* – with recent works including a photograph of the radio telescope at Parkes. Her entries to the Royal Agricultural Society's Easter Show in Sydney, in the early 1970s, were rejected, which she understandably found very disheartening. Olive assumed that her particular kind of photography – of flowers and landscapes – 'must be out of date and of no interest to anyone outside her family'.[8]

This rejection pointed to an underlying problem that would become more apparent: her lack of awareness of recent developments in the art photography scene. As Australian practitioners were beginning to be noticed, public institutions were beginning to establish collections of art photography, and commercial galleries were starting to proliferate, especially in Sydney and Melbourne. Choosing an agricultural show for the presentation of serious photographic works was a well-intentioned but ultimately misguided act. For Olive to have become familiar with the full range of options, two kinds of research would have been essential: travelling to see what was happening outside Cowra and reading the exhibition catalogues and exhibition reviews that were beginning to be published more frequently as art photography gained popularity.

Skeleton leaf, 1964, National Gallery of Australia, purchased 1987

This was a phase in Olive's life when, partially as a result of her isolation, she was out of step and out of time in a way that fellow practitioners such as Max Dupain and David Moore, both based in Sydney, were not. However, being rejected by the Royal Agricultural Society did not stop her from pursuing her own art photography; it only stopped her from looking for venues to exhibit the results. She continued to keep her art photographs to herself.

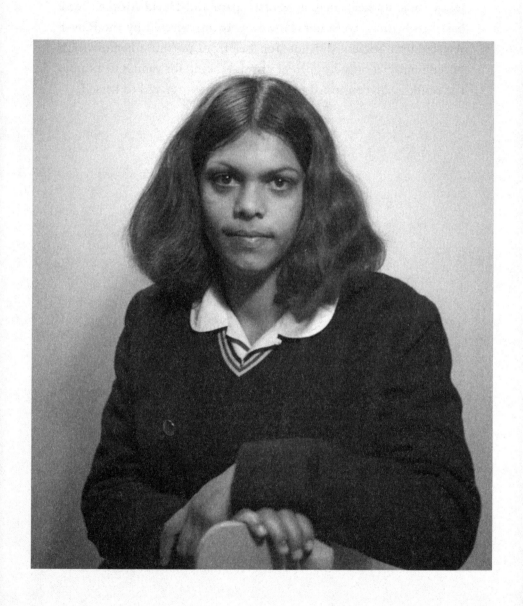

Jenny Coe, 1971, courtesy Cotton family and Josef Lebovic Gallery, Sydney

Jenny Coe

In Olive's most memorable portraits, such as this one of high school student Jenny Coe, something I interpret as honouring occurs. This relates to a longstanding humanist tradition in photographic portraiture where the aim is to take a photograph that is deeply respectful of the subject and succeeds in intuiting something fundamental about their character – honouring them. A member of a prominent Wiradjuri family, Coe grew up on Erambie Mission near Cowra and her parents were Aboriginal Land Rights activists. Coe, later Jenny Coe-Munro, would herself become deeply involved in Indigenous human rights, especially in the area of Aboriginal housing.

The teenager is well prepared for the photography session, which was booked by her mother, Agnes Coe, at Olive's studio. Neatly dressed in her Cowra High School prefect's uniform, shoulder-length hair freshly brushed, she is seated in a chair that provides useful support for her arm and her hands, which are lightly crossed. Olive, it seems, has decided that this portrait, this subject, should be photographed relatively close up, a decision that leads to mutual scrutiny. The lens of Olive's camera is responsible for giving us the exacting details of Coe's clothing, hair, skin and facial features, which we can examine at our leisure. But it is Coe's scrutiny that makes the photograph so compelling. She stares into the lens as the subject of the gaze, addressing the camera directly, knowingly, impressively.

It is difficult in cases like these to transcend cliché, but this is a powerful portrait dominated by the presence of the subject, whose strength Olive recognises. Jenny Coe is someone the viewer must face and, in turn, honour.

Loving Ross: the 1960s

Throughout the first half of the 1960s, during the summers when Olive and her now teenage children were away on their annual holidays at Lyeltya and Ross was at home looking after things, they wrote regularly to each other. He – and she – kept these letters. Their contents are prosaic, filled with information about the to-ings and fro-ings and little dramas of daily life. Peter has tonsillitis, Olive has been seeing various members of the Cotton family and has caught up with her good friend Nancy Hyde, they are waiting for the results of Sally's matriculation, and much more. It is topical information that has no enduring relevance to outsiders. But there is something about the letters from these five summers that is revealing and, to my mind, impressive. It is their loving, tender tone. Despite the many years that have passed and the numerous difficulties they have encountered, both separately and as a couple, he is still her 'Dearest Darling' and 'My Darling Husband', whom she loves 'very, very much'. She compliments him, telling him how proud she is of the way he looks: 'If you walked in looking bronzed and fit all these others would feel most insignificant!' – the 'others' were fellow teachers in the New South Wales Education Department courses she attended in Sydney in January 1961. And, without exception, she is solicitous and concerned about his wellbeing.

On one occasion, after he had dropped her and the children at Newport and driven back to Spring Forest on his own, she wrote: 'Dearest Darling, I do hope you arrived home safely, and that you weren't feeling too tired after the trip.' Then, a few days later, on

10 January 1961, when he was obviously still uppermost in her mind, she felt compelled to explain why one of her earlier letters could have been delayed in reaching him.

> Dearest Darling
> I've just written a letter to you and given it to Sally to post.
> However, it transpired that she posted it in the box at the end
> of this road, and Reedy says it is only cleared at 11 a.m. each
> day. It may not reach you on Thursday so this is just to tell you
> I love you and that the first letter is on the way.

Loving, yes. Protective, and a little anxious, too?

* * *

In the McInerney household, the 1960s was the period of greatest flux. The decade saw Olive re-engage with photography on a professional basis after opening her studio, and it was also when the children reached adulthood. First Sally then Peter matriculated from Cowra High School and moved away from home to Sydney to attend university. Sally remained in Sydney after completing her honours degree and teaching qualification and Peter embarked on an extensive period of travel, working in New Guinea and Mount Isa in Queensland. By the end of the decade, Olive and Ross were living on their own at Spring Forest.

'The new house'

A tent, a rented house, a tiny weatherboard cottage and then, around 1973, what Olive always referred to as 'the new house'. It was modular: two sections of a prefabricated barracks that had originally housed workers building the Carcoar Dam in the central west region of New South Wales. When the dam was completed, Ross successfully tendered for two of the barracks for $7500, but then found himself unable to pay for them, as he and Olive had no cash reserves and no possibility of obtaining a bank loan. Help came from Sally and her husband, Geoffrey Lehmann, who funded the purchase and the haulage, which cost an additional $7500.

Ross organised the construction of the brick foundations for the new house and arranged for the electricity to be connected. The pressure lamps that were used in the cottage were no longer necessary; electric lights, an electric refrigerator, stove and washing machine were all installed. The recently constructed bore provided a reliable source of water, ending the long dependence on tanks and the vagaries of rainfall in an area that was so often parched. The McInerneys' material circumstances had never been better. Olive was pleased and no doubt relieved. More than a decade later, when I first met her, she was still full of praise for Ross's initiative in upgrading their housing.

The site chosen for the new house was on top of a gentle rise a few hundred metres from the gravel road and the property's front gate. A short distance away, the now abandoned cottage sits a stone's throw from the road. Access to the new house is by a track that

runs up the grassy slope, which, with use over the years, gradually became more pronounced as a U-shaped driveway. Then, as now, there is only one way inside – from a door at the end closest to the drive, marked by a clump of red-brick steps. Immediately inside on the right is the doorway into the laundry, which doubled as a place to store the eggs, fresh-picked fruit and vegetables Ross and Olive always generously shared with visitors. Straight ahead is the long, dark hallway flanked by bedrooms whose original occupants, the construction workers N. Boardman, Ken Livio and Chris Parris, are named on the Dymo labels attached to the doors. Olive's bedroom is on the left-hand side and Ross's is the last room on the right, immediately before the living room. At the end of the hallway is the living space, with the dining and lounge areas lit by windows on both sides. Beyond, at the farthest point of the house, are the kitchen and extensive food storage areas. A second exterior doorway there has always been boarded up.

This detail helps gives a picture of the place where Olive and Ross lived together for thirty years, but for a visitor such as myself something less tangible was of greater interest. It was their attitude to their home and what they must have agreed they would, or would not, do to change it. Not removing the Dymo labels – any of which would have come off with a tug, as easily as tearing off a Band-Aid – is only one example. Not adjusting the brick steps that provide the only way into the house is another. Placed there by Ross, they are roughly built, improperly mortared and not level. This meant that every single day, numerous times a day, Olive wobbled for a tiny instant as she went in and out of the house. He chose not to level them, and so did she. Then there are the water stains on the ceiling in the corner of the dining room, the likely outcome of leaks or a flooding event during the barracks' previous service, which they left alone. All this suggests they did not feel the need to renovate, repaint or embellish their new home, or to erase the signs of the previous occupants and the building's history.

Their living conditions also related to what, over time, became a shared conservationist ethic. As one visitor observed, Ross deplored waste and wanted to be close to the earth; he and Olive had a 'natural humility' and would have found any display of wealth vulgar.[1] At Spring Forest, they were committed to preserving nature and having a minimal impact on the environment. One measure of their success was the bird populations, which began to flourish. Ross, who encouraged them with plantings of sunflowers and supplies of birdseed, watched them with pride: there were honeyeaters, choughs, wattlebirds, wrens, kingfishers, superb parrots, robins and more.

Careworn

Careworn is not a commonly used word these days – it seems strangely archaic – but it is the one that comes to mind in describing Olive's state in the 1970s, prompted by the contents of a document on Ross's Defence file in the National Archives of Australia. The document in question is a letter from a Mrs Hilda Wright, a voluntary health worker who visited Olive and Ross at Spring Forest on at least two occasions in 1975, when they were living in the new house.

21st July 1975
HILDA E WRIGHT
P.O. BOX 16
WOODSTOCK N.S.W. 2793

Officer in Charge
Central Army Records
Department of Defence (Army Office),
Albert Park Barracks,
MELBOURNE, VICTORIA, 3206

Dear Sir
I am a Voluntary Health Visitor who is seeking information.
 Service details required of one ROSS GEORGE McINNERNY [sic]. He served in the R.A.A.F., from 12th April 1943 to January 13th 1944. His number being 433503.

He also served in the A.M.F., his number in that service being N.X. 144787 ... details would be appreciated of his service and if possible the dates.

This man is in poor health due to a back injury sustained during his period on active service, and is unable to carry on a full-time occupation.

If you could fill in the required data then something useful can be accomplished to help this man.

He is married, has a family ... yet [is] not of the age for the retirement pension.

I propose to give the required details to the Repatriation Department, is this the correct procedure? His wife, at this moment is working to keep them both, and is not a young woman, she looks very tired, in fact, fit to drop.

I hope this information is of assistance to you, and that you, in turn, can help in this matter.

Yours sincerely

Hilda W. Wright.[1]

This was not Mrs Wright's first attempt to get financial assistance for Ross and Olive. The letter was a follow-up to one she had sent to Central Army Records a few weeks earlier, which is also on Ross's Defence file. In it, she expressed her concern for his health and wellbeing, noting that Ross 'is too hesitant to let the authorities know of his plight, and being an arthritic invalid myself I feel sorry for the state of mind this man is in'.[2]

Ross was obviously in ill health, but it is the image of the sixty-four-year-old Olive 'fit to drop' that I find especially sobering. The 1970s should have been so much easier than the previous two decades, since their parental responsibilities had ended, Sally and Peter had both married, and a succession of grandchildren had begun to arrive. Sally and Geoffrey Lehmann's three children, Julia, Lucy and John, were born between 1971 and 1974; and Sally's twins, Daniel and Edmund, with Errol Sullivan, followed in 1985.

Peter and his wife, Diane (née Donges), lived locally and their three children, Hannah, Brooke and Tom, were born between 1978 and 1987. However, although Olive was relieved of the pressure of earning a livelihood for the whole family, she remained the primary breadwinner, with Ross making very little from his small-scale farming activities and selling honey. She continued working in her Cowra studio, concentrating on portraiture and covering the occasional local wedding in order to generate an income.

In 1978, Olive was faced with another family tragedy when her youngest brother, Leslie, was accidentally killed, strangled by a machine he had invented to ease the severe back pain that had afflicted him for years. Les Cotton was survived by his wife, Miriam, and four children, who had to endure the protracted saga of an unsuccessful fight with his insurance company to receive his life insurance.

According to Sally's recollections, Olive and Ross's finances were so bad by 1978 that the bank almost foreclosed on Spring Forest. The sale of an old steam engine, which had been stuck incongruously in the front yard for years, was their unexpected lifeline. Due to its status as an antique, it yielded sufficient funds to prevent the disaster of foreclosure from happening.

* * *

Around this difficult time, Olive's fortunes in photography began to change. This was unexpected and not something she initially controlled. Up to this point, there was very little in her art photography that provided a tangible or visible record for the larger world to appreciate; while she was making some new negatives, there were no exhibitions or publications that gave her photography a public presence outside Cowra. When she began to come back into view, it was not her new work that attracted attention, but her old work instead, from the second half of the 1930s and early 1940s. The stimulus was the burgeoning interest in the history of Australian photography and in feminism.

In 1980, Gael Newton, inaugural photography curator at the Art Gallery of New South Wales, selected *Teacup ballet* and *Glasses* for her book *Silver and Grey: Fifty years of Australian photography 1900–1950.* Olive donated both photographs to the gallery's collection. The book was the first to place Olive's work in the historical context of Australian fine art photography, as historians and curators of photography began constructing a lineage of modern photography. She was in prestigious, better-known male company – Cecil Bostock, Harold Cazneaux, Max Dupain, David Moore and Wolfgang Sievers were some of the other inclusions.[3]

A year later feminist historians Barbara Hall and Jenni Mather chose nine of Cotton's vintage photographs for their pioneering exhibition Australian Women Photographers 1890–1950, which opened at the George Paton Gallery, University of Melbourne, in 1981. The exhibition grew out of their research for the self-initiated Australian Women Photographers 1890–1950 Research Project. In the late 1970s, Hall had begun compiling information about women photographers who were active in the late 19th and early 20th centuries but whose contributions had since been obscured – 'written over/overlooked', as she put it.[4] She had come across Olive's works in publications of the late 1930s and 1940s and followed up her initial research with a visit to Spring Forest in 1979, where she conducted a long interview to flesh out the details of Olive's then little-known life in photography.

Hall, Mather and their colleague Christine Gillespie were part of the first wave of feminists involved in retrieval research. Their stated aim was 'to amend an imbalance, and correct an injustice towards women photographers' by reconstructing what would otherwise have been a lost history of women's photography.[5] Max Dupain was not sympathetic to their endeavours. In his review of the Australian Women Photographers 1890–1950 exhibition, which toured to the Art Gallery of New South Wales in mid-1982, he took issue with the curators' feminist aims:

In a way it is a little pitiful that women photographers of this
country have segregated themselves into a clique of photographic
activity as though a pictorial separation existed between the
sexes … Final evaluations concern the forcefulness of the
photograph, not the gender of the person responsible for it.
Irrespective, it must be judged in current terms, as good, bad or
indifferent. (This exhibition is up for all three). So, at face value,
a political issue is set up, rather than a wholly pictorial one.[6]

In his view, gender and social politics were irrelevant to the
appreciation of photographs. Dupain assumed that aesthetic merit
could be objectively assessed and was the only element to consider
when making judgements of value. He went on to nominate a
few works he thought were successful, singling out two of Olive's:
Teacup ballet, which she had created when they were together and
which he knew intimately, and *Design for a mural*, produced the year
after their break-up, which he might not have seen before.

Olive Cotton's *Design for Mural* [sic], 1942, stamps itself
on one's memory more than most of them. An apparently
multi-negative splicing of shells and dancers set in a fairytale
landscape, it has richness of atmospheric whimsy – a dream
fantasy. The same intuitive sense of form and rhythm is
repeated in her forthright and animated *Teacup ballet*.[7]

Olive would, I think, have concurred with Max's view about the
irrelevance of the photographer's sex in photographic practice.
She felt she had always done what she wanted in her photography,
regardless of her sex, and said 'I don't like being billed as a "woman
photographer". I'd rather be thought of as an artist.'[8] This view was
not uncommon among other women photographers and artists of
her generation. Margaret Michaelis was equally emphatic that she
be considered as a photographer first and foremost, not as a woman
photographer and not as a feminist.

Nonetheless, Olive was very appreciative and respectful of the efforts of Hall, Mather, Newton and others whose commitment to feminist art and politics brought them not only to her work but to her in person as well. For this new generation of practitioners, curators and historians, she was an inspiring discovery, a leader in the field and a generous informal mentor.

The renewed interest in her photography spearheaded by these women set the stage for a renewed burst of creativity and productivity.

PART SIX

PART SIX

Striking a chord

Interest in Olive's work gathered momentum after being reintroduced to the public in the Australian Women Photographers 1890–1950 Research Project, but the full extent of her practice was still not known. That changed in 1985, when she held her first solo exhibition, the simply titled Olive Cotton Photographs 1924–1984, curated by Barbara Hall and shown at the Australian Centre for Photography's gallery in Oxford Street, Paddington, in Sydney.[1] This exhibition was the prime event in the 1980s that revived her reputation. It was made possible by a $5000 grant from the Australia Council for the Arts two years earlier, which enabled her to focus on her art photography, finally free of the obligations of the commercial photography that had been consuming her energy since the mid-1960s. She said in an interview for *The Age* that 'it was such a relief to be able to say to everyone in Cowra that I would not be doing any more weddings and I would simply be concentrating on my own work.'[2] She did, however, retain her studio. The Australia Council funding meant she could systematically trawl through her older negatives – a total of two thousand was mentioned – making prints of any she considered worthwhile.[3] At the same time, she kept creating new works, although, not surprisingly given her age and circumstances, they were relatively limited in number. Sixty-six photographs from the two phases of her career were selected for the exhibition.

The ACP was an apt venue as it was the flagship for art photography in this period. Established in 1973 after a long campaign by photographers, and with critical support from the

Australia Council, it was a not-for-profit organisation committed to promoting photo-based art, especially through a dynamic exhibition program. It featured the work of significant historic figures and emerging photographers from Australia and overseas. A selection of vintage prints by Harold Cazneaux was shown in 1984, and the following year, shortly before Olive's exhibition, it was the turn of photographer Jack Cato, who was also a photography historian and author of the first history of photography in Australia, *The Story of the Camera in Australia* (1955). The up-and-coming generation of Australian art photographers who exhibited in 1985 included Ann Noon, whose series *The Dive* was hung in a smaller space adjacent to the main gallery where Olive's work was installed.[4]

After the ACP, Olive Cotton Photographs 1924–1984 toured to Lake Macquarie Community Gallery in New South Wales in early 1986, and later that year to Christine Abrahams Gallery, a commercial gallery in Melbourne that regularly featured photography.

Olive's exhibition had an important point to make, encapsulated in the title and outlined by Barbara Hall in her text for the two-page catalogue. She wrote:

> It is cause for celebration that Olive Cotton's work is coming back into Sydney, forty years after she left Dupain's studio and with a major, forty year addenda enriched by raising, observing and living with children, and the steady contemplation of Nature's patterns.[5]

Hall stressed that Olive's engagement with photography was not confined to her years in Sydney, as was commonly assumed – it was ongoing. Of the sixty-six photographs presented, fifty dated from her Sydney period; of these, three were from the 1920s, thirty-four from the 1930s and thirteen from the 1940s. The other sixteen photographs came from the Spring Forest years, with five from the 1950s, two from the 1960s, four from the 1970s and five from

the early 1980s. In the desire to show Olive's full range, 'formal and conscious images' were shown along with 'the warmest, rapid impressions of the snapshot'.[6] Another of Hall's significant claims was that Olive's photographs 'strike a chord with contemporary tastes and interests', as demonstrated by the 'odyssey of young women photographers and students' who travelled to Cowra to meet her.[7]

Reviews of the show were appreciative. In Jill Stowell's assessment, 'The most memorable images, and there are many, call on the creative power of light.'[8] Curator Sandra Byron praised Olive's 'ability to consistently respond to her immediate environment with sincere and elegant visual optimism'.[9] She argued that a feminist reading of Olive's work provided useful context but was restrictive and, in sympathy with Dupain's views, suggested that it 'should not be confused with an appreciation of the work for its own sake'.[10] Byron concluded that:

It is wisest, as always, to return to the images themselves; a collection of vintage and refreshingly sensitive reprints which record and celebrate aspects of twentieth century life. Cotton's iconography, past and present, is emotional and accessible, her sincerity and dedication always preventing sentiment from regressing to photographic clichés ... No matter where the work is stylistically located in her career it is always Cotton's affinity with all her diverse subjects that proves the most affecting for the viewer.[11]

In his review for the *Sydney Morning Herald*, Max Dupain responded with great eloquence, adopting unusually poetic language to convey what he felt was the essence of Olive's photography.

The therapeutic calm of this exhibition is its major attraction.
It's like walking through the bush early in the morning
and suddenly being surprised by a tranquil lake; serenity

is the soul's narcotic ... In all these pictures of land forms,
of slender tracery, mysterious gorges and bright sunlit
poplars, there weaves a wholesome clannish thread of family
consciousness ...[12]

This passage is exceptional for its insightfulness and deep appreciation of Olive's achievement.

With her increased exposure, the market for Olive's photographs grew, stimulated by the activities of art museums and corporate and private buyers, all keen to purchase vintage Australian material. This was a period when the photography market was buoyant and a number of leading commercial galleries – Christine Abrahams Gallery and Deutscher Fine Art in Melbourne, aGOG (australian Girls Only Gallery) in Canberra, and Josef Lebovic Gallery in Sydney – all began selling prints by Olive. In response to the demand, the reprinting she had begun with Australia Council funding continued apace. In the late 1980s, on the advice of her dealer Josef Lebovic, she began editioning her work for the first time, in editions of twenty-five prints for the most popular images (she did not necessarily print the full edition in one session and not all editions sold out).

It was around the time of her exhibition at the ACP, in this busy, productive phase of her life and career, that I first met Olive Cotton. I was a member of the curatorial team in the Australian National Gallery's Department of Photography (now the National Gallery of Australia), headed by inaugural Curator of Photography Ian North from 1980 to 1985. Large groups of vintage material by figures considered central to the history of Australian photography – such as Harold Cazneaux, Max Dupain, Frank Hurley, John Kauffmann, Henri Mallard, David Moore, Axel Poignant and Wolfgang Sievers – were being acquired by the NGA for its rapidly expanding permanent collection of Australian photography. The aim was to form comprehensive holdings of Australian photography and selective groups of international photography. However, the

representation of work by women photographers was uneven, a situation the gallery was determined to address. Ten of Olive's photographs were bought for the collection in 1982–83, including a vintage print of *Teacup ballet*, and the priority was to acquire additional examples that would represent the range and depth of her practice. In 1987, in my role as Curator of Photography, I selected a group of twenty-seven photographs, mainly vintage prints. Olive generously supplemented the purchase with the gift of two photographs, *Grass at sundown* and *The way through the trees*.

In the 1980s, some of Olive's photographs were acquired by state galleries in Sydney, Melbourne and Adelaide, which ensured her inclusion in major shows of Australian photography. Queensland Art Gallery and Melbourne's Monash Gallery of Art would later make important purchases in recognition of her role in Australian modernism.

At the NGA, which had a dedicated photography gallery – opened by Max Dupain in 1982 – Olive was represented in several significant survey exhibitions of modernist photography. They included Here Comes the New Photography! 1920–1940, in 1984; and The New Vision: A Revolution in Photography 1920–1940, in 1987, both of which juxtaposed international and Australian photographs. In 1988, her work was selected by Gael Newton for inclusion in the landmark exhibition Shades of Light: Australian Photography 1839 to 1988, which was part of the gallery's ambitious bicentennial program dealing with different aspects of Australian art. *Teacup ballet* was reproduced in the book Newton wrote to accompany the exhibition. Shades of Light consisted of nearly one thousand works, the majority of which came from the National Gallery's own collection, supplemented with loans from other public and private collections in Australia and overseas. Olive received praise from art critic John McDonald for her 'outstanding pieces'. He argued that the exhibition 'should serve to make Australian photography look altogether greater, more complex and various than any of us might have expected'.[13]

* * *

The opening of Shades of Light was the occasion for an awkward encounter between Olive and Max, after not having seen each other for several decades. Olive noticed him in the large gathering and said something to Ross like, 'There's Max, we should go over and say hello.' After the formal speeches ended, they made their way through the crowd and Olive greeted him warmly. Max apparently did not recognise her. Is such a thing possible? Could she really have changed so much that he had no idea who she was? Or was he pretending not to know her? 'Max,' she apparently said directly to him, 'it's Olive.' After a brief chat, Olive moved away. Ross asked if she felt all right after what he had witnessed and interpreted as a bruising encounter. 'Yes,' she reassured him; she wasn't bothered by the incident and for some reason considered the exchange 'rather amusing'.[14]

A year or two after meeting Max at the gallery, Olive visited the Dupain studio in Sydney to see Jill White, his assistant. (By an extraordinary coincidence the White family had purchased Wirruna from Leo Cotton many years before.) Max was shocked at Olive's appearance and remarked to Clare Brown: 'Gosh she's changed. She's aged tremendously, probably due to the climate she's living in.'[15]

The conversational space

For visitors to Spring Forest, there was a pattern to follow in their interactions with Olive and Ross. It seemed to evolve naturally but was actually well practised and refined, and it was Ross who was in control. A lovely description of how the day unfolded for one unidentified visitor mirrors the experiences of others who made the trip especially to see Olive:

> And so it started. One way and another, it was to be a day of storytelling ...
>
> Ross is practised, wily, and full of charm. I fell under the spell ... Past, present and future, personality and morality – story by story, all was revealed before his immaculate artistry. Satisfied at last, Ross wandered out to fix the lawn mower, leaving me alone with Olive.[1]

My children loved Ross's stories, especially those involving encounters with snakes (Ross was once bitten by a deadly brown snake but recovered fully). It wasn't only the stories' content that was memorable, it was also Ross's manner of delivery. He could not be interrupted; the pauses he made to tamp down the tobacco in his pipe were a rhetorical flourish, not an invitation to his audience to enter into the conversational space. As he moved slowly through his wonderfully rich repertoire of stories, cursorily acknowledging Olive as he went – 'Isn't that right, Olive?' – she would gently,

affectionately and smilingly agree. I never saw her hurry Ross along, or show any sign of impatience with him or his storytelling performances. There was no indication from her that she either sought our attention or expected it.

Wild plum

Near where I often go for a walk, on the edge of a nature reserve in our Canberra suburb, is a wild plum tree which, for most of the year, I barely notice. But for an intense week or two every September, when it is impossibly laden with white sweet-scented blossoms and full of bees, it is exuberantly present and unmissable. When I see it like that, two images always come to mind, freshly remembered: Olive Cotton's *Wild plum* (1984), and Pierre Bonnard's wonderful little painting *Amandier en fleurs* (1945–47), in the collection of the Centre de Georges Pompidou in Paris. Both depict trees in full bloom and convey a sense of joy about spring and about the cycles of nature more generally.

They share something else which is not apparent in the images themselves but informs their making – Bonnard and Cotton were very familiar with the trees they chose as their subjects. Bonnard's almond tree grew in his garden at Le Cannet, where he lived from 1926 until the end of his life. 'Every spring,' he said, 'it forces me to paint it.'[1] (The Pompidou version was actually the last painting he completed before his death in 1947.) For Olive, the wild plum was also well known, one of many fruit trees growing at Spring Forest that she watched closely over the years. She said that it was:

> an ordinary little tree that had never been pruned. The nice
> thing about it was that the flowers were all over the tree
> whereas in a cultivated plum tree they cluster at the end of the
> branches. It was as though the flowers had just been sprinkled

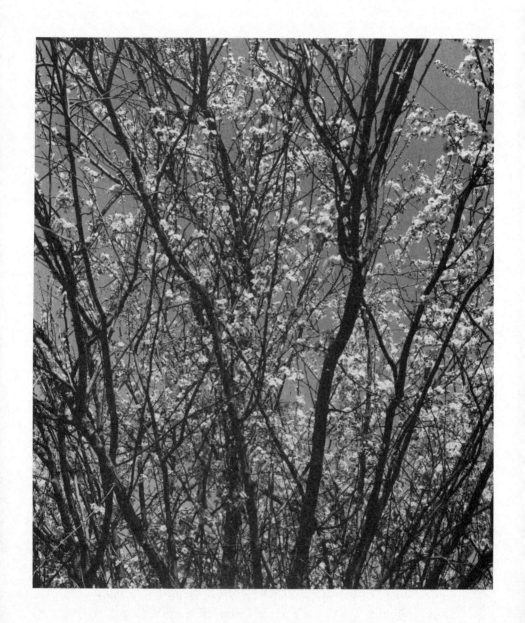

Wild plum, 1984, National Gallery of Australia, purchased 1987

all over the tree. The light was right, shining through the tree
and bringing all the specks of flowers to light.[2]

This description goes to the heart of the image's appeal. There is
no order in it, no central organising principle, which would have
been the case if she had included its central lower trunk as part of
the composition. Instead, she decided to raise her camera slightly
upwards, filling the composition with criss-crossing branches that
are so dense in the lower section you cannot see through them to
the sky. Dancing all over the darker branches is a chaotic flurry of
white blossom that charges the entire visual field with energy.

'Unbroken time'

The rush of institutional and public interest that came in the wake of Olive's show at the ACP meant she was busy. As busy as she had ever been – printing up old negatives, making prints for a growing number of clients and, whenever she could, exposing new negatives. This was when she developed a ritual that would sustain her over the next few years: once a fortnight, Ross drove her in to Cowra, where she spent two days in her studio and darkroom, staying the night at a nearby motel.

This shows that her desire to keep working with photography had not faded. The difference now was that she had what she regarded as the prerequisites for her creative work – solitude, uninterrupted time and separation from the myriad distractions of the external world. She could put into place exactly what she needed. This hard-won clarity is significant for Olive's own practice, but also flags elements that other artists consider essential to the creative process. Australian sculptor Rosalie Gascoigne, for example, held the same views about what was required to create new work.

> An artist's primary concern should be truth to self. To achieve this takes the best of one's time and effort ... in solitude ... [artists] get nearer to what they intrinsically have to offer.[1]

For visual artists, the studio has conventionally provided this privileged space, but for Olive, it was the combination of the studio space and tiny darkroom. 'It was wonderful,' she recalled, first

having a darkroom of her own, 'and nobody else coming in and out and having to use some of the apparatus.' Although sometimes considered in later years, a darkroom at home at Spring Forest was not something she wanted:

> When you're home other things are on your mind and you think you'd better stop for a minute and there's something you should go and do, or what am I going to make for tea tonight?[2]

The darkroom's physical separation from the external world is even more extreme than an artist's studio, where natural light, one connection at least to the outside, is usually prized. Tucked away in an artificial world tinged by the strange, dull illumination of the safe light, which prevented the damaging effects of light exposure to photographic film and paper, Olive's solitude was assured. She revelled in having 'time to think and time to concentrate', a large expanse of 'unbroken time'.[3]

* * *

Some years ago, the work of 16th-century French philosopher and essayist Michel de Montaigne was everywhere, due in part to the rapidly growing interest in the essay as a literary form. Robert Dessaix was one of the Australian writers who ruminated on Montaigne in an essay in his collection *As I Was Saying* (2012), and David Malouf was another, publishing his essay 'The happy life: the search for contentment in the modern world' in *Quarterly Essay* (2011). The interest in Montaigne also related to contemporary discussions on 'living well'. Montaigne's ideas about the indispensability and value of what he called 'the little back-shop, all our own, entirely free'[4] are especially pertinent to Olive's life view and attitude to her studio and darkroom. I suspect she would have loved the following passage, which Malouf quoted at length:

In this retreat we should keep up our ordinary converse with ourselves, and so private, that no acquaintance or outside communication may find a place there; there to talk and laugh, as if we had neither wife, nor children, nor worldly goods, retinue or servants ... Since God gives us permission to arrange for our own removal, let us prepare for it; let us pack up our belongings, take leave betimes of the company, and shake off those violent holdfasts that engage us elsewhere and estrange us from ourselves. We must undo those powerful bonds, and from this day forth we may love this and that, but be wedded only to ourselves ... The greatest thing in the world is to know how to belong to yourself.[5]

Malouf identified the origins of the belief in the 'need to be protected from the distractions, the temptations and the dispersive busyness of things' in classical traditions, whether Aristotelian, Epicurean or Stoic, which held that, 'Happiness lay in self-containment, self-sufficiency.'[6] I am sure that in her 'little back-shop' at Cowra, where Olive devoted herself to her art photography, she felt self-contained and self-sufficient, liberated from external pressures and the uncontrolled, indeed uncontrollable, aspects of her life.

A different point about the significance of her studio and darkroom relates to gender and Virginia Woolf's book *A Room of One's Own*, published the year Olive completed high school. Olive was not a feminist, and the establishment of her business and own working space was less a reflection of a desire for autonomy and independence than a practical measure to earn money. However, in these decades, her situation continued to be crucially shaped by gender, even if she did not see it that way. The interruptions and delays she experienced in her creative practice after the Second World War were typical for married women involved in the visual arts, literature and other creative areas.[7] Many struggled to combine their artistic and domestic lives, especially when motherhood entered the mix. Often women could not fully

concentrate on their creative work until they were in their fifties and sixties, finally free of childrearing and its responsibilities. Novelist Elizabeth Jolley was in her early fifties when her first book (of short stories) was published; and Olga Masters did not achieve literary success until aged in her sixties. Rosalie Gascoigne, who began exhibiting her sculptures in her late fifties, is a comparable example in the visual arts.

This brings me to a place of difficulty and several pressing questions. Did Olive succeed in producing a substantial body of new work in her Cowra years? Was there enough to stimulate and sustain her creativity, or did her run come too late? Barbara Hall touched on these matters in 1985, in her essay for the ACP catalogue, when she made the solicitous, almost protective comment that:

> One needs to appreciate the courage of an exhibition concept which will risk earlier and later work being seen as minor side panels to the middle-career images of the thirties and forties, within a sixty-year triptych.[8]

Hall's anxiety and slight defensiveness was understandable. Olive's photographs from the 1930s and 1940s dominated the exhibition, not those produced subsequently, which were far fewer and arguably often less powerful in pictorial terms.

Our expectations borne of traditional art history are that artists continue to evolve their vision and their practice throughout their lives, and sometimes this is the case. However, if this is the measure by which Olive's art photography is to be judged, she will not fare so well. From the mid-1980s to the mid-1990s, when she could finally relinquish commercial photography, there was no sudden outpouring of new negatives and prints. Nor were there dramatic changes in choice of subject matter or style. As before, she worked methodically and, crucially, she continued to draw strength from the natural world, concentrating on flower studies that hark back to those she had produced in the vital pre-war years, 1937–39.

Any changes she introduced were subtle, as two photographs, *Dead sunflowers* (1984) and *Quince blossom* (1992), reveal. Instead of picking the flowers and taking them to her Cowra studio for scrutiny and careful arrangement, she left them in situ at Spring Forest, waiting for the right sunlight, sky and clouds to create the desired pictorial effects.

Dead sunflowers was the result of one of Ross's initiatives. With feeding native birds in mind, he had planted giant sunflowers along the edges of the vegetable garden near the new house. When he was ready to cut down the dead plants and harvest the seeds, Olive intervened. She had been thinking about 'their photographic possibilities' for a few days and asked Ross 'to leave them a while longer until an interesting sky appeared as a suitable background.' He willingly obliged and she later recollected the sequence of events that led to a successful pictorial resolution, one that echoes *Papyrus*, made nearly fifty years earlier:

> Finally the hoped-for sky developed and I spent a long time moving amongst the tall dry stalks to select a viewpoint. From about ten different proofs I chose this one, taken with my camera almost at ground level.[9]

Of *Quince blossom*, she said: 'I photographed these blossoms in the tree, just as they were. Having selected my viewpoint, I waited until the sun was in the right position to bring out the subtle tones of light and shade.'[10] This is an image without drama, animated ever so gently by touches of sunlight on the perfectly formed blossoms. It represents the culmination of her desire to work in concert with nature and natural phenomena, the fundamental difference being that the later flower studies were not accompanied by the landscapes, as they had been in the earlier phase of her career.

However, what is conspicuous about these and other art photographs from the Cowra era is how old-fashioned they look. A photograph called *Soaring bird* (1993) makes this plain: the

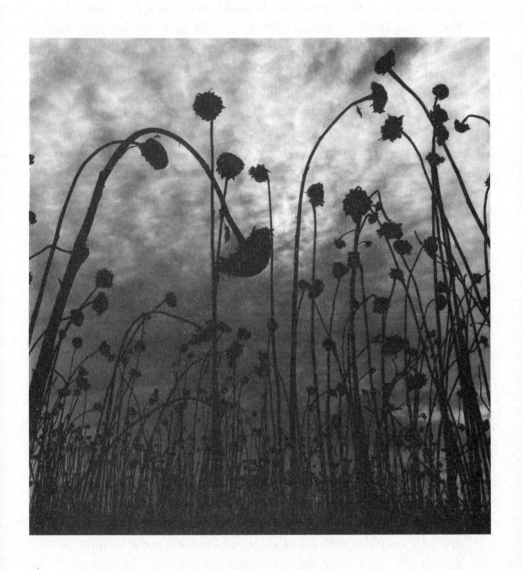

Dead sunflowers 1984, National Gallery of Australia, purchased 1987

conjunction of a half-dead eucalypt and a bird in flight symbolises the continuity of life, but for me the symbolism is well worn and sentimental. Taken at a time when photography was becoming a dynamic part of the art scene in Australia, and new approaches were flourishing as postmodernism began to take hold, the language of *Soaring bird* is anachronistic, both symbolically and formally.

This brings me back to Montaigne as a way of explaining the difficulties Olive faced at Spring Forest in her attempts to further develop her creative practice. The time Montaigne spent in his famed white stone tower immersed in his writing did not mean he withdrew from the world and abdicated any responsibility for society at large. He was, in fact, no recluse. From Virginia Woolf's perspective, his curiosity about the world and desire to connect to and communicate with fellow human beings were salutary lessons. But for long periods in Olive's life, an intense engagement with the larger world was not possible; her circle was small, confined mainly to family and close friends, and her activities centred on Spring Forest. The central, inescapable reality is that, after leaving Sydney, she was increasingly forced back into herself, and her once large world of photography shrank. Even when she returned to professional photography in the mid-1960s, her ambit did not expand significantly. It had become tiny and stayed that way.

In Sydney, she had been part of a vibrant milieu that may have distracted and sometimes frustrated her, but which nonetheless enriched her practice, and she had benefitted from working alongside equally engaged practitioners, such as Max, Damien Parer and Olga Sharp. Even when managing the Dupain studio and her male colleagues were scattered across the globe, she had a vital network of support, with the staff at Hartland & Hyde and the crucial friendships with talented, creative and energetic women. At Cowra, she was more on her own than she had ever been before.

Geographical and financial circumstances meant she was not in a position to attend many art or photography exhibitions, or acquire many books or specialist magazines. The bookshelves in

the living room at Spring Forest are lined with books on Australian history, poetry, natural history and field guides but do not contain many photography publications. Olive enjoyed the photo essays published in *Life* magazine in the early 1960s, but there is nothing to indicate that she was closely following recent developments, either in photographic history or contemporary photographic practice. Journalist Candida Baker noted in 1987 that on Olive's 'own admission she does not even read photographic journals'.[11] A copy of the influential book *On Photography*, by American writer Susan Sontag, given to her as a present, is still in pristine condition, with none of the signs of wear and tear that come from repeated reading.

This is not to say that she was disinterested in the efforts of other photographers. She praised the work of Carol Jerrems from the mid-1970s, which she saw at the National Gallery of Australia, possibly in the 1988 exhibition Shades of Light, which also included several of her own photographs. And she cited *Oaktree, Sunset City, California* (1932) as her favourite photograph by American photographer Ansel Adams, which was reproduced in a book given to her by radio producer Mike Ladd. The strong, graphic composition is dominated by a large oak tree silhouetted against a darkening sky, with the rising moon appearing as a small orb in the lower right section, not far above the horizon line. It is not one of Adams's most famous or extravagant displays of photographic virtuosity, and Olive no doubt enjoyed its simplicity and depiction of a timeless natural cycle. She wrote to Ladd:

> Someone sent me a postcard once with this picture on it and
> I wished that I had made that photograph myself! So I was
> delighted to find a larger print of it in this book – like meeting
> an old friend![12]

These references to the specific photographic works of Jerrems and Adams are illuminating but are isolated examples. Olive knew of

Max Dupain's and David Moore's ongoing work, which had a high public profile – both men had made a successful transition from the professional sphere into the contemporary art photography world – but there are no records of her views about it.

Given that Olive's art photographs from the Cowra era cannot be explained in the usual art historical terms of innovation and stylistic development, or contextualised as part of a larger art scene, and given that they were out of step with contemporary developments, how might they be best understood and appreciated? Max's reflections are very useful here. In his review of Olive's show at the ACP, he observed that: 'The influence of the Pictorial School is very apparent and even with her later work she remains faithful to her training and thinking in the Twenties and Thirties.'[13] What he saw, and appreciated, was the integrity of her practice, but he was also responding to its unchanging shape, its constancy. His observation about 'a wholesome clannish thread of family consciousness' that weaves through her work was profound, and goes to the heart of her accomplishment – a consistently expressed, wholesome clannish consciousness.[14]

* * *

There is another context for a small group of photographs from the last decade of Olive's art practice – what is known as 'late style'. Photographs such as *Dead sunflowers* (1984), *Seed head* (1990) and *Vapour trail* (1991) offer valuable perspectives on ageing and end of life.

Much has been written about the late and last works made by visual artists, musicians and writers as they face their own mortality. Two different streams of practice, indicative of divergent responses to imminent death, have been well documented. One, in the words of Palestinian writer Edward Said, expresses 'a spirit of reconciliation and serenity', and the other, which appealed most to him as he was facing his own untimely death, does not strive for 'harmony and

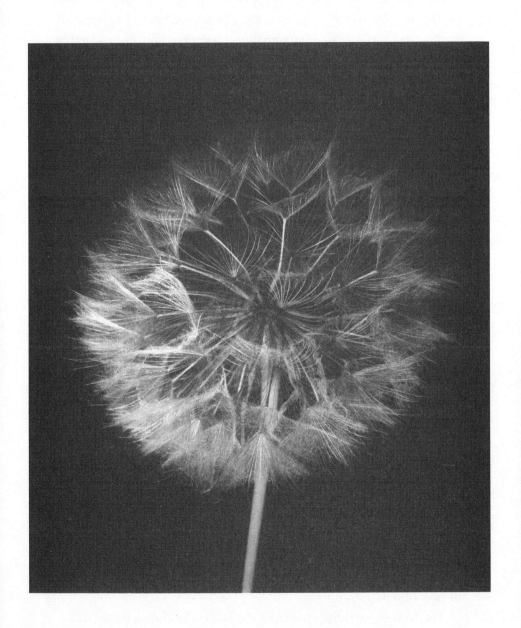

Seed head, 1990, National Library of Australia, nla.obj-136353607

resolution' but for 'intransigence, difficulty and contradiction'.[15] He saw the latter in the late work of Beethoven, and in the works of the writers Constantine Cavafy, Thomas Mann, Giuseppe di Lampedusa and others, where he found 'a deliberately unproductive productiveness, a going *against*'.[16]

In the visual arts, numerous artists have found a renewed artistic power in their late phase and created distinctive bodies of work that differ significantly from those produced earlier in their careers. These late works may be more experimental, bolder and more abstract. German art historian Walter Friedlander, for instance, argued this applied to French classical painter Nicolas Poussin, and others have nominated Goya, Rembrandt and Titian for their dramatic late shifts in approach and style. Monet's late paintings of waterlilies are another instance, appreciated as being more profound than anything done in his youth or middle age.[17]

However, Olive's late and last photographs did not mark a significant break with earlier work and continued to express a harmonious vision that dealt with nature in its different forms. Of her photograph *Seed head*, which she took at the age of seventy-nine, she said:

> … when weeding the garden I found this wonderful seed
> head. It was nine centimetres in diameter and its beautiful,
> delicate and intricate symmetry, composed of myriad parts, was
> breathtaking. I picked it with the greatest care, set it up before
> a black background and used a small low floodlight to show all
> its perfect detail.[18]

Once again, the salsify seed head she responded to was not an exotic or rare specimen, but it nevertheless commanded from her the utmost respect.

Her task was to use photography, both literally and metaphorically, as a medium of illumination, to create an image that would convey to the viewer a sense of the wonder, the rapture, she had originally

Vapour trail, 1991, courtesy Cotton family and Josef·Lebovic Gallery, Sydney

experienced. In terms of a literary alliance, this view resonates with William Blake's famous opening line from his poem 'Auguries of innocence': 'To see a World in a Grain of Sand/And a Heaven in a Wild Flower'. The flowers and natural details she photographed across the decades represented the cosmos in its most reduced and intense form.

Olive's strongest work always arose from her engagement with the known world, known in both empirical and emotional terms, and *Dead sunflowers*, *Seed head* and *Vapour trail* were not exceptional in this regard. Their subject matter belonged to the familiar, loved environment of Spring Forest, from which she extracted minute details and expansive views. In *Vapour trail*, for example, this was achieved by introducing a glorious abundance of sky. Olive had watched the lingering but ephemeral traces of jets flying over Spring Forest countless times before capturing a spectacular example where the trail feathers across a sky that fills over two thirds of the composition. Here the upward angle is used, not for the dramatic, dynamic effects sought in her modernist phase, but as a way of making her images less earthbound.

Olive's late works, like Margaret Preston's, leave an overwhelming impression of 'harmony and resolution', rather than the discordance Said wrote about so forcefully. The concerns she expressed were with human impermanence, the enduring power of the natural world and its perfection.

Life review

Olive's increasing public exposure went hand-in-hand with an intensely private process, the so-called life review phase that commonly takes place in older age. For someone so private, who never sought the limelight, the fact that her reflections were now of public interest must have struck her as curious. During the 1980s and 1990s, she generously made herself available for media interviews, mainly with Sydney-based newspapers and magazines.

Her life review phase had its tangible beginnings in her re-engagement with photography from the Sydney years. Aged in her seventies, she had to decide which photographs from the past she considered successful, and why, and which ones had continuing value for exhibition and publication. The process of evaluation was entwined with memory work. She did not turn to writing her memoirs, as is often the case with public figures, but agreed to being recorded for the National Library of Australia's oral history program, in 1988. In her interview with Diana Ritch, she is softly spoken, diffident, and sometimes almost tentative in mapping out the direction her life had taken.

The public rediscovery of Olive Cotton and her work invariably focused on her time at the Dupain studio, and especially on her relationship with Max. On this subject she remained highly discreet. In one interview, for example, she condensed their marriage, separation and divorce into three short sentences: 'In 1939 Max and I decided to get married. It wasn't working out well so we decided to separate in 1941. Then I wanted a complete change.'[1]

Intriguingly, in light of the account in the divorce proceedings, she recast their separation as a joint decision, rather than her own. Doing so stopped further questioning and speculation.

In this same period, Max was reviewing his own life. He published what is effectively his memoir, the essay 'Past imperfect' in his book *Max Dupain's Australia* (1984), which mentioned Olive and their shared Bond Street days with deep affection. More autobiographical writing appeared in the latter half of the 1980s, in exhibition catalogues and other publications. He, too, was the subject of much media attention but, in contrast to Olive, the focus was squarely on his work, rather than his personal life. By then, he was seen as the elder statesman of photography in Australia and well-known champion of a straight approach (he could not abide any kind of postmodern manipulation that was becoming commonplace during the 1990s, and was robust in his dismissal of colour photography). His high profile was assured through his own commercial and exhibition work, as well his writing, particularly his spirited photography reviews for the *Sydney Morning Herald*.

In her extensive interviews with Max in 1988–90 for her proposed biography, Clare Brown made several attempts to get him to talk about Olive. He was always reticent. His answers were brief, usually only a sentence or two in length, and they were invariably positive. When Brown asked him, for instance, 'What did Olive look like when she was young?' he replied, 'She was a very attractive girl physically and mentally. She is a very intelligent person.'[2] However, on one occasion, he gave more detail about his perspective on their break-up, reflecting that:

I can only put it down to one reason ... I was too bloody involved in photography. I'm sure that was it. It's the sort of thing you regret like nobody's business at this stage. But at that stage there was nothing you could possibly do about it. It is amazing that we are still friendly, not that there was any violent misbehaviour or anything of that character, just purely a mental

breach of a relationship. And I can quite understand it … she
wanted a family and I couldn't have cared less. I was working
fourteen hours a day in photography and that took its toll. But
I'm happy to know that she found somebody else. Ross, who is
a fine bloke, farmer, hell of a nice bloke.[3]

Max made two other related (and unpublished) remarks in other
contexts. In response to curator Ian North, from the National
Gallery of Australia, who queried why his relationship with Olive
had ended, he said ruefully: 'Ah, the impetuosity of youth!' But
nothing more. A few years later, in 1990, during one of his last
interviews with Brown, he sounded regretful, even hurt by a recent
meeting with Olive. This impression is conveyed by the typewritten
transcript; the way he spoke in the actual interview, however, may
suggest a different interpretation.

She was here for almost half a day the other day, and there
was never a glimmer, she never once had one … thought that
you could recognise referring to our early relationship, not the
slightest. I suppose it's a defensive mechanism taking over … [4]

As part of her biographical research, Brown approached Olive for
an interview but did not receive a reply. Max then wrote to Olive
on Brown's behalf, urging her to participate, but she declined. Her
reasons were likely to have been finely calibrated, tied to her sense
of privacy, as well as her protectiveness towards others, especially
Diana Dupain and Ross. She probably felt that a public airing of
information about her and Max's relationship had the potential to
make them uncomfortable – in Ross's case, this is almost certain
to have been true. Her unsureness of Brown, whom she had never
met, was another likely factor in her decision.

Olive held no grudges and, when interviewed for one magazine
feature, spoke of the significance of her relationship with Max in
typically generous terms: 'I was with him from 12 to 20 [in fact,

it was until she was 30 years old] and I don't regret those years a bit because he was probably the best friend I could have had and I learned a great deal from him.'[5]

* * *

The other point of public interest was Olive's move to the country, which had removed her and her work from view for decades. This was something film-maker Kathryn Millard sensitively raised in her lyrical documentary *Light Years*, released in 1991. Well into the main shoot, she posed the question Geoffrey Lehmann had formulated in his poem 'Photographs', which asked: 'Do you ever regret, Olive, your life of photographing country weddings and local children in silver nitrate?' For the only time during the filming Olive was overwhelmed with emotion, which Millard saw first-hand:

> Tears filled her eyes. We stopped filming and took some time
> for her to compose herself. Had a cup of tea, no doubt. I told
> Olive that I thought our audience would want to know more
> about her feelings on leaving her Sydney-based photography
> career behind. It was a family legend that the old Buick Ross
> and Olive had driven to their new home was still rusting
> outside on the grass – no longer required. 'How would she
> describe her feelings about the move?' I asked … I don't think
> she was able to answer that question in words. Olive said that
> she missed her relatives and friends, being so far away in the
> country. She missed the sea. 'But then, having children, I had
> a job to do. And that took all my time. And I could still go on
> taking photographs. Always with the thought that one day I
> would have a darkroom to make prints for myself.'[6]

This final statement was central to Olive's retrospective life narrative – even when her photographic practice could not be fully realised, she never abandoned it. A comment from Haidee

McInerney is also pertinent here: Haidee believed that Olive's 'love of photography overshadowed everything'. In her inner life, it was integrated with her past and always had a future.

* * *

As part of her life review, Olive reflected on her approach to photography and her technique. In various interviews, she reiterated some of the views she had expressed publicly fifty years earlier as the 'Lady behind the lens' (for the *Sydney Morning Herald*). She explained, for example, that as a child she had recognised intuitively that photography was ideal for her: 'when I was given a camera I really felt, this is what I want to do, this is my medium.'[7] She stressed that light remained fundamentally important and had never changed its role in her work, as the prompt to take a photograph, and the means to enliven whatever she chose to photograph: 'Light brings a subject to life ... That's the main thing about all my photographs, the light no matter what it's of. That's what draws me to take a photograph.'[8] Light's enduring appeal was not confined to natural illumination or the outdoors; artificial light also entranced her, and simply called for a different way of working: 'In the studio I play around with the lighting a lot, but outside I just watch and wait.'[9]

Also consistent was the deliberation of her approach. In advance of exposing any negatives, she selected her subject matter, circled around it to determine the best vantage point, and waited patiently for the right weather and light conditions, if she was working outdoors. This commitment to previsualisation explains why she made very few exposures of a subject and rarely cropped her negatives, preferring instead to print full frame. Previsualisation also meant she could be frugal with the amount of film she used, telling journalist Janet Hawley in 1998:

I spend a lot of time looking and composing the picture before
I take it. I only use black-and-white, it allows the photographer

more control and, in the developing and printing, you can make your work distinct. Each roll of film for this camera [her Rolleiflex] only has 12 frames, so I never squander them.[10]

Olive never saw her process as complicated and avoided trickery or overt contrivance: 'I never liked close-ups or zooms, never liked any tricks.'[11] The only exception throughout her career was the occasional use of composite printing, for example to obtain 'the sky I wanted. I kept a lot of negatives of different skies and clouds so I could do that.'[12] This use of two or more negatives was in keeping with her pictorialist training and legacy.

Echoing her advice to prospective women nearly half a century earlier, Olive believed that darkroom work was central to art photography. Printing specifically was a creative activity she could fully control.

I like to do everything myself from start to finish. I'd never give anyone else my negatives to print up for an exhibition, because then it's not my own work. There's a lot in the printing. Sometimes you can make three or four prints before you're satisfied, not just with the exposure but there might be some detail you want brought up or some portion you want darkened a little bit. I generally write down what I've done when I made a print because sometimes it takes me a long time to get what I want. So I note down to give nine seconds here and hold back a little here, which paper to get the right tones, and so on.[13]

In Sydney and Cowra, she dedicated herself to printing to the best of her ability, a slow process because of the artistry involved in producing the best possible print: 'I think it is extremely difficult to get everything right.'[14] When printing for her exhibition at the ACP in 1985, she was pleased if she managed to complete two prints a day.

And finally, in a comment to one of the many visitors she received at Spring Forest, she confided that photography was always an intensely personal process for her. The first task, she emphasised, was to satisfy herself:

All I can do is photograph what I like, the way that I like it ... When someone says they like it, that's a real thrill for me, to think someone else has got something out of it too.[15]

The 1990s

Olive Cotton's place within the history of Australian photography, and more specifically within Australian modernism, was secure by 1990. However, this was the decade in which her own activity as a photographer came to an end, when the energy shifted from her as a sole producer to other people, whose efforts ensured she and her work would become better known. This occurred not only through curated exhibitions and their associated publicity and critique, but also through Kathryn Millard's *Light Years* documentary.

Millard had been inspired to develop a film proposal after seeing Olive's solo show at the ACP in 1985. Its first iteration was the *Olive Cotton Archival Film Project*, supported by the Women's Film Fund of the Australian Film Commission (AFC) and the National Film and Sound Archive, as part of a scheme to make 'a filmed 16 mm interview with a significant Australian woman whose life had not been sufficiently documented on film'.[1]

Millard also wrote a one-hour program for ABC Radio called *Orchestrations in Light*, which incorporated extracts from the initial interviews she had conducted with Olive. Millard, who by now had spent a considerable amount of time getting to know her subject and got on well with her, saw possibilities for extending her project into a fully fledged documentary film that dealt with her 'life and work, photography and memory'.[2] She secured research and development funds from the AFC (and later, production funds as well), obtained some sponsorship from Agfa (the deep blacks and warm cast of their film stock were a good match with the feel of Olive's

photographs), and engaged John Whitteron as her cinematographer because of his 'beautiful eye for light'.[3] After a potential producer of the film made the clichéd suggestion that Olive's story be paired with Max Dupain's, as 'the mother and father of Australian photography', Millard ended up producing the film herself.

From the outset, Millard saw *Light Years* as a collaboration between film-maker and subject, and took a respectful, non-exploitative approach that grew out of her close observation of Olive and her work. As she has written, she wanted 'some of the gentleness that I observed in Olive's life and work to be one of the qualities of the film'.[4] Realising that 'Olive was very reticent to talk about some aspects of her personal life', she decided not 'to press on matters that were uncomfortable'.[5]

Millard also appreciated that Olive's involvement in making the film complicated her relationship with Ross, which the film crew attempted to ameliorate with practical measures.

> While we were filming, Ross became irritated with Olive
> [being] pre-occupied for long days. We arranged for a caterer
> to bring meals for them to heat at night so Olive would not
> have to cook. Ross complained about the food so Olive ... still
> had to cook the evening meal. Ross was sarcastic, too, about
> the embroidered camera strap with her name – Olive Cotton –
> made by one of her ... friends ... It was the kind of teasing
> that appeared to be all in good fun but sometimes had an edge.[6]

For a particularly memorable scene in *Light Years*, Millard brought Olive and Max together in Sydney to talk about Olive's work. This was their longest interaction in forty-five years and, although they could not have known it, it was one of their final meetings as well. The result is a curiously stilted but touching scene in which the frail, elderly pair sit side-by-side, a pile of prints nearby. Olive is wearing a patterned dress – probably her best, chosen with great care for the session – and Max is dressed casually in an open-necked

striped shirt. Together, while the camera is rolling, they look at Olive's photographs one by one and self-consciously make a few comments in response. The conversation never gets going. Even though the film is about Olive, she appears quietly deferential, and it is Max – still – who has the authority and holds the floor. When would she ever have been the centre of attention while in Max's company? He teases her about the fact that she was still using her old Rolleiflex camera – not knowing how poor she was, not realising that buying any new equipment had been out of the question during the materially impoverished decades she and Ross had endured. It was not until the Cowra studio years that she had been able to purchase a later model Rolleiflex.

<p style="text-align:center">* * *</p>

Millard's initiative in filming Olive and Max was timely. Max was already in poor health and died two years later, on 27 July 1992, at the age of eighty-one. He was buried at a private ceremony in Sydney, which was later followed by a memorial service, which Olive, Ross and Sally attended.

In Diana Dupain's obituary for her husband, she spelled out the character traits Olive also knew intimately, writing that he was

> … a romantic, pretty well self-contained and of basically
> retiring disposition, who was perhaps happiest creating his
> Castlecrag native garden and indulging in his great love of
> classical music – particularly Beethoven. He was sensitive
> and charming but with an Aussie sense of humour; with
> tremendous creative and work capacity, single-mindedness and
> an overwhelming, unbridled passion for photography – he lived
> and breathed it – and at times cursed it![7]

She drew attention to Max's complexity, as a 'man with many contradictions who strove to keep his life simple and his work

uncluttered and uncomplicated', and concluded her obituary with a statement encapsulating his beliefs about the importance of photography in contemporary life:

> Modern photography must do more than entertain; it must incite thought and by its clear statements of actuality, cultivate a sympathetic understanding of men and women and the life they create and live. I profoundly believe it can accomplish this.[8]

Later that year, Diana contacted Olive, as she had something to give her. In recognition of Olive's life with Max, Diana had assembled a group of his early photographs of her. Olive received them with pleasure.

* * *

In 1990, Olive's contribution to photography in Australia was honoured by Australia Post, which selected *Teacup ballet* as an image for a stamp. Delighted members of the Cowra Arts Council organised a small exhibition of her work, which was held at the Cowra Civic Chambers in 1991. Ross wryly remarked to me that the townsfolk were amazed to learn she had been living in their midst all that time, and suddenly became keen to know her.

On the gallery circuit, her photographs became a regular fixture as momentum for the inclusion of art photography in public art collections and programs continued to build. In 1992, in Canberra, aGOG's director, Helen Maxwell, organised a one-person show as part of her program championing the work of women artists. The show included twenty-four recently editioned prints of what were becoming Olive's signature works – *Teacup ballet*; *Fashion shot, Cronulla sandhills*; *Shasta daisies*; *Sesquicentenary procession, Sydney*; and *The sleeper* – as well as two vintage prints, *Orchestration in light* and *The patterned road*. The top sellers were *Shasta daisies* and *The*

sleeper, each eliciting three orders. Maxwell produced an exhibition catalogue to which I contributed a short introductory essay.

In 1993, now aged eighty-two, Olive was awarded a prestigious Australia Council Emeritus Award in recognition of her contribution to Australian photography. On his visit to Spring Forest not long after Olive received the award, radio producer Mike Ladd noted that, although it was worth several thousand dollars, it had not led to any obvious material changes in the lives of Olive and Ross. He recalled that 'there were no signs of any luxuries about the house'.[9] Ladd was there to record a radio program on the widely admired poetry of their former son-in-law, Geoffrey Lehmann, whose publications *Ross' Poems* (1978) and *Spring Forest* (1992) were 'based around' Ross's life and his stories of a rural life that was disappearing. Olive, Ladd observed, was self-effacing about her growing reputation, and was pleased that Ross was receiving some public attention as Lehmann's muse.

Further public recognition for Olive followed with exhibitions held at art museums, public and commercial galleries, and publication of the first book on her – *Olive Cotton: Photographer*, which was part of the National Library's series on Australian photographers. I was commissioned by the library to select the photographs, Olive contributed reminiscences about each image that were used in the book's captions, Sally wrote an engaging autobiographical essay, 'Life in the country', and I wrote a contextualising essay entitled 'Patterns in time'. *Olive Cotton: Photographer* was launched at the library in August 1995 by Annita Keating (wife of then prime minister Paul Keating), who had a personal interest in photography. The NLA Pictures Collection subsequently acquired a large group of photographs, again supplemented by a generous gift from Olive of additional works.[10]

Despite Olive's best efforts, meeting the growing commercial demand for her work was proving almost impossible. Her records from 1994 alone note the high volume of prints needed to fulfil orders: for example, the very popular *Shasta daisies* and *Windflowers*

required thirteen and nineteen additional prints respectively (both from an edition of twenty-five). Failing eyesight and frailty made printing and spotting hard (the latter requiring the application of special inks to mask any flaws, such as dust spots or hairs, transmitted from the negative). Sydney photographer Roger Scott took over some of the printing in accordance with her specifications and she approved and signed the resultant prints prior to their sale.

A show at Josef Lebovic Gallery in Sydney in late 1995 reflected the reality of Olive's failing health. The fifty-five photographs shown comprised a mix of vintage prints, later prints printed by Olive, and later prints by Scott and signed by her. The four vintage works, *Sky submerged*, *The way through the trees*, *Orchestration in light* and *Plum blossom*, all dated from the 1930s and were the most highly priced items. This reflects a basic tenet of the photography market, where vintage prints are more highly valued than modern prints for reasons of rarity. The exhibition was reviewed in very positive terms by Joanna Mendelssohn, who noted: 'The recovery of the reputation of Olive Cotton from the shadow of the modernist giant Max Dupain has proceeded apace in recent years, aided and abetted by new-generation feminist scholarship.'[11] She drew particular attention to the 'underlying intelligence in Cotton's work' and the 'pleasure in small details', and considered the Cowra images 'remarkable' for their use of sunlight and depiction of intimate moments.[12]

Olive's work was also sympathetically paired with Melbourne painter Clarice Beckett's in an exhibition, In a Certain Light: Clarice Beckett and Olive Cotton, curated by Felicity Fenner, with assistance from Jenny Bell, and shown at Ivan Dougherty Gallery in Sydney, in 1995. The exhibition featured twenty-nine works by Olive and forty-seven by Clarice Beckett. Fenner identified important parallels in the life and work of the two women artists: as adults, both had 'to juggle family responsibilities and their art practice, often struggling within a male-orientated social culture'.[13]

She commented that full recognition of their contributions to Australian art was 'a long time coming', posthumously in Beckett's case – she had died at the age of forty-seven – and late in life in Olive's. Neither woman left what Drusilla Modjeska has described as 'a paper trail', making the reconstruction of their lives and artistic motivations far more difficult. In terms of their stylistic affinities, the curators nominated light as a principal preoccupation: 'its capacity to reflect in a place or an object a spectrum of subtle psychological and emotional shifts'.[14] Fenner and Bell wrote that, in her work, Cotton retained 'an individual, meditative quietude that distinguishes her ... from her contemporaries'.[15] They closed their catalogue essay with the insightful comment that Cotton's photographs 'are unhurried; she uses the camera not to immortalise passing impressions, but to capture eternal truths at precise moments of greatest beauty or revelation.'[16]

While there were affinities in Clarice Beckett's and Olive's lives, there were significant differences as well. Beckett did not marry and had no children, and although for many years she was the full-time carer of her elderly parents, she continued to paint in areas close to her home in a bayside suburb of Melbourne and lived surrounded by her work; whereas, for Olive, for extended periods there was little visible evidence of her art practice.

As Olive became recognised as a modernist, her reputation as a key figure in the narrative of Australian women's art and feminism was also consolidated. In 1995, Roger Butler, Senior Curator of Australian Prints and Drawings at the National Gallery of Australia, chose a group of her photographs for the mixed-media exhibition Women Hold up Half the Sky, which surveyed the contribution of women artists to Australian art over 150 years. It was mounted as part of the national commemoration of the 20th anniversary of the United Nations International Women's Year and provided the backdrop for the launch of *Heritage: The national women's art book*, edited by Sydney art historian Joan Kerr, which included an entry on Olive.

For Olive herself, however, the art historical categorisation of her practice was totally irrelevant and the need for artistic freedom was paramount. As she explained late in life:

> I would not like to be labelled a romanticist, Pictorialist, modernist or any other 'ist'. I would feel neatly confined to a pigeonhole whereas I want to feel free to photograph anything that interests me in whatever way I like.[17]

Moths on the windowpane, 1995, courtesy Cotton family and Josef Lebovic Gallery, Sydney

Moths on the windowpane

The end point to Olive's life in photography was *Moths on the windowpane* (1985), taken one night when she was eighty-four. It is a prosaic scene, as her title indicates, a familiar nightly event in warm weather when moths are everywhere. Olive would have witnessed their massing against the windowpane in the living room countless times over the years, from varied vantage points, whether from the couch in the living room, or from the armchair on the opposite side of the room, or close-up when seated at the table in the dining room. When the time came to take the photograph – in keeping with her lifelong practice, she would have thought about it for a long while, watching and waiting – she chose her viewpoint carefully. She and her camera were positioned to take in the tall eucalypt that grew outside the living room window in the backyard just a short distance from the house. It is a tree so close you can hear the wind move through it.

What Olive photographed may have been prosaic on one level, but it was laden with symbolism on another. Moths are, of course, associated with mortality, typically living only a few days, seven to ten at the most. During their short lifespan, there is a great deal to be done, the attraction to light a destructive diversion, an evolutionary dead-end.

Aside from the moths and the tree, there are two other crucial ingredients in the image: the windowpane and the light. The artificial light that mesmerises the moths is inside, where Olive stands with her camera in the warmth and enclosure of a domestic

environment. Outside are the darkness and the spread of night, signifying the natural world and its unstoppable, unbreakable rhythms. Between the inside and outside, between artificial and natural, light and dark, is the glass on which the image – and its meaning – pivots. It is transparent and seemingly weightless, providing not a solid barrier but a passageway between one state of reality or being, and another. Olive foresees and, in her understated yet fully assured manner, creates an image of great profundity. It doesn't demand attention but quietly invites it.

There is a beautiful painting by Swiss-born artist Paul Klee called *Figure in yellow* (1937), which has helped me think differently about *Moths on the windowpane*. The painting dates from the last years of Klee's life, when he was knowingly suffering from an incurable illness. Its owner, art collector Ernst Beyeler, perceptively noted that, in part, he was attracted to the painting because: 'No fixed order is discernible, but signs frolic across the surface, radiating a wonderful freedom with a compelling rhythm and a very strong colouration.'[1] This effect holds true for *Moths on the windowpane*. The massing of the moths is random and asymmetrical and, while this could not be fully controlled by Olive, the composition is visually satisfying. Something Edward Said wrote in his reflections on late style resonates here, too: 'Lateness is being at the end, fully conscious, full of memory, and also very … aware of the present.'[2] In this late, indeed last photograph, resolution is not achieved lightly, indicating Olive's passive acceptance of her own mortality. A far more dynamic possibility is suggested instead – an active and unending relationship between different kinds of forces, including light, which entranced her for a lifetime.

Packing up the studio

When Calare Arcade, where Olive's studio was located, was about to be redeveloped in 1996, Tom Carment, a Sydney-based artist and friend of Sally's, helped pack up the studio's contents, emptying it out prior to demolition. He noted that the developers had offered Olive a rent-free space for a studio in the new building that was to be built, but she had declined. She had stopped using the studio much, finding printing too tiring. Tom later wrote about the day's proceedings:

Sally decided that we should do most of the initial sorting without Olive there, in case she found it too overwhelming or sad. This was fine with Olive who seemed on the surface quite unsentimental about the whole event – happy to leave it in Sally's hands. Olive's husband Ross too, seemed … concerned that I salvage as much of the re-usable infrastructure as I could – shelves, taps etc. – before the demolishers smashed it all, wasted it. The setting up of the dark room and office 35 years ago was still fresh in his memory and he was especially proud of the way the shelves had been constructed. Ross was probably masking his unhappiness at the realisation that Olive had become too old to carry on with the practicalities of this recovery operation. Sally told me later that he'd rung at the last minute to say he wasn't coming in to help, he just couldn't face it …

The first thing I did was take down the sign hanging from a chain by the door, painted by a signwriter in imitation of

Olive's youthful signature. 'Closed for Business,' I thought. The bulldozers were already busy shoving piles of bricks about immediately through the wall and Sally and I had to shout to hear each other. We opened up the door and stood there for a while. On the left hand side where you came in was a browned grey-green Caneite panel with a selection of Olive's commercial work stuck onto it with large rusty drawing pins: portraits of children and adults from the 1970's, with hair spruced up, brylcreemed and permed, long collars and wide ties, ruffle-necked and empire-line dresses. On the other walls were pinned her non-commissioned prints, some well known, some I'd never seen before: her ex-husband Max Dupain crouching down photographing a model on the Cronulla sandhills (a play within a play), clouds in the water, a burning log, a tunnel of trees at night. At waist height all around the walls ran the green laminated shelf which Ross [and his] brother-in-law Ray Turner had built in the 1950s, as over-engineered as the Harbour Bridge and held together with lots of long screws …

Stuffed behind all the diagonal shelf brackets were stacks of neatly-folded wrapping papers and envelopes of photographic paper (some still containing unused sheets which were up to twenty years old). I wondered whether this obsessive recycling was a hangover from wartime paper shortages or just sensible country town economising … In amongst all this brown, buff and yellow paper and neatly-tied skeins of string were lots of Olive's commercial prints: children, weddings and classrooms …

I … got to work with spanner and screwdriver in the darkroom next door. I dismantled a giant old enlarger of the type made for glass plates and probably not used for decades. I think Sally said it had come from Max's wartime studios in the city and was ancient even then. Every so often Sally would call from the next room and show me a puzzling object or exciting

discovery. She found a couple of prints she'd never seen before, two nocturnes: a tree stump on fire, and a galaxy of moths at the kitchen window. Some old copies of Sydney Ure-Smith's Australian Society of Artists Annuals from the 40s turned up. In small print on the third page I read that Olive was the photographer of all the paintings and sculptures in them. There was a handwritten dedication in one, which read: 'To Olive, for all her hard work', signed by Sydney.

Later that evening, by the fireplace at Iambi, I pulled them out and asked Olive if she remembered doing those jobs. Her recollections were surprisingly clear; of how she photographed each piece and what she thought of different artists: how she'd used a sheet of ground glass behind a particular sculpture, how she found Francis Lymburner self-obsessed and Douglas Annand very nice. Sally told me that in the 40s Francis Lymburner had a studio in the same building as Max Dupain's and one afternoon invited Olive in for tea. He offered her gin but she said just tea was fine. She felt a bit uncomfortable and when a big cat jumped into her lap she let it stay there, despite a dislike of cats, and stroked it. Francis stared at her for a while, then murmured, 'Lucky cat'.

Sally and I kept sorting the studio throughout the afternoon and began to load the van with things to keep and store. Ross brought Olive in around three-thirty. She looked about her old studio with calm interest (like that of a visitor, I thought) and thanked us for what we were doing. I showed her a pile of odd-shaped stencils (some of them stuck onto wire like fly swats) and asked her what they were for. She replied that she'd made them especially to block out parts of a photo she was printing. One, a piece of old stocking stretched across a cardboard window, was for 'softening things'. She told me to keep a big sheet of highly-polished stainless steel – she used to heat it up and use it for glazing prints on cloth-based paper, she said. The bulldozers had stopped, although we'd hardly

noticed, and stood frozen in the rubble as we walked in and out to the van. When we'd finished we shut the door for the last time and took a short cut across the car park to a local cafe to join Olive and Ross for tea. I felt a bit disoriented – a feeling Olive must have often had on leaving the studio after a long session of printing. I felt like I'd stepped out of daytime cinema – a black and white classic with a tearful ending. Some kids on their BMXs crossed our path, yelling at each other on their way home from school sport. There was a stillness of approaching evening in the sky flecked with high cloud and a flock of galahs was squawking and wheeling about above the caravan park by the river.

The next day Olive gave me a print of a gum tree against the sky. The signature is unsteady and there are white dust hairs on the darks, but I like it for that.[1]

Leaving Ross, two

How often did Olive go to leave Ross, or go further and actually leave him? At least once when her children were involved, and at least once when a grandchild, Lucy Lehmann, witnessed the event, though not what triggered it. Lucy wrote about what transpired during a visit to her grandparents at Spring Forest in 1996:

> I used to think Olive must have been so unworldly, so innocent, that she couldn't see – until too late – the trouble she was bringing onto herself when she married Max, with his eye for women, then Ross, jealous, bitter, bad-tempered (the list goes on until it ends with 'but strangely charismatic'). I also wondered whether fifty years of being married to Ross had broken her spirit, shaping her into his direct opposite.
>
> I soon had evidence her spirit had not been broken, when, at 85, she left Ross one more time. It happened quietly. I came back from a walk to find Ross puffing shamefacedly on his pipe, and a small coffee table spread with an embroidered cloth, two tea-cups, a plate of assorted creams.

Whatever occurred between her grandparents while Lucy was out of the house was sufficient to prompt decisive action from Olive. She enlisted her granddaughter's help, as Lucy explained:

> I drove the getaway vehicle, my mother meeting us in Yass in response to my plea for help, whispered over the phone. Olive

had a vague plan to move in with her sister, who was younger but in her 80s nonetheless. Instead she stayed in Sydney. I was at my mother's house one evening when the phone rang; Olive looked up expectantly, her eyes shining. I listened on with faint disapproval as she talked to 'Rossy'; her voice was soft and tender. It was their courtship all over again. I knew what was going on between them … She went back to 'Spring Forest'.[1]

This time the separation was much shorter than the first, forty years earlier, lasting days rather than months.

A force for change

In January 1999, I began work on a retrospective exhibition of Olive Cotton's photographs. The project was initiated by Judy Annear, former Senior Curator of Photography at the Art Gallery of New South Wales, who had been advised by Olive's gallery dealer, Josef Lebovic, that she was not well. All agreed that a retrospective would be timely. The Art Gallery of New South Wales's proposal was to tour the exhibition to the National Library of Australia and the National Gallery of Victoria in Melbourne.[1] I worked on the project as an independent curator during 1999 and 2000, collaborating mostly with Sally, who by then was looking after the portion of her mother's archive that had been moved to Sydney after the closure of the Cowra studio. It was in Sally's upstairs workroom at her home in Glebe that I saw for the first time *Only to taste the warmth, the light, the wind* – an instant and obvious choice for the cover of the exhibition catalogue. Works for the show came from the collections of the AGNSW, the National Library, the National Gallery of Australia and the McInerney family.

In his foreword to the catalogue, *Olive Cotton*, the then AGNSW director, Edmund Capon, stated that the exhibition continued the gallery's 'commitment to researching, exhibiting, publishing and extending the knowledge and appreciation of Australian and international photography. It is further demonstration of our commitment to the art and history of photography.'[2] Here was an opportunity to bring Olive's work to a new audience and reveal the

quality and complexity of her oeuvre. My concern was also with expanding what was known of her oeuvre by including examples of her commercial photography from the Cowra studio, along with some biographical material. The show was opened in Sydney in May 2000, and in July travelled to the National Library in Canberra, where it was attended by over 20,000 people in a three-month period.

Media coverage included a thoughtful, well-considered review by Robert McFarlane, photographer and critic, who wrote:

> As I followed Cotton's imagery along the first four walls of the exhibition, I began to realise that almost every photograph celebrated the romantic and the organic. Light flowed through and over grass, papyrus and trees and into empty, timeless, living spaces, and – in a number of images – to the sea and sky.
>
> So simple and poetic were these moments that they seemed to belong to an era before photography's birth. I toyed briefly with the idea of describing Cotton as a fine, 17th-century photographer, fantasising that many of her photographs would have intrigued Shakespeare, save perhaps those of the rugged Australian landscape.
>
> … Cotton's retrospective proves that the race does not necessarily go to the swiftest, cleverest or most financially successful artist. The body of work that unfolds to the unhurried viewer reveals a woman who stubbornly remained true to a vision that came, quite simply, from the heart.[3]

Art critic Bruce James was profoundly moved by seeing Olive's work. He argued that she was 'a force for change' in Australian photography and elaborated on what exactly he meant by that:

> I called Cotton a force for change. What does that mean, save that I'm struggling for a cliché that won't stunt her? I think she's among a small group of artists who are causing us … not simply to know ourselves better as a people but to like

ourselves more; not simply to admire the environment ... but to reverence it; not to look at Australia, but apprehend it.[4]

However, it was the phenomenal response shown in the visitors' book that was most telling. In her exhibition review, Lisa Byrne, then Director of Canberra Contemporary Art Space, remarked that the visitors' book 'makes for interesting reading. Within one week of opening, this book has almost five-and-a-half pages of one-line comments about Olive's photographic practice.'[5] She proceeded to ask a pertinent question: 'How does this work motivate such an emphatic response?' By the end of the show, the book ran to thirty-six pages of handwritten entries, which were overwhelmingly positive. There were, of course, predictable comments from young students – 'this is cool', 'Max was a babe!!!!' – but most visitors felt compelled to use at least a couple of adjectives to sum up their encounter with Olive's work, describing it as 'elegant and unpretentious', 'exquisite and evocative', 'most evocative and excellent'.

There was praise for Olive's technical abilities, for her mastery of black and white photography in particular. Her tonal control was judged as 'superb', so was the quality of her printing. A number of people remarked on the transformative power of her vision – the way she could 'transform simple, commonplace things'. Another visitor was amazed at 'how she can make such simple things so beautiful.' How she used light attracted the most comment, with visitors writing of her 'wonderful use of light, emotion' and 'excellent and inspiring use of subject and light with loads of feeling'. Within the constraints of the visitors' book format, the audience still registered an emotional dimension to Olive's photography and their encounter with it. Her photographs were often described as 'peaceful 'or 'tranquil'. Many were moved by the exhibition, one visitor writing very simply, 'I am touched.' And this, my personal favourite: 'The pictures captured a part of you, letting you imagine you are actually within them.' Another concluded: 'I could look at Cotton forever.'

These comments give an inkling into the relevance of Olive's photography to a contemporary audience. Free of agitation and unresolved, restless energy, her photographs are an elegant reminder to not be distracted by short-lived superficial pursuits. They are a powerful, non-didactic endorsement of states of being that are becoming increasingly alien – contemplation, restfulness, quietude – and of the singular importance of a rich inner life.

Olive was sent a copy of the visitors' book and I imagine she would have been overcome by the enthusiastic outpourings of her audience, by the numerous references to her as a national treasure. She wouldn't have made much of the praise, keeping it quietly to herself, but she would have been touched.

More public exposure followed in major exhibitions mounted by various cultural institutions, reflecting the acceptance she had gained as both photographer and modernist, one whose contribution was being thoroughly integrated into the primary art historical and curatorial narratives of Australian art.[6]

At home at Spring Forest, however, such achievements were becoming increasingly irrelevant to Olive, who, in Sally's words, was becoming more 'frail and forgetful'.

White irises

The events that led to Olive leaving Spring Forest after half a century were 'nightmarish'. Sally outlined them in a letter to Jean Lorraine, on 15 January 2001, as she knew that Jean was anxious about Olive's condition, and Sally appreciated the 'great bond' that existed between them. She was keen to reassure Jean that Olive was all right now that her situation had been stabilised, explaining:

> She has been becoming frail and forgetful for some time – for
> a few years, I think, though she has always seemed quite serene
> and observant in her own private, particular ways, and this has
> never really changed.
>
> Then, between the two shows [exhibitions of her work],
> about September, she fell and broke her leg – at home, and
> Ross was there, and very soon Peter and Diane, and the
> ambulance, were all there too. She made a good recovery but
> has not become 'mobile' enough to go back to Spring Forest.
> Really it is her vagueness and forgetfulness that meant this
> wasn't possible. Life at Spring Forest, and without proper
> nursing help close at hand, would have been, in my opinion
> (and others') very hard to manage. After much soul-searching
> and difficulty with various people's (ie mostly Ross's, certainly
> not Olive's) complicated personalities, she has become settled,
> and very well looked after, in the local nursing home at
> Cowra – it's called Weeroona ...

Ross always said that being a few years younger than Olive would be an advantage in old age because he would be able to look after her. He held true to his word and marriage vows, visiting her most days at Weeroona, making sure she ate her lunch and often sitting with her into the afternoon. If, for any reason, he could not be there, he would arrange for others to visit.

My friend Helen and I went once, shortly before Christmas 2001. By then, Olive's dementia was well advanced. She was as warm and solicitous as ever, although she did not know who we were, repeatedly asking us our names and saying them aloud in an effort to remember them. She was keen to make us a cup of tea, writing down our requests on a small pad of paper she had with her, but there was no way she could carry the action through.

Ross's sister, Haidee, later recalled that there were some white irises growing at Spring Forest near the new house, which she knew Olive had been 'waiting and waiting to photograph in the best light', her desire to photograph still very much alive. However, her fall and end-of-life circumstances overtook her, and photography of any sort was out of the question.

When it came to her dying, Olive was not able to prepare herself: her dementia had robbed her of that possibility during the months and years of her slow decline. She died at the nursing home on 28 September 2003, with Ross by her side. Her memorial service, conducted by the Reverend Susanne Pain, was held at St John's Anglican Church in Cowra the following week, on 5 October. It was a traditional service with prayers and psalms, and a musical tribute that was one of her favourite pieces, a lullaby by Frederic Chopin (Berceuse, opus 57, in D Flat major). A moving gesutre was a reading of the poem *Epitaph* by Wiradjuri poet Kevin Gilbert at the conclusion of the service. Its sentiments and unembellished language were in keeping with Olive's philosophy of life.

Weep not for me for Death is
but the vehicle that unites my soul

with the Creative Essence, God.
My spiritual Being, my love, is
still with you, wherever you are
Until forever.
You will find me in quiet moments
in the trees, amidst the rocks,
the cloud and beams of sunshine
indeed, everywhere for I, too, am
a part of the total essence of
creation that radiates everywhere
about you, eternally.
Life, after all, is just a
passing phase.

Two impressions have stayed with me from Olive's memorial service. The first is to do with the architecture of the church where it was held, a large self-consciously important building that was so at odds with the life she had led. My other memory does not relate to Olive but to Ross. He had chosen to sit a long way back in the congregation and acted as though the proceedings had nothing to do with him. Afterwards, at the afternoon tea held in the Parish Centre next to the church, I asked him what he thought about it all. He told me in a distracted, and what I interpreted as a defiant, way that he had not heard a single thing anyone said during the service because he was not wearing his hearing aid. He had it with him, taking it out of his pocket and showing it to me as proof, but had not inserted it.

Olive did not leave instructions for either her funeral or her burial, but a day or two after her death, Ross announced that he wanted her buried at Spring Forest. Until then, the family had hoped that the Morongla Creek Cemetery, thirteen kilometres south of Cowra, where other members of the McInerney clan were buried, would be her final resting place. Ross had selected a site at the top of the gentle slope behind the new house, and it fell to Sally to hastily make

the arrangements for a so-called 'farm burial'. The approval process, which normally takes a few months – involving among other things, a hydrologist's assessment of any potential health risks posed by contaminated run-off – was concluded quickly. The ground Ross had chosen for the burial site was far too hard and rocky to dig by hand and so Peter arranged to bring in a friend's backhoe to dig the grave.

A few days after Olive's death, a hearse drove her body from the funeral parlour in Cowra to Spring Forest, navigated the drive up the hill, across a paddock that was uncharacteristically sodden from recent rain, and came to a stop at the freshly excavated grave site. With the closest members of Olive's family in attendance, Sally and Peter said a few words and her coffin was lowered into the ground. The burial mound was topped with gum sprigs picked from trees growing nearby. The boulder Ross had in mind as a headstone was too heavy to move to the site and so a clump of irises, which Olive would have loved, was planted as the grave marker. The plants did not last long, consumed by wild horses grazing the property.

This quiet, modest woman would have been amazed by the amount of attention her death attracted in the following days, weeks and months. Obituaries were published in newspapers around the country and in national art magazines, and there was coverage on local and national radio.[1] She was lauded as a pioneer of modernism in Australia, with a distinctive aesthetic. Robert McFarlane perceptively noted that 'she somehow transmuted the banal into art' and 'had a kind of humility of vision'.[2] Gael Newton wrote of her 'many now iconic images suffused with the grace, economy and humanity which characterised her responses to the modern movement in Australian photography'.[3] And two years later, in honour of Olive and her love of portraiture, Ross, Sally and Peter McInerney, assisted by Josef Lebovic, established the Olive Cotton Award for photographic portraiture at Tweed Regional Gallery.

* * *

For a long time, I thought this story of Olive's life would end with her death. But it could not for two reasons: one was Ross and the other was Olive's photographs.

When Olive died, it did not mean that Ross moved to centre stage, but rather that something more subtle and nuanced came into play. Because her life had been entwined with his for nearly sixty years, it did not seem either appropriate, or indeed even possible, to write her into being while he was alive. I decided that, while he was living, she was effectively still in his care, and I did not want to disrupt this state of affairs in any way. Ross was to live another seven years, a period that, in biographical terms, represents a lengthy hiatus between the world of the lived and the real, and the world of the dead and story.

And then, of course, there were the photographs that are the very reason for this biography. Their life, their relevance did not end when Olive died, and they did not insist on any urgency.

'The rifle bird's song'

Now Olive is gone
and will not come back,
on hot nights I sit up late
turning a few pages
next to an old and noisy air cooler.
I smoke a pipe, using
George Grogan's trick,
a small metal button
or lump of charcoal
lodged in the tobacco –
half an ounce can be eked out for hours.
The unhappy
have no rituals to meet the daylight
each moment
the shock
of meaningless smells
unconnected sound.

From 'The rifle bird's song', by Geoffrey Lehmann

Letter-writing was a lifelong ritual for Ross, and he could be an attentive and regular correspondent. I have kept his letters from a two-year period, 2002–04, that spans Olive's term in the nursing home, her death and several months afterwards. Each letter is one or two pages long, written in his beautiful cursive style (Olive's

handwriting was not nearly so elegant or assertive). It is handwriting that identifies the age of its owner, the flourishes and formation of letters are old-fashioned, and I suspect he used a fountain pen rather than a ubiquitous ballpoint pen. Three of the letters were written when Olive was living at Weeroona, but what is noticeable immediately is her absence from them. It was as though she had already gone from his life. There are only two references to her, one oblique, the other direct. On 29 October 2002, he wrote: 'This is the first "letter" I've written for a couple of years but I must get started again. Things are quiet here and a bit empty but so far I am managing in a way.'[1] A few weeks later, he noted that he had been lent a Brumby utility so he could still visit Olive, but did not elaborate on where she was or how she was faring, which my family was keen to know.

Ross's voice in the letters is gallant and polite, and as I read them, I can hear him speaking aloud once again. There was something about the particularity of his language and phrasing, combined with the deliberation and firmness of his delivery, that was very distinctive. Every letter at some point included his thanks for friendship, and for keeping in touch. He extended his usual generosity, offering us a place to stay if needed – 'you would all be very welcome.' On one occasion, he offered an apology, which indicated he had been reflecting on a visit we had made: 'This is to apologise ... You asked if you could visit Olive's grave and I talked so much that I overlooked that. I am sorry. If you should ever visit again, please don't let me monopolise the conversation.'[2]

The letters covered a period of great sadness in Ross's life, following Olive's death and the tragic accidental death of his niece Micki, Haidee's daughter, just a few weeks later, in Gunnedah in New South Wales in October 2003, which greatly distressed him. He told me that: 'She was killed almost instantly after being hit by a 4-wheel D while taking the children to the school bus. I could not bring myself to go to the funeral.'[3] Mostly, however, the letters are filled with the little events occurring in his life, including some repairs to the new house which he was carrying out himself. Now

and then, he described the weather and its effects, 'very dry, very dusty here with impressive dust storms', and some of the goings-on in the area, 'Lots of smoke too, from stubble fires'.[4]

If there is a consistent thread in Ross's letters it is his interest in dogs and, more especially, his pleasure in the puppies he was breeding. After the birth of 'three beautiful blue kelpies', in February 2003, he kindly asked: 'Do you want one? I never sell them.' Another litter was born on a momentous occasion, the night of Olive's death, but he mentioned it only in passing, writing: 'There are five fetching puppies here born the night Olive died. The parents are black and tan kelpies but one must have some hidden Border Collie as some have Border Collie markings.'[5] A few weeks later, he proudly stated that 'the puppies are beautiful and the nicest I've had, I think.'[6] More litters arrived the following year and he wrote: 'Tell the boys there are now five pretty puppies, born seven weeks ago and not yet into mischief.'

* * *

The year after Olive's death, Ross met a local woman, Margaret Page, at a wedding. She became his partner for the next few years. Margaret was an Irish-born secondary schoolteacher who had settled in the Cowra region in 1969, where she married a local farmer (they later divorced) and raised her children. She did not meet Olive or Ross while Olive was alive, but, as was common in a small town, she knew of them. Sally wrote to Jean Lorraine to introduce Margaret to her, telling her that she was 'a lovely woman. It seems a remarkable turn-around in Ross's life; he had become so lonely and morose.'[7] Concerned that Jean might see Ross's re-partnering as disloyal or disrespectful to Olive, she said, 'it seems pretty miraculous and life-affirming to me.'[8] As their relationship deepened, Ross lived between Spring Forest and Cowra, eventually moving to the centre of town, into a house in Lachlan Street purchased by Sally's family and ideally located next door to Margaret. This was very familiar territory, known since childhood.

'The owl and the pussy-cat'

Ross was a lifelong smoker and a number of times, when beset by ill health, he feared he had cancer of some kind. In mid-2010, he was diagnosed with lung cancer and had a short stint in hospital because of bronchial problems. By September that year, the decision was made to move him from his home in Cowra to a nursing home nearby, where he could receive the professional care he needed. Sally suggested we visit him as soon as we could, due to the deterioration in his condition, and at the end of October my son and I drove to Cowra to see him for what we knew would be the last time. He was confined to his bed and looked so different that for a split second I didn't recognise him: he had lost a lot of weight, his face was thin, his chin seemed more prominent and he was unshaven, which was very unusual. However, he was as sharp-witted as ever, and had a salutary tale to tell about human folly. A man who wanted to buy Ross's lawnmower had visited him a few days earlier, pressuring him to sell it cheaply, 'now that he wouldn't be needing it anymore'. Ross was still savouring his delight in thwarting the sale.

As we were about to leave, Ross asked if we knew the poem 'The owl and the pussy-cat'. We did: it was in a much-loved book of children's verse we had at home. Ross told us that he was going to the place Edward Lear had written about. Together we recited the poem's famous opening lines, 'The owl and the pussy-cat went to sea/In a beautiful pea green boat', and then Ross continued alone, reciting the final verse in full.

And hand in hand, on the edge of the sand,
They danced by the light of the moon,
The moon,
The moon,
They danced by the light of the moon.

Ross died on 11 November 2001, aged ninety-two. His funeral service was held at St Raphael's Catholic Church in Lachlan Street, adjacent to the primary school he had attended in the 1920s, and just down the road from the house next door to Margaret's, where he had mostly lived since Olive's death.

Like Olive, Ross did not leave written instructions for either his funeral or disposal of his body. However, he had declared his preference several times in private to his family and publicly: 'I've instructed everyone concerned to roll me up in a sheet of second-hand corrugated iron and bury me on the hill, and if it's a good sheet, slip me off and reuse the sheet.'[1] Fulfilling his wishes was not practicable and so the family arranged for him to be buried at Morongla Creek Cemetery instead. A hearse transported him from the church in Cowra to the cemetery, and friends and family gathered around his grave on a hot spring day. A member of the RSL gave a traditional farewell in recognition of Ross's military service.

* * *

'Daft' is how Peter described his father's burial of Olive at Spring Forest in 2003. He was not the only member of the family who was distressed at the thought of Olive remaining up there on the hill, totally alone now that no-one in the family was living on the property. So, after Ross's death, they initiated their plans to disinter Olive and rebury her next to Ross. This occurred a few months later. The couple's graves now lie side-by-side in an outer row of Morongla Creek Cemetery; close by is a straggly strand of bush and beyond the wire fence are the stretches of paddocks Ross knew

intimately from his farm work in the area. Unlike the surrounding graves, theirs have no structures and no headstones with elaborate inscriptions. The simplest of plaques sits at the top of each grave. If you are looking for Olive Cotton, you will not find her here: the plaque marking her final resting place says, 'O. McINERNEY. DIED 28.9.2003. AGE 92'.

On listening

On my last visit to Spring Forest, I left the car at the roadside, opened the front gate, with its handwritten sign, and walked the short distance up the driveway to the new house. As I walked, I counted aloud the number of abandoned cars in the front yard, something my sons had always liked to do when we went to see Olive and Ross. Seventeen was the total I remembered from previous visits, but there was an extra car this time, one I didn't recognise. A white Subaru utility had joined the medley of Austins and was parked at the top of the drive. It was a relatively recent model, seemingly in good condition, and I wondered why it was there. The state of the Austin cars was far from uniform, depending on which parts Ross had removed, and the length of time they had spent in the yard, which in some cases now spanned decades. Around the back of the new house, the long empty chook pen looked forlorn, and Ross's honey shed, still crammed with bee- and honey-related paraphernalia, had become more dilapidated. Turning towards the old house, I could see Olive's traveller's trunk sitting quietly under the shelter of the back verandah, safeguarding the items she had brought with her from Sydney decades before.

At the new house, I climbed onto the familiar wobbly step and found that the screen door wasn't locked. It opened outwards and awkwardly, as it always had. But the smell that assailed me as I entered the house was new. The pungent odour of possum and rat urine was so strong, I instinctively held my breath and hurried down the hallway into the larger, open space of the dining and

living room. Evidence of the creatures' nocturnal forays was everywhere, and I could hear them fidgeting about in the walls and roof, presumably disturbed by my footfall. The kitchen looked like it had been ransacked, with jars of Ross's preserved fruit lying on their sides on the pantry shelves and on the linoleum floor. In other rooms of the house, which the rats and possums had neglected, more order prevailed.

I went back outside into the yard.

* * *

When Robert Dessaix was writing his book *Twilight of Love: Travels with Turgenev*, he visited the 'ancestral nest' of writer Ivan Sergeyevich Turgenev, his home at Spasskoye in the Russian countryside. The aim was 'to get a truer measure of the man', Dessaix's biographical subject.[1] He wandered around the house, now a museum, which made him feel 'disoriented, out of kilter', and unsettled. As he put it: 'I also couldn't help feeling I'd come to the wrong address. Or to the right address to find nobody home.'[2] However, once Dessaix left the house museum, its attentive visitors and well-informed guide, and went outside to walk around the grounds, he did something I had never thought to do. He imagined what Turgenev would have heard on a similar May morning some 125 years previously: 'Hammering and sawing, probably, horses neighing, someone shouting in the distance, a burst of laughter, muffled gun-shots.'[3]

In all my roaming around Spring Forest, I had looked and looked, but had never consciously listened. When I finally did so, I was struck by a simple, incontrovertible fact. It is so, so quiet! At Spring Forest, Olive would have heard very little from the human, domesticated world. In the early years, it would have been her small children laughing and chattering, chooks scratching in their pen, Ross chopping wood, dogs barking, an occasional car driving on the gravel road that passed their property. Later on, when the children had left home, perhaps it was the radio, the phone ringing, or Ross's

honey extractor whirring away in the shed. But these human sounds would have been interspersed with great tracts of silence.

This does not mean there was nothing else to hear. Standing outside, I realised that Olive was always surrounded by sounds emanating from the natural world. These were certainly less obtrusive but far more prolific. It was early summer, midday, and I could hear birds, bees, cicadas and, in a different register, the sounds created by the weather, including a hot wind that was gusting through the trees all around me.

* * *

When Olive was alive, I would never have gone into her private space, but on my last visit, it was something I felt compelled to do. In her bedroom, I touched the modest coverings on her single bed, and opened the small wooden wardrobe where her dresses and coats were still hanging. In the room next door, with the name N. Boardman forever on the door, her piano, which had kept its place on the left-hand wall, looked worn. Some of the keys were in poor condition, and I didn't want to touch them and hear a broken sound.

What I wanted more than anything was to stand at Olive's bedroom window and look at the view. I wanted to know what she saw when she got up and raised the blinds every morning. Her rooms face the front of the property and her bedroom window gives a wide view across the front yard, taking in the old house and some of the accretions that had built up at Spring Forest over time. What she looked at daily was messy and devoid of beauty. There was never any material here for her photography – she always looked elsewhere for that.

While standing at the window with the summer light streaming in, some of Haidee's insightful comments came back to me. 'Olive,' she said, 'was happy with what she had.' She 'had another world inside her head', a world Haidee described as 'secret'.[4] And yet

Olive's inner life was nourished by her relationship with the external world, and, most particularly, with nature. Perhaps this explains her and Ross's deep compatibility. In his poem 'Night thoughts without a nightingale', Geoffrey Lehmann imagines Ross in a moment of reflection, alone, on the edge of his land, but what he wrote could have applied equally to Olive.

It's dusk.
An immense and informative hush of insect noises
proclaims my irrelevance.

However, in Olive's and Ross's shared recognition of human irrelevance, there was also a fundamental difference in their outlook. This took shape slowly during the Spring Forest years. Ross's world view was infused with a profound sense of the pathos and irony, even the futility, of human life and endeavour. Olive's was not. Her view of human existence, as expressed through her photography, was optimistic and life-affirming. That is why she never doubted that her photographs would have a vibrant future.

Light and shade, 1937, courtesy Cotton family and Josef Lebovic Gallery, Sydney

Light and shade

The first resolved photograph in this book is Olive's delicate study of the bedroom she and Joyce shared at the family home in Hornsby – *Interior (my room)*, taken when she was twenty-two years old. For a long time, I puzzled over what might be its counterpart to end with, expecting it to come from the later phase of her photographic practice, the Cowra years, or even one of the last photographs she made in the early 1990s. But the photograph that has quietly and persuasively made a claim to bringing this story to a close is one of the most radical of her long, fruitful career. *Light and shade* was taken in 1937, the very best of years, when Olive purchased her own Rolleiflex camera and her photography went ahead in leaps and bounds. It probably dates from the camping trip she made with her father, uncle and cousin, when they travelled up the north coast of New South Wales, across to the New England Tableland and back to Sydney. It is an image that fares poorly in reproduction, because of the subtlety of tones and tonal transitions that occur in different sections, crucially between the dark foreground and light background hills and between the light back range of hills and light-toned sky above them. *Light and shade* is one of those photographs you have to see in the flesh, one that unequivocally rewards a first-hand encounter and close scrutiny.

Olive didn't record any comments about *Light and shade* either at the time it was made or subsequently, so it is not possible to know how she felt about it. While it was published in the magazines *Bank Notes* and *The Home*,[1] it did not attract any public commentary. It

. was not included in the group of photographs Olive selected for her show at the Australian Centre for Photography in 1985, which marked her re-emergence into the public photography world. But in recent years, it has come to be appreciated through exposure in the Olive Cotton retrospective exhibition at the Art Gallery of New South Wales, held in 2000.

Only one extant vintage print of *Light and shade* is known. It is not large (24.5 x 24.9 centimetres), but it is expansive, full of space that is insubstantial and indeterminate. It is radical in its abstraction, with the features of the actual physical site – hills, trees, rocks and river – delineated in a general rather than detailed way. This photograph is a stunning affirmation of Olive's conception of photography as 'drawing with light', created at the height of her powers. The command of light and the daring composition are certainly impressive, but ultimately what endures is something less obvious – the impersonal quality of the photograph. By this I mean that the image is detached, and the ego of the photographer, and by implication the viewer, are irrelevant. The world Olive depicts is human-less and huge, far greater than any individual could ever be. Thus, the significance of *Light and shade* is not confined to Olive's views about photography. It can also be seen as an avowal of her anti-materialism, her abiding love of nature and her gentle advocacy for a rapt engagement with the natural world. All of these sustained her to the end, in her photography and her life.

Endnotes

PART ONE

The trunk
1 Haidee McInerney, conversation with the author, 2 March 2013.
2 Max Dupain, 'Olive Cotton: Works that act as the soul's narcotic', *Sydney Morning Herald* (*SMH*), 16 October 1985, p.14.
3 Olive Cotton, interviewed by Diana Ritch, 1988, National Library of Australia, nla.obj-216730895.

Wirruna
1 Details of the house's interior and grounds are from Helen Barker, *Houses of Hornsby Shire: Volume 11 1880–1938*, Hornsby Shire Historical Society, Hornsby, NSW, 1989, pp.123–4.
2 For a photograph of the Channon family, see Mari Metzke, *Pictorial History: Hornsby Shire,* Kingsclear Books, 2004, p.96.
3 *Cumberland Argus and Fruitgrowers Advocate*, 13 April 1901, p.121.
4 Olive Cotton, interviewed by Diana Ritch. The third daughter, Dora Cotton, had poor health.
5 See Bede Nairn, entry on Francis (Frank) Cotton, *Australian Dictionary of Biography* (*ADB*).
6 'Late Mrs Sarah Channon', *The Methodist*, 1 March 1930, p.15.
7 Miriam Cotton, letter to the author, 17 February 2017.
8 The *Australian Dictionary of Biography* has a combined entry for Frank, Leo and Frank Stanley Cotton.
9 Olive Cotton, interviewed by Diana Ritch.
10 Bede Nairn, entry on Leo Cotton, *ADB*.
11 Olive Cotton, interviewed by Diana Ritch.
12 'Hornsby', *Cumberland Argus and Fruitgrowers Advocate*, 8 August 1914, p.8.
13 Ibid.
14 Helen Ennis and Sally McInerney, *Olive Cotton: Photographer*, National Library of Australia, Canberra, 1995, p.16.
15 Olive Cotton, interviewed by Diana Ritch.
16 Ibid.
17 Ibid.
18 Helen Ennis and Sally McInerney, *Olive Cotton: Photographer*, p.37.
19 Nairn, entry on Leo Cotton, *ADB*.
20 Jean Cook, conversation with the author, 4 February 2004.
21 Frank Cotton, letter to McInerney family, c.September 2003, collection of the McInerney family.

'My medium'

1 An alternative date of 1924 is also cited. Around 1932 Olive began to use an Icarette camera and then a quarter-plate Graflex camera.

2 A group of 102 black and white photographs and fourteen glass plate negatives taken by Leo Cotton in Antarctica is in the collection of Sydney's Powerhouse Museum.

Newport

1 Olive Cotton, interviewed by Diana Ritch.

2 Helen Ennis, 'Interview with Max Dupain', *Max Dupain: Photographs*, National Gallery of Australia, Canberra, 1991, p.11.

3 Leo knew George and had written in support of his business, praising its scientific approach and thoroughness. Leo Cotton, letter, 12 April 1918, MS 93 Clare Brown papers, Box 7, folder 1, National Gallery of Australia Research Library and Archives, Canberra. Clare Brown was a journalist who arrived in Australia from New York in 1988 and began research for a biography on Dupain in 1990. She secured Dupain's full cooperation; he provided her with primary material, including letters and journals, and introductions to friends and acquaintances whom she contacted, and in many cases interviewed. The biography was discontinued for personal reasons after Dupain's death and Clare deposited her archive at the National Gallery of Australia.

4 Ruth Harrison, *Sydney Kindergarten Teachers College, 1897–1981: A pioneer in early childhood education and care in Australia,* Sydney Kindergarten Teachers College Graduates Association, Waverley, NSW, 1985, p.228.

5 Max Dupain, autobiographical writing, 29 January 1991, MS 93 Clare Brown papers, Box 2, folder 3, National Gallery of Australia Research Library and Archives.

6 Max Dupain, interviewed by Clare Brown, 23 September 1990, MS 93 Clare Brown papers, Box 2, folder 8.

7 Helen Ennis and Sally McInerney, *Olive Cotton: Photographer*, p.55.

8 Olive Cotton, interviewed by Diana Ritch.

Maxwell Spencer Dupain

1 Max Dupain, typewritten notes, c.1976, in *Max Dupain Modernist*, State Library of New South Wales, Sydney, 2007 [exhibition catalogue], p.4.

2 Max Dupain, autobiographical writing, 3 June 1990, MS 93, Box 2, folder 8.

3 Ibid., 29 January 1991, MS 93, Box 2, folder 3.

4 Ibid., MS 93, Box 1, folder 3.

5 For a full discussion of George Dupain's views, see Isobel Crombie, *Bodyculture: Max Dupain, photography and Australian culture 1919–1939*, Peleus Press in association with the National Gallery of Victoria, Mulgrave, Victoria, 2004.

6 Joan Sample, interviewed by Clare Brown, 30 November 1993, MS 93, Box 2, folder 10.

Deepening thought

1 *Lucis,* September 1991.

2 Ibid.

The university years

1 Elizabeth Harrison, Sydney Kindergarten Training College, Darlinghurst, NSW, 1914.
2 Janine Burke, *Australian Women Artists 1840–1940*, Greenhouse, Collingwood, Vic., 1980.
3 *The Modern Speller: Word building and grouping for children from six to eight years*, Angus & Robertson, Sydney, 1932; Ethel Cotton and Sarian Newton-Russell, *Rainbow-pattern Arithmetic for Children of 6 and 7 Years*, Angus & Robertson, Sydney, 1934.
4 'The Late Mrs Leo Cotton', *SMH*, 9 October 1930, p.12.
5 Helen Ennis and Sally McInerney, *Olive Cotton: Photographer*, p.16.
6 'Quinn-Channon', Family Notices, *SMH*, 3 August 1932, p.4.
7 Unnamed author, 'Olive Cotton, artist', c.1992, MS 66 Papers of Helen Maxwell Gallery, National Gallery of Australia Research Library and Archives, NGA, Canberra.

'A perfect specimen'

1 Sir Dudley de Chair, *The Sydneian*, May 1928, p.2.
2 Max Dupain, autobiographical writing, 3 June 1990, MS 93, Box 2, folder 8.
3 Max Dupain, 'Contentment', p.33, and 'The sea at night', p.37, *The Sydneian*, August 1929.
4 Max Dupain, interviewed by Clare Brown, 26 August 1990, MS 93, Box 2, folder 8.
5 Ibid.
6 *The Sydneian*, November 1928, p.23.
7 He was inspired by Ian Hay's book *The Shallow End* (1924), which he reviewed in *The Sydneian*, August 1929, pp.34–5.
8 Max Dupain, *The Sydneian*, August 1930, p.30.
9 Max Dupain, autobiographical writing, 3 June 1990, MS 93, Box 2, folder 8.
10 *The Sydneian*, May 1928, p.10.
11 Max Dupain, autobiographical writing, 3 June 1990, MS 93, Box 2, folder 8.

Dupain's apprenticeship

1 Max Dupain, interviewed by Clare Brown, 19 July 1990, MS 93, Box 2, folder 8.
2 Ibid.
3 Ibid.
4 'Australian camera personalities: Max Dupain', *Contemporary Photography*, no. 2, January–February 1947, pp.15–16, 559; and Dupain, autobiographical writing, MS 93, Box 2, folder 8.
5 Cecil Bostock, AGNSW Research Library collection.
6 Max Dupain, interviewed by Clare Brown, 19 July 1990, MS 93, Box 2, folder 8.
7 Max Dupain, 'Past imperfect', p.20.
8 Max Dupain, typewritten notes, c.1976, p.6.
9 Max Dupain, interviewed by Clare Brown, 11 October 1990, MS 93, Box 1, folder 7.
10 Max Dupain, autobiographical writing, Clare Brown, MS 93, Box 1, folder 3.

11 Max Dupain, typewritten notes, c.1976, p.6.
12 Max Dupain, 'Past imperfect', p.19.

'Darling lass'
1 The letter is in the collection of the McInerney family.

Great possibilities
1 Interview with Olive Cotton in 1981, quoted by Barbara Hall and Jenni Mather in their book *Australian Women Photographers 1840–1960*, Greenhouse, Melbourne, 1986, p.83.
2 Max Dupain, typewritten notes, c.1976, p.8.
3 The gum bichromate and bromoil processes are based on the same principle: sensitised paper is exposed to light under a negative and the paper is washed to selectively remove soluble areas of gum arabic and gelatin respectively; pigment is then applied to the print with a brush and the print is redeveloped.
4 Harold Cazneaux, *The Australasian Photo-review*, 15 October 1932, p.482.
5 Harold Cazneaux, 'Photography in Australia', *Photograms of the Year*, 1930, p.13.
6 Harold Cazneaux, *The Australasian Photo-review*, p.478.

Art and science
1 See, for example, Max Dupain, 'Past imperfect', p.20.
2 John Hetherington, *Norman Lindsay: The embattled Olympian*, Oxford University Press, Melbourne, 1973, p.143.
3 Norman Lindsay, *Creative Effort: An essay in affirmation*, Palmer, London, 1924, p.4.
4 Ibid., and p.2.
5 Ibid., p.3.
6 Ibid., p.16.
7 Max Dupain, 'Past imperfect', p.20.
8 Max Dupain, typewritten notes, c.1976, p.9.
9 Ibid.
10 Ibid., p.6.

PART TWO

The Bond Street operation
1 Max Dupain, interviewed by Clare Brown, 3 June 1990, MS 93, Box 2, folder 8.
2 Max Dupain, autobiographical writing, MS 93, Box 2, folder 8.
3 Max Dupain, 'Past imperfect', p.12.
4 Linda Slutzkin and Dinah Dysart, *Charles Meere (1890–1961)*, S.H. Ervin Gallery, National Trust of Australia (NSW), Sydney, 1987.
5 Nancy D.H. Underhill, *Making Australian art 1916–49: Sydney Ure Smith, patron and publisher*, Oxford University Press, South Melbourne, Victoria, 1991, p.16.
6 Max Dupain, autobiographical writing, MS 93, Box 2, folder 6.
7 Unnamed author, 'Olive Cotton, artist', c.1992.
8 Max Dupain, interviewed by Clare Brown, MS 93, Box 1, folder 7.
9 Richard Coleman, 'Vanished scenes of town and country life exposed in a lifetime's photography', *SMH*, 3 December 1983, p.42.

10 Candida Baker, 'The return of a naive photographer', *The Age*, 15 August 1987, p.12.
11 Max Dupain, autobiographical writing, MS 93, Box 2, folder 6.
12 Max Dupain, 'Past imperfect', p.7.
13 Interview with Olive Cotton, Australian Women Photographers Research project, 1981, National Gallery of Australia registry file 81/842.
14 Max Dupain, 'Past imperfect', p.12.
15 Max Dupain, 'Past imperfect', p.8.
16 Olive Cotton, interviewed by Diana Ritch.
17 Max Dupain, autobiographical writing, MS 93, Box 2, folder 8.
18 Olive Cotton, unpublished notes, collection of the McInerney family.
19 Frank Cotton, letter, collection of the McInerney family.

Being modern

1 Margaret Preston, 'Why I became a convert to modern art', *The Home*, vol. 4, no. 2, 1923.
2 Sydney Ure Smith, 'Editorial', *Art in Australia*, no. 20, June 1927.
3 'Music and drama', *SMH*, 20 July 1935, p.10.
4 See, for example, Deborah Edwards and Denise Mimmocchi, eds, *Sydney Moderns: Art for a new world*, Art Gallery of New South Wales, 2013.
5 Max Dupain, typewritten notes, c.1976, p.9.
6 Gael Newton established that he owned copies of *Das Deutsche Lichtbild* from 1927, 1930 and 1933–36; see her book *Max Dupain*, David Ell Press, Hunters Hill, NSW, 1980, p.123. Clare Brown examined Dupain's library before the dispersal of his books after he died and noted that it also included copies of the English publication *Photograms of the Year* and the long-running annual *Modern Photography: The studio annual of camera art*. The proprietor of Gilmour's Bookshop, Mr L.S. Larsen, was European.
7 Saxon Mills, 'Modern photography, its development, scope and possibilities', *Modern Photography*, 1931, p.2.
8 Ibid., p.6.
9 Ibid., p.10.
10 Ibid., p.14.
11 Max Dupain, *The Home*, 16, 1 October 1935, pp.38–9 and 84.
12 Copies from 1924, 1926 and 1935 were in Dupain's library.
13 Max Dupain, 'Past imperfect', p.12.
14 Margaret Preston, 'Aphorism 46', *Margaret Preston: Recent paintings*, Sydney Ure Smith, Sydney, 1929.

Teacup ballet

1 Helen Ennis and Sally McInerney, *Olive Cotton: Photographer*, p.25.
2 This print, 15.3 x 20.9 centimetres, was in Olive Cotton's collection.
3 Olive Cotton, interviewed by Diana Ritch.
4 Preston held a very successful one-person show at Grosvenor Galleries in 1929 and reproductions of her prints, paintings and writings on art regularly appeared in Ure Smith's publications. She was the subject of a special issue of *Art in Australia* in 1927 and of the illustrated portfolio *Margaret Preston: Recent paintings* in 1929.

5 Frank Moorhouse, *Dupain's Australians*, Chapter and Verse, Sydney, 2003, p.11.

6 Ibid.

7 Cotton was the only woman selected for the Australia Post commemoration; the other stamps featured photographs by Dupain, Wolfgang Sievers and an unidentified 19th-century photographer.

8 Joanna Mendelssohn, 'Three artists: Olive Cotton, Judy Cassab and Louis Kahan', *The Australian*, 17 November 1995, p.14.

Surrealism

1 See Christopher Chapman, 'Surrealism in Australia', in *Surrealism: Revolution by night* [exhibition catalogue], National Gallery of Australia, Canberra, c.1993, pp.216–301; and Simon Maidment and Elena Taylor, eds, *Lurid beauty: Australian Surrealism and its echoes* [exhibition catalogue], National Gallery of Victoria, Melbourne, 2015. Note that Dupain's review of Man Ray and his surrealist experimentation predates the work of painters such as James Gleeson.

2 Helen Ennis and Sally McInerney, *Olive Cotton: Photographer*, p.9.

3 Published by Random House and Cahiers d'Art.

4 *The Home*, 1 October 1935, p.38.

5 Max Dupain, typewritten notes, c.1976, p.7.

6 Max Dupain, autobiographical writing, 3 June 1990, MS 93, Box 2, folder 8.

7 Ibid.

8 Ernest Osborne, 'Sur-realism: The most "modern" art', *SMH*, 19 September 1936, p.13.

Flower studies

1 Tim Bonyhady, 'The Bush becomes the Garden', in Peter Timms, ed., *The Nature of Gardens*, Allen & Unwin, 1999, p.143.

2 Ibid., p.146.

3 Margaret Preston and Thea Proctor, 'The gentle art of arranging flowers', *The Home*, June 1924, p.38.

4 Helen Ennis and Sally McInerney, *Olive Cotton: Photographer*, p.64.

5 Ibid., p.58.

6 Ibid.

7 Ibid., p.54.

'Harmonic perception'

1 Helen Ennis and Sally McInerney, *Olive Cotton: Photographer*, p.3.

2 Ibid., p.52.

3 Olive Cotton, journal, 1937, collection of the McInerney family.

4 Ibid.

5 Unnamed author, 'Olive Cotton, artist', c.1992.

6 Helen Ennis and Sally McInerney, *Olive Cotton: Photographer*, p.68.

7 See Ian Burn, *National Life and Landscapes: Australian painting 1900–1940*, Bay Books, Sydney, 1990, and Geoffrey Batchen, 'Endurance', Natasha Bullock, ed., *Harold Cazneaux: Artist in photography*, Art Gallery of NSW, 2008, p.128–9.

The sea's awakening
1 Helen Ennis and Sally McInerney, *Olive Cotton: Photographer*, p.26.

'A break for independence'
1 Helen Ennis and Sally McInerney, *Olive Cotton: Photographer*, p.6.
2 Chris Vandyke was a close friend Dupain made at art school; he later became a builder.
3 Max Dupain, interview with Michelle Potter, 11 September 1990, http://nla. gov.au/nla.oh-vn1276615.
4 Jean Lorraine, 'Billy Tea', *Chasing a Breeze*, unpublished memoir, copy sent to Sally McInerney from Jean Bailey's family.
5 Jean Lorraine, in Sally McInerney, *Family Fragments*, Editions and Artist Book Studio, Canberra, 2004.
6 Jean Lorraine, 'Growing up', *Chasing a Breeze*. Her first husband's name was Alan Noonan.
7 Jean Lorraine, 'The Boy in the Straw Boater', *Chasing a Breeze*.
8 Jean Lorraine, 'Adventure Owed' and 'Everybody Lies', *Chasing a Breeze*.
9 Jean Lorraine, 'Not about me (Olive Cotton)', *Chasing a Breeze*.
10 Jean Lorraine, 'Billy Tea', *Chasing a Breeze*.
11 Jean Lorraine, 'Not about me (Olive Cotton)', *Chasing a Breeze*.
12 Jean Lorraine, 'Billy Tea', *Chasing a Breeze*.
13 Ibid.
14 Neil McDonald, *Kokoda Front Line*, Hachette Australia, Sydney, 2012, p.38.
15 Jill Matthews, *Good and Mad Women: The historical construction of femininity in twentieth century Australia*, Allen & Unwin, Sydney, 1984, p.135.
16 Marie Stopes's sex manual *Married Love*, 1918, was widely circulated and particularly influential.
17 Figures quoted by Jill Matthews, *Good and Mad Women*, p.37.
18 Max Dupain, interviewed by Clare Brown, 20 August 1991, MS 93, Box 1, folder 7.
19 Ibid.
20 For a full discussion of George Southern's significance to Dupain and Cotton, see Isobel Crombie, *Bodyculture*, Ch. 7, especially pp.154–61.
21 George Southern's diary, 17 February 1931, quoted by Isobel Crombie in *Bodyculture*, p.160.
22 Isobel Crombie, *Bodyculture*, p.159.
23 Ibid.
24 Neil McDonald, *Kokoda Front Line*, p.17.
25 Jean Lorraine, 'Everybody lies', *Chasing a Breeze*.
26 Steve Meacham, 'Portrait of a lady', *SMH*, 12 July, 2003.
27 Jean Lorraine, 'Everybody lies', *Chasing a Breeze*. Haidee McInerney recounted that during the war John McInerney was devastated to see photographs in a magazine of Jean posing nude. According to a friend who witnessed his response, he was extremely distressed, and he thought that his 'heart would break'; telephone conversation with the author, 15 February 2013.
28 George Dupain, *Battling Obesity*, Briton Publishing, Sydney, 1935.

Max after surfing

1 William A. Ewing, *The Photographic Art of Hoyningen-Huene*, Rizzoli, New York, 1986, p.132.
2 'Defence in Clothes. Smartness and Intellect', *SMH*, 6 December 1937, p.6.
3 'Australian Camera Personalities: Max Dupain', *Contemporary Photography*, p.58.
4 Max Dupain, 'Past imperfect', p.11.
5 'Photographer's discovery', *SMH*, 11 December 1937, p.19.
6 Olive Cotton, interview with the author, August 1996. Johanna McMahon reproduces Dupain's portrait of Hoyningen-Huene with Jessie Trinden as 'Trixie the Mermaid', in which the hydrangeas mentioned by Cotton are clearly visible. See her 'Max Dupain's Mysteries', *Portrait*, no. 61, Summer 2018/19, p.20.
7 On 18 December 1937, the *SMH* published two photographs of Noreen Hallard and two of Zara Gaden, p.11; additional photographs published in *The Home*, 3 January 1938, pp. 62–3.
8 *Australian Women's Weekly*, Christmas Day, 1937, p.15.
9 'Defence in Clothes. Smartness and Intellect', *SMH*, p.6.
10 'Photographer's Discovery', *SMH*, 11 December 1937, p.19.
11 Ibid.
12 Stephanie Holt, 'Olive Cotton', *Art and Australia*, vol. 33, autumn 1996, p.239.
13 Victoria Hynes, 'Girl on film', *SMH*, 5 July 2002.
14 Ross McInerney, conversation with the author, 13 May 2000.
15 Frank Moorhouse, *Dupain's Australians*, p. 51.
16 Isobel Crombie, *Bodyculture*, p.190.
17 She would explore this chiaroscuro effect in later atmospheric portraits of John McInerney and of Jean Lorraine.

Lucille

1 *Australian Women's Weekly*, 22 February 1936, p.2.
2 Lucille Wyatt, interviewed by Clare Brown, 18 June 1991 MS 93, Box 1, folder 10.
3 Ibid.
4 Ibid.
5 Ibid.
6 Ibid.
7 Ibid.
8 Ibid.
9 Ibid.
10 'To be married in December', *SMH*, 30 August 1939.

The Max Dupain Studio, 1937–39

1 See scrapbook from the Dupain studio held in the AGNSW Research Library and Archives, which contains examples of advertising and illustrative work. Olive may have had a hand in compiling it to show prospective clients what the studio was capable of producing.
2 Kay Lester, 'Max Dupain: Artist, photographer', *Monocle*, June 1937, p.37.
3 Max Dupain, 'Past imperfect', p.12.
4 They originally set up a darkroom in the laundry at Le Guay's family home; Powell later recalled that they took turns processing their film, with one of them

waiting 'outside the door with an alarm clock used as a timer'. Geoffrey Powell, letter to Gael Newton, 27 June 1988, NGA registry file 84/667.

5 Ibid.

6 This scrapbook is in the collection of the National Gallery of Australia's Research Library and Archives.

7 Max Dupain, 13 August 1938. My thanks to Craig Hoehne for bringing this to my attention.

8 Ron Maslyn Williams, quoted by Neil McDonald, *Kokoda Front Line,* p.19.

9 Osmar Green, *Green Armour*, 1992, quoted by Frank Legg, *The Eyes of Damien Parer*, Rigby Limited, Adelaide, 1963, p.26.

10 Max Dupain, 'Past imperfect', p.12.

11 Olive Cotton, interviewed by Diana Ritch.

12 Neil McDonald, *Kokoda Front Line,* p.27.

13 Max Dupain, 'Past imperfect', p.12.

14 Max Dupain, autobiographical writing, 3 June 1990, MS 93, Box 2, folder 8.

15 Max Dupain, 'Past imperfect', p.12.

16 Damien Parer, letter quoted by Neil McDonald, *Kokoda Front Line*, p.26.

17 Max Dupain, 'Past imperfect', p.12.

18 Dupain focused more on the performers' external appearance in order to fulfil his commissions for the J.C. Williamson firm and for Sydney Ure Smith, who published his portraits of dancers in *The Home* and *Art in Australia*. After the performances in Sydney, Kirsova toured with the company to New Zealand and wrote to Cotton from the Hotel St George in Wellington, thanking her 'for the lovely photographs you sent me and for the feathers, for which I am very grateful to you, it was very sweet of you to think of me'; letter in collection of the McInerney family.

19 Frank Moorhouse, *Dupain's Australians*, p.12.

20 Kay Lester, 'Max Dupain'.

The Budapest String Quartet

1 Helen Ennis and Sally McInerney, *Olive Cotton: Photographer*, p.32.

2 Ibid.

'Stepping into the dark'

1 Max Dupain, 'Art of the camera – its amazing growth', letter to the editor, *SMH*, 30 March 1938.

2 Ibid.

3 G.H. Wilson, letter to the editor, *SMH*, 1 April 1938, p.6.

4 Arthur Smith, letter to the editor, *SMH*, 2 April 1938, p.8.

5 W.H. Moffitt, letter to the editor, *SMH*, 4 April 1938, p.11.

6 Harold Cazneaux, letter to the editor, *SMH*, 8 April 1938, p.8.

7 Max Dupain, interviewed by Clare Brown, 20 August 1991, MS 93, Box 1, folder 7.

8 *Exhibition of Photographic Studies by Contemporary Camera Groupe*, David Jones Exhibition Gallery, Sydney, 1938.

9 'Camera Art: Contemporary Group exhibition opened', *SMH*, 22 November 1938, p.2.

10 Ibid.

11 Ibid.
12 *Exhibition of Photographic Studies by Contemporary Camera Groupe.*
13 Jan Gordon, 'Art in photography', *The Penrose Annual*, vol. 40, 1938, p.26.
14 Ibid.
15 Ibid.
16 Ibid., p.27.
17 'The lady behind the lens', *SMH*, 29 March 1938, p.13.
18 Ibid.
19 Ibid.
20 Ibid.
21 Ibid.
22 Ibid.
23 Ibid.
24 Ibid.
25 Ibid.

Marriage

1 Joan Sample, interviewed by Clare Brown, 30 November 1993, MS 93, Box 2, folder 10.
2 Ernest Hyde, interviewed by Clare Brown, 15 June 1990, MS 93, Box 1, folder 11.
3 Joan Sample interviewed by Clare Brown, 30 November 1993, MS 93, Box 2, folder 10.
4 Ibid.
5 Barbara Beck, telephone conversation with the author, 16 February 2016.
6 Ernest Hyde, interviewed by Clare Brown, 26 May 1990, MS 93, Box 1, folder 11.
7 Joan Sample, interviewed by Clare Brown, 30 November 1993, MS 93, Box 2, folder 10.
8 Lucille Wyatt, interviewed by Clare Brown, 18 June 1991, MS 93, Box 1, folder 10.
9 Helen Ennis and Sally McInerney, *Olive Cotton: Photographer*, p.9.

Figures in the landscape

1 Olive Cotton, interview, in Barbara Hall and Jenni Mather, *Australian Women Photographers*.
2 Ibid.
3 Helen Ennis and Sally McInerney, *Olive Cotton: Photographer*, p.65.
4 For detailed discussions of *The sunbaker*, see Gael Newton, 'It was a simple affair: Max Dupain Sunbaker', *Brought to Light: Australian art, 1850–1965*, Queensland Art Gallery, Brisbane, 1998; and Geoffrey Batchen, 'Max Dupain *Sunbakers*', *History of Photography,* vol. 19, no. 4, winter 1995, pp.349–57.
5 Helen Ennis, 'Interview with Max Dupain', p.18.
6 Ibid.

Two girls at Bowral

1 Jean Lorraine remembered the photograph being taken at Newport; see Steve Meacham, 'Portrait of a lady'.

2 Jean Lorraine, 'Everybody lies', *Chasing a Breeze*.
3 Max Dupain, 'My best picture and why', *Australia: National Journal,* 1 December 1940, p.19.
4 Jean Lorraine, in Sally McInerney, *Family Fragments*.
5 Max Dupain, 'My best picture and why'.
6 Ibid.
7 Max Dupain, interviewed by Clare Brown, 15 November 1990, MS 93, Box 1, folder 7.

War
1 Jean Lorraine, 'Everybody lies', *Chasing a Breeze*.
2 Stuart Macintyre, *A Concise History of Australia*, Cambridge University Press, Cambridge, UK, reprint 2003, p.184.
3 Ann Elias, *Camouflage Australia: Art, nature, science and war*, University of Sydney Press, Sydney, 2012, p.19.
4 Ibid., p.23. This view is shared by art historian Nancy D.H. Underhill in her biography of Ure Smith, *Making Australian Art 1916–1949: Sydney Ure Smith, patron and publisher*.
5 John D. Moore was the father of photographer David Moore.
6 Stuart Macintyre, *A Concise History of Australia*, p.187.

PART THREE

'The instability of everything'
1 Damien Parer, letter to Olive Cotton, c.June 1942, collection of the McInerney family.
2 Ibid.
3 Damien Parer, letter to Max Dupain and Olive Cotton, 3 October 1941, collection of the McInerney family.
4 Damien Parer, letter to Max Dupain and Olive Cotton, 14 December 1940, collection of the McInerney family.
5 Ibid.
6 Ibid.
7 Ibid.
8 Ibid.
9 Ibid.
10 Ibid.
11 Ibid. Quoted by Neil McDonald, *Kokoda*, pp.43–44.
12 Damien Parer, letter to Max Dupain and Olive Cotton, 3 October 1941, collection of the McInerney family.
13 Damien Parer, letter to Max Dupain and Olive Cotton, 14 December 1940, collection of the McInerney family.
14 Ibid.
15 Damien Parer, letter to Max Dupain and Olive Cotton, 3 October 1941, collection of the McInerney family.
16 Ibid.

The Dupains

1 The sole known vintage print is in the National Gallery of Australia collection.
2 This album is in the Parer papers in the Mitchell Library at the State Library of New South Wales.
3 Max Dupain, 'Past imperfect', p.15.

The 'bust-up'

1 Unnamed author, 'Olive Cotton, artist', c.1992.
2 'Photography club', *Frensham Chronicle*, vol. iv, no. 6, January–August 1941, p.321.
3 Ruth Ainsworth, *Frensham Chronicle*, vol. iv, no.6, January–August 1941, p.306.
4 Ibid.
5 Ibid.
6 Phyllis Bryant, *Frensham Chronicle*, vol. iv, no. 6, January–August 1941, p.313.
7 Ibid.
8 Damien Parer, letter to Max Dupain, 1942, quoted by Neil McDonald, *War Cameraman: The story of Damien Parer*, Lothian, Port Melbourne, Victoria, p.24.
9 Barbara Beck, telephone conversation with the author, 16 February 2016.
10 Susan Chenery, 'Out of the shadows', *HQ*, April 1995, p.52.
11 Janet Hawley, 'When Olive went bush', *Good Weekend*, *SMH*, 16 May 1998, p.34.
12 Betty Roland, interviewed by Clare Brown, 30 July 1990, MS 93, Box 1, folder 11; Barbara Beck, telephone conversation with the author, 16 February 2016.
13 Jill White, 'Double exposure', *Good Weekend*, *SMH*, 7 August 2004, p.26.
14 Ernest Hyde, interviewed by Clare Brown, 14 June 1990, MS 93, Box 1, folder 11.
15 Ibid.
16 Max Dupain, interviewed by Clare Brown, 11 October 1990, MS 93, Box 1, folder 7.
17 Jill White, 'Double exposure', p.26.
18 Elizabeth Marie Parer, interviewed by Clare Brown, 5 August 1991, Box 1, folder 10.
19 Max Dupain, interviewed by Clare Brown, 19 July 1990, MS 93, Box 2, folder 8.
20 Ernest Hyde, interviewed by Clare Brown, 15 June 1990, MS 93, Box 1, folder 11.
21 Ibid.
22 Jean Cook, conversation with the author, 4 February 2004.
23 Barbara Beck, telephone conversation with the author, 16 February 2016.
24 Michael Richardson, 'A therapeutic calm', *Photography*, vol. 42, no. 9, September 1991, p.9.

The company of women

1 See Powell's work published in *Man* and the literary magazine *Pertinent*, Le Guay's in *Youth* and Burke's in *Harvest*.
2 'An army job', *SMH*, 8 March 1941, p.10.
3 'Only woman N.C.O.: Is 26 and attractive', *Sunday Mail*, 9 March 1941, p.7.
4 Ibid.

Transition

1 Unnamed author, 'Olive Cotton, artist', c.1992.
2 Olive Cotton, interview, in Barbara Hall and Jenni Mather, *Australian Women Photographers*.
3 Max Dupain, 'Past imperfect', p.15.

Shared problems in photography

1 For an earlier consideration of this theme, see Helen Ennis, 'Partnerships: On Olive Cotton', *Photofile*, Sydney, no. 53, April 1998, pp.25–7.
2 Olive Cotton, interviewed by Diana Ritch.
3 Quoted in Max Fulcher, 'Coming events/special interest', *Graphic Monthly*, August 1986.
4 Helen Ennis and Sally McInerney, *Olive Cotton: Photographer*, p.28.
5 Ibid., p.29.
6 Max Dupain, interviewed by Clare Brown, 29 July 1990, MS 93.
7 Max Dupain, interviewed by Clare Brown, 9 November 1989, MS 93.
8 See Shaune Lakin, 'The photographic partnership of Olive Cotton and Max Dupain', in *Max and Olive* [exhibition catalogue], National Gallery of Australia, Canberra, 2016, p.39.
9 See Jane Alison and Coralie Malissard, eds., *Modern Couples: Art, intimacy and the avant-garde*, Prestel Publishing in association with the Barbican Art Gallery, 2018.
10 Lucia Moholy, *Moholy-Nagy: Marginal notes*, Scherpe Verlag, Krefeld, 1972, p.55.
11 Sally McInerney arranged for prints from her mother's old negatives to be offered for sale through the Josef Lebovic Gallery, Sydney.
12 Geoffrey Powell, telephone conversation with the author, July 1988, National Gallery of Australia registry file 84/667.
13 Geoffrey Powell, letter to Gael Newton, 27 June 1988, National Gallery of Australia registry file 84/667.
14 Joan Brown, interviewed by Jennifer Gall, National Library of Australia, 1995, ORAL TRC 3294/5.
15 Sonia Delaunay, quoted in Whitney Chadwick and Isabelle de Courtivron, *Significant Others: Creativity and intimate partnerships*, Thames and Hudson, London, reprint 2018, p.34.
16 Olive Cotton, interview, in Barbara Hall and Jenni Mather, *Australian Women Photographers*.
17 Ibid.
18 Ibid.
19 Ibid.
20 Ibid.

'Really great years'

1 Olive Cotton, interview, in Barbara Hall and Jenni Mather, *Australian Women Photographers*.
2 Damien Parer, letter to Olive Cotton, c.June 1942, collection of the McInerney family.
3 See Nancy D.H. Underhill, *Making Australian Art*, p.170.
4 Olive Cotton, interviewed by Diana Ritch.

5 Ibid.
6 Helen Ennis and Sally McInerney, *Olive Cotton: Photographer*, p.34.

The Dupain diary

1 Janet Malcolm, *The Silent Woman: Sylvia Plath and Ted Hughes*, Picador, Australia, 1994, Ch. 1.
2 The transcript of Max Dupain's diary is in the Clare Brown papers, MS 93, National Gallery of Australia Research Library and Archives.
3 Cotton had her own copy of Gauguin's book, although nothing indicates it was as consequential for her as for Dupain.
4 Max Dupain diary, 2 February 1942.
5 Max Dupain diary, 11 February 1942.
6 Max Dupain diary, 3 February 1942.
7 Max Dupain diary, 4 February 1942.
8 Max Dupain diary, 6 February 1942.
9 Max Dupain diary, 3 February 1942.
10 Max Dupain diary, 4 February 1942.
11 Max Dupain diary, 7 February 1942.
12 Max Dupain diary, 5 February 1942.
13 Max Dupain diary, 26 February 1942.
14 See entry on Nelson Illingworth by Noel S. Hutchison, *ADB*.
15 Max Dupain, interviewed by Clare Brown, 19 March 1990, MS 93 Box 2, folder 8.
16 Max Dupain diary, 2 February 1942.
17 Damien Parer, letter to Max Dupain, quoted in Neil McDonald, p.163.
18 Ibid.

Divorce

1 'Business as usual: But not on home front', *Truth*, 21 February 1943.

A reasonable sum

1 'Divorce papers Maxwell Spencer Dupain – Olive Edith Dupain', 13495, Divorce and matrimonial cause case papers, 1304/1943. See also 1304/1942.

'The boy next door'

1 Joan Rose (née Sample), interviewed by Clare Brown, 30 November 1993, MS 93, Box 2, folder 10.
2 Olive Cotton, interview, in Barbara Hall and Jenni Mather, *Australian Women Photographers*.

PART FOUR

Meeting Ross

1 Helen Ennis and Sally McInerney, *Olive Cotton: Photographer*, p.38.
2 'The Late Mr. John McInerney, Senr.', *Burrowa News*, 6 June 1930, p.1.
3 John (1916–53), Ross (2 May 1918–2010), Bryce (1921–2007), Barry (1926–2016), Gavan (1928–2010), Roger (1931–) and the only girl, Haidee (1933–2019).
4 Sally McInerney, *Family Fragments*.

5 Ibid.
6 Haidee McInerney, telephone conversation with the author, 15 February 2013.
7 Confidential Report, 28 November 1942, National Archives, NX144787 B883.
8 Candida Baker, 'The return of a naive photographer', p.12.
9 Olive Cotton, letter to Ross McInerney, 21 March 1944, collection of the McInerney family.
10 Ibid.
11 Ibid., 12 September 1943.

Prescience
1 Olive Cotton, letter to Ross McInerney, 17 November 1944, collection of the McInerney family.
2 Ross McInerney, letter to Olive Cotton, not dated [loose page], collection of the McInerney family.
3 Ross McInerney, letter to Olive Cotton, 25 November 1944, collection of the McInerney family.
4 Ross McInerney, letter to Olive Cotton, 5 December 1944, collection of the McInerney family.

Cordiality
1 Olive Cotton, letter to Ross McInerney, 22 November 1944, collection of the McInerney family.
2 Max Dupain, letter to Olive Cotton, 28 April 1944, collection of the McInerney family.
3 Ibid.
4 Ibid.

The gift
1 Frank Legg, *The Eyes of Damien Parer*, p.46.
2 Damien Parer, letter to George Silk, 7 April 1944. The couple were married at St Mary's Catholic Church in North Sydney on 23 March 1944.
3 John Brennan, 'How Parer died', *The Bulletin*, 25 October 1944, p.7.
4 Frank Legg, *The Eyes of Damien Parer*, p.46.
5 Olive Cotton, letter to Ross McInerney, 23 March 1945, collection of the McInerney family.
6 'Parer family papers ca. 1941–2004', State Library of New South Wales.

Absent Without Leave
1 Confidential Report, National Archives of Australia, NX144787 B883.
2 Document, National Archives of Australia, NX14478 A471 62694.
3 John McInerney journal 1945–1948, National Library of Australia, MS9718, p.83, entry 9/12/43.
4 Document, National Archives of Australia, NX14478 A471 62694.
5 Ibid.
6 Olive Cotton, letter to Ross McInerney, 17 November 1944, collection of the McInerney family.
7 Document, National Archives of Australia, NX14478 A471 62694.

8 Ibid.
9 Ross McInerney, letter to Oive Cotton, 25 November 1944, collection of the McInerney family.

A talisman
1 Ross McInerney, letter to Olive Cotton, 8 December 1944, collection of the McInerney family.
2 Olive Cotton, letter to Ross McInerney, 12 November 1944, collection of the McInerney family.
3 Janet Malcolm, 'A House of one's own', *Forty-one False Starts: Essays on artists and writers*, Text Publishing, Melbourne, 2013, p. 72.

'We'll show the world how to live!'
1 Ross McInerney, letter to Olive Cotton, 14 February 1945, collection of the McInerney family.
2 Ross McInerney, letter to Olive Cotton, 15 February 1945, collection of the McInerney family.
3 Ross McInerney, letter to Olive Cotton, 10 February 1945, collection of the McInerney family.
4 Beryl McInerney, quoted by Ross McInerney, letter to Olive Cotton, 18 February 1945, collection of the McInerney family.
5 Olive Cotton, letter to Ross McInerney, 6 February 1945, collection of the McInerney family.

'My sweetheart husband'
1 Olive Cotton, letter to Ross McInerney, 17 January 1945, collection of the McInerney family.
2 Olive Cotton, letter to Ross McInerney, 27 March 1945, collection of the McInerney family.
3 Olive Cotton, letter to Ross McInerney, 9 November 1944, collection of the McInerney family.
4 Olive Cotton, letter to Ross McInerney, 21 March 1945, collection of the McInerney family.
5 Ross McInerney, letter to Olive Cotton, 8 March 1945, collection of the McInerney family.
6 Olive Cotton, letter to Ross McInerney, 31 January 1945, collection of the McInerney family.
7 Olive Cotton, letter to Ross McInerney, 21 March 1945, collection of the McInerney family.
8 Ibid.

'Versatility'
1 Olive Cotton, letter to Ross McInerney, 31 January 1945, collection of the McInerney family.
2 *Australia National Journal*, August 1943, p. 31. The negative is in the collection of the McInerney family.
3 Margaret Preston, letter to Olive Cotton, collection of the McInerney family.

4 Olive Cotton, letter to Ross McInerney, 20 January 1945, collection of the McInerney family. Cotton is not credited as the photographer, but this was the only history of Australian art published in this period.
5 See Helen Ennis, *Margaret Michaelis: Love, loss and photography*, National Gallery of Australia, Canberra, 2005.
6 One of her city views was published in John D. Moore's *Home Again: Domestic architecture for the normal Australia*, Ure Smith, Sydney, 1944.
7 Helen Ennis and Sally McInerney, *Olive Cotton: Photographer*, p.33.
8 Jean Lorraine, 'Lucy', *Chasing a Breeze.*
9 Ibid.
10 The exhibition was shown at the Kodak Salon in Sydney and reported in the *SMH* on 26 September 1945.
11 Quoted by Ann Elias, *Camouflage Australia*, p.29.
12 Helen Blaxland, *Flowerpieces,* Ure Smith, Sydney, 1946, p.8.
13 Ibid., p.7.
14 Ibid., p.45.
15 Ibid., p.42.
16 Olive Cotton, letter to Ross McInerney, 14 February 1945, collection of the McInerney family.
17 Olive Cotton, letter to Ross McInerney, 27 March 1945, collection of the McInerney family.
18 Jean Lorraine, 'Not about me (Olive Cotton)', *Chasing a Breeze.*

Sturt
1 Winifred West, *Frensham Chronicle*, January–August 1941.
2 Winifred West, *Sturt and the Children's Library*, Olga Sharp for Winifred West, Wahroonga, NSW, 1946, unpaginated.
3 Winifred West, *The Frensham Book: 100 pictures by Cazneaux of an Australian school*, Art in Australia, Sydney, 1934, unpaginated.
4 Ibid.
5 Helen Ennis and Sally McInerney, *Olive Cotton: Photographer*, p.21.
6 Unnamed author, 'Olive Cotton, artist', c.1992.
7 Winifred West, letter to Olive Cotton, 15 November 1945, collection of the McInerney family.
8 Winifred West, letter to Kathleen Hassell, 1946, quoted in Priscilla Kennedy, *Portrait of Winifred West*, Fine Arts Press, Gordon, NSW, 1976, p.149.

Homecoming
1 Ross McInerney, letter to Olive Cotton, 25 November 1944, collection of the McInerney family.
2 Olive Cotton, letter to Ross McInerney, 6 February 1945, collection of the McInerney family.
3 Ross McInerney, letter to Olive Cotton, 9 February 1945, collection of the McInerney family.
4 Candida Baker, 'The return of a naive photographer'.

A new marriage

1 Pat Harrison, telephone conversation with the author, February 2017.
2 Helen Ennis and Sally McInerney, *Olive Cotton: Photographer*, p.18.

Post-war photography

1 Max Dupain, 'Past imperfect', p.16.
2 'Australian Camera Personalities: Max Dupain', *Contemporary Photography*, vol. 1, no. 2, January–February 1947, p.58.
3 Hal Missingham, foreword, *Max Dupain*, Sydney Ure Smith, Sydney, 1948, pp.7–9.
4 Max Dupain, 'Some notes about photography', *Max Dupain*, Sydney Ure Smith, Sydney, 1948, p.10.
5 Geoffrey Powell, 'Camera art', *Progress*, 7 September 1945, p.17.
6 Craig Hohne has pointed out Powell saw himself as a socialist realist photographer, a position that aligned with progressive Marxist values, rather than as a documentary photographer per se. See *Forged under the Hammer and Sickle: The case of Geoffrey Powell, 1945–1960*, master's thesis, Griffith University, Brisbane, 2017.
7 Geoffrey Powell, 'Camera art', p.17.
8 Harold Cazneaux, 'Landscape photography', Oswald L. Ziegler, ed., *Australian Photography 1947*, Ziegler Gotham Publications, Sydney, p.17.

PART FIVE

A canvas home

1 Helen Ennis and Sally McInerney, *Olive Cotton: Photographer*, p.57.
2 Ross McInerney, letter to Olive Cotton, 28 April 1947, collection of the McInerney family.
3 Ibid.
4 Olive Cotton, letter to Ross McInerney, 29 June 1947, collection of the McInerney family.
5 Olive Cotton, letter to Ross McInerney, 29 September 1947, collection of the McInerney family.
6 Ibid.
7 Ross McInerney, letter to Olive Cotton, 28 December 1947, collection of the McInerney family.
8 Olive Cotton, letter to Ross McInerney, 25 March 1948, collection of the McInerney family.
9 Olive Cotton, letter to Ross McInerney, 23 February 1948, collection of the McInerney family.
10 Ibid.
11 Ibid.
12 Olive Cotton, letter to Ross McInerney, 29 September 1947, collection of the McInerney family.
13 Jean Lorraine, letter to Olive Cotton, 2 April 1951, collection of the McInerney family.
14 Helen Ennis and Sally McInerney, *Olive Cotton: Photographer*, pp.17–8.

Trying hard

1 Olive Cotton, letter to Ross McInerney, 28 March 1949, collection of the McInerney family.
2 Ibid.
3 Olive Cotton, letter to Ross McInerney, 7 January 1948, collection of the McInerney family.
4 Janet Hawley, 'When Olive went bush', *Good Weekend*, *SMH*, 16 May 1998, p.33.

Spring Forest

1 Olive Cotton, letter to Ross McInerney, 28 March 1949, collection of the McInerney family.
2 Geoffrey Lehmann, *Leeward: A memoir*, NewSouth Publishing, Sydney, p.303.
3 Unnamed author, 'Olive Cotton, artist', c.1992.
4 Leo Cotton, letter to Olive Cotton, 1 January 1950, collection of the McInerney family.
5 Ross McInerney, letter to Olive Cotton, 10 January 1952, collection of the McInerney family.
6 Ross McInerney, letter to Olive Cotton, 16 January 1953, collection of the McInerney family.
7 Haidee McInerney, conversation with the author, 2 March 2013.
8 Haidee McInerney, telephone conversation with the author, 15 February 2013.
9 Helen Ennis and Sally McInerney, *Olive Cotton: Photographer*, p.17.
10 John McInerney, journal, 1945–1948, National Library of Australia, MS9718, p.83, entry 9/12/43.
11 Helen Ennis and Sally McInerney, *Olive Cotton: Photographer*, p.17.
12 Ibid., p.20.
13 Janet Hawley, 'When Olive went bush', p.33.
14 *The 'Cotton' primary speller (a sequel to the 'Cotton speller'): A word study and reference book designed to stimulate interest in and appreciation of words in reading, spelling and speech*, Angus & Robertson, Sydney, 1955. The endorsement was by Mr H.A. Williamson.
15 Helen Ennis and Sally McInerney, *Olive Cotton: Photographer*, p.14.
16 Unnamed author, 'Olive Cotton, artist', c.1992.
17 Helen Ennis and Sally McInerney, *Olive Cotton: Photographer*, p.14.
18 Candida Baker, 'The return of a naive photographer'.
19 See Niki Francis, *'My own sort of heaven': Rosalie Gascoigne's stellar rise to artistic acclaim*, PhD thesis, Australian National University, 2015, ch. 12, p.325. As Francis has noted, Rosalie Gascoigne referred to this in an interview with Robert Hughes: Rosalie Gascoigne Artist, Tape 8. The line is from 'Youth', a poem by Frances Croft Cornford.

On flying and other personal matters

1 P.A. Bourke, 'The Gilbert whistler in New South Wales', *The Emu*: official organ of the Royal Australasian Ornithologists' Union, vol. 54, March 1954, p.163; Olive's photograph is plate 20.
2 Sally McInerney, *Family Fragments*.
3 Paddy Keneally, letter to the editor, *SMH*, 18 January 2003.

4 See John Sinclair, *Sepik Pilot, Wing Commander Bobby Gibbes*, Lansdowne, Melbourne, 1971.
5 Sally McInerney, *Family Fragments*.
6 See Garry Wotherspoon, *Gay Sydney: A history*, NewSouth Publishing, Sydney, 2016.
7 Janet Cotton, letter to Olive Cotton, 16 October 1953, collection of the McInerney family.

Anecdote
1 Joan Brown, interviewed by Jennifer Gall, National Library of Australia, 1995, ORAL TRC 3294/5; Geoffrey Lehmann, *Leeward*, p.304.
2 Haidee McInerney, telephone conversation with the author, 15 February 2013.
3 Ibid; Barbara Beck, telephone conversation with the author, 16 February 2016.
4 Bill Johnson, conversation with author, 25 March 2013.
5 Lucy Lehmann, *Ampersand Magazine*, winter 2013, pp. 32-45.
6 Bill Johnson, conversation with the author.
7 Jean Cook, conversation with the author, 4 February 2004.
8 Bill Johnson, conversation with the author.
9 Geoffrey Lehmann, *Leeward*, p.304.

Cowra High School
1 Unnamed author, 'Olive Cotton, artist', c.1992.
2 Ibid.
3 Frank Walker, letter to the author, 5 February 2013.
4 Olive Cotton, letter to Ross McInerney, postmarked 11 January 1961, collection of the McInerney family.
5 Olive Cotton, letter to Ross McInerney, postmarked, 17 January 1964, collection of the McInerney family.

The Cowra studio
1 Helen Ennis and Sally McInerney, *Olive Cotton: Photographer*, p.14.
2 John McDonald, 'Olive Cotton: The Cowra Breakout', *Australian Financial Review*, 16 January 2003, p.41.
3 Ibid.
4 Ibid.
5 Ibid.
6 Helen Ennis and Sally McInerney, *Olive Cotton: Photographer*, p.64.
7 The exhibition was organised by Joy Ewart, who had painted Cotton's portrait for the Archibald Prize. Cotton's photographs were numbers 140–4 in the catalogue: *Power house, Lily, Winter willows, The Budapest String Quartet* and *Radio telescope*.
8 Helen Ennis and Sally McInerney, *Olive Cotton: Photographer*, p.23.

'The new house'
1 Mike Ladd, telephone conversation with the author, 15 March 2014.

Careworn

1 Mrs Hilda E Wright, 21 July 1975, National Archives of Australia, NX144787 B883.
2 Mrs Hilda E Wright, 3 July 1975, National Archives of Australia, NX144787 B883.
3 Newton wrote a pioneering monograph on Dupain in 1980, which, however, made only passing mention of Olive Cotton: Gael Newton, *Max Dupain*, p.29.
4 Barbara Hall, 'Finding our way, tracing their footsteps', *Australian Women Photographers 1890–1950* [exhibition catalogue], George Paton Gallery, Melbourne University, Parkville, Victoria, 1981, p.3.
5 Ibid., p.6.
6 Max Dupain, 'What women managed to achieve when the camera was primitive', *SMH*, 24 June 1982.
7 Ibid.
8 Unnamed author, 'Olive Cotton, artist', c.1992.

PART SIX

Striking a chord

1 The exhibition was held from 9 October to 3 November 1985.
2 Candida Baker, 'The return of a naive photographer'.
3 Richard Coleman, 'Vanished scenes of town and country life exposed in a lifetime's photography', *SMH*, 3 December 1983, p.42.
4 The Director of the ACP in 1985 was Tamara Winikoff. Young photographers who showed that year included Ruth Frost, Christopher Koller, Steven Lojewski, Anne MacDonald and Les Walkling.
5 Barbara Hall, 'Introduction', *Olive Cotton Photographs, 1924–1984*, Australian Centre for Photography, Sydney, 1984.
6 Ibid.
7 Ibid.
8 Jill Stowell, 'Six decades of creative imagery', *Newcastle Herald*, 3 April 1986, p.5.
9 Sandra Byron, 'Olive Cotton: Photographs 1924–84', *Photofile*, Sydney, no. 4, summer 1985, pp.28–9.
10 Ibid
11 Ibid.
12 Max Dupain, 'Olive Cotton: Works that act as the soul's narcotic'.
13 John McDonald, 'Capturing our changing image', *SMH*, 27 February 1988.
14 Ross McInerney recounted this incident to the author.
15 Max Dupain, interviewed by Clare Brown, 19 July 1990, MS 93, Box 2, Folder 8.

The conversational space

1 Unnamed author, 'Olive Cotton, artist', c.1992.

Wild plum

1 Pierre Bonnard, https://nga.gov.au/bonnard/detail.cfm?IRN=122444.
2 Unnamed author, 'Olive Cotton, artist', c.1992.

'Unbroken time'

1 Rosalie Gascoigne, quoted in Janine Burke, *Field of Vision: A decade of change: Women's art in the seventies*, Penguin Books, Ringwood, Victoria, 1990, p.36.

2 Olive Cotton in *Light Years*, a film about her life and work by Kathryn Millard, Lexicon Films, 1991.

3 Ibid.

4 Quoted by David Malouf, *The Happy Life: The search for contentment in the modern world*, Quarterly Essay, 41, 2011, p.2.

5 Ibid., p.3.

6 Ibid., p.45.

7 See Susan Sheridan, *Nine Lives: Postwar women writers making their mark,* UQP, St Lucia, 2011.

8 Barbara Hall, 'Introduction', *Olive Cotton Photographs, 1924–1984*, Australian Centre for Photography, Sydney, 1984.

9 Helen Ennis and Sally McInerney, *Olive Cotton: Photographer*, p.53.

10 Ibid., p.12.

11 Candida Baker, 'The return of a naive photographer'.

12 Olive Cotton, letter to Mike Ladd, 9 November 1993, correspondence provided to the author by Ladd.

13 Max Dupain, 'Olive Cotton: Works that act as the soul's narcotic', p.14.

14 Ibid.

15 Edward Said, 'Thoughts on *Late Style*', *London Review of Books, vol. 26, no. 15, 5 August 2004.*

16 Ibid.

17 See Ross King, *Mad Enchantment: Claude Monet and the painting of the Water Lilies*, Bloomsbury, London, 2016, p.304.

18 Helen Ennis and Sally McInerney, *Olive Cotton: Photographer*, p.51.

Life review

1 Olive Cotton, interviewed by Diana Ritch.

2 Max Dupain, interviewed by Clare Brown, 23 August 1990, MS 93, Box 2, folder 8.

3 Ibid.

4 Ibid.

5 Susan Chenery, 'Out of the shadows', p.52.

6 Kathryn Millard, letter to the author, 15 April 2016.

7 Unnamed author, 'Olive Cotton, artist', c.1992.

8 Ibid.

9 Ibid.

10 Janet Hawley, 'When Olive went bush', *Good Weekend, SMH*, 16 May 1998, p.35.

11 Ibid.

12 Ibid.

13 Unnamed author, 'Olive Cotton, artist', c.1992.

14 *The Age*, 15 August 1987.

15 Unnamed author, 'Olive Cotton, artist', c.1992.

The 1990s
1 Kathryn Millard, letter to the author, 15 April 2016.
2 Ibid.
3 Ibid.
4 Ibid.
5 Ibid.
6 Ibid.
7 Diana Dupain, *The Sydneian*, no. 329, March 1993.
8 Ibid.
9 Mike Ladd, telephone conversation with the author, 15 March 2014.
10 Exhibitions were held concurrently at the Josef Lebovic Gallery in Sydney and Deutscher Fine Art in Melbourne to coincide with the release of the National Library of Australia book.
11 Joanna Mendelssohn, 'Three Artists: Olive Cotton, Judy Cassab and Louis Kahan'.
12 Ibid.
13 Felicity Fenner and Jenny Bell, *Clarice Beckett, Olive Cotton: In a certain light*, Ivan Dougherty Gallery, Sydney, 1995, unpaginated.
14 Ibid.
15 Ibid.
16 Ibid.
17 Olive Cotton, unpublished notes, collection of the McInerney family.

Moths on the windowpane
1 Ernst Beyeler, *Paul Klee: Fulfilment in the late work*, Fondation Beyeler, 2003, p.123.
2 Edward Said, 'Thoughts on *Late Style*'.

Packing up the studio
1 Tom Carment, 'Olive's studio', www.tomcarment.com/stories/2005/6/7/olives-studio.html.

Leaving Ross, two
1 Published in Lucy Lehmann, *Ampersand*. Lucy also made a short film, *Five Hundred Acres*, in 1997, which was shot at Spring Forest.

A force for change
1 Due to delays with the completion of the Ian Potter Centre: NGV Australia building at Federation Square, the latter did not eventuate.
2 Edmund Capon, foreword, Helen Ennis, *Olive Cotton*, Art Gallery of New South Wales, Sydney, 2000, p.4.
3 Robert McFarlane, 'Talking Cotton down on the farm', *SMH*, 17 May 2000, p.21.
4 Bruce James, exhibition review, 'Arts today', ABC Radio National, 24 May 2000.
5 Lisa Byrne, 'Olive Cotton', *Muse*, August 2000, p.10.
6 These group exhibitions include: Mirror with a Memory: Photographic portraiture in Australia, which I curated for the National Portrait Gallery, 2000;

Federation: Australian art and society, curated by John McDonald, National Gallery of Australia, 2001; Sydney Moderns: Art for a new world, curated by Deborah Edwards, Art Gallery of New South Wales, 2013; Dreams and Imagination: Light in the modern city, which Melissa Miles curated for Monash Gallery of Art, Melbourne, 2014; The Photograph and Australia, curated by Judy Annear, Art Gallery of New South Wales, 2015. In 2016, Olive received sustained attention in the National Gallery of Australia's touring exhibition, Max and Olive, curated by Shaune Lakin, Senior Curator of Photography.

White irises
1 See, for example, the *SMH*, *The Australian* and *The Daily Telegraph*, to name a few; and *Art Monthly Australia*, *Art and Australia* and *Photofile*.
2 Quoted by Sharon Verghis, 'Humble pioneer of modernism dies', *SMH*, 1 October 2003.
3 Gael Newton, National Gallery of Australia, email, 18 October 2003, NGA artist's file.

'The rifle bird's song'
1 Ross McInerney, letter to the author, 29 October 2002.
2 Ross McInerney, letter to the author, 23 February 2004.
3 Ross McInerney, letter to the author, 2 November 2003.
4 Ross McInerney, letter to the author, 3 April 2004.
5 Ross McInerney, letter to the author, 21 October 2003
6 Ross McInerney, letter to the author, 7 November 2003.
7 Sally McInerney, letter to Jean Lorraine, 6 February 2005, collection of the McInerney family.
8 Ibid.

'The owl and the pussycat'
1 Janet Hawley, 'When Olive went bush', p.35.

On listening
1 Robert Dessaix, *Twilight of Love: Travels with Turgenev*, Pan Macmillan, Sydney, 2004, p.229.
2 Ibid
3 Ibid.
4 Haidee McInerney, conversation with the author, 2 March 2013.

Light and shade
1 The alternative title is *Mountain shadow, Wollomombi Gorge, NSW.*

Acknowledgements

The origins of this biography go back to the mid-1980s when I first met Olive Cotton. She and her husband, Ross McInerney, were wonderfully warm, generous friends over many years. Their daughter, Sally McInerney, has been at the heart of the project, providing me with access to vital information and sharing her insights into the past and those who inhabited it. I am also indebted to Olive and Ross's son, Peter McInerney, and other members of the extended Cotton and McInerney families, especially the late Haidee McInerney, Bill Johnson, Merren Coad, Pat Harrison, Robyn Richardson and the Reverend Miriam Cotton.

My thanks to Geoffrey Lehmann, who kindly gave permission to quote from his poems, and to Margaret Page, Ross McInerney's partner in his last years, for her hospitality and lively conversation.

Clare Brown's pioneering biographical research on Max Dupain has been vital. I have drawn extensively on the interviews she conducted that relate to Olive's life with Max Dupain. They have informed and enlivened the narrative in ways that would otherwise not have been possible.

Those who shared their reminiscences of Olive were numerous. They included the late Tony Annand, the late Barbara Beck, the late Joyce Evans, Anne Harris, Heather Kiely, Mike Ladd, Cathy Laudenbach, Deirdre Macpherson, the Murray girls, Annette Guterres, Marie Learmont, Louise Oehlers and Christina Murray, Frank Walter, Merilee Webster and Jill White.

Kathryn Millard, director of the documentary film *Light Years*, was a wise, thoughtful colleague. Greg Daly shared his enthusiasm for Olive's work, which culminated in the 2002 exhibition he curated for Cowra Regional Art Gallery. Liza and Nigel Chalk showed me through the Cotton's former home, Wirruna, in Hornsby. Josef Lebovic, director of the Josef Lebovic Gallery in Sydney, helped with various enquiries.

Niki Francis was an amazing research assistant. Others who provided invaluable research leads were Jenny Gall; Craig Hoehne (on Geoffrey Powell); Rose Cullen, Local Studies Librarian, Northern Beaches Council; Bridget Minatel, Archivist, Sydney Grammar School (in relation to Max Dupain); and Elena Taylor.

The project was dependent on the assistance of colleagues around the country over two decades and I would particularly like to thank: Julie Robinson, Senior Curator, Prints, Drawings and Photographs, Art Gallery of South Australia; Isobel Crombie, Deputy Director, National Gallery of Victoria; Nat Williams, Treasures Curator, and staff at the National Library of Australia; and staff at the Mitchell Library, State Library of NSW. Judy Annear, former Senior Curator of Photography, Art Gallery of New South Wales, was dedicated to ensuring Cotton's work would be better known and appreciated. At the National Gallery of Australia, Shaune Lakin, Senior Curator of Photography, who curated the exhibition Max and Olive in 2016, was unstinting in his support; Peta Jane Blessing, Archivist, and Thea Van Veen, Rights and Permissions Officer, were also very helpful, as was Gael Newton, former Senior Curator of Photography.

My research and writing were supported in a number of other crucial ways. In 2012, I was awarded a New Work Grant from the Literature Board of the Australia Council, and a Peter Blazey Fellowship, which gave me time to write during a residency at the Australia Centre, University of Melbourne. The *ABR (Australian Book Review)* George Hicks Fellowship, 2013, meant I could refine my material at an important stage. The result of the fellowship was the essay 'Olive Cotton and the Spring Forest years', published in

ABR in July 2013. I have greatly appreciated the encouragement of Peter Rose, editor of *ABR*.

My colleagues at the Australian National University School of Art & Design, especially Professor Denise Ferris, Head of School, have been supportive throughout the project. A research fellowship funded by the Humanities Research Centre, Research School of the Humanities at ANU provided me with teaching relief in 2014.

This book has also benefited from discussions with many other generous and inspiring colleagues, among them Magda Keaney, Kim Mahood, Angela Woollacott and Nicole Moore.

My friend Helen Maxwell and I frequently visited Olive and Ross during the 1990s with my sons Ben and Jack, which we always greatly enjoyed. Helen, my father David Ennis, Tim Bonyhady, Anne Brennan, Sally McInerney and Claire Young read the manuscript and helped make this a better book. Ben and Jack assisted with photography and archival research and, with their partners Rose and Amy, were steadfast in their support.

At Fourth Estate, I am indebted to Catherine Milne, publisher, who embraced this biography well before it was formed, and to Scott Forbes, Senior Editor, for his exemplary professionalism.

To my partner, Roger Butler, once again, I owe my greatest debt. He has brought his knowledge, meticulousness and sensitivity to this project and nurtured it over many years.

Index

Page numbers in **bold italics** refer to images.
For an index of Olive Cotton's photographic works,
see page 533.

Index

Index

531

Index of Olive Cotton's photographic works

Page numbers in **_bold italics_** refer to images.

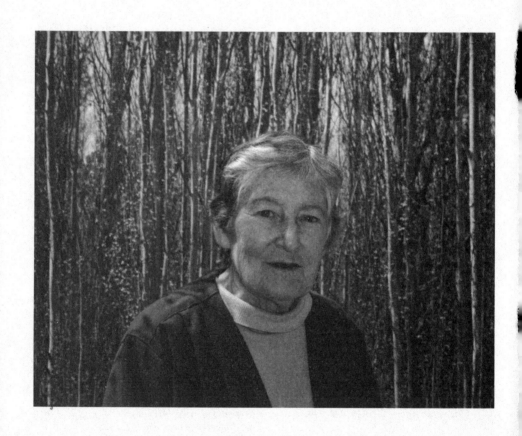

Sally McInerney, *Olive Cotton at Spring Forest*, 1995, National Library of Australia, nla.obj-136357346